The Business of Tomorrow

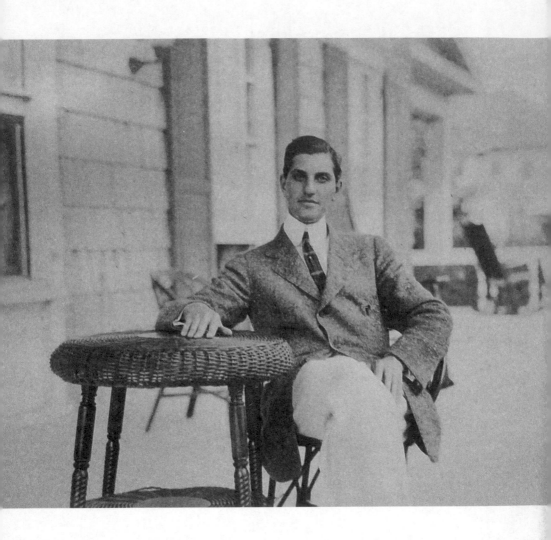

THE
BUSINESS
OF
TOMORROW

The Visionary Life of Harry Guggenheim—
From Aviation and Rocketry to the Creation of an Art Dynasty

DIRK SMILLIE

PEGASUS BOOKS
NEW YORK LONDON

THE BUSINESS OF TOMORROW

Pegasus Books, Ltd.
148 West 37th Street, 13th Floor
New York, NY 10018

First Pegasus Books cloth edition October 2021

Interior design by Maria Fernandez

Library of Congress Cataloging-in-Publication Data is available.

ISBN: 978-1-64313-420-8

10 9 8 7 6 5 4 3 2 1

Printed in the United States of America
Distributed by Simon & Schuster
www.pegasusbooks.com

For Lorelei, beloved

Contents

Introduction

N itin Nohria, former dean of the Harvard Business School, once coauthored a study of how business leaders of the air age shaped the history of aviation. In his introduction, he admitted one bias: a passion for flying (and memberships in million mile clubs at three airlines). When Nohria left India for America, he arrived in a Boeing 747 jumbo jet. "Some of my best memories are travels on airplanes."

In the study, Nohria and his Harvard team revealed a hidden figure in aviation—a "foundational entrepreneur"—whose influence they compared to digital pioneers Jeff Bezos (Amazon), Meg Whitman and Pierre Omidyar (eBay), and Larry Page and Sergei Brin (Google). The study concluded that this entrepreneur, having received "scant mention" in aviation history "may have actually had more influence on the eventual growth of the U.S. airline industry than the Wright brothers." That entrepreneur was Harry Frank Guggenheim.

A pilot himself, who was obsessed with flying, Harry used every financial tactic he could think of to advance aviation—microfinance, public-private partnerships, R&D grants, safety and design competitions, airplane reliability tours. At a time when most people had never seen an airplane, Harry believed aviation would one day be fundamental to the transportation infrastructure of the United States.

Using his family's great wealth, Harry bet big on flight technology and devised alternative metrics to assess the results. He helped create a viable business model for aviation and transformed public acceptance of flying. In doing so he jumpstarted the air age, possibly by decades. In fact, the very 747 Nohria boarded for America was invented by Joseph Sutter, graduate of an aviation engineering school funded by Harry Guggenheim.

At the turn of the century the Guggenheims operated the largest mining conglomerate on earth. Six decades later the Guggenheim museum opened, creating a landmark in New York and recasting the family as stewards of a global art brand. Harry carried the torch between the old and the new eras, connecting them with a record of aggressive philanthropy and entrepreneurship. Aviation was just the first chapter of Harry's life. Impact investor, technologist, start-up accelerator—Harry played a multitude of roles across five different sectors of American business, gambling large chunks of the family fortune on enterprises it had never been in.

For nearly a decade Harry was the sole financial backer of Robert Goddard, the father of modern rocketry. Goddard's work became the foundation of the space age. From there, Harry went on to publishing and the arts. With wife Alicia Patterson, he cofounded Newsday, the nation's most successful suburban newspaper. Late in life, he led the building of the Guggenheim museum, mediating between two contentious forces: architect Frank Lloyd Wright and the Guggenheim's director, James Sweeney.

Those who knew Harry did not mince words in describing him:

- *Fiorella LaGuardia*, former mayor of New York City: "the guy who put one over on me in Italy"
- *John Hanes*, Roosevelt's undersecretary of the treasury: "He was a very brilliant man"
- *Frank Lloyd Wright*, architect: "Harry doesn't like controversy. Harry likes to win"

- *Charles Lindbergh*: "He was an extraordinary and wonderful man, and among my closest friends"
- *Thomas Messer*, third director of the Guggenheim museum: "a tyrant"
- *Madeleine Albright*, former secretary of state "the man who alternately charmed and intimidated us"
- *Bill Moyers*, former LBJ press secretary and publisher, Newsday: "His intuitions I found all admirable. It was his opinions that were not."
- *Gen. James (Jimmy) Doolittle*, WWII air ace: "A great American"
- *Alicia Patterson*, Harry's third wife and cofounder of Newsday: "that son of a bitch"

Harry's first two marriages, as he saw them, were his only true defeats—their failures entirely his fault, he said.

As his investments weaved their way into the very fabric of American life, Harry made forays into politics and diplomacy. He had the ear of five U.S. presidents, spending time with each in the Oval Office. His years as U.S. ambassador to Cuba during the revolution were more than he bargained for, nearly costing him his life. Among his closest friends was Charles Lindbergh—a relationship that survived searing criticism on the eve of WWII.

Until now, Harry's story lay buried among the five major works produced on the Guggenheim family over the decades. Within those collective 2000 pages of family history, he remains a Delphic figure. A deeply private person, he left behind no journals, diaries, or memoirs. His letters to friends, family members, and business associates are at times revealing, but opaque when it came to his inner thoughts. He was patrician, at times aloof, and even those closest to him said he was a difficult man to figure out. Yet Harry clearly wanted to be understood and remembered. He bequeathed to the Library

of Congress some 115,000 items—a massive trove of consequential and quotidian memos, notes, correspondence, reports, legal papers, speeches, and business documents over six decades. He left his home, Falaise, to be administered as a museum, choosing how its furniture should be arranged and what items in his bedroom would be seen by visitors.

As a writer at *Forbes* for a decade, I've been fascinated by stories of how great family business dynasties were built. Most do not last. Often the second or third generation doesn't possess the ambition or the imagination to carry on a family enterprise in a modern era. In many cases the next generation is simply content to enjoy their inherited wealth, making a career out of leisure. Harry chose a different path. The institutions he built over his lifetime, and the impact they continue to have, form one of the great business backstories of the 20th century.

Bandits and Bullion

I

In the summer of 1891, William and Solomon Guggenheim faced the most dangerous journey of their lives. Their destination was a small town in Mexico, where they would establish the next great outpost in the Guggenheim mining empire. They would bring the family's vast knowledge of extracting metals from the earth to a land whose enormous mineral wealth had been mined for centuries, yet remained largely untapped. In the coming years the Guggenheims would build railroads, hire steamboats, erect smelters, and construct entire mining towns to transform millions of tons of ore rich with copper, silver, lead, iron, zinc, and other metals that would find their way into newly electrified American homes, military munitions, automobiles, and factories. The metals unlocked from their mines in Mexico and elsewhere would fuel the Second Industrial Revolution.

But Mexico's earthbound riches lay untapped for a reason. For most of the 19th century Mexico was a land of unending war, political upheaval, and revolution. There was the War of Independence (ending Spanish colonialism); the Mexican-American War (losing Mexico one-third of its

territory to the United States); the Caste War of Yucatán (touched off by the Mayan uprising of 1847); and the occupation of Mexico by France in the 1860s. Nearly every president of Mexico in the 19th century had been a military commander.

To some in the Guggenheim family, sending William and Solomon to this land of chaos and revolution was a fool's errand. What experience had they traveling to isolated deserts, high plains, and remote mountain passes where a chance encounter with bandits, revolutionaries, or renegade soldiers could be fatal? But if they succeeded in staying alive, the rewards would be staggering. Both brothers had proven themselves in business—William, yard foreman at the Guggenheims' giant smelter in Pueblo, Colorado, and Solomon, who had successfully handled the sale of the family's early businesses in Europe. They could be relied upon to capitalize on the Guggenheims' many contacts in the country and to find the right sources for acquiring building materials and labor. Their father, Meyer, had chosen them as much for their wits and gumption as their business acumen. After crossing the border that summer, Solomon, a man of refined tastes whose name would someday grace a world-famous museum in New York City, strapped a pistol to his belt each morning and traveled with armed lookouts. William, the youngest of the seven Guggenheim brothers, did the same.

Meyer Guggenheim sensed a coming change in the political culture of Mexico. He believed, correctly, that the nation was finally entering a period of political stability. Lawlessness and revolution defined the old Mexico. With the mining know-how of the Guggenheims and investments from a new wave of foreign speculators, then-president Porfirio Díaz sought to shape a new Mexico. Díaz would dangle tax breaks and make sweetheart land deals to entice foreign investors to build a national infrastructure where none existed. What was coming was a boom era of economic development: the *Porfiriato*.

Díaz could usher in this new age because he controlled all the levers of power, including a rubber-stamp legislature. His generals and military

leaders, who ran the provinces and the cities, enjoyed the fruits of this new engagement with foreign capitalists. In the decade following William and Solomon's arrival in Mexico, some $1.2 billion in foreign investment flooded into the country, growing its gross national product by an average of 8 percent each year. To do business in the new era, investors like the Guggenheims naturally had to pay local authorities the *mordida* (or bite in Spanish, slang for bribe). If one wanted to site a railway line to a new mining claim, or secure water rights to operate machinery, the right *mordida* would be proffered to police or local military units. A mordida would also be paid to ensure safe transport of the weekly *raya*, or payroll, typically a thousand or more pesos sealed in canvas sacks.

William and Solomon's destination that summer was Monterrey, a small town in northeastern Mexico. They would oversee construction of a giant smelter modeled after the Guggenheims' existing plant in Colorado. At the time Monterrey was a town of some twenty-five thousand inhabitants, mostly indigenous Indians occupying one- and two-story limestone homes. Ringed by a series of peaks, Monterrey's defining landmark was a giant notch resembling a saddle on a mountaintop, the *Cerro de la Silla*, or Saddle Hill. In the years of the *Porfiriato*, Monterrey had begun to modernize. Yet it remained a town of insular poverty. Streets were poorly cobbled and unpaved; the smell of sewage hung thick in the summer air. Its residents were deeply suspicious of outsiders. As one account of life there noted: "The men of the town hid beneath their huge hats and talked about the coming of the yanqui while their wives pounded the corn with mortar and pestle and took the family wash to the creek to scrub."

Extracting silver in Monterrey was backbreaking work, still done in the ancient ways. Ore taken from the mines was spread across shallow pits, then crushed into a fine gravel with huge stone rollers. The ground rock was then sprinkled with mercury, salt, and blue stone (a crystalline compound), then trampled by a herd of mules. Known as the "patio method," the crushing action caused a chemical reaction in which the silver dissolved

into the mercury which, when heated, would give up the silver. Until the arrival of the Guggenheims, such practices in Monterrey had changed little in 350 years.

II

William Guggenheim wanted to be as close as possible to the new smelter, located just six miles out of town. He set up his living quarters on the property—essentially a shack thrown together by two-by-fours, wood planks, and sheets of corrugated iron. His Scandinavian chief engineer, Van Yngling, lodged nearby in a two-story farmhouse. William was introduced to middlemen who, in turn, brought laborers and construction materials to the site. According to William, construction proceeded as planned until late one moonlit night, when screams from Van Yngling's bedroom shattered the desert silence. Men cursing and feet scuffling across the floor could be heard, then nothing. Alerted to the melee, William rushed to the ground floor of the home. Stepping inside, he noticed blood dripping through the wood planks of the ceiling, pooling on the stone floor below. Upstairs, William's chief engineer, nearly hacked to death, was still alive. "His assailants, who had gained access to his room by raising a ladder to the window, had literally cut him to pieces. He was bleeding from almost 30 jagged wounds, and died soon after the doctor arrived," wrote William. Accounts differ as to whether the attack came from workers angry over a wage dispute or retribution for an affair Van Yngling was having with a local landowner's wife.

A short while later William himself was the target of a robbery-turned-murder. He had taken a train ride to inspect the prospective site of a tunnel to be built at the Guggenheims' Reforma Mines, a series of mammoth lead deposits the family had secured in northeast Mexico. At that time the train only ran to the town of Monclova. From there one had to travel farther by horse and wagon over some sixty miles of dry, sandy roads marked only

by an occasional small village. William got there a day late. Stopping at a nearby village, he found it "wild with commotion." On the evening prior, when William was expected, the owner of a nearby hacienda was driving his wagon in the dark and, mistaken for William, was ambushed and killed. His young son was found wandering in the mountains the next day. Later captured, the murderers "confessed that they had slain the wrong man, mistaking him for William Guggenheim, their intended victim, knowing he was due and believing that he was carrying considerable money and valuables with him."

The Guggenheims quickly learned to hire engineers and managers proficient not just in metallurgical science, but in handling weapons and bluffing enemies. A man who possessed such talent was John Hays Hammond, later the Guggenheims' chief engineer in Mexico. Hammond was the prospecting world's version of Indiana Jones, a survivor of countless engagements with hostile Native American tribes and rogue units of the Mexican military. Some of the most dangerous mining districts he traveled through were deep in the state of Sonora, in western Mexico, its mountains and deserts inaccessible except by mule and horseback. On the rare occasion when Hammond's wife traveled with him, he gave her a loaded pistol. Better to commit suicide than be captured by hostile forces, they agreed.

Traveling on behalf of the Guggenheims one summer in a remote stretch of mountains, Hammond took an extra precaution, hiring fifteen Yaquis and organizing them into his personal bodyguard. The customary weapon was a machete, but Hammond bought rifles for his hired troops and taught them expert marksmanship. These skills came in handy at Minas Nuevas, an old silver mining works the Guggenheims asked Hammond to take over as superintendent.

Given the site's 2,000-foot elevation and isolated setting, Hammond immediately set about building fortifications around an old hacienda serving as the gateway to the compound. He expected it would be just a matter of time before they were accosted, and Hammond was correct. A band of about

one hundred revolutionaries on horseback soon arrived. A "colonel" rode up to Hammond, explaining that he was sorry to have to exact a *préstamo* (forced loan) upon the camp. He needed to buy corn for his horses. Hammond looked him dead in the eye and declined the request. Undeterred, the colonel warily eyed the Yaquis at the camp, making the absurd suggestion that Hammond lend him all of his bodyguards' rifles so that the colonel's troops might protect Hammond from the Indians he himself had hired. Nearby Yaquis were in the midst of an uprising against Mexican authorities and would surely turn on Hammond, warned the colonel. Hammond waved off the concern and explained that his well-armed bodyguards had no intention of giving up their weapons. The colonel, losing patience, then set down an ultimatum: if Hammond didn't turn over his men's weapons, they would be taken by force. Hammond, unfazed, stated that he was ready for such an attempt. Who would be first to try to scale the high adobe wall surrounding the hacienda before being torn apart by a hail of bullets? asked Hammond.

The siege went on for days, but Hammond would not yield. As he recalled: "Our appearance was, indeed, formidable. In addition to our barricade, we had mounted several locomotive headlights with which we were able to sweep the surrounding country after nightfall. Furthermore, we carefully allowed the secret to leak out that, concealed all about the premises, were dynamite caches which could be exploded by an electrical apparatus. This extraordinary preparation for warfare made such a decided impression that, after several days of blood-curdling threats and a few potshots to let us know they were beaten but unbowed, the disconsolate patriots moved off and left us free to continue our labors."

III

Hammond delivered many financial triumphs to the brothers while working for the Guggenheim Exploration Co. (Guggenex), the mining development

entity the family firm had begun. His uncanny sense of discovering new mining properties and forecasting their payouts was well worth his wildly high compensation. Under a five-year contract Hammond's salary was $250,000 a year (about $6 million today), plus a percentage of the yield of the mining properties he located. At the time his compensation was believed to be the highest salary paid by a U.S. employer. With Hammond's expertise, Guggenex rivaled the U.S. Geological Survey in its breadth and depth of knowledge of mining wealth in the United States.

The brothers could afford Hammond's salary; labor costs in Mexico were far cheaper than in parts north, and Mexican silver was generally purer than the ores of the American West. The push into Mexico would be a clever end run around the punishing economic effects of the McKinley Tariff of 1890. It came about, in part, because Colorado miners were angry at the flood of cheap ore coming from Mexico. That drove down wages. To protect American mining companies from such foreign competition, the act had established a massive jump in ore import duties.

The tariff had much to do with why William and Solomon came to Mexico in the first place. Over dinner one evening with his seven sons back at the family's New York home on W. 77th St., Meyer vented his frustration and proclaimed a solution: "Our government is very foolish. If we can't bring Mexican ore to Pueblo, let us take a smelter to Mexico." The Guggenheims did just that, circumventing the crushing new tariff by building their own smelters in Mexico. They were modeled on the Colorado plant, whose six massive furnaces could process over 100,000 pounds of ore a day.

In the summer before Solomon and William's trek, Meyer used his Mexican legal and diplomatic contacts to arrange for a meeting between his oldest son, Daniel, and President Díaz. Daniel would meet with Díaz at the National Palace on the Plaza Zócalo, built on the ruins of the palace of the last Aztec emperor. As one account described it: "In a stately, high-ceiling room in the old Palace, Díaz and Daniel Guggenheim sat down together. . . . The physical contrast between the two principals was striking.

Díaz was then sixty, and an impressive figure. His high, wide forehead sloped up to still white hair; his eyes were alert and piercing. He had powerful jaws, a massive square chin, a large expressive mouth, a short thick neck, and a snowy mustache. There was a challenge in the lift of his head. He looked the fighter that he was. Opposite him was the well-turned-out American. Daniel had just reached his forty-fourth year. He, too, was short, but less stocky than the dynamic Díaz. His hair was prematurely white; his hazel eyes were friendly; his whole personality exuded charm. He made a graceful foil for the muscular President."

The Guggenheims received their concession from Díaz, allowing them to import machinery across the border at little or no cost; to establish smelters, one for copper in the south, at Aguascalientes; another for lead in the north, at Monterrey; and to pay no state or local taxes inside the country for two decades. It was a prescient deal. By the turn of the century, Guggenheim-owned smelters processed 40 percent of the lead and 20 percent of the silver mined in Mexico.

The deal with Díaz was a milestone for the Guggenheims, setting off an expansion of the family metals business into one of the most powerful mining companies on earth. Decades later, new institutions would define the Guggenheim brand—New York's Guggenheim Museum and a $315 billion Wall Street firm, Guggenheim Partners. Yet the roots of all these businesses—mining, the arts, Wall Street—owe their origins to a period of family history even further back in time, and to a single investment of a few hundred dollars in stove polish.

IV

In 1848 the first Guggenheims immigrated to Philadelphia from Lengnau, a tiny Jewish community just twenty miles north of Zurich. Lives of Jews and Christians were segregated in this tiny community. Separate entrances

for the two faiths remain visible today in many homes there. Anti-Semitism existed in the New World and the Old, but the Guggenheims of the mid–19th century were astonished to read letters from relatives who had emigrated to the United States describing a culture where one could get ahead regardless of one's station in life. There was discrimination, yes, but no laws preventing Jews from entering certain professions, as there were in Lengnau. So one day Simon Guggenheim (Meyer's father) and his future wife, a widow, and her children emigrated to Philadelphia. The area was populated by the Pennsylvania Dutch, whose German language they spoke. The Quakers and Swedes who lived there were more welcoming to them than many of their Christian neighbors in their own Swiss community.

In America, Simon could afford but a tiny home for his large family in a working-class Philadelphia neighborhood. He and son Meyer traveled door-to-door selling household "notions"—spices, embroidery, and their top seller: stove polish. Once applied, it stopped cast-iron stoves from rusting. But stove polish of that day made the hands filthy and was tough to clean off. So young Meyer employed a new formula to make the polish easier to remove: he added soap to its ingredients. Investing several hundred dollars of his profits into materials to produce the polish himself, he later bought a sausage-stuffing machine to fabricate chunks of polish into uniform sizes.

This innovation made Meyer's polish a favorite. The proceeds allowed him to expand into another product, with even greater promise: "essence of coffee." Like Howard Schultz, Meyer Guggenheim didn't invent coffee—he just served it better. At the time coffee was a luxury enjoyed by the wealthy. Why shouldn't the masses enjoy it, too? To sell to a broader market, Meyer bought low-quality beans and ground them with ingredients like chicory, which added flavor, and possibly baking soda, which neutralized acid and gave it a smoother taste. This product, too, was a financial hit.

Meyer married his stepsister Barbara and soon moved the family to a bigger house in a tonier corner of Philadelphia. Meyer, a slight man whose bristling sideburns had grown into muttonchop whiskers, was by

all accounts a dignified, private character. But when he saw the huge rewards small innovations could bring, his mind began to burn up with ideas. He kept a constant eye out for other underserved business niches that he could boldly push. He opened a tailor shop and a grocery. During the Civil War his coffee sales boomed, as did his sales of mustard seeds and wooden shoe pegs to the Northern Army. (Wooden pegs, a seemingly obscure item, were needed by the thousands to attach soles to shoes.) Then Meyer set his sights higher, looking for opportunities in established businesses with limited competition that could be expanded. During the war he bought the patent rights to a lye-making company. He then improved the production process and lowered prices, undercutting a larger competitor who had held a virtual monopoly on the business. The move forced the competitor to buy him out, landing him $150,000 cash (about $2.3 million today).

Meyer and Barbara's family grew rapidly: first came Isaac, Daniel, Murray, and Solomon; then Jeanette and Benjamin, followed by twins Robert and Simon; and then William, Rose, and Cora. Robert died at age nine, leaving seven brothers and three sisters.

After the Civil War Meyer invested in a small, financially strapped railroad line he believed would someday form part of a larger route. Another good gamble. He bought the railroad stock cheap then sold it for a premium to railroad titan Jay Gould, who bought him out for $320,000 (nearly $5 million today). Another opportunity emerged when a distant relative in St. Gall, Switzerland, offered Meyer a consignment of excess inventory he held of lace and embroidery. In the late 19th century, handmade lace was used everywhere—tablecloths, pillows, dresses. Discovering that a new generation of machines could produce the material faster and at lower cost, he foresaw some nice margins in the business. Meyer sent sons Daniel, Murray, and Solomon to learn the business in Europe. He built small factories in St. Gall to mass-produce the fabric. Son Isaac was dispatched to New York to open an office to receive the lace imports. With the next generation firmly

embedded in the family enterprise, Meyer recast the business as a partnership and called it M. Guggenheim's Sons in 1881.

The surplus from Meyer's embroidery sales and earnings from stock market deals got him thinking about an offer from a former partner in his grocery venture. It began as a loan request for Meyer to cover the investment costs of two silver mines in Leadville, Colorado: the A.Y. and the Minnie (named for its owner, A. Y. Corman, and his wife Minnie). Apparently Meyer didn't take to heart Mark Twain's reported definition of mines at the time: "A mine is a hole in the ground owned by a damned liar!"

Meyer didn't think his former partner was a liar, but neither did Meyer want to be a lender. He wanted a better position on the deal. A counteroffer was made: How about an equity investment of $5,000 for a one-third interest in the two mines? His partner accepted. As time went on the mines yielded little if any earnings. And then the shafts of the mines flooded, shutting down operations. Distressed, Meyer traveled to Leadville to assess the situation firsthand. Another partner wanted out and sold part of his share to Meyer, giving Meyer a controlling interest. Ever the optimist, he doubled down. Meyer hired an engineer and purchased four 25-horsepower steam pumps to "dewater" the mines and ordered the excavations be dug deeper. Operations restarted.

Some weeks later, back in New York, Meyer received a telegram from Leadville: RICH STRIKE, FIFTEEN OUNCES SILVER, SIXTY PERCENT LEAD. It was incredible news. Meyer would soon be earning about $1,000 a day. Stove polish was a good start. But Leadville was the real beginning of the Guggenheims family's path to staggering wealth.

As Meyer further invested in mining it became obvious who was making the real money—and it wasn't him. To extract the precious metals of his mines, every pound of ore had to be run through a smelter, which separated metal from rock using high heat generated by furnaces. Smelting required far less labor than mining. Charges by smelter operators often meant that smelter owners were making more money in fees than Meyer was making

from his raw ores. The future of the family firm became instantly clear. Meyer would wipe out the middlemen by building his own smelters.

One day he crystallized this business philosophy to his sons: "My boys, I can see great things coming in this country. Watch those railroad men! They are taking little railroads and tying them together. The little (rail) roads fight each other and nobody makes much money. They join, and there's millions, and you hear of Vanderbilt, Fisk, Gould, men of many, many millions. The time is coming in this fine country of ours when all these businesses will be big. Either big, or nothing at all. You will be gobbled up there, in your little business. America is growing. You must grow with it. Forget about your little laces. Many years ago I carried a few yards of lace with me up and down Pennsylvania and New Jersey, selling a little here, a little there. I saved money, I forgot about peddling and went into a bigger business. Ever since I have gone into bigger businesses. And now I intend to go into the biggest business of all. Maybe it will cost me a million dollars. And what is a million in a country like this? Nothing!"

Meyer sold the embroidery factories in Europe and built his first smelter in Pueblo, Colorado, strategically placed at the crossroads of where ore would originate from the A.Y. and the Minnie in the north and from mines in Mexico to the south. Just as the Rockefellers would move from oil wells into oil refining, the Guggenheims would move from mining into smelting. Two decades later the growth of this new business would prompt the meeting between Daniel, grandson of a stove polish peddler, and the president of Mexico at the Presidential Palace in 1890.

A final milestone that year: Daniel's second son, Harry, was born. The future patriarch would someday run the family enterprise and, like Meyer, take the Guggenheims into businesses they had never before dreamed of entering.

The Apprentice

I

Harry's early childhood years paralleled an era of ferocious growth in the family business. As Bernard Baruch, financier and longtime business partner of the family put it, the Guggenheims "roamed the globe in search of profitable holdings, stripping the hillsides of Nevada, Utah, and New Mexico of copper porphyries; developing tin mines in Bolivia, gold mines in Alaska, diamond fields in Africa, rubber plantations in the Belgian Congo, copper mines and smelters in Mexico and copper mines and nitrate fields in Chile." They were aided by the frothy public markets. Bonds and securities spread the risk and enabled colossal economies of scale for their mining operations. As Baruch put it: "It was the Guggenheims who made mining an investment."

In the late 19th century copper was about the best investment of all. Copper transmission lines made the era of the telegraph possible. Copper wiring laid the foundation for the electrical age. Imagine the volume of copper wire required to lay telegraph lines along the thousands of miles of US railroad routes (the telegraph was used to transmit times to keep

railroads running on time), and to Western Union offices throughout the United States, and later to Europe via undersea cable. Imagine the staggering quantities of copper wire required to build out the nation's electrical grid, city by city, to small and large towns, transmitting AC current to private homes, apartment complexes, office buildings, municipal works, and hotels.

Imagine everything else that required copper: textile factories and chemical plants, ships' hulls and locomotive engines, roofs, doorknobs, locks, drawer pulls, curtain rods, faucets, valves and pipes, pots and kettles, clocks and watches, coins, medical tools, shell casings for ammunition needed for pistols and rifles, and every variety of military weapon and explosive. Copper was used in heaters, defrosters, radio components, radiators, the patinas of public sculpture. (The Statue of Liberty was made with 179,220 pounds of copper.) World copper production went up tenfold between the years 1880 and 1890. Not a bad business to be in.

So the Guggenheims found new mines and built new smelters, transforming themselves from silver barons to copper kings. But it was just the beginning of M. Guggenheim's Sons. The new incarnation of the family firm had been formed to manage Meyer's booming mining businesses, making each of his seven sons an equal partner. If there was one dynastic imperative, it was Meyer's emphasis on consensus decision-making. As family lore has it, Meyer gathered his sons around the meeting table one day and handed each one a slender stick, following the old Aesopian fable. He told each son to break it; each stick snapped easily. Then Meyer reached down and produced a tight bundle of another seven sticks and passed it around the table, asking each brother to break it. None could. "So it is with you," said Meyer. "Together you are invincible. Singly, each of you may be easily broken."

The power of that unity played out on a grander stage during Harry's childhood. It was the era of the great trusts, and in the mining world there was none bigger than the one forged by Henry Rogers, the man who had helped create the Standard Oil trust. Rogers used the oil trust

as the template for his mining enterprises, consolidating smelters and ore refineries scattered around the country. He rolled up these independent lead, silver, and copper smelters into a cartel-like entity called the American Smelting and Refining Company (ASARCO). This consolidated company drew an extraordinary market capitalization. Some, Benjamin and William included, felt the stock was wildly overinflated. Still, it posed a competitive threat to the smaller collection of Guggenheim mining interests. The brothers' answer was to create their own public company, Guggenex (Guggenheim Exploration Co.) in 1899. But to do so required more investment capital than the brothers possessed—they would have to bring in outsiders like William C. Whitney and his son. (The latter would take a seat on the board.)

Two years later ASARCO faced financial problems. Its leadership pressured the Guggenheims to join the trust. Meyer turned to the son with the greatest business savvy, Daniel, to fend off their rival. Daniel thought up a better hand to play. After declining to join ASARCO, Daniel turned the tables, quietly engineering a series of stock purchases that soon formed a controlling stake in his larger competitor.

Taking control of ASARCO was a deft countermove. It gave the Guggenheims control of the most powerful mining business on earth. Soon after, the brothers teamed up with J. P. Morgan and Jacob Schiff to form the Alaska Syndicate, purchasing Alaska's Kennecott Mountain and hundreds of thousands of acres around it to develop one of the biggest copper reserves in history. The freezing Arctic wilderness had no infrastructure, of course; everything was built from scratch, including a 200-mile railroad constructed over moving glaciers and river deltas, creating a path from the copper mountain to the sea.

The ASARCO takeover solidified Daniel's position as the next family patriarch. But opening family ventures up to outsiders and becoming beholden to the public markets irked the younger brothers. In 1901 William and Benjamin resigned, unbundling the seven sticks.

II

After Meyer and Barbara moved their family from Philadelphia to New York, all the brothers found homes in and around Manhattan. They were now in the financial and media capital of the world. The battle for ASARCO had played out in the nation's newspapers, turning the remaining five brothers into business celebrities. Virtually any comment on any business topic by one of the Guggenheims became newsworthy. Daniel and his brothers now managed an expansive network of mines and smelters from the Rockies to the Sierra Madres, in North and South America. At the birth of the 20th century they controlled much of the world's copper and some 80 percent of its silver, generating wealth that would place them alongside the Rockefellers, Fords, Astors, and Vanderbilts.

Most well-to-do New York families of that time built or bought summer retreats outside the city. The Guggenheims gravitated to West End, New Jersey, a kind of Jewish Newport. Their homes were just down the road from the Seligmans, the Loebs, the Lehmans, and the Bloomingdales. Meyer played the gaming tables and bet at the nearby Monmouth race-track but never wagered extravagant sums. In those days most people weren't born in hospitals, but at home, so it was in West End that Harry, the second son of Florence and Daniel, was born on August 23, 1890, delivered by Dr. Simon Baruch (father of Bernard), a former Confederate surgeon who was the family physician for both Meyer and Daniel. The home was probably a summer rental—Harry's parents later built their own summer estate, Firenze, in Elberon, an unincorporated community just south of West End. Daniel named it after his wife, and the fact that Florence was her favorite Italian city. Harry was their second child; his older brother, M. Robert, was born five years prior; his sister, Gladys, arrived five years after Harry.

All three children would spend summers at Firenze, where two white marble lions sat regally beside its entrance. Inside, the enormous foyer was

supported by Roman columns, a white marble floor covered with rugs and animal skins, a realm of nobility. There were Pompeiian-style bronzes arrayed near a fountain framed by palms and ferns. Red silk damask lined the walls of the library. The portrait gallery reflected Daniel's Old World tastes, displaying Corots, Daubignys, and Homer Dodge Martin's master-piece, *Westchester Hills*. The home was designed by Carrère & Hastings, architects of the New York Public Library (where a similar pair of famous white marble lions guard its entrance). Harry, his siblings, and his cousins had the run of the estate, from riding stables and tennis courts to chicken coops and two 400-foot greenhouses. Daniel was a gentleman gardener, with belladonna lilies among his favorite plantings.

In building these summer retreats, each brother labored fiercely to outdo the others. Nearby was Solomon's estate, The Towers, a fantastical Moorish-style residence festooned by turrets, minarets, balconies, and cupolas (locals referred to it as Aladdin's Palace). Spanning some one hundred rooms, visi-tors often got lost inside. A set of stained glass windows on a second-floor parlor room were embedded with medallions, each representing an event in Guggenheim family history. Not to be rivaled by Solomon or Daniel, brother Murray commissioned his own Beaux Arts masterpiece, also built by Carrère & Hastings. Murray and wife Irene modeled the thirty-five-room mansion after the Grand Trianon in Versailles.

The brothers' mansions were jokingly called "cottages" (as seasonal visi-tors to Maine call their summer estates "camps"). Harry and his cousins delighted in coming and going from these architectural wonders all summer. All but one cousin seemed to enjoy their time in Elberon. (Peggy Guggen-heim, one of Benjamin's daughters and enfant terrible of the family, didn't care for the town, calling it "the ugliest place in the world.")

Growing up, Harry was never close to his older brother, Robert, appar-ently his mother's favorite. Florence shared Robert's wry sense of humor and fawned over his good looks, defined by a strong, square jaw and deep-set eyes. All of Robert's frivolity, his never-ending goofing off, and failure to

take anything seriously, seemed to bring nothing but affection from Florence, and jealousy from Harry.

Harry instead drew close to cousin Edmond, the son of Uncle Murray and Aunt Irene. Edmond was two years older than Harry and his first business partner. When Harry was ten, Daniel thought the time had come for his son and Edmond to gain some sales experience. The cousins were given responsibility for raising chickens at Firenze and peddling their fresh eggs to a buyer in New York, all arranged by Daniel. "For months the youthful partners tended incubators, mixed rations, repaired the ravages to their hennery by an autumn cyclone, and delivered eggs to the manager of the St. Regis Hotel, their principal customer." After two years of sales, Daniel closed the business. Harry later wrote, "Father's objective was to give us experience in business and to teach us how easy it is to lose money. . . . We got the experience and father lost the money."

III

At age eleven Harry got his first chance to address a public audience, though his remarks are unknown. The occasion was the dedication of a limestone synagogue on the grounds of the Jewish Hospital in Philadelphia in memory of Henry S. Frank, the husband of Florence Guggenheim's sister Rose. The Franks were close to Daniel and Florence; they traveled and spent time together socially in Elberon. A year before Harry was born, Henry Frank died, leaving Florence's sister a widow. Harry's middle name, "Frank," was likely chosen in honor of Florence's late brother-in-law.

The Guggenheims were big donors to Jewish charities. But Meyer and Barbara were also members of Temple Emanu-El, New York's fashionable flagship of Reform Judaism. Meyer felt Orthodox Jewish practices reinforced the Guggenheims' "separateness" at a time they were seeking to assimilate into American culture. They did not wish to be hyphenated Americans. This

distancing from orthodoxy, beginning with Meyer, continued with Daniel and Florence, and with their children. The third generation of Guggenheims in America would attend nondenominational private schools, and some would marry into non-Jewish families.

As the family mining empire grew Daniel and Florence and their three children moved from their home in Philadelphia to a larger, more stylish townhouse at 12 W. 54th St. in Manhattan. The neighbors were just ordinary folks, like the gentleman who lived two doors down and came to the doorstep one day, ringing the bell and saying, almost apologetically, "I just thought I'd drop by to be neighborly." It was John D. Rockefeller Sr. On spring weekends Harry spent time at the family riding stables near the home of Meyer and Barbara, who lived at 36 W. 77th St., a brownstone just a block off Central Park, facing the Museum of Natural History.

Harry and Edmond enjoyed wreaking havoc together, especially when the victims were unsuspecting aunts and uncles at Friday night gatherings, a tradition the family continued at Meyer and Barbara's Manhattan home. Around the dining room table, beneath a brilliantly lit chandelier, some twenty or more Guggenheims would come for dinner. There was always talk about the days in Mexico and the latest news from the partners' mining properties. Harry and Edmond were too young to yet play a role in the family business, but one night they put on a vaudeville-inspired skit lampooning Wall Street, which brought Meyer to tears of laughter. In the evenings Harry and Edmond found perverse pleasure in occasionally breaking off a finger from a statue in the front parlor, or once stealing their uncle Isaac's new silk hat and using it as a flying projectile, leaving it in tatters. Eventually Meyer had enough and banned both cousins from attending the Friday night dinners together, forcing them to alternate their appearances.

After Meyer died in 1905 while vacationing in Florida, Harry and Edmond staged a final act of defiance. As the huge funeral procession left Temple Emanu-El heading to Meyer's final resting spot in Salem Fields,

Brooklyn, Harry and Edmond ditched the motorcade and headed to a nearby bar for beer and sandwiches.

Such mini-rebellions wouldn't have gone over well amid the buttoned-down order of the Columbia Grammar and Preparatory School, attended by both Harry and Edmond. One of New York's elite private schools, it was founded just prior to the Revolution in the rear of an upholstery shop. It had been a prep school for King's College (now Columbia University) but ended that affiliation in 1864. By the early 1900s the school had one hundred students in attendance, many from prominent Jewish families. The school was in a four-story building on E. 51st St., then under the reign of Benjamin H. Campbell, a Dickensian character who headed the school for some forty years.

Headmaster Campbell left a lasting impression on Harry. He was a short, "falcon-eyed" gentleman with a "terrifying exterior." He had done well in the stock market and lived in a Victorian mansion in Elizabeth, New Jersey (nightly dinners were served by an elderly butler). Campbell wore the same Victorian coat and beat-up hat for years, never held faculty meetings, and enforced frugality: "Every scrap of paper was saved, every piece of string small or large was carefully rolled up for future use." No one, not even the assistant headmaster, was allowed into his office. Apparently Campbell required such privacy lest a call come in on the private phone he installed, keeping him in touch with his Wall Street broker during trading hours. If he was buying Guggenheim mining stocks at the time, he probably did well.

IV

Harry thrived in his years at Columbia Grammar. He became president of the school's Literary and Debating Society at age fourteen, making a winning argument against Tory political policies. Unlike his father Daniel, a small, barrel-chested fire hydrant of a man, Harry was thin, tawny in

complexion, his face set off with pale blue eyes, with unusually long, tapered fingers on hands resembling those of a concert pianist. Harry made the school's hockey and football teams and clinched first place hurling the twelve-pound shot put at the school's field games one spring. In his junior year Harry was a member of Columbia Grammar's automobile club. School records list him as the driver of two vehicles: a 1906 Mercedes (forty-five horsepower) and a Marsh motorcycle. The Marsh resembled a bicycle with a small single cylinder engine in the middle of its frame.

Driver's education being a thing of the future, Harry and Edmond motored around New York and out to Elberon with no particular regard for traffic laws. Over three years, the teens racked up four speeding arrests and one car crash. At fifteen Harry was arrested for speeding on Staten Island, pulled over by a much-exasperated bicycle cop. The policeman, after catching his breath, likely explained to Harry that the legal limit was 8 mph and Harry was doing 40 mph. (Edmond provided the $100 bail to spring his younger cousin before his court appearance.)

One winter day, when Harry was seventeen, he and Edmond were cruising along Broadway on Manhattan's West Side when they spotted a sidewalk altercation involving a group of boys (apparently known to them). Edmond pulled over and engaged the group. As much shouting ensued, the cousins failed to notice the electric streetcar bearing down on them some 150 yards behind. Edmond attempted to restart his car but the engine would not turn over. Moments later the trolley crashed full speed into the back of the vehicle, sending both cousins flying through the air. Apparently neither was badly injured. Later, when Edmond racked up his third speeding offense in two years, he was sentenced to a day at the Tombs, a notorious New York City jail. Luckily for Edmond, the sentence was pronounced at 3:00 P.M., and the Tombs closed at 4:00 P.M.—his time served a mere thirty-five minutes.

In early 1907, Daniel and Florence watched their neighbor Rockefeller accelerate his buying binge of nearby homes, including ten properties on the

Guggenheims' block. Harry's parents decided on a change, moving around the corner to a ten-room suite at the St. Regis, a luxury hotel just completed by John Jacob Astor. Its eighteen stories towered over the nearby homes of the Vanderbilts and Rockefellers. Daniel and Florence's children would be looked after not only by their own personal housekeepers, but by the hotel's house and kitchen staff. Growing up in a hotel didn't suit Harry or his sister Gladys. The stream of visitors coming and going, phones ringing, packages arriving—it was all a constant annoyance. Hotel butlers and maids were always interrupting things. When it came to meals, the children often ordered off the room service menu, whose items rarely changed.

After Harry's high school graduation he and Edmond were off on another trek, this time to Idaho, where the two went fishing and hunting at a camp the Guggenheims and Harrimans shared. It had been decided that Harry would enroll in the Sheffield Scientific School at Yale that fall, where John Hays Hammond occasionally lectured. Daniel was grooming Harry to enter the family business, as Meyer had groomed him. Returning to New York, Harry started his freshman year at the Sheffield School learning the building blocks of the metallurgical world: how to assay bullion; the workings of reverberatory furnaces and electrolytic refining; methods of extracting cadmium and mercury; and the use of mine machinery. He joined the cross-country and track teams and the gun club (he was an average shooter, ranking fifth that fall) and tried out for the Drama Association (but appears not to have won a slot). Harry was more interested in Yale's tennis team—during his summers at Elberon he had developed into a gifted player. Here, too, he hit a wall. Harry was denied a spot on the Yale squad, rebuffed by what was said to be an anti-Semitic coach. Records at Yale offer few other clues about his freshman year. But sometime during his first term he spoke to his father about taking a hiatus from formal education. He had met a young woman—it was possible he might soon start a family. Daniel thought it over and approved of the hiatus on the condition Harry agree to an apprenticeship at one of the family mining properties. Harry enthusiastically accepted,

perhaps reasoning that one week at a Guggenheim mine or smelter would be more instructive than a semester's worth of theoretical courses.

It would have been easy for Harry to choose a property operating within the safety of his own country. But the stories of his uncles' Mexican exploits were legendary. Why not live some of his own adventures in a faraway land? Whatever his motivations, he appeared to have gained his father's acceptance of an assignment south of the border. So Harry left Yale after one term, packed several trunks of belongings, and headed to Aguascalientes, hub of Guggenheim mining operations in Mexico.

<p style="text-align:center">V</p>

To get there Harry would have traveled to El Paso by rail then transferred to the Mexican Central Railway, controlled at the time by an American business syndicate. On this route he would likely have taken Daniel's private railroad car, the "Starlight," used by his father on trips to Mexico City. It was the Air Force One of train cars, similar in layout to his uncle Solomon's private car, which ran about eighty feet long, with an observation room at one end, two bedrooms and bathrooms, a large dining room in the center, and at the opposite end a pantry, kitchen, and sleeping quarters for servants.

The railcar journey through Mexico indeed brought some of the lore of the family business to life. Landscapes rolled by unlike any Harry had seen in New England: forests of tall Saguaro cactus, fields of cottonwood, blooms of fiery red ocotillos and yellow desert marigolds. The mountainous peaks on the horizon rose to attain seemingly spiritual heights. When Harry reached his destination he found a town built upon volcanic hills overlooking the Aguascalientes river. Its hot springs drew entire Mexican families, some coming for the waters' medicinal properties, others simply to wash their clothes. The town's oldest thermal springs flowed inside old stone bathhouses. Over each door were the names of John the Baptist and his

disciples. Next to each apostle was the water temperature. Upon entering, a young boy arrived with a tray that held neatly folded towels, a jagged square of pink soap, and a soft-bristled maguey brush.

Harry would have explored the town's dozen or so plazas, walking through the lush Jardín de San Marcos and the Tivoli de Hidalgo. The residents of Aguascalientes passed the time in simple ways, elderly men beneath shade trees selling horsehair hats, groups of young women gathered around small tables, swathed in sarapes, their shiny black hair pinned back neatly. Brilliantly colored embroideries slowly emerged from the precision of their threadwork.

Outside Aguascalientes lay agricultural lands rich with corn, wheat, barley, black beans, chickpeas, and lentils. The town had a postal service and telegraph office and traded the wares of its pottery works and tanneries with other towns in nearby states. Its distilleries produced Licor de Tuna, a potent brew from the brilliant red fruit of the prickly pear cactus. For those who could afford to ride them, recently built electric trams ran from the east side of town to the Plaza Principal, and to the Guggenheims' smelter works, about five miles northwest of town.

Reporters back in New York soon learned of Harry's assignment at Aguascalientes. One headline summed it up: FUTURE HEAD OF SMELTER TRUST A DAY LABORER. Harry's early days were humble beginnings indeed: "Notwithstanding the great wealth of his father, young Guggenheim is shown no favors by the local officials and employees of the smelter here in the matter of employment . . . When he came down here in a private car and applied to the manager of the local plant for a position he is said to have been told that the only opening was in the ore bins, where he would have to work with a gang of poor and tattered Mexicans."

On his first day Harry arrived in blue overalls, a cotton jumper, and a large sombrero. He brought dinner with him—a handful of tamales—inside an old lard bucket. He watched and learned how to sort ores, feeling the

muscles in his back and arms harden up from the labor. He was paid $1 a day and reported to two people: the affable B. T. Colley, a Scotsman and expert trout fisherman who was assistant superintendent at the Guggenheim smelter; and William C. Potter, who from 1905 to 1911 was general manager of the southern department of ASARCO. Potter was fifteen years Harry's senior; he came from a New England family of old colonial stock. A sharp inquisitive nose, tall forehead, and cleft chin gave him a severe look, as though he were permanently glowering. In the beginning, there was no small talk with Potter; he was all business. But over time Harry came to know and admire his boss. He also got along well with Potter's quiet, artistic wife, Carol, whom Harry likely first met on one of his visits to see Potter at ASARCO's Mexico City office.

Harry's daily routine included visits from a Spanish tutor hired by Potter. Harry kept his father apprised of what he was learning at Aguascalientes via mail. Many of Daniel's early missives to Harry bristled with parental advice and thoughts on achieving success. What was important for a young person, wrote Daniel, was a cultivation of the mind. He sent Harry a great number of books to read. Harry in turn recommended books for his father to read. One suggestion was the classic suspense novel *The Man from Wall Street*. Daniel, apparently no lover of fiction, hated it, writing back: "I appreciate the gift . . . but not the book. Life is too short and it is an absolute waste of time to read something that has no merit."

In another letter to Harry, Daniel noted, "Nights wasted are a poor recompense for you in after years." Daniel had good reason for wanting his son to be steeped in the values he felt had brought the family success. "The present number of failures in life, as I see it," he wrote Harry, "are due to lack of tenacity." Another letter references a passing down of the family legacy: "I am expecting you to relieve me in the not too distant future. You have the brains, I am confident. I hope you will not fail in the tenacity."

VI

During his Mexico days Harry grew a fulsome mustache—every Mexican worker had one. When he departed Aguascalientes for site visits to mines he would typically begin by railcar then join a mule train for the balance of the journey. To the northwest, a trek through the Sonoran Desert would have been physically arduous, even for a teenager. Sweat pouring off his brow, his legs would ache from hours of riding muleback. A trip like this would require a pack train of a dozen or so mules and horses, a scout, possibly several engineers, a translator, and a cook. On a typical journey the slow-moving caravan would come to agonizingly long halts, awaiting the sign from the lookout rider a mile ahead of them. Seeing no bandits or hostile forces in the area, the scout would signal an all-clear by waving a handkerchief in the air. The group could then move forward, eventually arriving at one of the many Guggenheim copper, silver, lead, or iron mines. In the late afternoon frijoles and tortillas would be the staples. Meat was scarce because guns were required to hunt live game, and guns were expensive. Indigenous Mexicans, able to hit a rabbit with a boomerang-like throwing stick at a great distance, faced no such dilemma. Harry's pack train would be eating better, of course, bringing more sumptuous items like jerked beef, canned vegetables, and preserved fruit.

The locations of Guggenheim mines stretched far into the Mexican frontier and onto the high plateaus of the Sierra Madre Occidental; and to central Mexico and the mining towns of Zacatecas, Guanajuato, Pachuca, Catorce, Matehuala, and Las Charcas. Even with the Guggenheims' modern mining methods, working conditions would be a shock to any first-time visitor. It would have been an odd juxtaposition for Harry, traversing the beauty of desert canyons and lush pine forests at high elevations, only to arrive in a small valley crowded with workman's shacks in the middle of nowhere, welcomed by the deafening poundings of the stamp mills.

Most of the mining workforce was unskilled laborers from rural areas comprising work crews under a contract system. Workers were paid by the task, or job, rather than daily wages. Harry would have seen the changeover of technology at the mines, from hand drills to pneumatic drilling, and that every mining camp was essentially an assembly line. At a silver mine a tunnel would be dug horizontally into the mountainside, with a vertical shaft then created by blasting. The climb down would be on long, notched pine logs, known as chicken ladders. Wherever the veins of silver ran, the human-cut shafts would follow. Shaft mining was dangerous work done by Mexicans and foreign workers who labored in poorly ventilated shafts prone to cave-ins and flooding. Laborers used steel-tipped iron rods to break loose chunks of ore and drop them into huge bull-hide sacks. The sacks of rock would be hauled up and transported to a stamp mill—essentially a mechanical rock crusher, which pulverized ore down to small fragments. The heavy stamps, resembling vertical poles with iron shoes at their base, would be raised and dropped on the rock with earsplitting effect, sending clouds of dust billowing out of the timbered frames housing the two-story device. As primitive as these mining works and refining methods might have appeared, they were leading the economic modernization of Mexico.

Returning to the U.S. in the summer of 1909, the comforts of home must have felt luxurious. For a while, Harry kept the mustache. Like many young men at nineteen, he liked cars and girls, so naturally he asked a young woman he had met before heading to Mexico to be his date at that summer's Carnival and Mardi Gras in Long Branch, New Jersey. The festival sponsored auto races and an over-the-top contest, the Auto Floral Parade. Harry apparently didn't enter the races that summer, but he did compete in the parade. Contestants turned their touring cars into outlandish floats of every shape and size. One was transformed into a model of the Wright Brothers' original flyer; another was cleverly engineered as a giant model of a sailing ship. Stiff competition, but Harry had gone all out, probably to impress his date. His float on wheels was a giant purple swan whose arching neck

bobbed at a height of twenty feet, its wings and body reportedly decorated with some 4,000 lilac hydrangeas. As it rolled down the avenue, a reviewer lavished praise: "The extended wings waved majestically in the breezes, and the towering neck, with bending head, made the ensemble more realistic." No doubt the largest swan ever sighted in New Jersey.

Nestled together on the back of the beast, in the driver's seat, were Harry and next to him his date, Helen Rosenberg. She was four years his senior, the daughter of German-Jewish émigrés. The pair drove slowly along the parade route, waving at a crowd who shouted their encouragement at the spectacle. The judges were impressed, too: Harry and Helen took first place. The newly christened king and queen of the floral parade would marry the following year.

But first Harry would complete the last leg of his Mexican apprenticeship. In the final stretch of his apprenticeship he studied how Guggenheim mining properties were managed, working out of the firm's Mexico City headquarters. The office was just a few blocks from Chapultepec Park, the regal home of President Díaz. Rumors were sweeping Mexico City that revolution was coming and Díaz could soon be overthrown. Francisco Madero, a wealthy landowner and scion of one of the elite families of Mexico, had challenged Díaz in the election that year. Madero gained widespread support and looked as though he would win. But just before the election Díaz had his rival arrested. Madero escaped from jail and fled to Texas, where he called for an armed insurrection against Díaz. Among those backing Madero was General Francisco "Pancho" Villa, leader of a large force of recruits in the north.

In Mexico there was much admiration for Madero's planned democratic reforms. To the Guggenheims he was an unknown. Madero had been deeply critical of President Díaz's sweetheart deals with U.S. and European business interests. How would a new regime deal with foreign investors? As the standoff between Díaz and Madero continued, Harry made a hasty return to New York.

In early November 1910, Harry and Helen arrived at New York's city hall to obtain their marriage license. Helen was twenty-four, Harry was only twenty, so Daniel and Florence had to authorize their consent. At the time Helen lived with her family and several servants in Manhattan, her father then earning a good living as a silk manufacturer. The late afternoon wedding was at the Rosenberg home, only family members in attendance, numbering about fifty guests. Edmond was best man. The couple elected not to have a reception, showing no interest in emulating the showy nuptials of other Guggenheim marriages.

His apprenticeship now over, it was decided that Harry would continue his studies abroad. Daniel had an English friend whose son was studying at Pembroke College, Cambridge's third oldest college and home to an accomplished tennis team. Harry and Helen apparently took an instant liking to the idea. A few weeks later they were steaming to England.

A Proper Education

I

H arry and Helen boarded the RMS *Lusitania* in late November, 1910, destined for Liverpool, then on to Cambridge. The journey would have given Harry plenty of time to contemplate his coming days in England. Pembroke College's five acres, like a tiny garden plot, sit just south of the city center and are a short walk to the River Cam. The river—really a shallow canal—divides Cambridge, with colleges occupying land on both sides of the waterway. Students and tourists have for decades climbed into the flat-bottomed boats, or punts, traversing the water with a guide standing in the rear, Venetian-style, extending a pole into the gravelly bottom to nudge the boat gently along—"punting on the Cam." What emerges on this route are the famous "Backs"—the rear sides of colleges like St. John's, Clare College, Trinity, and Magdalene. Most dramatic is King's College Chapel, its gothic spires soaring to extravagant heights. The chapel was begun in the late 15th century during the Wars of the Roses. Such scenes on this little waterway have remained largely unchanged for the past 500 years.

Harry had arrived at an ancient temple of English education. Pembroke, a constituent college of Cambridge, was founded on Christmas Eve, 1347, by Marie de St Pol, wealthy widow of Aymer de Valence, the Earl of Pembroke. In that year she was granted a license to establish a "house of scholars" by King Edward III. The Foundress, as she is known, sought to create Pembroke "for the salvation of her soul" and the souls of her late husband and other relatives, and to commemorate her marriage. At that time there were but four colleges within the University of Cambridge.

Over the next two decades the Foundress's bid for salvation grew: she added land to Pembroke's southern border, creating a garden and meadow, and erected a small chapel, the first in Cambridge. It was funded by Matthew Wren and completed by his nephew Christopher Wren, architect of St. Paul's Cathedral in London. The roughly thirty scholars at Pembroke had living quarters, a kitchen and dining hall, Master's lodgings, a barber, and a laundress. Medieval education focused on the arts and theology by means of lectures and debates. Pembroke's first scholars, also known as Fellows, shared rooms with one another, spoke in Latin, and followed the Foundress's far-reaching moral code. Drinking parties and outside guests were discouraged. Fellows were to pay all debts promptly. At all times, they were to "refrain from murmuring."

Theology was the touchstone of all constituent colleges at Cambridge, but Pembroke outdid its sister colleges by producing twenty-two bishops in its first 300 years. Most of them were former heads of the school. One was Pembroke master Nicholas Ridley, later the Bishop of London and Westminster, Pembroke's most famous historical figure. Ridley was a leading thinker on the new Protestantism and one of the most influential clerics in England, preaching sermons attended by the king. Unfortunately, as the Reformation tore England apart in the mid-16th century, Ridley wound up on the wrong side of the theological tracks.

In one sermon, before he knew of King Edward VI's death, he termed the princesses Mary and Elizabeth, putative heirs to the throne, as illegitimate.

Ridley was charged with heresy, arrested, and imprisoned in the Tower of London. Iron-willed and anchored to principle, he refused to recant. In October of 1555 Ridley and fellow Protestant Hugh Latimer, the Bishop of Worcester, were taken to a spot opposite Balliol College in Oxford, where they were chained to a stake. After bags of gunpowder were festooned around their necks, a fire was lit beneath them, and they began to burn. The sight was unbearable—Ridley's brother-in-law stepped forward and added kindling to the fire to shorten Ridley's suffering. The effort apparently backfired—Ridley's legs burned for some time before the fire consumed the rest of him. The former master's brutal death is well remembered at Pembroke. An ancient archway leads to Ridley's Walk, where a plaque commemorates his martyrdom, as do his portraits elsewhere on campus. Since Ridley's time Pembroke has produced some illustrious expats and alumni: Prime Minister William Pitt, Rhode Island colony founder Roger Williams, Israeli diplomat Abba Eban, audio innovator Ray Dolby, and the assassinated British MP Jo Cox.

When Harry arrived at Pembroke to begin classes in early 1911 he must have felt himself a time traveler. His early walks around Pembroke would have taken him along paths connecting seven centuries of architecture. He would have encountered medieval courtyards and perfectly kept lawns, tastefully cultivated gardens, cobblestone paths lined with rosebushes and creepers. He would have marveled at the magnificent stone carving of Pembroke's coat of arms over the archway of its 14th-century gatehouse on Trumpington Street, the oldest in Cambridge. Across that threshold one encounters Old Court's original chapel-turned-library, and Wren Chapel, constructed in the early 1660s and guarded silently by the neo-Gothic Victorian clocktower looming nearby.

In his early days at Pembroke he imagined his fellow students saw him as a "curiosity" and a "stranger from another land." In many ways he was. In a class of about one hundred students, he was the only American at Pembroke; one of only ten Americans at Cambridge that year. All students

were required to attend chapel; Harry's Jewish heritage would require a dispensation not to attend. As a married couple, Harry and Helen couldn't share the communal dormitories of young men at Pembroke. No matter, Daniel had found them a unique accommodation at the edge of campus.

Upon arrival Harry was greeted with some personal advice by the school's head butler, Arthur Chapman, known as "Chappie." As Harry recalled, Chappie told him, "Mr. Guggenheim, there are two types of people in this world: those with brains and no money, and those with money and no brains. The ones with brains are always trying to separate the ones without brains from their money." Harry took the admonition in the spirit given, which is to say: you're one of us now. He embraced this rapport with characters who have since become legendary at Pembroke. One was Harry's tutor, William Sheldon Hadley, a Fellow who came to the college several decades earlier to become a scholar of the classics.

Tutors meet with their charges throughout terms at Pembroke, acting as both academic advisors and liaisons to other parts of the college. Hadley was of stocky build, with close-set eyes and a lampshade mustache, an inveterate jokester with an expansive intellect. Over tea, the conversation might veer into a harangue on the misunderstood nature of the plays of Euripides, a mini-treatise delivered by Hadley with an actor's flourish. With Hadley as tutor, Harry would also have had the benefit of knowing most of his fellow students before meeting them. Hadley was known for his extraordinary recall of each year's incoming class—their names, their schools, the degrees they had earned. He and Harry developed a close friendship that would last many years.

Another influence on the freshman from America was Henry Gordon Comber, a Fellow and larger-than-life presence. A stout gentleman with piercing dark eyes, Comber's broad, bristling mustache formed a visual anchor to his massive bald dome, resembling a human battering ram. Like Harry, Comber had taken three years off in his teens to work in Latin America. (Comber worked in Valparaíso, Chile, where his father was a

lawyer.) Comber entered Pembroke as an undergraduate and a few years older than his peers. Most everyone at Pembroke affectionately called him the "Old Man."

Students at that time came to Pembroke from independent boarding and day schools across the U.K.—Harrow, Charterhouse, Aldenham, Malvern, Marlborough. The Old Man, from Marlborough, had been captain of the school's hockey team and possessed a contagious passion for university games. If Hadley was Harry's academic tutor, Comber was his athletic mentor. A jock to the core, the Old Man was twice captain of the hockey team and a promoter of the Lawn Tennis Club, a sport Harry excelled at during summers at Elberon. He and Comber would likely have spent time on Pembroke's grass courts and compared notes on respective family exploits in Chile and in Mexico. One could imagine Comber ribbing Harry that he, Harry, had apprenticed in the wrong country. Chile, with its relatively stable political system (although, like Mexico, suffering from widespread poverty), must have sounded like a Latin paradise compared to Harry's odyssey in Mexico, then in the midst of revolutionary fervor.

II

Of greater interest to Harry would have been Comber's tennis game. They could play on a set of private courts most Pembroke players had no idea existed. The courts were at the home Daniel rented for Harry and Helen—as usual, nothing but the best—a nearby seventeen-room estate called Leckhampton House. It was built in the 1880s by Frederick Myers, a schools inspector, and his wife, Eveleen, a gifted portrait photographer whose work is in London's National Portrait Gallery. Constructed on some six acres, the estate was of extraordinary size for a single student and his wife to occupy—about the size of Pembroke College itself. Naturally, Daniel had procured for Harry and Helen five servants: a housemaid, parlor

maid, kitchen maid, lady's maid, and cook. In addition, two tenants lived on the property year-round, husband-and-wife gardeners, residing nearby in a little cottage of their own.

Frederick Myers had died a decade earlier; his wife Eveleen now spent much of her time at her mother's home in London, hence their estate was available to rent. Leckhampton was built in the style of a Cotswold manor, consisting of the upstairs bedrooms for family and visitors, a balcony over-looking the gardens, a reception hall leading to a ground floor veranda, a south-facing library, drawing room, dining room, and servants quarters. Of particular emphasis were the tennis courts—the London architect who designed Leckhampton was a Cambridge Blue (a Blue is awarded to a Cambridge player on the winning team of any number of sports and their annual matches against Oxford) who later designed the elite Queen's Club courts in London.

Helen would have had the immensity of the Myers's garden to work in and enjoy, with Eveleen Myers likely making crucial introductions to members of the Cambridge social roster. Harry had classes to attend, social outings, and mentors like Hadley and the Old Man to spend time with. What would it be like for a young Mrs. Guggenheim during her time in Cambridge? In the era just prior to Helen and Harry's arrival, according to Gwen Raverat's biting memoir of the time, "It was a Utopia of tea parties, dinner-parties, boat-races, lawn tennis, antique shops, picnics, new bonnets, charming young men, delicious food and perfect servants." Over the decades, society life in Cambridge had changed little.

On Tuesdays during the spring term Harry's day would have started in the early hours at Leckhampton. Rail-thin and still sporting his Latin mustache, he would suit up in tennis whites to hit with one or more of the half-dozen members of the college's tennis team. It's likely the Old Man would have had some things to say about Harry's match play and baseline defense (and his apparent penchant for foot-faulting). At Leckhampton he could work on it all: half-volleys, topspin, slice serves. Harry's daily playing

schedule brought his game up considerably. Besides that, it surely beat riding a mule for hours under a blazing Mexican sun.

Following an early morning game, Harry might then take breakfast with Helen. From Leckhampton it would be a fifteen-minute walk to class along Sidgwick Avenue, a wide, quiet road lined with young plane trees. The path would take Harry over a cast-iron bridge straddling the Cam River, crossing into central Cambridge. Navigating the maze of medieval streets on the ancient campus, one would walk by many of Cambridge's constituent colleges, each marked by an ornately carved doorway portraying the college's coat of arms, each a mini-fiefdom bestowed by Royal Charter.

On Tuesdays and Thursdays Harry would walk or bike to a lecture hall for a 10:00 A.M. class with John Maynard Keynes, the man who would transform the world's economic paradigms and whose ideas would guide Franklin Delano Roosevelt and the New Deal. In those days Keynes still delivered his talks extemporaneously, not from a script, as he later would. Inside an amphitheater-like lecture hall, Harry and his classmates sat on long wooden benches arranged by raked seating. Keynes's wildly popular stock exchange talks drew standing-room-only attendance.

Harry would also see Keynes for private tutoring at King's College, just up Trumpington Street. Tutoring was a lucrative side business for Keynes, though he despised it, not because he disliked students, but because of the time it carved from his schedule. Arriving at Keynes's three-room office on Webb's Court, Harry might have noticed a pile of recent issues of Britain's prestigious *The Economic Journal*, to which Keynes had just been named editor. Harry would certainly have noticed the four-paneled mural of naked grape pickers, men and women cavorting in a vineyard during a harvest. The postimpressionist nudity was painted by Keynes's lover at the time, Duncan Grant. After tea and cake Keynes would lean his tall, lanky frame back into an upholstered chair, beginning a conversation about the workings of money markets or foreign exchanges. It was a

Socratic-style, question-driven dialogue. Keynes had a bit of a stammer, but it didn't matter; his clever, overwhelming intellect made it impossible to win any argument. Keynesian ideas held little sway with Harry, a young man raised in a family of deficit-hawk uncles—laissez-faire Republicans with little faith in state-guided investment or progressive taxes. On the other hand Keynes's belief in the agenda-setting power of business likely appealed to Harry. "Money . . . is, above all, a subtle device for linking the present to the future," Keynes would say.

Harry's extracurricular passions largely involved tennis and boating. He does not appear to have joined any of Cambridge's secret societies. Harry passed on the Night Climbers, whose ranks once included Lord Byron. (Harry would have admired the fact that the Climbers were always in jacket and tie, even when scaling chapel spires at odd hours, leaving behind small pieces of furniture at towering heights to prove their feats.) One venue Harry did spend time at was the elite Hawks Club on All Saint's Passage, probably as a guest of Henry Carlyle Webb, known as Carlie, a member there who had become Harry's doubles partner on the Pembroke tennis team.

III

Like Harry, Carlie Webb was an oddity. Carlie attended Christ's College and was perhaps the only student who happened to own a university while attending college himself. Carlie had inherited an agricultural school in Northern England years earlier after the sudden death of his father from pneumonia. The college was a radical institution for its time, set up by amateur farmers as an alternative for Northerners who couldn't afford to attend the Royal Agricultural Society. Harry clearly had little in common with Carlie's intimate knowledge of crop rotations and poultry science (excepting young Harry's "hennery" in Elberon). But on the tennis court they bonded,

finding their respective playing skills well matched. They quickly became a formidable combination in doubles play.

As much as Harry loved tennis, it was Pembroke's intellectual culture that made the freshman from New York feel as though he had landed in the right place. Afternoon tea with Hadley was never dull. Harry's tutor seemed bent on amassing the largest repository of texts on French history in England, evidenced by his 1,700-volume personal library on the subject. He was known to recount, sometimes with fanatical energy, his inventory of memoirs, narrative histories, rare manuscripts, and periodicals chronicling the French Revolution (which included interpretive histories from the English perspective). His collection included French journalism of the 1790s and editions of the early years of the illustrated *Revolutions de Paris* edited by Louis-Marie Prudhomme. Hadley's expansive interest in medieval French culture, in particular its art and architecture, is likely where Harry was first exposed to the ideas that would inspire, just a decade later, the building of his own estate, Falaise, in Sands Point, Long Island.

In the evenings Harry attended the nightly dinner, referred to as "Hall," where oil portraits of the martyred Ridley and other former Masters of the college, ancestral guardians of Pembroke, stare out in glowering judgment. The medieval dining protocols remain largely in force today: gowns are worn at Hall and grace is said before and after every meal. Fellows sit at the high table, passing a silver goblet and basin among themselves, pouring a little water onto napkins to refresh their faces. After dinner, the last Fellow in attendance gives a customary bow before leaving.

Back at Leckhampton, Harry and Helen lived a kind of horticulturist's dream, thanks to the home's prior occupants. Frederick and Eveleen Myers had left behind one of the most impressive gardens in all of Cambridge. It had been planted with yellow lilies, syringa and sweetbriar, pansies, roses, hollyhocks, crocuses, tulips, snapdragons, mulberries, marigolds, peonies, azaleas, and daffodils. The fruit trees of its orchards were laden with apples, plums, and pears. On the south side of the home was a towering

copper beech. As they developed this botanical wonderland, the couple used so much water for their gardens that they once drew a complaint from the local water utility, asking them to cut back.

Harry's home in Cambridge held one other claim to fame—a history of some odd significance, which the young Guggenheims would have become aware of early on. Just a couple of decades earlier the estate had been ground zero for Frederick Myers's experiments in psychic phenomena. Some of the world's most famous mediums had visited Leckhampton. Spiritualism, seances, hypnotism, and parapsychology were all the rage in Victorian England, much of it a reaction to a loss of faith in Christianity and the publication of Darwin's *On the Origin of Species*. Arthur Conan Doyle, Alfred Russel Wallace, and even Queen Victoria were passionate believers in the paranormal world.

At Leckhampton Myers cofounded the Society for Psychical Research with Henry Sidgwick, a tennis chum and founder of nearby Newnham College. The Society sought to investigate claims of spiritualism using scientific methods to test them. Myers, who coined the term *telepathy*, often had an assistant secretly observe séances at Leckhampton through a peephole in his secretary's office. These experiments drew some of Cambridge's leading thinkers, forming a prominent academic circle. "If you were an intellectual or a bohemian in Cambridge at the time, Leckhampton would have been a place you visited," said John David Rhodes, a widely published cinema scholar at Cambridge and current warden of Leckhampton. Among visitors to the house, prior to Harry and Helen's arrival: William James, a close friend of Myers's and once a lunch visitor, and Sir George Darwin, an astronomer and son of Charles Darwin, who participated in a séance at Leckhampton, "but was not persuaded" of the presence of spirits. It is not known whether Harry or Helen encountered poltergeists or experienced anything occult at the Myers's old home. (The séance observer's room at Leckhampton is now the property manager's office, the peephole blocked by a wall safe.) Yet the Society for Psychical Research continued to thrive

in Harry's day—John Maynard Keynes's appointment books reveal that he, too, attended its meetings.

IV

On trips down to London, or occasional jaunts to Paris, Harry would snap up books by the armful, for his father, for cousin Edmond, and no doubt a title or two for Hadley. In Paris Harry also had a close family connection: his uncle Benjamin kept an apartment there and lived in Paris for part of the year. He did so as president of the International Steam Pump Company, which built the elevators in the Eiffel Tower. On April 9, 1912, Harry met Benjamin for lunch in Paris—it was an afternoon to remember. Benjamin was married with a wife and three daughters, Benita, Hazel, and Peggy, all of whom were in New York, yet he lived the life of playboy entrepreneur (though of questionable success—at the time the steam pump company was burning through cash).

Benjamin had movie-star good looks, wore crisply tailored suits and high collars, favored boater's hats, and often tucked his umbrella neatly under his right arm—always a gentleman. Benjamin was also a veteran of those early, gritty days in Mexico. Over lunch that afternoon, which lasted several hours, Benjamin talked to Harry about his life since resigning from Guggenheim Brothers a decade earlier. Harry would have likely discussed the challenges of married life at college. Did he let on that Helen was pregnant? They might have spent more time together, except that Benjamin had booked passage to New York the following day. He would leave on a steamer from Le Havre in time to arrive for daughter Hazel's ninth birthday, he said. Harry was apparently the last family member to see Benjamin alive.

Upon arriving in Le Havre, Benjamin discovered his ship would be delayed due to a stokers' strike. He could still get passage, however, aboard the maiden run of the White Star Line's newest liner, the *Titanic*, departing

the following day. Ben booked a stateroom for himself and his valet, and reportedly a separate room for a young blond Parisian cabaret singer he was seeing. Late into the evening of April 14th, as the disaster unfolded and the mammoth vessel began its descent into the pitch black 28°F waters of the North Atlantic, Benjamin turned down a seat on a lifeboat. Keeping his wits, he went back to his room with his valet, Victor Giglio. The pair dressed in their evening clothes and returned to the freezing upper deck to help women into lifeboats. According to one account, Benjamin said they were going down with the ship "like gentlemen." Before they did, Benjamin asked his room steward, who would serve as an oarsmen on an escaping boat, to convey a message to his wife, Florette: "Tell her I played the game straight to the end and that no woman was left on board because Ben Guggenheim was a coward." By one account, Benjamin's Parisian mistress survived, stating to family members that Ben had saved her life by ensuring she got a seat in a lifeboat. She apparently booked passage immediately back to France and was never heard from again.

That year, while one Guggenheim was lost, another arrived. On Sept. 3, Harry and Helen's daughter Joan was born. The Myers's old nursery at Leckhampton would once again be used. The baby became Helen's new preoccupation as Harry spent more time at the Hawks' Club and on the tennis courts. In his third and final year at Pembroke, Harry's tennis game became all-consuming. He and Carlie Webb were an unbeatable combination in doubles play. Harry was named president of Pembroke's tennis team. To make it this far in a foreign culture, as an American—a Jewish American, no less—must have given him a sense of karmic satisfaction for the indignities he suffered at Yale.

England hosted Wimbledon that summer. Elimination rounds held at universities would winnow down players to the most talented contenders, and Harry's Pembroke squad was on a roll. They won the championship during the intracollege rivalry of Cambridge's other teams, clinching the "Cupper's Cup." That sent them to the ultimate university tennis rivalry:

Oxford vs. Cambridge. Harry and Carlie's luck held—the Cambridge team soundly defeated Oxford, earning its players the silver cup and a "Cambridge Blue." The Cambridge-Oxford win seeded Harry and Carlie high in the rankings—high enough for them to reach the first round of play at Wimbledon that year.

In 1913 Wimbledon had been around for nearly four decades and was already considered the preeminent tennis championship in the world. When the first day of the tournament arrived in late June, Harry and Carlie likely took the train from Cambridge to Wimbledon Station near Worple Road, the tournament's old playing grounds. Some 10,000 fans attended that summer. Among the innovations that year was a new "motor roller," resembling a small steamroller, used to flatten Wimbledon's famous grass, replacing horse-drawn rollers. Wimbledon's returning champion was Anthony Wilding, the matinee idol New Zealander who was perhaps the game's first real celebrity, educated at Cambridge a few years earlier. He was a handsome young man who drove by motorcycle to tournaments and had flown on prototype airplanes near Reims just a few years after the Wright Brothers flew their first solo flights at Kitty Hawk.

Players that summer came up through the All-Comers draw, placing Harry in the first-round men's singles. He immediately lost to a little-known Englishman (6–3, 6–1, 6–0). Then, uniting with his doubles partner, Carlie Webb, Harry must have gotten his second wind. The pair landed in the first-round of the men's doubles championship, pitted against two Englishmen—Henry Wilson-Fox, the son of Queen Victoria's physician and a future member of Parliament, and George Caridia, a two-time silver medalist in tennis at the summer Olympics just a few years earlier. Harry and Carlie knew that Caridia, in particular, would be formidable. But at the last minute an injury was reported on the opposing team. The Brits could not start. With this wild bit of luck, the set was ceded to Harry and Carlie as a "walkover," sending them to the second round without playing a stroke.

The doubles team they would now face comprised the Australian Ernest Hicks, a recent manager of that nation's Davis Cup team, and the German Oscar Kreuzer, who had won a bronze medal at the men's singles at the summer Olympics in Sweden.

It was a blisteringly hot day and press accounts of Kreuzer, a left-hander, were ominous. *The Guardian* termed him "the steadiest Continental performer ever seen at Wimbledon." Kreuzer had a gift for psyching his opponents into making errors, demoralizing them. He was a power hitter whose forehand matched a monstrous backhand drive, allowing him to cover the court while barely moving out of position. The pressure from the assembled crowd in the bleachers, always a factor in play, must have felt enormous to Harry and Carlie, the obvious underdogs.

As the match got underway spectators cheered at every stroke, their enthusiasm rising as the volleys went on. The first set started and ended with a thud for Harry and Carlie, who suffered a 6–1 defeat. Sensing a blowout, the crowds at Wimbledon likely had no compunction about yelling advice. The humiliation caused Harry and Carlie to fight back—they delivered a strong rally in the second game. But Kreuzer's volleys were like cannonballs. Harry's foot faulting was a problem. They lost again, 6–4. In the third match they would have given their all, taking chances, protecting the baseline at all costs and bringing the sharpest net game they could muster. It ended no better at 6–1. Harry and Carlie had been outmatched and outplayed. Their moment of glory was over.

By the time Harry took his final exams in the summer and winter of 1913, his academic exposure had included railway economics, how the Bank of England controls money markets, the U.S. financial crisis of 1907, the functions of jobbers and brokers on the London Stock Exchange, how the gold supply influences consumer prices, and the history of agricultural labor. He had studied Adam Smith and Robert Malthus and had been tutored by the already famous Keynes. In his chemistry exams, Harry's real world knowledge of Guggenheim mines would have made certain test

subjects a slam-dunk, such as the following question that appeared on his final exam: "Give a short account of the preparations and properties of the chief compounds of tin."

On Dec. 19, 1913, Harry graduated from Pembroke, having achieved a third class in Chemistry and a second class in Politics. These were average grades. But to an American, the pomp and circumstance of earning an undergraduate degree at Cambridge must have felt something like a knighthood. Graduation took place at Cambridge's Senate House, the entire affair conducted in Latin, beginning with a silent procession of academic dignitaries entering the great hall. Led by the university's historic disciplinary officers, known as the esquire bedells, they were trailed by the university's vice chancellor, who was draped in a crimson ceremonial robe, followed by the proctors. The senior proctor opened the proceedings with a series of formal statements, at the end of which one of the bedells escorted the vice chancellor to a chair in front of the dais, where candidates for degrees were presented. An official of the university called each candidate. After Harry came forward, he knelt as the praelector gripped Harry's right hand, intoning:

"Auctoritate mihi commissa admitto te ad gradum caelibem atrium in nomine Patris et Filii et Spiritus Sancti." (By the authority committed to me, I admit to you the degree of Bachelor of Arts in the name of the Father and of the Son and of the Holy Spirit.) Harry rose, bowed to the vice chancellor and left the proceeding to receive his diploma in a room adjoining the great chamber. Harry later received an M.A. from Pembroke, an academic ranking that did not require further study in the British system.

Harry's three years at Cambridge had seemingly flown by. But did they prepare him for what was coming? His father had an assignment for him upon his return which, like the Guggenheims' expansion into Mexico two decades earlier, would be another turning point for the family business.

Ores of Chuqui

I

On their return from Cambridge, Harry and Helen went hunting for an estate to rent on the North Shore of Long Island. Two of Harry's uncles had bought properties in the area, where a winding coastline revealed peninsulas, harbors, meadows, and woodlands overlooking Long Island Sound, dotted by small towns like Oyster Bay, Northport, and Huntington. It became known as the Gold Coast after tycoons of the Gilded Age landed here and built their palatial estates, some 500 in all. Over time the coastline became dotted with the chateaus and villas of families with names like Chrysler, Whitney, Morgan, Woolworth, Tiffany, and Hearst. Eventually golf courses and yacht clubs emerged and the Gold Coast's lush expanses of forest became preserves for skeet shooting and fox hunting. It all felt very far from city life. Yet the North Shore is close enough to the city that on a clear day you can see the face of the Metropolitan Life clocktower in lower Manhattan.

The Gold Coast was also where Howard Gould, heir to the railroad fortune of his father, Jay Gould, was building his gargantuan dream house,

Castle Gould. It was modeled after Kilkenny Castle in Ireland, including a tower and moat—but four times as big. A lust for palaces ran in the family. Years earlier Gould's father had offered the Mexican government $7 million for Chapultepec Castle, the summer residence of the Mexican president, but was rejected. Jay Gould began building his own feudal domain by purchasing 350 acres of prime Gold Coast woods overlooking Hempstead Bay. Shortly after construction began his marriage to actress Katherine Clemmons fell apart, setting off a bitter public divorce. Gould accused his wife of cheating on him with Wild West showman William "Buffalo Bill" Cody. Lawsuits flew. Contractors and laborers accused the Goulds of nonpayment of fees. Newspaper stories recounted every allegation in their divorce proceedings—drunken orgies, servants treated badly, extravagant shopping sprees by Clemmons. Every chapter of this real-life soap opera was followed by high society, their collective eyebrows arched as they devoured the details over breakfast. Daniel Guggenheim followed the saga, too. But his interest wasn't so much in the debauchery. Daniel sensed a coming opportunity.

Harry and Helen found a starter castle, of sorts, in Great Neck, just down the road from Castle Gould. Called "Nirvana," it was owned by W. Gould Brokaw, a millionaire yachtsman who was making a name for himself in the new sport of powerboat racing. Nirvana was modest by Gold Coast standards (a mere forty-two acres), but it had aspirational grandeur. The Mission Revival–style residence was fronted by a towering Greco-Roman portico at its entranceway as if to say: "You've arrived." Nirvana's sweeping Italian gardens were framed by terraces and balustrades, overlooking coastline fronting Little Neck Bay. Brokaw had built a half-mile racetrack there for his thoroughbreds. The neighborhood would soon be immortalized by F. Scott Fitzgerald, who decamped nearby a few years later to begin his epic nove *The Great Gatsby*.

In 1915 Harry and Helen had a second daughter, Nancy. Harry was now spending most of his time in the city, attending meetings at M. Guggenheim's

Sons, headquartered at 71 Broadway, a twenty-one-story office building near the southern tip of Manhattan. To Harry, watching the uncles in action was a fascination. Business associates of the brothers sized each of them up in stark terms: Daniel, a natural-born leader with executive abilities, "a little fellow sitting in a big chair and dominating the entire room from it." Isaac, the oldest son and the firm's office manager, a quiet accounting whiz, "but inferior as a businessman." Simon, who had served one term as a U.S. senator from Colorado, fluent in Spanish, French, and German, "always a gentleman." Murray, "the salesman of the company" and a lover of hothouses and gardening. Solomon, affable and charming but possessing a temper—he once head-butted a fellow boarding school student who made an anti-Semitic remark. "Sol was always pounding away at something," said an associate.

All treated one another with attentive deference. As Harry recalled some years later: "Right after my return from Cambridge . . . I was permitted for the first time to sit in on the daily conferences of the brothers in my father's office. Having spent the previous three years at an English school, where courtesy was standard procedure, I was struck at once by the good manners which prevailed at the conference table. My father and his brothers treated one another with an old world respect that was rare even in those days and, I suppose, practically nonexistent in the business world of today. One of the rules of the firm was that no important step could be taken without the unanimous consent of the partners. Frequently it was my father's task to introduce these new steps and to bring the others along with him. It wasn't always easy."

The brothers met frequently, sometimes several times a day, around a long mahogany table. Meetings were often impromptu, announced at the last minute by a messenger running up and down floors to round up those required to attend. In the early days this drove John Hays Hammond crazy. He recalled a meeting one day that began with a tedious discussion of a report from a superintendent of a money-losing mine, the Zaragoza

in Mexico. "Good Lord!" shouted Hammond, turning to Murray. "Don't you realize that your entire investment in the Zaragoza would only pay my salary for about a month? I'd be saving money if I bought it myself and shut it down, yet you are taking up half of my working time in these endless discussions. These post-mortems are just a waste of my valuable time and yours! I can't get anything important done if you insist on talking trivialities." At that, Hammond stormed out of the room.

"Well," said Murray, "J.H.H. certainly has a temper!"

Daniel suffered frequent stomach trouble and hypertension, probably from moments like these. When he felt a knot in his stomach coming on he would say his "Little Mary" was acting up. Presiding over the brothers' meetings, Daniel kept a bottle of Vichy water and a pitcher of milk beside him, which brought him relief.

Sitting at this council table, Harry learned how the empire was built. In Aguascalientes Harry could hold a chunk of clay slate in his hand and guess the proportion of its copper, silver, lead, or zinc. Now he listened to how the deals to buy these millions of tons of ores were capitalized and how the mining towns for laborers were built and organized. He came to understand that a large part of the brothers' business strategy was calculated bets on technology. Why did Daniel once spend $6 million on a smelter and $2 million for a copper refining plant in Utah, given the ore there was so inferior that no one had ever made money from it? He was banking on improvements in refining processes. "If we can't discover scientific methods to lower our costs . . . we deserve to lose our business," said Daniel. These methods were the differentiators of the family partnership, as was the very quality of the documents to investors explaining new ventures. The heavy paper stock and elegant typeface of a Guggenheim prospectus resembled a sales brochure for a luxury home. To hold a Guggenheim offering document was to possess "a marvel of topographical beauty . . . expensive to the touch and suggestive to the imagination."

A frequent topic of discussion around the table was "welfare work" for ASARCO's labor force. While Harry was at Cambridge, the Guggenheims

and the syndicates they were partners in (particularly coal and oil concerns) came under fire for their ironfisted clampdowns on striking workers. Strikebreakers were sent in to crush labor protests, and clashes with workers produced multiple fatalities. Newspaper accounts portrayed the brothers as "heartless, soulless exploiters" of the working class. Daniel was called to discuss the matter before hearings of a congressional task force called the Commission on Industrial Relations.

The packed audience, including muckraker Ida Tarbell and labor activist Mary G. Harris Jones (known as Mother Jones), was shocked by Daniel's testimony. Mindful of the family legacy and knowing that his retirement years weren't far off, Daniel detailed reforms for ASARCO mines that made better treatment of workers a business imperative. He suddenly appeared to oppose some of the trust's own practices. Daniel talked about workers' rights and reforms he was making, arguing for a bonus system for consistent work attendance, a social infrastructure of housing and education, an eight-hour workday, and a ban on employing workers under the age of sixteen. The idea was to persuade workers to choose work over revolution. Commenting on Daniel's ideas, Tarbell, the woman whose exposé on monopolistic practices at Standard Oil helped lead to the oil giant's breakup, said: "He was earnest in his sympathy for the laboring men and radical in his ideas of what should be done to improve their lot."

Harry paid close attention to the proceedings—he was being groomed as his father's successor. Yet Harry had doubts about joining the family business. When Harry's uncle Simon was elected U.S. senator from Colorado in 1907, Harry, then seventeen, requested permission to tag along with the senator-elect, getting an inside look at Simon's preparations to join the upper house of the U.S. Congress. Simon was a popular figure, finding friendly crowds and supporters everywhere he went. No one called him a soulless exploiter (at least not to his face). Harry was inspired. The visit culminated in a New Year's Day dinner with his uncle before he was sworn in. Later, as he completed his studies at Cambridge, Harry wrote Daniel a

letter suggesting that the mining business might not be his path forward. "You have reached the summit of your industrial mountain, and I ought now to climb my own."

II

A run for public office was about the last thing Daniel Guggenheim wanted for his second son. Describing politics as a nest of vipers, a realm where you could trust no one and no one trusted you, Daniel urged Harry to think about an assignment he had in mind at the family business. If he accepted he would be made full partner at the firm, equal, at least in title, to his uncles. Harry learned his cousin Edmond was joining M. Guggenheim's Sons under a similar arrangement. The "seniors" (Daniel, Isaac, Simon, Solomon, and Murray) felt the time was right to officially recruit the "juniors" (Harry and Edmond) to fill the seats vacated years earlier by William and Benjamin.

As Harry thought it over, he and Helen were also contemplating their life on the Gold Coast after an incident just before Thanksgiving of 1915. Late one night a burglar entered Harry and Helen's home through a French window on the ground floor. The visitor silently crept into Harry's room without waking him up. Then the bandit had the bad fortune of stepping into Helen's room. The sound of an opening bureau drawer awakened Helen, who sat up and turned on the light. A man with a black handkerchief over his face stood before her, holding a revolver. Helen began screaming. The thief quickly backed out of the bedroom, Helen in pursuit. According to one account, she followed him down the hallway, yelling at him until he went "tumbling down the stairs." The commotion caused Harry and several servants to emerge from their bedrooms as the intruder exited the house and bolted into the woods. Now it was the young Guggenheims' turn to be chronicled in the tabloids. Newspapers covered the incident with headlines like MRS. GUGGENHEIM SCORNS PISTOL IN HANDS OF MASKED THIEF

and MASKED BURGLAR FAILED TO SCARE FINANCIER'S WIFE. ONLY GOT $100 BEFORE MRS. GUGGENHEIM DROVE HIM AWAY.

Helen was not a woman to be messed with. But the experience seems to have nudged Harry and Helen back to the city. In Manhattan they chose another small palace of a home to rent at 870 Madison on the Upper East Side, just a block off Central Park. Built by Robert Chesebrough, the inventor of Vaseline, it was a neo–Italian Renaissance gem, five stories, with an elevator and a significant library. Harry and Helen's house staff now numbered nine: three maids (French, Swedish, and Irish), a Dutch houseman, an Irish footman, an American-born butler, a French governess, and two cooks from Ireland. Both Joan and Nancy would continue to be schooled at home by tutors. The move brought Harry closer to the office, fast becoming his second home. It also brought Helen closer to her own family. (Her parents and brother lived on W. 78th Street in Manhattan.)

Daniel found travel invigorating; he and Florence were frequently off to Europe for weeks at a time. The days Daniel was in the office each month enabled him to see Harry in a new light. His son was now an elegantly dressed young man with a precocious mustache; a freshly minted Cambridge graduate with a sharp analytical mind, comporting himself as would a much older man. True, Harry was contemplating a career outside of the mining world, yet he seemed to enjoy the business banter among his uncles over their mining properties and asked deeply analytical questions. At times he sounded like an accountant. Daniel was pleased to see this kind of engagement in his second son, a quality undetected in his first. Older brother Robert, who held limited interest in the family enterprise, would later say, "Every wealthy family supports at least one gentleman of leisure. I have elected to assume that position in mine."

In a future era Harry's other sibling, his younger sister Gladys, might have been groomed for leadership. She was a whip-smart, clever, and self-confident young woman. But Gladys had abandoned her plans for Bryn Mawr while Harry was at Cambridge. She married Roger Straus, whose uncles owned

Macy's. Straus would later join the Guggenheim family foundation and mining interests.

Perhaps a relief to Daniel was the fact Harry appeared not to be a skirt-chaser or possess the hyperpromiscuity of his playboy uncles, the late Benjamin and youngest brother, William. Harry's dignified old-soul demeanor reminded some of the understated panache of his Uncle Solomon (but without the impulse to head-butt peers who insulted him). Harry never missed an opportunity to talk up the superiority of Cambridge's ancient rituals, his uncles were bemused at the sudden appearance of an Anglophile in the family. For the job Daniel had in mind, however, good manners and respect for tradition would be of limited value.

III

The explosive growth in Mexican foreign investment was spilling over to other countries in Latin America. In 1914 nearly half of all U.S. foreign investment went to the region. In northern Chile, the Guggenheims had secured mining rights to an area rich in copper known as Chuquicamata; locals called it Chuqui. Daniel received conservative estimates of reserves of around 700 million tons of ore containing an average 2 percent copper, a high concentration. The surface mining area the Guggenheims had procured was about four miles in length and one mile wide. The ore appeared mainly in two forms: vein deposits—well-marked fissures, just a few feet wide—and the far more lucrative "lode." The latter was the part of the deposit that began at an elevation of about 9,000 feet, comprising a vertical depth of about 1,000 feet. The brothers had never seen anything quite like it. More than a mother lode, Harry's father had staked a claim on one of the largest copper reserves of the 20th century. It was the Alaska Syndicate and Kennecott Mountain all over again.

An advance team began building the infrastructure needed for the brothers' initial exploration work, including a small mining camp. To

scale up operations they needed to expand the camp into a well-planned mini-city that could house an expected workforce of 10,000. Perhaps to Harry's astonishment, Daniel told Harry that he wanted him to build the town to meet this demand. Harry would focus on worker housing, grocery markets, a hospital, and social diversions for laborers. It was a trial-by-fire assignment but Harry recognized the opportunity. It was a chance to play a crucial role in building the infrastructure for what would be the jewel in the Guggenheim Brothers' mining crown.

To get up to speed, he would first work with the teams designated to bring water and power to the site. Edmond was named manager of operations and would oversee transportation. Harry and Edmond would report to William C. Potter, Harry's old boss in Mexico. The elegantly produced prospectus for Chuqui was a good primer, offering accounts of the region's precolonial Inca civilization, geologic features, climate, topography, prospective costs, and estimated profits.

The rationale in choosing Harry for the job had some merits: his apprenticeship in Mexico had given him a working knowledge of the demands of a mining camp outside the United States. He had proved he could acclimate quickly in a foreign culture and was nearly fluent in Spanish, having been tutored at Aguascalientes. All good in theory. But the reality was that Chuqui's massive copper deposits were some 800 miles north of Santiago, on the western slopes of the Andes, deep into the Atacama Desert. A vast, desolate landscape of harsh beauty, one can see the snowcapped peaks of the Cordilleras to the east, rising like a Latin American Mt. Fuji. But there is no water in the Atacama. Over a century had elapsed without a drop of rain falling, noted some reports. The remoteness of the location made building anything, much less an entire town, an extraordinary challenge.

How did Harry's uncles come to acquire this mother of all copper lodes in the first place? It was another good bet on technology. Copper had long been mined in the Atacama, first by the Incas, then the Spaniards. In 1910 industrialist and mining magnate Albert Burrage bought the mining rights to the

area around Chuqui from a handful of English and Chilean speculators. But the high levels of chlorine in the rock made extracting copper difficult. Daniel asked E. A. Cappelen Smith, a Norwegian mining engineer hired by the Guggenheims, to see if he could improve the refinement process. Smith experimented and came up with a vastly improved extraction process. In 1912 Daniel sent his mining engineers to test ores using Smith's method, which involved leaching samples with sulfuric acid. The trial was a success. Daniel conferred with his brothers; they collectively voted to acquire the rights from Burrage, setting up the Chile Exploration Company for operations and the Chile Copper Company as a holding entity. The latter raised $95 million in stock to finance the venture, plus a bond issue arranged by Bernard Baruch, raising another $15 million. It was equally good news for the Guggenheims that, compared to the revolutionary chaos unfolding in Mexico, Chile was a paradise of political stability, just as Harry's mentor, the Old Man, knew. The country's leaders were constitutionally elected. As in Mexico, labor costs in Chile were cheap and the government was cooperative in keeping taxes and import duties low.

As initial mining operations began, the Guggenheims reckoned they would need enough explosives to blow up the Rock of Gibraltar. Massive caches of dynamite were soon hauled deep into shafts. One charge required as much as 500,000 pounds of gunpowder. A detonation like this could break down a million tons of ore in a single blast. To mine and process the ores, Chuqui would need technology, transportation, and labor on a Herculean scale. Only a handful of large companies in the world could muster such resources, or the capital to acquire them.

Up until then the chief method of hauling ore from mines in the Atacama Desert had been by ox cart. The Guggenheims would have to build a network of narrow-gauge railroads and create access to vast amounts of water and power. Once that was done, giant electric shovels and churn drills could do much of the work. Towering cranes would be needed to move debris, locomotives to bring machinery and timber for construction of

buildings and hangars. In a stroke of good timing, the Panama Canal had just been completed. Used heavy machinery was available relatively close by. As mining operations got underway, the Guggenheims would buy a small fleet of freight steamers to transport the refined copper back to the United States, delivering equipment and supplies on the return trip. It all had to be shipped in: belt conveyers, ore crushers, leaching tanks, dechloridizing plants, electrolytic tank houses, 3-ton electric furnaces, 10-ton traveling cranes, 85-ton locomotives.

Much of this technology ran on electricity. It would come from the port town of Tocopilla, some ninety miles to the west. Of course, Tocopilla had no electricity—the Guggenheims would simply build their own power plant there. Tocopilla, on the seacoast, was chosen because fuel needed to run the plant could be delivered by ship, and cooling water would be obtained by distilling seawater. The Guggenheims chose Siemens to construct what would be the largest power plant in the country at the time. It would transmit electricity along a 100,000-volt line running to Chuqui up and down ninety miles of hills, all of which sat on an earthquake zone.

A bigger challenge was the lack of water in and around the mining site. Nearby watersheds contained too much salt for the water to be potable. Water was so scarce in the area that prior to the Guggenheims' arrival it was hauled by tank cars from the nearest railway station, then put in barrels on carts to the mine road, and from there transferred to coal oil tins and delivered by pack animals.

This was essentially transporting water uphill by llamas. The small volumes of water hauled in this way might be adequate for cooling drill bits used in small excavations, but not nearly enough for human needs at a mining camp with several thousand workers. Harry joined the team contemplating a solution, and they soon had an idea: Make the water go down, not up. The firm would expend $1.6 million ($40 million today) to construct a gravity pipeline sixty miles long, a foot in diameter, connecting concrete storage reservoirs at the main mining site with springs

in a mountain range east of Chuqui. The higher elevation springs produced a downhill flow of water for a system that would eventually deliver 800,000 gallons of water a day.

IV

The mandate from Daniel was to expand the mining town to scale up operations by early summer of 1915. With power and water established, Harry threw himself into the job with a sense of urgency. At the core of his responsibilities would be matching the demands of a vast mining operation with the human needs of the miners, their wives, and children. He had Guggenheim mining camps out west and his own experience in Aguascalientes as templates. He could rely on the aid of his uncles, whose contacts in the Chilean government would arrange for contractors and suppliers who could advise on where to source materials and labor. But the factor that helped Harry most was his hiring of B. T. Colley, the Scot who had been assistant superintendent at the Aguascalientes smelter. While Harry was in Cambridge, Colley had gone on to work for the Guggenheims at a smaller mining operation in Chile and was the architect of the mining town there. Colley would be Harry's point man on creating an infrastructure that would attempt to establish a stable social order at the camp.

Harry and Colley settled on the idea of creating two towns: the New Camp (for Chilean laborers) and the American Camp (for American workers and executives). Harry's plan would include a hospital, churches, markets, and a local security force. Housing for laborers was ranked from A to D (general foremen would live in A houses; native laborers in the D houses). The community would have three *pulperías chilenas*, or company stores, segmented like the housing system. The higher your status in the labor force, the better access you'd have to higher quality goods.

What Harry could not control was the handful of pop-up barrios alongside the company town. The areas were rife with gambling, prostitution, and violence—conditions that existed in virtually all mining towns in the West. As one account of Chuqui's barrios noted: "Blood ran often. Any incident whatsoever was reason for fights to break out and knives to flash. No one who came here could be assured of leaving with his life, and even less with his wallet. Even if he won something, he might still pay his debt on the road home. Numerous crosses mark the site of frequent assaults near the barrios."

Harry had limited means to stop mayhem in neighboring areas and fewer ways to control prostitution. Half the incoming workforce were single men—they needed to blow off steam, said Chuqui's labor recruiters. Harry asked them to seek out more married men, who would move to Chuqui with their families. Harry also established some "wholesome" amusements for his workforce, diversions like social clubs, a movie house, and a horse racing track.

As Chuqui expanded, developments in Europe grew ominous. The Balkan Wars had begun and the Ottomans were being expelled from Serbia, Montenegro, Bulgaria, and Greece. The uncertain fate of the Ottoman Empire escalated tensions between European alliances. Every undergraduate at Cambridge, and at all English colleges, felt in varying degrees they would soon be on a European battlefield. On July 28, 1914, barely a year after Harry's return from Cambridge, war broke out in Europe, followed by Britain declaring war against Germany. Knowing that so many of his former classmates would be in uniform, Harry's thoughts would have turned to those he was closest to in Cambridge—Hadley, who had since been named Master of Pembroke, the Old Man, and Carlie Webb. America held tight to its noninterventionist stance. Woodrow Wilson soon ran for reelection on the promise, "He kept us out of war." But for how long? So many American citizens had cultural ties and family roots in European nations.

The war in Europe set off a financial boom for the Guggenheims, at first. Lead and copper were in high demand for armaments and explosives. In 1915 the family's refinery in Omaha loaded an average of ten trains a day with 6,000 tons of pig iron. Munitions factories in Britain used it to make 600 million bullets that year. Later, Daniel and other mining barons like John D. Ryan agreed to steep price cuts, notably in copper, pushing down Chuqui's profitability.

That summer, as Harry and William Potter prepared for a return to Chile, several memos arrived from Alfred Burrage's son, an employee at the camp. The news was that a series of strikes had been threatened by machinists, electricians, and carpenters demanding shorter hours and higher pay. Fred Hellmann, whom Daniel had appointed general manager, was in Tocopilla at the time, so Pope Yeatman, the engineer who had replaced John Hays Hammond at Guggenex, was filling in. Under Yeatman, the potential strikes were about to unleash chaos on Harry's town.

According to one memo: "Yeatman talked with each member of the Grievance Committee in turn . . . One cause of complaint—Operating Dept. put on ten hour day; Construction force have [sic] been working 9 hours a day. Want overtime pay for work on Sundays; also time and a half for overtime work during week." The memo warned, "Police to handle situation . . . There was a threat to blow holes in big tanks."

Upper management was having its own problems: based on the veiled references in one memo, it seems the wife of a Chuqui executive was having affairs with multiple married men and that the wife's sister was also involved. Meanwhile, the hard-partying ways of the general manager's wife had also become an issue. "Mrs. Hellmann's presence harmful to camp. During Hellmann's absence she has had many parties all late and very wet. As result men not up to their work and women neglect their homes . . . While Yeatman was having meeting with strike committee Mrs. H. came to office from a lunch pretty well 'lit up.' She wanted to address the committee and it took considerable force on Yeatman's part to get her out of room."

Yet another memo compiled a list of complaints about the camp itself:

"Hospital absolutely poor. Located long way from town. Men have to walk about two miles after closing hour to see doctor."

"Accounting Dept. not in good condition."

"Schuster says men not satisfied with living conditions . . . Believes club necessary at once."

"Hay, Asst. Mgr., very unpopular."

"Town worst planned he has ever seen. Outrage the way buildings have been placed."

Harry bore a large part of the responsibility for the mess (though some problems predated him). There was no time to assign blame. His father's labor reforms in mind, Harry methodically laid out his solutions: reorient the layout of the town; expand the hospital from one building to six; commission safety protocols to reduce accidents; invest in hiring a business manager to oversee the accounting department; and expand the flow of information on developments at Chuqui being reported back to New York. He also cut the 12-hour workday to eight hours and set up a pension plan. To placate upper management Harry quickly commissioned what he called an "American Club" for senior staff, with a ballroom, billiard room, reading room, bowling alley, and swimming pool.

After managing some of these early conflicts, Harry moved ahead with an expansion of worker housing. He did his research: simple timber with corrugated iron for roofing would do, he thought, along with beaver-board partitions to subdivide rooms. But these early structures were difficult to heat, especially when temperatures in the Atacama plunged at night. Harry consulted colleagues and found a fix: he swapped out the timber using adobe bricks made from a mix of locally obtained pampa dust and cement, a formula that delivered better insulation at a cheaper cost.

Once relations with labor unions improved, operations began to run more smoothly. Chuqui's population soon topped 12,000 residents, 5,000 of whom were daily workers. These were the laborers who manned

the drills, the steam shovels, and the locomotives that made possible the thousands of pounds of crushed ore extracted from the mine each day. Eventually some twenty languages were spoken by residents. Bolivians sold street food on corners; Chinese and Japanese émigrés ran groceries and barber shops.

Harry considered the town a success and later chronicled its development in a seven-page article in *Engineering and Mining Journal*. He romanticized the virtues of his company town and the staggering production of copper it was delivering. (Naturally there was no mention of the threatened strikes, complaints about healthcare, the drunken antics of Mrs. Hellmann, or the neighborhood dens of iniquity.)

"Instead of the ragged, barefooted, irresponsible laborer of five years ago," boasted Harry, "there is a well-dressed, well-shod workman with a spark of ambition burning within him. Great has been the improvement with the men, it has been even more marked with the women and children. The latter, in their school house, compare favorably in appearance with the children in the public schools of the United States . . . Experiences at these properties has taught that so-called welfare work is worthwhile, not only from the human but from the economic results to be achieved."

Cultural critics at the time offered a different take, accusing the youngest firm partner of gringo paternalism. They took him to task for the inequities of the New Camp vs. the American Camp. Each camp had its own *pulperías*. Why should some workers enjoy well-known U.S. brands, from cornflakes to imported liquor, while others get the dregs? It was *favoritismo*.

Janet L. Finn, author of an in-depth cultural history of Chuqui, echoed the point but put some of the criticisms in perspective. Finn interviewed old and new residents of Chuqui about the "company town" approach (begun by Harry and largely kept in place by a subsequent owner). "Even the most vocal critics told stories of the 'good old days,' when the hard life had its rewards and the community its vitality. Critiques of corporate paternalism

and Yankee imperialism were tempered with warm memories of soccer matches, movies, and fiestas."

Back in Santiago, two authors working on a history of Chuqui lobbed another criticism at Harry, suggesting he possessed a shallow understanding of Chile and an unhealthy obsession with copper: "In his ignorance, Harry Guggenheim doesn't have even a remote idea about our country. He ignores that before Chile Exploration Company . . . we already had colossal riches such as Chañarcillo, Tamaya, and Caracoles, besides the prodigious nitrate industry, unique in the world, and the coal, agriculture and livestock industries in the central and southern regions." In fact, both Harry and Daniel saw nitrates as the brothers' next big investment. What they could not have foreseen was the role the new business would play in the coming rift between Harry and his uncles. The young and the old members of the firm would soon take very different paths.

Showdown

I

I n 1915 there appeared a new axis of power in the Western world—the mighty Equitable office building in downtown Manhattan. Its owners promoted the new skyscraper with literary flourish: *Here in the very maelstrom of commerce, in the master markets of mind and money, housed in the biggest building of the age, you will have every incentive to grow, every opportunity to expand, every stimulus to thrive.* The Equitable was a Beaux Arts superstructure, thirty-eight stories, occupying an entire city block, with 1.2 million square feet of space and fifty-three elevators. It was a giant communications hub, nearly every floor wired for telegrams and cablegrams, telephones in lobbies, telephones in offices, even telephones in the elevators.

Some of the era's most powerful masters of the universe in shipping, manufacturing, insurance, and finance decamped to the new building, from General Electric to the Federal Reserve Bank of New York. So did M. Guggenheim's Sons, now Guggenheim Brothers, the name change reflecting the next generation (and to avoid further legal headaches from

William Guggenheim, who had sued his brothers claiming they cheated him out of Chuqui's riches and objected to continued use of the term "sons").

Guggenheim Brothers occupied the entire thirty-fifth floor; ASARCO would move into the floor below. From these heights one could see New York harbor and the distant New Jersey shore. The Partners Room embodied old world gravitas—stuffed armchairs in the corners, walls paneled in German walnut, marble fireplaces at either end. Here too was a gilt-framed portrait of Meyer, his watchful gaze bracketed by the flaring white whiskers of his mutton chops. Along one wall of the Partners Room a panel concealed a secret door leading to a staircase down to Daniel's shadow office at ASARCO (the entities were legally required to be separate—Guggenheim Brothers was a holding company; ASARCO traded on the New York Stock Exchange).

Another tenant at the Equitable was a Scottish-born financial journalist who had recently founded a magazine called *Forbes*. The B. C. Forbes Publishing Company was just a dozen floors below the Guggenheims. Bertie Charles Forbes came up one day to interview Daniel, pausing to admire the sweeping Corot landscape on the wall, for which Daniel had paid $100,000 ($2.5 million today). A row of glass display cases held glittering samples of ores from the family mines.

Forbes alighted on a corner chair and asked Daniel the question he had asked all his famous subjects: What are the elements required to achieve success? Daniel sat back, paused a moment, and said: "How did you manage to get this interview with me? You didn't get it the first time you tried, nor the second. But you showed both tenacity and tact. You kept at it until you discovered a channel of approach that you knew would probably succeed. Your tenacity got you in here, and your tact has induced me to talk to you in a way I am not in the habit of talking for publication." Tenacity was what he looked for in his workforce, Daniel told Forbes. "Give me the choice between a man of tremendous brains and ability but without tenacity, and one of ordinary brains but with a great deal of tenacity and I will select the tenacious one every time."

It was the same advice Daniel dispensed to Harry during his Mexican apprenticeship. In Chile, Harry had showed nothing if not tenacity building out a mining town under extreme conditions. Working with his uncles would require a different skill set.

Upon arriving on the thirty-fifth floor each day, the firm's newest and youngest partner would greet the security guard and hear the early morning clamor of the workplace: phones ringing, the banter of clerks and clatter of typewriters banging out reams of correspondence and financial statements related to the many Guggenheim business entities. The sweet burning smoke of pipe tobacco filled the air, along with snippets of conversation: "Yes, Mr. Murray will see you on Tuesday at 10:30 A.M. . . ." or "Mr. Dan is traveling in Bolivia at present . . ." The first-name references were a tradition of necessity. In the early days, when visitors arrived to see one of the brothers, asking for "Mr. Guggenheim," several heads would bob up at their desks. So began the practice that each brother, and now the nephews, would be addressed by their first name.

Cousin Edmond would be at 120 Broadway most days, giving Harry a confidant and an ally in the office. There were always mini-conclaves in progress, small meetings among Harry's uncles and visiting investors, mining engineers, lawyers, and financiers, and plenty of mountebanks. Many came seeking capital investments to develop mining properties or financing in exchange for equity stakes in mining ventures. Unlike John Hays Hammond, Harry enjoyed his uncles' endless meetings, particularly those in the Partners Room. Like his father, Harry was a snappy dresser, always in a neatly tailored three-piece suit, his six-button vest revealing a broad chest. In his left vest pocket he kept a small silver box of matches. When a meeting began Harry would strike a match and fire up the bowl of his English billiard pipe, clenching it in his teeth, patiently listening to his uncles run down the latest operational challenges in far-flung corners of the world. Daniel was frequently on the road with Florence; his directives often arrived by cable. He and Florence seemed at times consumed

by wanderlust. Daniel told B. C. Forbes that he had crossed the Atlantic seventy times by the age of forty.

II

Harry's work in Chile proved he had the analytical skills to manage big budgets, big egos, and complicated accounting, all in a foreign country. It was now crucial that all partners know the new rules of the recently established corporate and federal tax policies. Harry seemed to get wonky gratification poring through the labyrinth of these new tax rules. He was probably delighted, then, when the brothers named him chair of Chilex's (Chile Exploration Company) executive committee, where the key financial decisions were made about the brothers' Chilean operations. When the federal tax authorities hit Chilex with a $4.3 million back tax bill, Harry went into action. He worked up an analysis with the accountants arguing that a major reserve of copper inventory had been mistakenly claimed as taxable. The counter-analysis saved the partnership some $4 million. Harry sent around a smugly crafted memo to Daniel, Isaac, Solomon, Murray, Simon, and Edmond, noting: "You will be interested to know that the Chile Exploration Company was faced with a possible extra assessment by the Government . . . of $4,538,278.49." The actual bill would be a mere $63,870, he reported, ending the memo with a comparison of similar assessments exacted on the firm's top five competitors, all of which were higher.

Over the months Harry's office rituals included a close reading of the previous night's cables carrying news from both the Continent and Latin America. The war in Europe had a silver lining for the Guggenheims, of course—a massive demand for metals. But the war closer to home, in Mexico, posed real risks to the Guggenheims' supply chain. Harry had finished his apprenticeship in Mexico on the eve of the revolution. The uprising shattered the economic stability of the *Porfiriato* and the security of

mining throughout the country. Díaz's privatization had opened the doors to foreign investors and modernized the country. But it had also made Mexican oligarchs rich, breeding resentment among the poor and working class.

While Harry was away at Cambridge, Francisco Madero, who had unseated President Díaz and become president, was himself removed and assassinated following a military coup led by Gen. Victoriano Huerta. The power grab unleashed a bloody civil war. President Wilson tried to counter Huerta's seizure of power by backing Venustiano Carranza, then head of Constitutionalist forces whose military backers included Pancho Villa. The old Mexico was back.

The Guggenheims operated some thirty mines and five major smelters in the north, many of them in the heart of border states controlled by Pancho Villa's ragtag army, the División del Norte. The brothers would have some hefty *mordidas* to pay to keep their mines open, especially in Aguascalientes, territory that represented a significant part of Pancho Villa's territory. The brothers reportedly paid Villa in cash and gold for protection. Harry's role in such off-the-books transactions is unknown, but he would surely have been aware of another clandestine development involving Villa in a town he knew well. Aguascalientes, where Harry had learned to sort ores, had become the headquarters for a small fleet of planes Villa had acquired. A decade before Daniel and Harry began investing in aviation, they were the unwitting financial backers of Pancho Villa's air force.

An American, John S. Berger, a circus promoter turned aviation broker, had sold Villa a fleet of eight Wright airplanes. Piloted by Americans (also supplied by Berger), Villa used them mostly to scout enemy movements and drop munitions on enemy forces below. But Berger also sold planes to Villa's rivals. Once in the air, confusion reigned as to whose planes belonged to whom. In one instance Villa's forces, sitting on horses, fired wildly into the air, bringing down an incoming aircraft. When Villa's troops rode up to the plane's badly injured pilot, still in the wreckage, they shot him nine times. The pilot, it turned out, was one of their own scouts.

A conference in Aguascalientes among Mexico's four competing military rivals resulted in Villa breaking with Carranza. But this posed a problem for the Guggenheims. Wilson continued to back Carranza, and the Guggenheims could not defy their own government. They affirmed their support of Carranza, which naturally enraged Villa, who now considered Daniel and Harry his enemies. Villa began looting Guggenheim mines, in one case, according to Berger, removing some $2 million in semi-refined gold. Berger said Villa directed him to load the Guggenheim gold into Villa's private railroad car at Aguascalientes and ship it to Juárez, then onto a refinery in Ohio. The cache was sold for $1.5 million, a sum reportedly returned to Villa in the form of a bank draft.

Besides wreaking havoc on Guggenheim mines, Villa unleashed reprisals on other U.S. targets, attempting to drive a wedge between the United States and Carranza. The most deadly was a massacre of American mining employees in the middle of the night in the hills near Chihuahua. At about 4:00 A.M., Villa's men commandeered a passenger train filled with stamp mill workers, a mine foreman, a storekeeper, an assayer, and others. They were employees of both ASARCO and the nearby Cusi Mining Co. The Americans were beaten, bayonetted, and stripped of their clothing, which was searched for valuables. Survivors were lined up and shot to death. Some seventeen Americans were murdered. Also aboard the train was $200,000 in payroll cash belonging to the Guggenheims, according to one report, which Villa's men made off with. The *New York Times* covered the atrocity with four page-one stories; members of Congress called for armed intervention in Mexico. Daniel and Harry were enraged; Daniel ordered ASARCO employees to depart from much of northern Mexico. After this, Guggenheim mines were continually shut down, restarted, then closed again, based on constantly shifting levels of security for workers. The train massacre, followed by Villa's attack on Columbus, New Mexico, a few weeks later, set off the famed "Mexican Expedition," in which Wilson sent a U.S. Army unit across the border to capture Villa, which it failed to do.

III

Pancho Villa's air scouts weren't much of a factor in the Mexican Revolution, but Harry was fascinated by the new arena of war in the skies over Europe. Newspapers delivered dramatic recaps of air-to-air skirmishes involving French, German, and English fighters. They flew fragile machines, made mostly of flammable wood, with little if any navigational equipment. Flying was by visual guidance in all weather—sun, clouds, fog, or rain. In the early days of the war pilots fired on each other with service revolvers and shotguns. But air-to-air combat evolved quickly. Early Italian Caproni combat aircraft, for example, required a second flier to stand in a metal cage above the center engine, his back to the pilot as he fired a mounted machine gun at pursuing planes. Not for the faint of heart.

Public opinion remained in favor of continued U.S. neutrality, but was shaken in May 1915, when a German U-boat sank the RMS *Lusitania* off the coast of Ireland. Harry knew the ship, having taken it with Helen on their maiden trip to Cambridge. Over 1,000 passengers were killed, including 128 Americans. Historical accounts note the ship had munitions on board. But Americans were infuriated that no warning was given before the sinking.

The war soon became personal to Harry in other ways: older brother Robert would enlist in the army, becoming a general's aide in the 69th Regiment. Cousin Edmond signed up as an army private, transiting to Camp Meigs to work in the Quartermaster Corps. Most of Harry's graduating class at Pembroke was already on battlefields in France and Belgium, along with Master Hadley's sons (one would die during treatment of his battle injuries, the other would lose a leg). Even the Old Man was in uniform, serving as a major in the British Intelligence Corps at Boulogne.

The brutality of land warfare and the trenches was obvious to anyone reading their daily newspapers, which is to say, everyone. Tennis star Anthony Wilding, with four Wimbledon championships under his belt (including those in which Harry had played), was killed when a howitzer

shell exploded on the dug-out shelter he was in near Neuve-Chapelle. Then came news of Carlie Webb, Harry's doubles partner at Cambridge. Carlie had made captain in the 5th Battalion Border Regiment and was sent to the front in October 1914, landing in Le Havre. The unit saw action in a series of skirmishes, winding up at the Battle of the Somme, one of the bloodiest engagements in military history. While Carlie was commanding a trench mortar battery, the regiment came under fire and he was killed instantly.

Harry had lost perhaps his best friend at Cambridge, with whom he had shared some of the happiest days of his life. Carlie's death was a tipping point, Harry later said, in his decision to enlist for service. The question was, which service? He had time to think. Anyone with any interest in aviation those days was reading *Aerial Age Weekly*, whose pages featured vividly drawn illustrations of combat in the sky—edge-of-your-seat accounts of pilots doing battle thousands of feet in the air. The pilots of the French aerial fleet were equipped with machine guns that could fire 600 rounds per minute. The new arena of aerial combat was wildly perilous, yet to many it seemed a good alternative to the trenches.

Europe was miles ahead of the U.S. in military aviation. At the time the U.S. Navy and Army had but a handful of airplanes in their commission. Harry's Uncle Solomon knew this—he had given generously to a campaign by the Aero Club of America to raise money for a squadron of airplanes attached to the militia of each state. As a statement from the Aero Club put it: "Every military and naval authority in Europe now recognizes that a navy without aerial eyes is as helpless as a submarine without a periscope . . . and a nation without aerial forces is as helpless as was the *Lusitania* at the time of her sinking."

Out on the Gold Coast a group of Yale undergrads wanted to become those "aerial eyes" for the navy. They began flying lessons to train enough of themselves to form a military aviation unit for the U.S. Naval Reserve. It was organized by Frederick Trubee Davison, son of Henry Davison, an architect of the newly created Federal Reserve. Word reached Harry about what these

young Yalies were up to. Inspired, Harry acted quickly, forming his own smaller group of aviator-volunteers and arranging for his own flying lessons.

Did Daniel have concerns about his son's decision to train in an ad hoc, amateur flying corps for the Naval Reserve? If so, Harry would have placated his father with assurances about the relative safety of his training plane. He took lessons aboard a Curtiss Flying Boat, a hybrid boat-airplane (if one had to crash, better it be on water). The watertight compartments meant the plane would never sink. Harry might also have explained to Daniel that aircraft are more stable over water than land, given that rivers, lakes, and oceans offer unbroken surfaces, unlike the contours of land and nearby structures, which cause air to be more turbulent.

In March of 1917 Harry, being a young man of means, purchased his own Curtiss Flying Boat to train on. Its legendary maker, Glenn Hammond Curtiss, ran the flying school for his planes and gave Harry some of his first lessons. Curtiss was a meticulous teacher, drilling his future pilots on the function of every feature of their crafts. Students learned how shoulder-yoke ailerons were used for lateral balance, the workings of the V8 water-cooled piston engine, how power was distributed from its cylinders to its crankshaft. Harry knew a few things about the workings of his old Mercedes. But automobile engines ran at various speeds heading to their destination, unlike an airplane engine, which had to run at full speed most of the time. If a motor began to sputter, a pilot would need to quickly identify the problem. Was the misfire a lack of airflow to the carburetor? Or was it a clogged fuel line? Knowing the answer could mean life or death.

Nose-to-tail the Curtiss Flying Boat measured twenty-six feet, bisected by an enormous forty-five-foot wingspan. Inside the open cockpit were two sets of identical controls for teacher and student. Harry recalls the first thing he was told by his instructor: "See those instruments? Pay no attention to them. In the first place, they are not accurate . . . I want you to get the feel of the ship regardless of instruments." His first flights were the equivalent of what pilots called "grasscutting"—flying just a few feet above the water.

He apparently got the hang of it quickly, learning how to time thrust and trajectory, nudging the controls in one direction or another to keep the giant craft flying both straight and level. Along the way Harry probably got an earful from Curtiss about his archrivals, the Wright Brothers, who had taken Curtiss to court, accusing him of patent infringement. Those court battles slowed the rollout of new wing designs, Curtiss said. Even so, the navy forged ahead by commissioning the production of existing models. In an era largely without radar at sea, the flying boats could patrol for enemy ships and conduct air-sea rescues. They could provide artillery spotting and tactical reconnaissance. The U.S. Navy was banking on such capabilities. When Harry bought his Curtiss that spring there were some thirty-eight naval aviators in the country. By the end of the following year, there were 1,650.

In April the U.S. joined allies Britain, France, and Russia, declaring war on Germany. Elated at the news, Harry banged out a letter to his former tutor, Sheldon Hadley, the new headmaster at Pembroke: "Dear Master, At last I am delighted to say we are in with you . . . We are of course in a very poor state of preparedness for the undertaking and it will take a good while to reach the point where we can be of material aid in France, but the entire resources of this country are now being devoted to preparation. Several weeks before the declaration of war, which seemed inevitable to me, I ordered an aeroplane and got a start in learning to fly while on a two weeks holiday (the first I've had since I left you) at Palm Beach, Florida. Within a few weeks' time some others with sea planes and I will have started an informal flying unit where me and some others who cannot afford boats can learn to fly sufficiently well to secure commissions in the flying corps probably before the government will have even organized their training schools. There are only a handful of aviators and planes in this entire great country and practically no facilities as yet for instruction in flying . . . I can't tell you how delighted I am that we are going to help. Love to you all."

IV

Two months later Harry was ready for his first solo flight in the Curtiss. He took off, ascending high above the water, the deafening roar of the engines behind him, a fierce wind crushing his goggles into his face. One can imagine his exhilaration at solo piloting this giant winged motorboat for the first time. He continued flight trials at Port Washington and Bay Shore, Long Island. Finally, Harry was certified to fly the Curtiss F boat, both biplane and triplane. A short time later he was commissioned a lieutenant in the U.S. Naval Reserve Force and assigned to the U.S. Naval Air Station at Bay Shore, where he learned military map sketching, wireless telegraphy, and instrumentation. On Sept. 14, 1917, Harry was registered in the Naval Reserve for a term of four years.

Harry again wrote to Hadley on Sept. 18: "Dear Master, I have just received a commission as Lieutenant (junior grade) in the Naval Reserve Flying Corps. I shall be busy in Washington for a week or two and will sail as now arranged the first or second week in October. I do hope by way of England . . . Please inform Mr. Comber and Chappie as I presume you are in constant communication with the former and have the latter nearby. 'Au Revoir'"

Harry left New York for Paris by steamer on Oct. 20. Along the way, as always, were newspapers to read filled with exploits of daredevil pilots triumphing in dogfights. The stories failed to mention that the life expectancy for combat pilots was extremely low. In some cases, pilots received just a few hours of training. The military spent little time focusing on pilot safety; their goal was to win the war. They also required competent minds to inspect planes for mechanical safety and structural integrity, and to detect attempts at sabotage. The military needed those with strong analytical skills to undertake reviews of dozens of prospective sites along European coastlines to build new naval air stations.

On all counts Harry fit the bill. He had learned much from Curtiss about the building, servicing, and transport of seaplanes, expertise that

was in short supply. Harry's first assignments, then, were for the Navy's Office of Operations, starting with a lengthy inspection of a network of fifteen seaplane stations supporting aerial missions in France. He went on to England and Italy to help organize such operational hubs knowing, for example, what distances hangars would need to be from the water or how to modify planes for special-purpose missions.

The second wave of the Spanish flu was taking a huge toll on servicemen in Brest and Moutchic, exactly where Harry was going to inspect hastily built air stations for seaplanes and kite balloons. It was a short assignment, fortunately. His next stop was Pauillac to help set protocols for the assemblies of planes and their repair work—the area was a key hub for American naval aircraft shipped to France. From there it was on to Lacanau to collect performance data on arriving planes, and to Arcachon to evaluate proposed sites for the stationing of dirigibles. Harry was dispatched to do the same at air facilities at Rochefort and St. Trojan-Les-Bains, followed by an assignment to help manage the siting of naval air stations at Lake Bolsena and Porto Corsini, Italy.

Harry's Italian mission required a visit to Rome to procure Caproni bombers from Italian manufacturers for the navy. But there was a hitch: the army also wanted the bombers and its representative had already landed. Harry's nemesis was a well-connected officer on leave as a U.S. congressman from New York, army captain Fiorello La Guardia. Even for a Guggenheim, this was stiff competition. La Guardia was fluent in Italian and recently dined with Italy's King Victor Emmanuel III. The future New York mayor tried to sabotage Harry's efforts by spreading the rumor that he was seeking the planes to protect Guggenheim copper mine operations. As Harry said later: "A neat stratagem, but it didn't work." Harry persuaded the Italians to give the navy the bombers.

A final assignment took Harry to the Naval Air Station in Killingholme, England, where Curtiss H-16 patrol planes made in the United States would be assembled and flown out to be used in antisubmarine warfare and as air

cover for North Sea convoys. That year he was promoted to lieutenant commander. During his time in uniform Harry had not engaged enemy fighters in dogfights nor shot down any Fokker Triplanes. But he had learned to fly and gained enormous practical knowledge about aviation. Air travel, both military and civilian, was in its infancy, yet it was obvious to Harry that it would someday be a transformative force in both realms.

Later that year the Armistice was signed. On Dec. 2 the RMS *Mauretania* dropped anchor at Pier 54 in New York, returning the first 4,000 U.S. troops to America. Harry was among the first to disembark. There to greet him was Helen, then on duty with the dockworkers branch of the Red Cross Canteen Service. Back in Cambridge, stone tablets soon appeared in a Pembroke chapel cloister bearing the names of the 305 Pembroke men who never returned. The staggering death toll makes up 27 percent of all Pembroke men who served in the war. The high number of those who perished reflects the fact that most Pembroke graduates became officers, and the casualty rates for officers were double those of lower military ranks.

The war had separated Harry and Helen for a year, compounding the distance that had already grown between them. Harry's long days at 120 Broadway, weeks away on treks to Chile, then months away during the war took their toll on a couple who now bickered frequently. Perhaps Harry and Helen simply married too young and too impetuously.

V

While Harry was taking flying lessons from Glenn Curtiss, Daniel had closed on a remarkable real estate deal on the Gold Coast. Harry's uncle William had bought a fifty-acre estate in the area; Isaac had constructed an Italian Renaissance–style palace next to the Woolworth estate, calling it Villa Carola. But these were mere cottages in the shadow of the property

Harry's parents had acquired. Daniel purchased Castle Gould, the behemoth estate owned by the most dysfunctional couple in America, paying a reported $600,000 (perhaps half its actual value). What he obtained was a forty-room Tudor and Gothic mansion and an accompanying castle (with another forty rooms), all on 350 acres. The castle was surrounded by a moat and accessed by a drawbridge. Daniel rechristened it Hempstead House, for Hempstead Bay, which it overlooks.

Now Daniel had a Xanadu for his golden years, a comforting fact as the copper business lurched into a period of volatility. Daniel and fellow copper king John D. Ryan had lowered copper prices during the war, expecting them to later bounce back. Instead, the price of copper went into a nosedive after the war—from twenty-four cents per pound in 1918 to eighteen cents per pound in 1919. Reserves of stockpiled copper were released after the Armistice was signed, pushing down foreign demand. The secondary market for copper was struggling, too. Scrap metal from the battlefields of Europe was harvested for copper, pushing down demand from overseas. Around this time the exchange rate dropped between the dollar and the Chilean peso, pushing up operating costs at Chuqui. In the coming months copper prices rallied, then flatlined again, causing major drops in projected income from the mine. On top of this, the bonds issued for Chuqui a decade earlier would soon come due. When it came time to pay these bonds the brothers would face a copper cash crunch.

All this weighed heavily on the partners. While the brothers pondered their options, Harry and William Potter prepared to visit the firm's tin mines in Bolivia, where they planned to build a $200,000, six-mile aerial trolley line to haul larger volumes of tin from the mines to the mills. They made the voyage by steamer, accompanied by both of their wives. It was one of several trips the Guggenheims took with the Potters. On these long voyages Harry became closer to the slender, artistic Carol Potter; the pair soon became intimate. Harry was romancing his boss's wife (apparently less risky if your boss's boss is your father).

The tin business did not produce enough sales to compensate for the Guggenheims' copper troubles. But Daniel and Harry both felt that a new venture, nitrates, could produce a mother lode of income for the firm. Nitrates, used in medicines, fertilizer, and explosives, were the chief export of Chile. On his trips to Chuqui Harry would pass by vast desert nitrate fields, harvested at the time using the Shanks method, a slow and laborious refining process. After discussions with Guggenheim engineering genius E. A. Cappelen Smith, Harry felt certain the process could be radically improved. Daniel shared this belief and thought that if the partners could capitalize on a coming consolidation of the industry, nitrates could be the business of the future. Smith went on to develop a new refining process with a higher extraction efficiency, reducing production costs by up to 25 percent. "Nitrates," proclaimed Daniel, "will make us rich beyond the dreams of avarice!"

After the Guggenheims and the Potters returned from Bolivia, Carol filed for divorce from William; Harry followed suit with Helen. The decrees were well timed; only a few days elapsed before Harry and Carol made a quiet trip to New Jersey for a private ceremony, where they married (both for the second time, and both with two daughters of their own). Carol had divorced her husband on the grounds that his obsession with business led to an abandonment of their personal life. Harry made no public statements about his split from Helen. (Some years later he blamed himself for the failure of their marriage.) He must have felt a degree of liberation: he was now a war veteran and a skilled aviator, with a strong future at the family firm and, on top of it all, in love again.

But things were changing back at Guggenheim Brothers. Daniel, Murray, and Solomon, the triumvirate that had managed ASARCO, decided to retire and devote their time to the family partnership, leaving Simon to take over as ASARCO president and several new Guggenheim-backed board members. This caused friction with Karl Eilers, a major share-holder and son of a cofounder of the trust, who had been a longtime rival

of Simon's. Eilers felt the brothers had for years manipulated ASARCO's finances for their personal benefit and cut ASARCO stockholders out of Chuqui's immense profits. After a series of court challenges and mediation between the factions by former U.S. president William Howard Taft, the parties struck a compromise. The Guggenheims agreed to the selection of a new board, one not dominated by their interests. The great mining trust could no longer be treated "as an unchallenged fiefdom" or a "rubber stamp" of the Guggenheims, noted one account. Simon would remain president, savoring at best a Pyrrhic victory.

While one boardroom battle was over, another lay ahead. As the price of copper continued to drop, an unusual offer came from a familiar rival: John D. Ryan, a man who held major interests in silver and electrical power and headed Anaconda Copper. Daniel circulated a memo about the proposal to be discussed. When the day came, the seniors and the juniors gathered in the Partners Room. There was a heaviness in the air, mirrored by the dour expressions of the seniors. Breaking the tension, Daniel, the slight man in the large chair, quickly got down to business. Noting ominous predictions for the near-term price of copper and the coming demand from bondholders, he explained that an offer from Anaconda would solve both problems. He laid out the deal terms: Anaconda was offering $70 million ($1 billion today) to buy two million of the 3,800,000 shares of Chile Copper, giving Anaconda control of the crown jewel of their Chilean copper reserves, leaving the Guggenheims minority shareholders.

Sell a majority stake in Chuqui? Harry knew this was coming, but to hear it from his own father's lips was devastating. The fix was in, of course: the seniors had already decided. Daniel argued that the staggering amount of cash would recapitalize the firm for future investments. The firm would focus on the next big business: nitrates. Harry likely thought the argument absurd—in Chuqui the Guggenheims already possessed the largest single source of low-grade copper in the world, a mine projected to deliver riches for one hundred years. (Today, nearly a century later, this has proved true.)

Chuqui was the firm's future and therefore Harry and Edmond's future, was it not? Harry glanced across the table to measure Edmond's reaction, a look that must have been sheer disgust. The sale would be a betrayal of the sweat equity Harry had put into Chuqui. The staggering logistical headaches he had managed, the egos of managers he had to assuage to get things done. The difficulties locating laborers, the unending search for building materials as the war in Europe made such procurement nearly impossible. Was all of this to create a retirement package for the uncles, leaving behind a much smaller company and the junior members on the hook to find future mining properties like the one they already had?

The meeting reportedly went on for some time. Angry arguments made by the juniors fell on the deaf ears of the seniors. Pounding his fist on the table, Daniel erupted out of his seat, yelling at his son, Harry attempting to yell over his father. An offer like this would never come their way again, shouted Daniel. Simon, whom Harry had always admired, chimed in repeatedly, "There's no choice but to sell, there's no choice but to sell." Gone was the collegiality of the past; gone, too, was Meyer's old mandate that decisions be made by consensus. Solomon seemed to be the only senior at the table with doubts. He often voiced opinions sympathetic to the board's youngest members—would he stick with them now? Solomon admired Harry's chutzpah; clearly he had the DNA of his father. And Solomon had his doubts about the future of nitrates. But the lines on his aging face seemed to deepen as it became obvious the sale was a done deal. In the end Solomon voted for the sale with the other seniors. It was time to let Chuqui go.

VI

Harry and Edmond left the Partners Room that day in sullen rage. They had been outvoted on a decision they truly believed was a bad turn for the partnership. It left them just one card to play. Two weeks after the

boardroom showdown Harry and Edmond resigned from Guggenheim Brothers. Daniel, usually two steps ahead of everyone, apparently hadn't foreseen this mutiny. A painful schism opened between father and son, between the head of the firm and the young man whom he was grooming to be the next family patriarch.

With time, Daniel perhaps thought Harry would change his mind. Harry and Carol had married just weeks earlier; Daniel did not want to throw cold water on what should be a joyous moment in their lives. In fact, Daniel was extremely fond of his new daughter-in-law. Carol was tall and poised, rail-thin, and erudite, an elegant woman. Her presence had a calming effect on Harry, her youthful face defined by a glancing, seductive smile and expressive, swooping eyebrows. Carol had an artist's sensibility and a talent for rendering figurative drawings and silhouettes. She possessed an impressive social pedigree. The social registers of both New York and her hometown of Chicago had long recognized the Morton family name. She was the daughter of Paul Morton, secretary of the navy under Theodore Roosevelt. Carol was also the granddaughter of Julius Morton, secretary of agriculture under Grover Cleveland. She was the niece of Joy Morton, founder of Morton Salt.

Daniel did not want this sudden family crisis to get worse. So Daniel and Florence came up with a wedding gift Harry and Carol couldn't refuse: a ninety-acre parcel of land cut from the Hempstead House estate, much of it on bluffs overlooking the sound. The gift would include $250,000 (nearly $4 million today) for the newlyweds to build a home. Neither rental nor starter castle, this would be their own piece of the Gold Coast.

If this was Daniel's attempt to keep Harry in the fold, it worked. Harry and Carol humbly accepted the gift. They chose to build a Norman-style manor house on the land and christened it "Falaise." The name is French for cliff, but their inspiration may have come from the Chateau de Falaise, a castle at the birthplace of William the Conqueror, the man who launched the Norman conquest of England and became its first Norman king (a

reference Hadley would approve of). Harry divided the design and construction work between a noted New York architect, Frederick Sterner, and the firm of Polhemus & Coffin, which specialized in homes in the style of small French chateaus and manor houses.

Just a week after the $70 million check arrived at 120 Broadway, Harry and Carol boarded the SS *Paris* on their way to a European honeymoon and a hunt for home furnishings. Sterner accompanied them for part of the trip. Harry and Carol visited art and antiques dealers in Paris, Marseille, Avignon, Fontainebleau, Lyon, and Rouen. They went on to Rome, Florence, Sorrento, Perugia and Palermo, and then to Algiers and Tunis. They shipped back architectural fragments from medieval ruins, Dutch bricks, Renaissance paintings, and 17th-century wood carvings. They acquired a stone fireplace mantle so large it had to be broken apart and reassembled, and lava stone columns that would frame the arched wooden entrance door at Falaise, reminiscent of Pembroke's 14th-century gatehouse.

When they returned from Europe a few months later, Harry and Daniel picked up where they left off. Harry had not budged on his decision to leave the firm. Daniel thought the ethos of the partnership was clear: the younger members enjoy the benefits of being full partners, but carry a major load of the work, while the seniors contribute and manage the capital of the firm to make the work of the juniors pay off. To resign as a junior member and continue to hold positions in firm investments, as Harry and Edmond did, was a betrayal, thought Daniel. To sell Chuqui was to forfeit a major piece of the junior members' future, thought Harry—that was the real betrayal.

Daniel worked up a fulsome letter to his son: "I had expected that you would decide to continue your interest, and had hoped, because I thought it was your duty to do so, that you would come forward and offer to carry your share of the burden in making these enterprises a success. The Seniors agreed, substantially, to carry on the burden of the finances while it was understood that the Juniors would carry on the burden of the work. As we *must* keep on with the finances. I cannot appreciate, after you and Edmond

as members of the Firm joined us in reaching a conclusion to go into these ventures, by what process of reasoning you assume and feel justified in dropping out and leaving us to carry both burdens. It is true that you have offered to relieve me personally and assist me in performing my duties, but this, of course, I cannot accept as a solution . . . Time is passing, death may overtake any of us, Juniors or Seniors, and we ought in some way . . . keep our bundle of sticks tied closely together." Ah, the sticks. What would Meyer Guggenheim do? Daniel did not send the letter but crafted a replacement matching the earlier version in substance, in a softer tone.

Harry's rebuttal was brief: "Dear Father: I have before me your letter of yesterday which I receive with some surprise . . . I have particularly tried to make my viewpoint clear in our recent conversations, both just before my departure for and after my return from Europe. These conversations were as unpleasant to me as they obviously were to you." Harry deflected his father's accusation of disloyalty, stating he knew his father's letter "was prompted by your zeal for my welfare and love for me, and as such I read it." But Harry stood firm. "Throughout this, if you like 'misunderstanding,' I have tried to follow the advice that Shakespeare made Polonius give to his son, viz. 'To thine own self be true, and it will follow as the night the day thou canst not then be false to any man.'"

Some weeks went by, more conversations ensued between father and son, not by letter but over walks through Hempstead House's vast acreage as Falaise was completed. It's possible Carol played a moderating role in Harry's conversations with his father. In the end Daniel reconciled himself to Harry's decision to leave the firm, apparently with the understanding that Harry would likely return to the firm someday. Harry and Carol gave Daniel and Florence another granddaughter, Diane, on April 23, 1924. The realignment between Harry and Daniel was the start of a new kind of relationship between father and son. From this point on the senior Guggenheim increasingly relied on the junior.

CHAPTER SIX

Godfather of Flight

I

In 1923 Daniel resigned from his directorship at ASARCO, the last formal position he held with the trust, and with the family business. The young journalist who came to see Daniel, B. C. Forbes, had ranked Daniel as the thirteenth wealthiest person in America, with an estimated net worth of $70 million (over $1 billion today). The Guggenheims were described as the American Rothschilds. Any visitor to Hempstead House would agree. As guests approached its main portico a giant sundial clock came into view over the entranceway, and behind it arrowslits cut into the walls, mimicking an ancient design allowing archers defending a castle to fire on enemies. Inside, one could get a neck ache looking up at the sixty-foot-high foyer, a cathedral-like expanse of space. Ascending to the first and second floors, one would be guided by bannisters embellished with carvings of ancient Celtic knots. Along the walls of the first floor were medieval tapestries, Jacobean antiques, and paintings by Daubigny, Homer Martin, and Corot. Daniel kept Gould's library intact (modeled after a chamber built by King James I). The billiard room, its ceiling finished in brilliant gold leaf,

was accessed through massive doors liberated from a 17th-century Spanish palace and carved with depictions of soldiers of the Middle Ages. Down the hall a two-ton safe stored the home's silver service and Florence's jewelry during their many trips abroad.

Daniel added or completed other features of the estate: tennis courts and a nine-hole golf course. A description at the time cast Daniel as a gentleman farmer who enjoyed the self-sufficiency of his own fiefdom, a man who "ran a dairy, slaughtered his own cattle, hung his own beef, cured his own hams, sausage, and bacon, raised his own fruits and vegetables, canned his own preserves, killed and ate his own hens and pheasants." From a widow's walk on the roof, accessible through a special door, one could take in a panorama of the grounds, nearly two miles. Harry and his siblings would later have "apartments" at Hempstead House and come to ride horses. The grounds staff numbered about two hundred workers, including fifty day attendants and a house staff of eighteen. The signage on the property had been a final bit of serendipity. Gould had fabricated the letter *G* to represent his family name on gates and archways everywhere. No need to alter it; the *G* now stood for Guggenheim.

Daniel had been a charitable giver to Jewish associations, the New York City symphony, and the city's botanical gardens. Approaching sixty-seven, he now thought about how his wealth could deliver a more perdurable impact. His two early ideas—funding agricultural education and building on the reforms he had made in the workplace—felt useful, but incremental. Government efforts had begun to play a larger role in both. Over the months, as he mended fences with Harry, Daniel got a regular earful from his aviator son about the coming Age of Flight. Daniel had never seen Harry so preoccupied with a hobby. Flying will be the business of the future, Harry would say. If so, would it also be worthy of philanthropic investment, wondered Daniel. He wasn't sure.

Untethered from the family business, Harry spent many hours in the air, piloting his own plane on hops around Long Island. He spent much time

comparing notes with fellow aviators about the sorry lack of airstrips and non-existent meteorological information for fliers. Harry knew the dangers of his new obsession, this flying business—but what an incredible business it could be. There had been explosive growth in air travel on the Continent after the war. But the United States, in Harry's estimation, was sadly lagging behind.

The Wright Brothers invented powered flight at Kitty Hawk in 1903, yet the first scheduled airmail service hadn't begun for another fifteen years. Why was that? For one thing, the Wrights did not welcome competitors. When Glenn Curtiss, maker of the Flying Boat and one of Harry's first flight instructors, employed new wing warping design on his planes, the Wrights hit Curtiss with a patent infringement suit, halting production. In the coming years the Wrights would spend $152,000 in legal fees to fight Curtiss (and spend even more in subsequent suits against other manufacturers). As a study of early aviation leadership later confirmed: "The stubbornness with which the Wrights tried to protect the technological evolution of their invention greatly influenced the early dynamics of the U.S. airline industry."

In the mid-1920s the government passed the Air Mail Act, allowing the U.S. Post Office Department to contract out airmail delivery to aviation start-ups like Colonial Air Transport and Western Air Express. But regular passenger service remained virtually nonexistent, unless one counted the annual five hundred or so adventurous people who bought tickets on airmail flights, sitting atop mailbags as they flew to their destinations.

Americans still regarded flying as dangerous and foolhardy. Most had never seen a plane in person, other than at traveling airshows, where barnstormers stunted their planes and wing walkers seemed to take even greater risks than trapeze artists. The "legitimate" pilots were those delivering U.S. Post mail, or twentysomethings like Harry who had joined the Naval Air Reserve during the war.

Young people attracted to the world of aviation tended to dismiss the risks. At New York University a four-course experimental program in

aeronautics was a favorite of students in their senior year. It focused on airplane and propeller design and principles of aerodynamics. The fledging aviation industry was so small that virtually every graduating senior in the program was assured a job. So NYU decided to establish a permanent aeronautical engineering program, if it could raise the money to fund it. An organizing committee was formed and Harry was invited to join it by NYU faculty member Alexander Klemin, a talented English engineer and fellow flying enthusiast whom he had likely met on Long Island.

The committee estimated the cost would be $500,000 ($7 million today). Its members proposed a public fundraising campaign. Harry countered that it would be tough to raise that much money for a single school. He instead offered to gauge the interest of his wealthy uncles in funding the endowment if NYU chancellor Elmer Ellsworth Brown would write a letter making the pitch—perhaps a "Guggenheim School of Aeronautics"? Harry brought the chancellor's note home to his father at Hempstead House, where Harry and Carol were staying while Falaise was being finished. As one account described it: "Dan looked at the letter as if he were inspecting a sample of ore, said he would like to sleep on it, and went to bed." Harry would have his answer the following day. "Daniel arose in the morning, joined his son in the walnut-paneled, stained-glass-windowed Elizabethan breakfast room, and over scrambled eggs, bacon, toast, and coffee, served by a liveried, white-gloved houseboy, told Harry not to bother to send the letter out, that he would put up the money himself, all that was needed." The following month Daniel announced the endowment. It would underwrite a propeller laboratory and wind tunnel, endow three chairs and research assistants, and pay for a two-story research facility.

It was big news that father and son Guggenheims were suddenly tapping the family fortune to back a business most Americans knew very little about. The gift was lauded by newspapers around the country. To Harry's immense satisfaction, Orville Wright agreed to chair the fund's advisory committee. That October, 400 faculty members, students, and guests assembled at

NYU to watch Daniel Guggenheim sink a shovel into the ground and inaugurate the Daniel Guggenheim School of Aeronautics. Daniel noted: "Were I a young man seeking a career in either science or commerce, I should unhesitatingly turn to aviation. I consider it the greatest road to opportunity which lies before the science and commerce of the civilized countries of the earth today."

II

The endowment signaled that aviation was no longer a novelty, but potentially a new form of transportation that would rival railroads and automobiles. As the *Philadelphia Inquirer* put it: "The dream of aviation as a public utility is clearly on the verge of realization in this country. The Guggenheim endowment should give that realization a powerful impetus." This was a poetic, but grandiloquent, sentiment. The truth was that academia was nowhere near fulfilling this dream. Just five universities in the entire country offered courses on aeronautical engineering. Harry began thinking of the NYU program as a trial run for a bigger national template. The NYU endowment was already moving the family brand and legacy beyond its traditional roots—mining—into a new business sector. Many investors and philanthropists still considered aviation too risky. That was precisely the problem, argued Harry. As a pilot himself, he knew that as long as basic safety precautions were followed, flying was as safe as driving.

The executive branch of the federal government was talking about aviation, too, but as of yet there was little federal policy guiding it. President Coolidge appointed a board to evaluate what the government's role should be. It was headed by Dwight Morrow, Coolidge's former Amherst classmate and partner at J. P. Morgan. The board would soon lay out a framework for regulating air navigation and licensing pilots. Morrow

had also been a financier for Guggenheim mining properties; he and Harry got to talking. In late December 1925 Harry went to see Morrow in Washington, well prepared to discuss an idea his father had sanctioned, but would require the Coolidge administration's help: a national multimillion-dollar fund to advance aviation. Harry made his pitch to Morrow, explaining the novel financial model he had devised. The fund wouldn't be philanthropy in the traditional sense, nor was it intended to furnish permanent subsidies of any kind to aviation. Rather, Harry saw it as a kind of financial "spark plug."

The approach loosely resonated with Commerce Secretary Herbert Hoover's philosophy of "associationalism"—a precursor to public-private partnerships. Morrow was apparently impressed, both with the financial strategy Harry laid out and the stunning level of support his father was willing to commit. Harry's host just had one question: Would he be available for a meeting with President Coolidge later that morning?

Harry was elated. But he knew that Coolidge was a frugal, small-government conservative. In one instance, after being asked to spend more on military aviation, Coolidge coldly asked: "Why can't we just buy one airplane and have all the pilots take turns?" Coolidge would have to be convinced that the Guggenheim plan would boost aviation with little or no financial help from the government. And that depended on how much Coolidge was willing to listen at all. The president generally believed that 90 percent of his visitors didn't deserve what they asked for. Often, he would sit back in silence. "If you keep dead still they will run down in three or four minutes," he would say.

Harry was escorted to the White House executive building and introduced to the president in the Oval Office. The famously taciturn Coolidge sat back and listened to Harry's outline of what the fund could accomplish. Harry assured Coolidge, a fellow Republican, that the scope of the fund's work was entirely a free-market approach, not a scheme for subsidies, like the European system. It would give momentum to

aviation's fledging R&D efforts, which would spark private sector investment. The fund would be unique in two ways: 1) It would not make money. Any income generated would be returned to the fund. 2) It would not be permanent. The fund would exist as a financial catalyst for a limited time, just long enough to help set the wheels of industry in motion.

Coolidge seemed intrigued. He picked up the phone and called his secretary of commerce. "Hoover, be at the White House for lunch at 12:30," he said, hanging up. Soon after, First Lady Grace Coolidge arrived, gregarious and outgoing, a mirror opposite of her husband, followed by Secretary Hoover. Over lunch Harry further outlined the aims of the fund and its unique approach to financing.

From there the lunch party moved to the presidential study, where Harry hoped Coolidge would be intrigued by the notion that early adopters of city-to-city flights would be business travelers, given how much faster planes could travel to business destinations than railroad or automobile. The president seemed oddly skeptical. "What's the use of getting there quicker if you haven't got something better to say when you arrive?" he asked. That barb aside, Coolidge had clearly warmed to the idea of the fund. Hoover, too, liked the concept. By the end of the visit Harry had managed to gain the support of both the current and future U.S. president, and also tour some of the West Wing. The conversation concluded when Coolidge turned to his commerce secretary, stating abruptly, "Hoover, show Mr. Guggenheim to the elevator." Harry quickly returned to New York to give his father the good news, noting that the president was "pretty high-handed with his office help."

The trip to Washington was a milestone for Harry; the entrée he suddenly had into the executive branch was intoxicating. In discussing it all with his father, the idea was settled upon that the fund would only exist for a few years, so it was crucial to make every moment count. The new entity would be called the Daniel Guggenheim Fund for the Promotion of Aeronautics. Daniel seeded it with $2.5 million, later adding another

$500,000 ($44 million today). With his father's financial backing, and with the support of Coolidge and Hoover, Harry easily enlisted a who's who of business, science, aeronautics, and the military as directors of the fund. Among those who accepted the invitation: Rear Admiral Hutchinson Cone (head of all U.S. naval forces in Europe during World War I); George Goethals (who had directed the building of the Panama Canal); Elihu Root (Theodore Roosevelt's secretary of state); Albert A. Michelson (first American to win a Nobel Prize in physics); plus Orville Wright, Dwight Morrow, and Trubee Davison.

It had been over twenty years since the Wrights had first taken to the air. Over that time, planes soared higher and faster largely because they harnessed greater horsepower. The average aircraft engine possessed 12 horsepower in 1903; 35 horsepower in 1908; 112 horsepower in 1914; 243 horsepower in 1917; and 450 horsepower in 1918.

This conveyed to Harry one fundamental truth: the invention phase of the airplane was over. Now it was time to make aircraft even faster and capable of navigating in challenging weather; to convey the inherent safety of flying to the public; and to build a labor force and production infrastructure to scale up manufacturing. Without these interdependent spokes in the wheel, thought Harry, air travel would take years to expand beyond regional routes, and airplanes would remain essentially handmade products. (Perhaps three to four airplanes a day were produced by the average aircraft factory at that time.)

Newspaper reporters now came calling on Daniel and Harry seeking opinions not on mining or the stock market, but on the future of air travel. In interviews, they made their roles clear: Daniel, the backer; and Harry, the strategist. "I am not an expert on aviation," confessed Daniel in an interview. "Practically all of my interest has come through my son, Harry, who enlisted at the beginning of the war and has flown overseas and in this country. His enthusiasm is too contagious. It has captured me."

III

Harry found office space for the fund at 598 Madison Ave. in Manhattan. It would have no sweeping Corots on the walls, no elegant suites nor telephones in the elevators. It was a war room, of sorts, for this aviation crusade. While the grants to come would be generous, Harry made a point of keeping the overhead of the fund low, about 3 percent annually.

The Wrights' trials at Kitty Hawk were regarded by Harry as virtually a religious event. He obtained a relic of those early flights—a fragment of the Wright Brothers' hangar—which he had framed and placed on a boardroom table. Harry's passion for aviation seemed to resemble the intensity of a spiritual path. "The greatest inspiration that aviation brings to me is the possibilities that it offers for increasing contacts between the nations of the world and for extending the boundaries of civilization," he said.

Like 120 Broadway, the fund headquarters was a hub of intelligence, its shelves piled with the latest aeronautical bulletins, newsletters, company announcements, and back issues of *Aviation Age Weekly*. Harry now had his own council table, around which he could harness the brainpower and the vast connections of leading thinkers. In their early meetings Harry steered discussions toward taking stock of the industry, assessing the capacities and needs of current and emerging airplane manufacturers, and how U.S. aviation compared to the rest of the world. As one aviation historian put it: "By 1925 it was probable that Harry Guggenheim knew more about what was going on in world aviation circles than any other man in America."

To communicate the fund's work, Harry hired Ivy Lee, a public relations pioneer who had worked for the Rockefellers. Lee crafted a series of public releases about the fund, the first noting how far behind American aviation was compared to Europe. "As of 1926, European nations flew 500 commercial planes in regular service over 14,200 miles of air routes whereas in the United States aircraft manufacturers were 'almost exclusively engaged' in producing military warplanes. To match the European investment

proportionately, the United States would require 5000 airplanes, an investment of $100 million."

Europe had America beat by the sheer numbers of passengers and planes in the air. How did they do it? The answer, in a word: Americans. The majority of passengers flying on European aircraft were U.S. tourists. They bought seats on Italy's flying boat passenger service and booked flights running between London and Paris all summer long. At a time when American airline passenger service was virtually nonexistent, European airlines were flying Americans all over the Continent.

Harry organized a fact-finding trip with Admiral Cone to get a closer look at some of the other drivers of growth in Europe, in particular aeronautical research. They set off for three months, interviewing aviators, executives, and inventors in England, France, Spain, Germany, and Holland. It was widely known at the time that the most common cause of flying accidents was stalling in midair. A stall doesn't mean the engine stops; it means the plane's speed isn't fast enough to keep it aloft, causing it to nosedive. So one of Harry's first stops was in England to attend the demonstration of a breakthrough design addressing the problem—a "wing slat." When added to the forward edge of a plane's wing this "mini-wing" has the effect of cutting airflow over the top of the wing and reducing the loss of lift when a plane slows down. It stabilizes planes in flight and reduces landing speeds. As aerospace historian Richard P. Hallion put it: "A 1926 biplane without a slat might stall at 50 mph. With a slat its stall speed might be reduced to 35 mph." In short, it was a remarkable innovation that widened the margins of safety during landings. (The design is still used on planes today.)

Harry spent weeks assessing technical training programs and interviewing European air service operators. Two clear findings emerged: The first was that the superiority of European aviation was rooted in government spending. The second was that this spending exposed a tremendous weakness in the system. Europe subsidized small air carriers because most of them

lost money. But those subsidies removed incentives to innovate—much of Europe's air traffic consisted of aging WWI aircraft.

The trip hammered home to Harry that the United States held intrinsic advantages over Europe. Geographic boundaries in Europe made aviation routes shorter (there were no such border issues between states). Bad weather in northern Europe caused major delays for carriers and poor service in those regions (North America generally has far better weather). It was obvious that the United States had numerous potential advantages in aviation which it simply had not capitalized on.

Sitting in his steamer cabin on the long voyage back across the Atlantic, Harry synthesized the findings he and Admiral Cone had made into a list of thirty-five development ideas, each with an estimated funding cost—thirty-five financial spark plugs. The foundation of Harry's approach would be the national rollout of university-based aviation education and applied aviation research. It was both seed money to stimulate the air age workforce—production engineers, mechanics, technicians—and funding for research discoveries that would make aircraft safer and easier to fly.

Harry and the fund awarded endowments to two schools they judged to be the most promising, giving Stanford University $195,000 (nearly $3 million today) and the California Institute of Technology in Southern California, known as Caltech, $305,000 ($4.4 million today), for both research and instruction. Harry struck a novel arrangement with Caltech via the chair of its executive council, Robert A. Millikan, a Nobel Prize winner in physics. The plan called for Millikan to lure Dr. Theodore von Kármán, perhaps the top aeronautical scientist in Europe at the time, to Caltech to head the new Guggenheim program. Then teaching at a German technical institute, von Kármán had delivered groundbreaking papers on jet propulsion and aerodynamics. During World War I, while in the Austrian air service, he developed one of the world's first helicopters.

Von Kármán agreed and soon arrived in Pasadena, later splitting the program between aeronautical research in California and a dirigible research

lab in Akron, Ohio. Von Kármán was enlisted by Harry to advise the fund on two other schools chosen to host programs—the University of Michigan, granted $78,000 ($1 million today), and the Massachusetts Institute of Technology, granted $230,000 ($3.3 million today), both for aeronautical engineering.

IV

Looking for a candidate in the Pacific Northwest, Harry received a proposal from a then-fledgling aviation pioneer named William Boeing, who was hiring university engineering graduates to work in his small airplane production shop. Boeing asked for funding to establish a building for an aeronautics curriculum at the University of Washington. The fund agreed to a grant of $290,000 ($4.2 million today) to the school, chosen also for the fact it was close to air routes to Alaska, a potentially huge market. Geographical considerations led to a similar grant to the Georgia School of Technology (there was little presence of aviation education in the South), awarded $300,000 ($4.3 million today) for a school of aeronautics and an aviation research center.

As this massive university education push got underway, Harry steered a series of discussions at the fund to undertake a "safe plane" competition, offering prizes of up to $100,000 ($1.5 million today) for aircraft that could demonstrate the greatest control at the lowest speeds. Inspired by the wing slat trials he witnessed in England, the fund would also offer five $10,000 secondary awards. Competitions like these had been around for years and had been featured in *Aviation Age Weekly*. But $100,000 was a far bigger purse than most. Harry put Orville Wright in charge of the competition committee. Months of debate went on over what performance measures constituted "safe." Among the agreed-upon rules: competing planes were required to fly at 35 mph and glide at 38 mph without stalling; establish

their rate of climb to at least 400 feet per minute; and land and take off on a 100-foot runway, surrounded by obstacles. "Any plane that meets the acid test of these requirements will be a pretty safe ship," said Harry.

The contest drew twenty-seven initial competitors, but Harry's rules were so demanding that only two made it to the qualifying round. The dropouts included two planes that had crashed. The final round was held on a cold January morning at Mitchel Field in Long Island, just south of Falaise. In the end, the Curtiss Tanager, a biplane with a tapered cabin under its arching wings, beat the Handley Page by a single point. One look at its takeoff suggested why. On its winning flight, the Curtiss made a short taxi, lifting off the ground at a near 45° angle. The floating ailerons on the lower wings and slats on the upper wings delivered immense lift. On landing, the pilot brought his craft to a stop within a ninety-foot roll. The slots and flaps on the Curtiss gave the plane unique levels of control, especially while landing.

Pilots understood how such an innovation added huge margins of safety, but did the public? Harry believed that to really convey the safety and dependability of flight, a more personal demonstration was required. His solution was to underwrite a "reliability tour." Floyd Bennett and Richard E. Byrd made their pioneering flight over the North Pole in 1926 (whether they actually got there has since been questioned by historians). Harry asked Bennett whether he'd be willing to tour the country in the plane he and Byrd flew, the Fokker Trimotor *Josephine Ford*. Traveling state to state, it would bring the reality of air travel to towns in dozens of cities and generate public interest in the building of airports.

Bennett agreed. Over a six-week period he traveled 7,000 miles, landing in forty-five cities. An average of 12,000 people came out at each stop, allowing some 540,000 citizens to see the plane in person. Bennett gave interviews in each town and delivered speeches assuring that his plane was not unique or experimental; it was the kind of plane the average passenger would be perfectly safe in. As Harry said in a statement: "I think it a remarkable demonstration of the advances already made in aviation that the same

plane which carried Commander Byrd and Pilot Bennett over the North Pole is able to complete a swing around the country with no more difficulty than would be found in a motor trip over present-day roads."

This was a counternarrative to the bread-and-butter press coverage of aviation at the time. Most newspaper stories about airplanes were prompted by mishaps like midair explosions or crash landings. One of the great satirists of the day, and a fan of the coming air age, Will Rogers, wrote: "Five people killed in plane yesterday and it is headlined to-day in every paper. Saturday in Los Angeles at one grade crossing seven were killed and six wounded and the papers didn't even publish the names. It looks like the only way you can get any publicity on your death is to be killed in a plane. It's no novelty to be killed in an auto anymore."

Working with Ivy Lee, Harry tried to reframe press coverage of aviation accidents. He sent a letter to editors of leading papers suggesting questions journalists should ask when reporting an airplane accident, such as: "Were both the airplane and the pilot licensed?" "Was the landing field in bad condition?" "Was there a defect in the mechanical structure of the plane?" "Was there an adequate number of modern safety devices?" In other words, said Harry, "it was suggested that the newspapers should find out the actual cause, as under normal conditions accidents in aviation are very rare."

Harry's list of thirty-five spark plugs was far from exhausted. The fund identified the need for a clearinghouse of aviation law that would track the latest legal and regulatory news affecting the sector. It was called the Air Law Institute at Northwestern University. The fund also launched what soon became a respected publication in the field, the *Journal of Air Law* (now the *Journal of Air Law and Commerce*). This added to the body of scholarship on aviation Harry and the directors sought to build through the commissioning of technical papers, lectures, and conferences on a huge range of aeronautical subjects.

Another extension of aviation into the commercial sector was surveying from the air, with obvious implications for agriculture and real estate.

Syracuse University received a $30,000 grant from the fund for aerial surveying and mapping. This produced an unexpected windfall for the town of Middletown, Connecticut: aerial surveying revealed nearly 2,000 buildings which hadn't been included for tax assessments. Much to the annoyance of some real estate owners, the survey sparked a rise in local taxes.

Harry and the directors also spent time thinking through a downward extension of aviation education to primary schools, where young people tend to get their first ideas about flying. Harry organized an aviation literacy committee to produce a dossier of quick-reference materials sketching the history of flight. It included a glossary of aviation terms and a recommended reading list of books on flight. Some 7,000 of these packets were distributed to schools nationwide.

There was also the matter of recognizing pioneers and risk-takers in early aviation. Harry, Daniel, and fund directors discussed ways to acknowledge their contributions. Their simple solution was to establish an award (which would also make an excellent tool to publicize the fund's work, noted Ivy Lee). Called the Daniel Guggenheim Medal, it would recognize trailblazers in the field. Among them would be Orville Wright, William E. Boeing, Donald W. Douglas, Leroy R. Grumman, Marcel Dassault (and later, Charles Lindbergh and Robert Goddard).

Nearly all of the fund's work focused on the future, but what of preserving aviation history? Harry and the directors had an idea for that, too. They approved a grant for $140,000 ($2 million today) to the Library of Congress to assemble and preserve a massive collection of aviation art and literature. One shipment, arriving aboard the RMS *Aquitania*, comprised four collections of several hundred years of aeronautica, weighing some three tons.

Harry brought an obsessive energy to these fund initiatives, however large or small the grant. One could criticize the fund's shotgun approach. But Daniel's generosity gave Harry and the fund a pool of risk capital that would not be judged by a stock price or net profits. It was venture philanthropy

whose dividends would come in the form of graduates from Guggenheim aviation schools, breakthroughs in airplane safety, and the build-out of an industry.

Harry and Daniel agreed it would operate for just a few years. If the financial spark plugs were deployed in the right places, they would have done their job. As Harry's staggering aviation initiatives stacked up, *Popular Science* named him the "Godfather of Flight." But the fund's biggest achievement lay just ahead—as did the start of the most consequential friendship of Harry's life.

Lord of the Wings

I

I n early 1927 Harry's aviation fund was approached by several pilots, each seeking financing for an attempt to fly nonstop from New York to Paris. The $25,000 prize for the first flier to do so was offered by Raymond Orteig, a French-born hotel mogul. Harry and the fund directors refused to back anyone, believing the trip was too dangerous. In recent months two pilots had died trying; another two had simply disappeared over the Atlantic.

Undeterred, more aviators planned to make the flight. Newspapers devoted thousands of column inches to following their preparations. In the running was the man who had flown to the Arctic, Admiral Richard Byrd, fresh off the "reliability tour" Harry had funded. Another competitor, a twenty-five-year-old airmail pilot from the Midwest, announced he would make the journey alone, with no copilot. The flight would cover some 3,600 miles nonstop, much of it over open sea at night, requiring the pilot to stay awake and alert for at least thirty consecutive hours.

Harry had gone to visit Byrd and to wish the admiral good luck. Now he wanted to meet Byrd's rival, the young solo flier who would take off from

an airstrip just south of Falaise. When Harry arrived at Curtiss Field he spotted the nose of the craft just inside the open door of a cavernous, dark hangar. The pilot was nowhere in sight. Harry struck up a conversation with the designer of the plane's engine. It was a Wright Whirlwind, whose nine cylinders radiated outward behind the propeller, like spokes in a wheel. The design allowed it to be air-cooled, though at the cost of being exposed to the elements. The plane was silver-gray, with small rectangular windows in its tiny doors, opening just beneath the wings. Inside, the cockpit appeared strangely bare. Every item of weight had been removed to compensate for its heavy payload of fuel. A wicker chair and seat pad was jerry-rigged into the floor of the cockpit. Near the base of it was a sad pile of sandwiches—two roast beef, two ham, one egg salad.

Suddenly the pilot appeared, a gangly young man with close-cropped blond hair. Introductions were made; the pilot invited Harry to take a look inside the cockpit. Harry climbed in, the chair creaking precariously as he sat back. In front of him was an oval-shaped instrument panel. It was a sheet of plywood painted black, into which gauges had been bolted. There was no windshield or means of directly looking forward, a sacrifice for more gas storage and to make the entire fuselage more aerodynamic. Fuel was stored in front of the plane and in wing tanks to balance the weight. Through the left window was what the pilot called his "periscope," resembling a metal shoebox holding mirrors extending laterally out the left window, allowing him to see what was in front of him.

During the flight the weight of the plane would be evenly distributed by siphoning fuel from each tank at intervals, the pilot manually opening and closing valves to send gas to the engine. Anticipating that cold temperatures above the Atlantic might freeze water vapor and choke fuel to the carburetor, the pilot had a carburetor heater installed after landing in New York. Harry marveled at these minor innovations. The pilot had tried to anticipate everything. Harry asked about safety equipment—that is, the lack of it. To reduce weight the pilot had no radio or parachute in the cabin,

just an inflatable black rubber raft he had bought at a sporting goods store. The sandwiches weren't for the flight, but for survival at sea assuming he'd still be alive after crash landing in the North Atlantic. Harry climbed out of the cockpit and politely ended the conversation, wishing the pilot good luck. "When you get back from your flight look me up," he said cheerily then turned back to his car. In truth, Harry considered the plane a death trap with wicker furniture. "He's doomed," he thought, walking hastily away.

For several days, the pilot, Charles Lindbergh, waited for weather to clear over the Eastern Seaboard, holed up in his room at the Garden City Hotel in Long Island. Lindbergh made a few ventures around town and spent an afternoon at Coney Island. Though young, he had plenty of experience: flight instructor, mechanic, airmail pilot. He was used to navigating bad weather mail routes between Chicago and St. Louis. He had graduated first in his class in the U.S. Army Air Corps and held the rank of captain. Lindbergh hadn't approached Harry's aviation fund because he had already lined up financial backing. A group of St. Louis investors pooled their money to build the plane for some $10,000. Plenty of people were rooting for the underdog pilot. Two days after Harry's visit with Lindbergh, the forecast for the North Atlantic looked about as good as it would get. Lindbergh's historic flight has been recounted many times over the years, of course. But a brief recap of the journey sets the context for Harry's close friendship with Lindbergh, which began with this pivotal moment in history.

It was early in the morning of May 20, 1927. Lindbergh had gotten little sleep the night before. He loaded his plane, *The Spirit of St. Louis*, with as much gas as it could take—topping off its five tanks with 451 gallons. After a bumpy takeoff Lindbergh ascended to the air over Long Island, flying through an early-morning drizzle. He banked north toward New England and began checking his New York state map for landmarks.

The Spirit wasn't the steadiest of aircrafts, requiring constant attention to its stick-and-rudder controls. He soon settled into a sequence of checking gauges that he would follow for hours: A glance at the primary compass

(to check course), turn-and-bank indicator (to ensure the plane was flying straight), altimeter (which approximated height of the plane from sea level, corrected by the known terrain), air speed meter and clock (to calculate distance), engine speed and temperature, and oil pressure. In the hours ahead, to estimate wind velocity he would drop altitude to assess the height of waves.

Lindbergh passed over Nova Scotia, then Newfoundland, circling above St. John's. A few hours later he was over the Atlantic, approaching a vast field of icebergs on one side, open sea on the other, without a landmark in sight. Soon darkness and fog set in. He climbed to 10,000 feet, an altitude just clearing the eerie outlines of the vast diaphanous cloud tops below him. Then came some bad weather, thunderheads and possibly a magnetic storm, causing both of his compasses to malfunction. With his flashlight he spotted a shiny layer of ice forming on the struts of his wings. With great reluctance, his stomach knotting up, he made a decision to backtrack and fly around the bad weather, but such deviations ate up fuel and pushed him far off course.

Soon the night sky opened to reveal moonlight and stars. It did not last long. A little while later, now in his 20th hour, he was flying blind again, navigating through a massive fogbank. He was well acclimated to the roar and vibration of his monoplane's engine, cotton stuffed in his ears to mute the sound. He continued on, half-asleep and fighting the onset of hallucinations, knowing that his biggest challenge was simply staying awake. Hours later, in the approaching daylight, he could see a vast seascape dotted with whitecaps. He flew *The Spirit* as close as ten feet above the ocean surface, the wind whipping the frothy tops of the waves, spritzing his face with a thin salt spray through the window. Later that afternoon he found himself over the southwest coast of Ireland and just six hours from Paris. He felt his fatigue lift as he entered the airspace of the Continent. With night again approaching he could see lighted boat traffic along the Seine. He followed the lights of the river to Paris. As the Eiffel Tower came into view, he felt a second wind, a burst of adrenaline. He banked around the landmark

and made his way to where he thought the landing field would be. When Lindbergh left Long Island there were just a few hundred onlookers to see him off. Landing at the field at Le Bourget that night on the outskirts of the city, some 150,000 people awaited him. Lindbergh was the first man to fly nonstop, solo, between the continents of North America and Europe. He calculated he had been awake sixty-three consecutive hours.

<div align="center">II</div>

Anyone pondering the significance of the flight could pick up the next day's *New York Times*, whose giant banner headline proclaimed: LINDBERGH DOES IT! The *Times* devoted the entire front page of the paper to the flight and four additional pages on the inside. In the coming days Lindbergh was decorated with the French Legion of Honor and was a guest of both King Albert of Belgium and King George of England. Every famous figure in the world, it seemed, was inspired to offer their congratulations to Lindbergh, from Pope Pius XI to Mussolini. President Coolidge sent military transportation for Lindbergh and his plane to return to the United States. When Lindbergh landed in New York some four million people lined a ticker tape parade route in lower Manhattan—more than half the population of New York City. Later he would lunch with President Coolidge and the cabinet, receive the Congressional Medal of Honor and make the cover of *Time*, named by the magazine as its first Man of the Year and the youngest person ever to grace the cover. An obscure airmail pilot from the Midwest suddenly became the most famous person in the world.

Lindbergh received about $5 million in business offers during his first month after returning to America. He was pitched a $300,000 contract from Adolph Zukor to appear in a movie for Paramount Pictures and a $500,000 deal from William Randolph Hearst to star in a series of films opposite Marion Davies. He turned both down. "People behaved as though Lindbergh had

walked on water, not flown over it," wrote Lindbergh biographer A. Scott Berg. The name Lindbergh would soon show up in school textbooks. Streets were being named for him. "Mountains, lakes, parks, boulevards, islands, bays, and beaches across America and beyond were renamed in his honor."

Harry saw Lindbergh's flight as a transformational moment—an "epoch-making event" and a "godsend to aviation." The flight legitimized everything the fund was attempting. Like everyone in the emerging world of flight, Lindbergh knew what Harry and the fund were doing for aviation. When Lindbergh came to Washington, he met with Dwight Morrow, the longtime Guggenheim family confidant whose board had established the U.S. Army Air Corps the year before. Morrow urged Lindbergh to speak with Harry about his future plans. Harry, in fact, had a proposal in mind for the young pilot. A meeting was arranged for June 17 in the operations office at Mitchel Field. Joining Lindbergh and Harry was Donald Keyhoe, a staffer at the aeronautics branch of the Department of Commerce. The idea they agreed on was a goodwill tour, much like Admiral Byrd's but on a grander scale. Harry offered to finance a three-month coast-to-coast aviation tour piloted by Lindbergh, bringing *The Spirit* to forty-eight states. The tour would keep the momentum of his transatlantic flight going and be a powerful tool to promote the safety and reliability of aviation, a goal Harry and Lindbergh passionately shared. Looking over a U.S. map together, they devised a general outline; details would soon be worked out.

They next met at Falaise. Lindbergh arrived early to go fishing with Harry in the sound. Keyhoe and Milburn Kusterer, another Commerce Department staffer, were on the balcony at Falaise when Harry and Lindbergh returned. Lindbergh was dressed in khakis and a flannel shirt, his face lightly bronzed from the sun. Harry had arranged production of an oversized map, laid on a large table at Falaise. It detailed a proposed route, indicated by zigzagging lines, tracing a city-to-city path across the nation, starting with nearby Hartford, Connecticut. Keyhoe would be Lindbergh's aide, Kusterer the tour's advance man.

Harry's first concern was how Lindbergh would arrive safely at the dozens of airstrips and military bases chosen as landing spots. Harry suggested a no-fly zone at each stop. "*The Spirit of St. Louis* is 'blind,' and someone might get in front of you," said Harry. "I think we had better ask everyone to stay out of the air until you have landed."

Lindbergh disagreed, shaking his head. "I don't want all the pilots to think we're trying to order them around. I can keep clear of other ships."

"Probably you could," countered Harry, "but everyone who could fly would be in the air and there would be chances of the less skilled pilots bumping into each other." Lindbergh thought for a moment then gave in, recognizing that just one crash would turn the tour into a disaster.

Lindbergh brought up another safety concern, suggesting the need for a plan to stop crowds from rushing onto the field where *The Spirit* would land. "I've seen a propeller kill a man, and I don't intend to have anyone hit by my ship if I can help it," said Lindbergh.

Harry turned to Kusterer. "The Colonel is right," he said (Lindbergh had been promoted to colonel upon his return from France). Harry told Kusterer, the advance man, to make security arrangements at every landing spot that would prevent such mishaps. Kusterer would do this by arriving by train a few days ahead of each landing.

One thing Harry learned from the Byrd tour was the importance of a press plan. Ivy Lee would help with this, but Harry designated Keyhoe as the man on the ground to manage reporters and allot dedicated time for press access to the aviator. On a tour with so many landings, parades, and speeches, bad press about something was bound to arise. "Keyhoe, as the Colonel's aide you will have to be a sort of buffer and take all the knocks." said Harry. After discussing the route and timing of the arrivals, Lindbergh met Harry's attorney, Henry Breckinridge, who had been Woodrow Wilson's assistant secretary of war. Lindbergh warmed to the affable Breckenridge and was charmed by his wife, Aida de Acosta, an aviator herself who was the first woman to solo pilot a blimp. Breckinridge soon became Lindbergh's

legal advisor, helping Lindbergh sort through the dozens of business offers bombarding him by the day.

In the weeks before the tour Lindbergh planned to publish a book about his flight, which was then being ghostwritten for him. He had signed a contract with publisher and aviation enthusiast George P. Putnam. But when Lindbergh received the draft, he hated it. It was filled with errors and crafted in a tone he felt had not at all captured his voice. So Lindbergh decided to write the book himself. He would need a retreat to work on the manuscript. Harry had an idea: Why not write it at Falaise? Lindbergh agreed and started immediately. Harry and Carol gave Lindbergh the upstairs northeast bedroom overlooking the sound. It had an old writing desk and a small balcony. Lindbergh worked on his draft in longhand using the ghostwritten version as an outline.

He finished less than a month later, completing just under 40,000 words. It was a short autobiography beginning with his childhood and ending with the famed landing at Le Bourget. It was called *We*, a reference Lindbergh said referred to himself and his backers, not himself and his plane (as many media stories reported). The book came out just a few weeks later and within a month had sold nearly 200,000 copies.

Just before the start of the tour, Harry joined Keyhoe and Kusterer at Mitchel Field, along with another member of the tour team, Phillip Love, Lindbergh's old airmail and army flying friend. As the man bankrolling the venture, Harry had some final words to Lindbergh's team: "Colonel Lindbergh is the commanding officer. If anything very unusual comes up he will decide it. Goodbye and good luck."

III

At the start of the tour the advance plane left a half hour ahead of Lindbergh and *The Spirit*. In Hartford a crowd of 100,000 awaited. Here and at nearly

every stop the same protocol was followed: landing at 2:00 P.M., followed by a parade, a speech by Lindbergh (usually on the safety of aviation and the need for airports), a meeting with reporters, and a banquet with city leaders. At some locations Lindbergh would visit a hospital or a potential site for an airport. Often he was invited to stay at hunting lodges, estates, and privately owned ranches. He declined most of the invitations. Instead he kept to his schedule, arriving at each city precisely at 2:00 P.M.

Lindbergh wrote to Harry frequently during the tour, initially with glowing reports. From Pittsburgh: "I am completely satisfied with the results of the tour up until the present but the turmoil of each city brings memories of those two short weeks of quiet which I spent with you on Long Island and I often wish that it would be possible to have a few of those days now and then on this flight."

From Milwaukee, Wisconsin: "The plane is standing up wonderfully and the engine is still in perfect condition with about 165 hours airtime. The N.Y.-Paris plugs are all functioning perfectly and give every indication of continuing to do so for a number of hours to come." Upon arriving in Detroit, Lindbergh spent the night at Henry Ford's home and the following day took Ford for his first airplane ride, lasting fifteen minutes. Ford and Lindbergh shared the cramped space inside the cockpit, with Ford practically in Lindbergh's lap.

For cities Lindbergh flew over, but did not have time to land in, a message was prepared and placed in a canvas bag. An orange streamer was attached to make it visible, then it was thrown overboard by Lindbergh. It read:

Aboard "Spirit of St. Louis" On Tour
GREETINGS:

> We regret exceedingly that the limited time and extensive itinerary of the United States' tour prevent us from landing in your city. We wish, however, to send you this greeting from the air to express our sincere appreciation of your interest

in the tour and in the promotion and expansion of commer-
cial aeronautics in the United States. We feel that we will be
amply repaid for all of our efforts if each and every citizen
in the United States cherishes an interest in flying and gives
his earnest support to the air mail service and the establish-
ment of airports and similar facilities. The concerted effort
of the citizens of the United States in this direction will result
in America's taking its rightful place within a very short time
as the world leader in commercial flying.

It was signed, "Lindbergh," "Harry F. Guggenheim" and "W. P. Mac-Cracken Jr." (the latter was assistant secretary for aeronautics at the Department of Commerce).

Photographers swarmed Lindbergh at every landing, coaching him for their photos: "Come on now, Colonel—give us that famous smile! Shake hands with the mayor—look this way, Lindy—hold it! Wave your hand Colonel. Come on with that smile!" After riding in a few parades Lindbergh could count the nicks and bruises on his arms. Fans grabbed at him and threw flowers or small airplane models into the parade car. At one hotel stop it was Phil Love's turn. His collar and tie were pulled badly out of shape, having been manhandled by police who didn't recognize he was part of the entourage. Not only had he been assaulted by the authorities, said Love, "Somebody hit me on the head with a box of candy during the parade."

"Where is it?" asked Lindbergh. "Don't tell me you threw it away."

About a month into the tour came newspaper stories contending that its breakneck pace had put Lindbergh into a state of nervous exhaustion. Lindbergh denied the accounts and wrote a note of assurance to Harry from Sioux Falls, South Dakota, addressing him, as he did in every letter, as "Mr. Guggenheim": "In regard to the press stories concerning my health: those I have read have not the slightest foundation. I have refused to discuss my personal affairs to any large extent in my interviews and altho [*sic*] I

have made statements to the contrary, my impending breakdown seems to make good copy. We are doing a great deal of flying on the tour. About 80 hours in the last thirty days. This is more than the average mail pilot flies but we find that this type of flying is restful rather than exhausting." Lindbergh's rest days were Thursdays and Saturdays, but he chose to fly on many of those days, casting doubt on the reports of his state of exhaustion.

Lindbergh's landings continued, always on time, but some journalists covering the tour complained that Keyhoe was limiting press access to Lindbergh. They also griped that Lindbergh's touring entourage moved too fast for crowds to even get a glimpse of him. Keyhoe indeed was becoming a punching bag. An editorial in the *Minneapolis Daily Star* noted: "Hundreds of thousands of people who have lined the streets waiting for Colonel Lindbergh to appear, have not been able to see him even for a portion of a second, so swiftly did he pass in an automobile. Many children and even some old, gray-haired women were seen to weep with disappointment because the flying colonel whisked by so rapidly that they did not see him at all . . . Colonel Lindbergh is touring the country for the purpose of making good will for the cause of aviation. Yet the fact remains that Mr. Keyhoe is making ill will ten times faster than Colonel Lindbergh can manufacture good will."

The editorial caught the attention of Commerce Secretary Hoover, who also seemed to blame Keyhoe, compelling Lindbergh to make another rebuttal to Harry from Pierre, South Dakota: "I do not believe that these complaints are just and I know that Keyhoe has tried hard to keep things running smoothly." However, he assured Harry, "In the future we will go to an unreasonable extent, if necessary, to keep the reporters satisfied."

In Los Angeles Lindbergh got a Hollywood welcome. Marion Davies and Mary Pickford feted him at the Ambassador Hotel. The next day Louis B. Mayer picked up Lindbergh for a tour of MGM Studios, followed by a visit with William Randolph Hearst. Before leaving L.A. Lindbergh received a

request from cornflake king W. K. Kellogg. If Lindbergh agreed to fly over his ranch, Kellogg would build a small airport for the area. It was one deal from a business mogul Lindbergh was happy to accept.

On the final day of the tour, Oct. 23, Lindbergh touched down at Mitchel Field at exactly 2:00 P.M. Some 2,000 spectators watched him make the final landing. Lindbergh took questions from reporters, then he and Harry headed to Falaise for what Lindbergh described as a long vacation. An estimated 30 million Americans had attended a Lindbergh appearance that fall (at least a quarter of the nation's population at the time). Lindbergh tallied some key metrics from his journey:

Number of miles flown: 22,350
Number of stops: 82
Times late: 1
Speeches made: 147
Dinners attended: 69
Number of miles paraded: 1,285
Number of states visited: 48

The one stop Lindbergh had been late to was Portland, Maine—a heavy fog obscured the landing field and caused him to circle for over an hour.

The Lindbergh tour accomplished what Harry intended: to change the narrative of air travel. People began to see beyond the image of airplanes as stunt vehicles at carnivals or expensive toys for the leisure class. The experience of seeing Lindbergh coming and going so effortlessly in *The Spirit* instilled confidence in flying. Safe and punctual landings reinforced the idea that airplanes could arrive and depart with the precision of trains and the safety of automobiles. The Guggenheim-backed tour also delivered a major payoff to Lindbergh the author. Nonstop press coverage kept *We* at the top of the best sellers list, selling more than 600,000 copies in the coming months. The only undesirable result of the tour, from Lindbergh's

perspective, was that it made him an even bigger star, a winged Galahad chased constantly by reporters.

He found refuge at Falaise. Lindbergh could fly to Harry and Carol's home by seaplane and dock his craft near the seawall below the house, out of sight of photographers. Or he could land a plane at the horse pasture near Falaise cleared for this purpose. In the evening Harry's longtime butler and valet, English-born Walter Moulton, would leave slips of paper next to beds for everyone staying at the house to write down their breakfast order. Lindbergh got to know Harry and Carol's teenage daughters, Nancy and Joan, who were in awe of the fact that they were in the presence of the most famous man in the world. As everyone prepared for a dinner of beef Wellington one Sunday, Nancy came to the dining room wearing a bright shade of lipstick. Harry was not amused, pulling his daughter aside to tell her, "Would you please go upstairs and wipe off that lipstick immediately!"

IV

Lindbergh became part of the Guggenheim court, showing up for social events hosted by Harry and Carol, to swim or play tennis. He marveled at their never-ending formal meals—the affairs could go on for hours. Typically Harry liked to begin these functions with gin cocktails and martinis in the lower level library, followed by a walk upstairs to the dining room, just off the foyer. Guests would find their place settings around a table set with colorful Italian embroideries, tassels on each corner, the centerpiece an emerald-green glass bowl brimming with yellow zinnias. Green was Carol's favorite color, judging by her viridescent wine glasses, green ashtrays, and even the salt and pepper shakers cast in green glass. The butlers, overseen by Walter Moulton, wore black dress coats and tails, with black-and-white striped pants, the maids in green sateen dresses with white aprons. A typical lunch started with a round of pickled artichokes, sardines, filet of salmon,

green olives on ice, slices of ham, hardboiled eggs drizzled in a light dressing, baskets of freshly baked bread and wafers. Then the main course: breasts of chicken on an elaborate china platter, surrounded by browned potato balls, followed by dishes of French beans and spinach. For dessert: wild huckleberry pie, precut in a Pyrex dish, passed around the table, accompanied by sugar and cream. Finally, the arrival of fingerbowls for everyone, each with three ice cubes floating in water. A platter of black cherries made its way around the table. Guests would pluck their cherries and drop them into the ice water before consuming them. Then a return to the library for coffee and the lighting of pipes and cigarettes. If the weather was nice, the smoking ritual would unfold on the deck overlooking the sound, where Walter would be back again, beckoning guests with a small cedar box of Harry's favorite Cuban cigars—Herman Upmanns—blended with the rich tobacco of the Vuelta Abajo.

Lindbergh found far more enjoyment in his moments of solitude at Sands Point, say, a walk to the orchards at Falaise, where he could pick peaches, or an undisturbed trek through the forest paths to the sheep shed, the stables, or the beach below the house for a swim in the gentle waters of the sound. Harry was continually surprised that Lindbergh wanted nothing to do with the lucrative business offers by those seeking to cash in on his celebrity. Lindbergh seemed to have no desire to leverage his fame. Mostly, it just seemed like a burden. He could not understand how his single feat, built on the shoulders of so many others, had become a transformational moment. As Lindbergh later wrote: "I was astonished at the effect my successful landing in France had on the nations of the world. To me, it was like a match lighting a bonfire. I thought thereafter that people confused the light of the bonfire with the flame of the match, and that one individual was credited with doing what, in reality, many groups of individuals had done."

Harry now called Lindbergh by his nickname, "Slim." Harry was twelve years older, yet they had much in common: both cerebral by nature, both

kept a tight check on their emotions, both meticulous planners, both solid Republicans. Both enjoyed hunting and fishing. Lindbergh later recalled: "Harry loved the Sound. We often went swimming or lobstering (he kept a number of lobster pots buoyed offshore). At night we would pole along the coast in a small flat-bottom boat, spearing flounder by torchlight."

They traveled together, by plane, and enjoyed devising plans to evade trailing reporters. For many summers, Harry rented a home in Santa Barbara. When Lindbergh flew out to California to visit, he would sometimes land at a small, nearby airport, leave his decoy plane, board another one, then fly to a second airport, where Harry would be waiting with a car. The ruses were always short-lived. It was impossible to be Charles Lindbergh and remain hidden for long.

Carol got on well with Slim and enjoyed the company of his mother, Evangeline Lindbergh, who occasionally stayed with Harry and Carol in their Manhattan apartment at 455 E. 57th St. near the East River. Lindbergh was a guest there, too, staying at an art studio Carol kept above the apartment. The Guggenheims were just down the hall from the Breckenridges. Evangeline had a particular fondness for the Guggenheims' youngest daughter, Diane, once bringing her a collection of dollhouse furniture.

Back at Falaise, Harry and Lindbergh carried on endless conversations about aviation and its future. When these long sessions went into full gear Carol vanished into the solitude of her art. Like David Hockney's famed illustration *The Princess in Her Tower*, Carol spent long stretches in the studio at the top of the Norman-style tower off the courtyard at Falaise. It wasn't the warmest part of the house (Harry and Carol spent months battling a contractor to fix the heat). Carol produced many of her "silhouettes" there. She would ask her subject to sit with a bright light on one side, a sheet of black paper on the other, then draw their profile on the paper. One of her more elaborate creations was a needlepoint sampler she called *The Lady and the Unicorn*, after the famous Parisian tapestries, which hung for many years in the Lindbergh guest room.

Following the national tour Lindbergh received a request to undertake another—this time from Dwight Morrow, recently appointed ambassador to Mexico. Morrow wanted Lindbergh to fly south for a multicountry Latin American goodwill tour, starting in Mexico City. Lindbergh was delighted by the idea. His acceptance of the offer was serendipitous: At a U.S. Embassy reception in Mexico City Lindbergh met Morrow's daughter Anne, then a senior at Smith College. She was instantly smitten, as was he with her.

When he returned from Latin America, Lindbergh's first date with Anne was at Falaise. After Lindbergh left to retrieve a rented plane for the occasion, Carol and Harry had a field day gossiping about the pranks Lindbergh perpetrated on his aides during the air tour. "We have to warn you about him" they would say. One especially successful hoax by Lindbergh involved a fake bear attack. During the air tour the group took a camping break in Montana. Lindbergh disappeared into the woods with a bearskin, paws attached, which he used to create tracks and then left in a lifelike pose near the camp, setting off pandemonium. Anne Morrow was probably also warned to keep her perfume bottle close, because Lindbergh had used fragrances sent by well-wishers to soak the coats of his aides just before the start of a banquet. Of course, for the date with Anne at Falaise, there were no hijinks. Lindbergh took Anne up for a romantic tour of the sound and the Manhattan skyline.

Slim didn't hide the fact he was like family to Harry and Carol. On one visit with Anne at Falaise, Lindbergh greeted her at the front door, walking her into the foyer without announcing himself. He picked up a stack of mail left bundled for him on a table. Harry and Carol's arrival had been delayed so Lindbergh took Anne out to Falaise's broad terrace overlooking the sea. He pushed the button Harry had installed on an exterior wall to summon servants. Once the housekeeping staff arrived, Lindbergh directed them to show Anne to her room.

They were married two years later. Lindbergh taught Anne to fly; she became his copilot and the two of them accepted a series of assignments

mapping air routes overseas. For the newly founded Northwest Airlines, they scouted what became known as the Great Circle route, plotting a flight path that shaved 2,000 miles off a trip between New York and Tokyo. They savored their time alone. Returning to the United States, they found it was once again impossible for the Lindberghs to visit a bank, restaurant, department store, steamship pier, or railroad station without being swamped by fans and photographers. Their refuge was Falaise and, they hoped, a new home of their own on land purchased in Hopewell, New Jersey. It would bring them little relief. "Tabloid reporters went through the Lindberghs' garbage, pilfered their mail, and offered bribes to their servants for tidbits about their private lives." In coming years Anne would say that flying was the only time she really had alone with her husband.

Eyes in the Sky

I

The Guggenheim aviation fund office at 598 Madison was a cartographer's dream, its walls festooned with maps of all sizes depicting the rollout of fund initiatives. They were the flight plans for the air age: one map charted 900 potential locations for new airports across the country; another illustrated proposed new air corridors above the cities of America. There were maps pinpointing coming locations of Guggenheim aeronautics schools and programs, and maps of the zigzagging routes taken by the Byrd and Lindbergh reliability tours.

By the late 1920s the air age was capturing everyone's imagination. Many Sunday newspapers carried a new section, the Aviation Page, profiling new pilot training schools or the latest aviation fashions—bespoke helmets, goggles, and heated flight suits. Crashes and air mishaps were a constant topic, but so was air safety. One aircraft maker developed a personal ejection seat. In an emergency, a trap door would open, dropping the seated passenger through the floor, a built-in parachute returning them (and their seat) safely to earth.

Private airstrips were popping up everywhere. Yet in Harry's own back-yard, New York, the city had yet to build an airport. New York political leaders squabbled over where to build it, and discussions dragged on. Many thought there should be five airports, one in each of the city's five boroughs. Everyone had an opinion—the city's Board of Estimate, the Chamber of Commerce, real estate boards, the New York State Legislature. So did Congressman Fiorello La Guardia: he wanted the city's principal airport to be on Governors Island, just off the Battery in New York Harbor. Its loca-tion would be an ideal transit point for seaplanes that could ferry financial industry workers to Wall Street, he said.

New Jersey beat New York to the punch and built the area's first regional airport in Newark in 1928. Given most of the air traffic at that time consisted of U.S. Mail planes, Newark became the postal service's eastern terminus. (Nearby train connections relayed the mail quickly and efficiently to its destina-tions.) Of course, Newark's new airport injured the pride of New Yorkers. The communications capital of the world had to rely on New Jersey to get its mail.

Commerce Secretary Hoover, working with the New York Port Authority, formed an advisory committee to break the logjam over siting the city's first major airport. Hoover asked Harry to chair its key working group (the only major non-fund project Harry would work on that year). With all the other fund initiatives in progress, Harry and the committee found time to evaluate some forty prospective locations within the city and generated a short list of sites with the greatest promise. The job called for yet another map—Harry ordered a large detail survey to be produced, pinning it on a prominent wall at 598 Madison. The map depicted each of the proposed site's boundaries, proximity to population centers, and known weather pat-terns. After this Harry joined a handful of other committee members in flying over these locations, seeing from the air what pilots would actually encounter on landing.

Harry's group ultimately recommended four sites, among them Barren Island, on the shores of Jamaica Bay in Brooklyn. It had many advantages:

flatness of terrain, predictable weather, low wind speeds, and it was already owned by the city. La Guardia disagreed, noting that his choice, Governors Island, was a shorter distance to lower Manhattan. The city was unconvinced—it chose Barren Island (later renaming it Floyd Bennett Field). Its dedication drew some 25,000 attendees, among them Lindbergh, Trubee Davison, and New York mayor Jimmy Walker. The crowd watched 597 aircraft fly over the field, the largest single group of planes to fly in U.S. history.

In its early years Bennett Field was a success. But the U.S. Postal Service kept Newark as its New York metropolitan hub for airmail because Bennett Field continued to lack major transportation links to Manhattan. It was twenty miles to midtown, a distance the Postal Service considered too far, and there were questions as to how the airport would expand over time. Bennett Field turned out to be a questionable location, demonstrated years later by the building of airports closer to Manhattan, like LaGuardia, and one capable of handling far more traffic, John F. Kennedy.

II

Harry was eager to get on with another, simpler project he and Lindbergh had been discussing for months: a national program of "air mapping." During his tour, Lindbergh had trouble finding landing fields because the cities themselves were hard to identify from the air. Couldn't every major town in America simply paint their community's name on a large rooftop? Next to it would be an arrow pointing to the nearest airport and the letter *N* superimposed on a second arrow pointing north. Harry and Lindbergh even recommended a color and size for the signage: chrome yellow, in block letters ten to twenty feet long.

A similar project on air mapping had been started by the Commerce Department, but Hoover, as usual, was happy to let Harry and the fund

take the reins. Hoover's staff ensured the fund got a list of postmasters at cities and small towns who, in turn, could help identify locations for the markings. Harry got the cooperation of civic organizations, railroad stations, and oil companies, and the help of 7,600 dealers of the Ford Motor Co., whose showrooms had the kind of large roof area needed.

Harry campaigned for the idea in person, stopping one day in El Paso. Speaking before a business audience, he said that for the price of a few cans of paint, a city like El Paso could expand its economy by boosting commercial aviation. Air mapping may have seemed a crudely simple idea, but it was crucially important. "Just as the automobile would be very greatly handicapped without signposts along the highways, so commercial aviation has been hampered by the lack of proper identification of towns and cities by roof markings." Harry also promised a sweetener: every community that participated would get an engraved certificate of appreciation signed by Lindbergh. By the end of the campaign, nearly 6,000 towns and cities across the country had marked their locations with twenty-foot-high letters on the roofs of buildings.

Like Lindbergh, Daniel had an office at 598 Madison and frequently visited. Harry's father gazed at the fund's maps and found himself astounded at the urgency his son was bringing to bear on the fund's multiplying projects. Daniel had never flown in an airplane (given his heart disease, doctors warned against this), but the fact that American companies had begun buying aircraft for executive transportation signaled an emerging market to him: business travel.

Businesses that could afford their own planes christened them with brand-building nicknames like "Flying Chef" (Roper Gas Ranges) or "Ace of Shades" (Morgan Paint Company). Companies were buying their own planes because large-scale passenger travel was still a thing of the future. Most air operators didn't believe they could yet make money flying large numbers of passengers. There were a handful of exceptions, including some celebrity start-ups. Legendary filmmaker Cecil B. DeMille founded the

short-lived Mercury Aviation in Los Angeles. Syd Chaplin, Charlie Chaplin's brother, launched a seaplane passenger service from Long Beach, California to Santa Catalina Island, which also didn't last long.

Harry and Daniel agreed that business travelers would be the early adopters of commercial aviation. Could the fund devise an entrepreneurial spark plug for this potential market? Harry and Daniel believed they could, settling on the idea of a model passenger airline that could demonstrate safety, reliability, and profitability. But Harry disagreed with Daniel on timing. Following the fund's massive rollout of education and training, Harry believed there was still work to be done in safety and navigation. Daniel thought that the public had been well convinced of the safety of flight; now was the time to develop business templates to encourage existing carriers, most of them in the mail business, to consider branching into passenger service. Eventually Daniel's persistence won out.

To find an operator willing to launch this pilot project Harry identified private airmail carriers who had already begun flying small groups of passengers on their mail flights. He invited them to a meeting at the fund's office. Airmail carriers made so little money in those days that Harry had to send them round-trip train tickets in advance just to ensure they'd show up. On the appointed day the invitees assembled at the boardroom at 598 Madison and Harry made his pitch: a business model drawing on railway economics. Early railroads in the United States were financed in part by their own financial spark plugs—transportation loans from the government. Harry reasoned that the same principle could be applied to aviation. The fund, Harry said, would be willing to offer any interested airmail carrier a generous equipment loan to establish a model passenger service, along with improved weather data and oversight from the Commerce Department in planning the route.

The response was not positive, the carriers expressing nearly "universal condemnation" of the idea. Mail carriers who attended the meeting felt that their profit margins were already thin. They could scarcely afford

to gamble on a new branch of service, even with equipment loans. If an accident occurred it could have a disastrous impact on their business. Two carriers, however, did express interest. One of them, Western Air Express (WAE), ran mail routes in the California market, home to better weather, and therefore a better test bed. It had been founded just a few years earlier by a former race car driver, Harris M. "Pop" Hanshue, who enlisted former WWI aviators to pilot his mail planes. He operated a Los Angeles-Las Vegas-Salt Lake City route and gave his pilots simple flight instructions: "Stay to the right of the railroad tracks to avoid colliding with the plane headed in the opposite direction." Harry struck a deal with Hanshue and wrote into the agreement that multi-engine planes would be the aircraft of choice for the model airline (a key safety factor—if one engine failed the remaining engines could guide a plane to safety).

A short time later the fund granted a $150,000 equipment loan to WAE for the purchase of three tri-motored passenger airplanes to fly on a daily schedule between Los Angeles and San Francisco. Harry and Lindbergh took a test flight on one of the planes, declaring the craft airworthy. The target audience for this trial route, business travelers, would have been pleased by the company's description: "The air-line distance between Los Angeles and San Francisco is 365 miles and the time necessary for the flight over this route will be approximately three hours. Planes will leave either terminal at 10:30 o'clock in the morning and will arrive at the other terminal at 1:30 o'clock in the afternoon." Once airborne, all the comforts of the workplace would be offered to its twelve passengers. "Lunch will be served in the air, and magazines, the latest editions of newspapers and radio entertainment and market reports will be available."

The company didn't mention some of the less flattering realities of these passenger flights—that they were chilly and loud, given the cabin was largely uninsulated. Cabins were unpressurized. That meant they could fly only so high, making them more susceptible to turbulence at lower altitudes. Yet it was easy to forgive such conditions when a businessperson in L.A. could

travel to a meeting in San Francisco on a three-hour plane ride, versus spending the whole day on a train.

The California experiment was aided by a fund meteorological committee whose job was to set up a model weather service along the route. The U.S. Weather Bureau offered daily forecasts across the country, but these reports were worthless to pilots who weren't taking off within a short time of the forecasts. To the west of the WAE flight path lay the Pacific Ocean. Taking off from the north, it was crucial to know the density of coastal ocean fog in Southern California, just as a pilot leaving Los Angeles needed to know the state of early-morning fog in the San Francisco Bay Area. Fog of any type was a shapeshifting menace to pilots, putting them in danger of flying into hills and mountains, especially in California's Sierra Nevadas.

Harry and the fund commissioned weather reporting stations delivering weather data three times a day to the terminals in Los Angeles and San Francisco. The data was made available to any pilot in the area. Each of the stations, spaced about twelve miles apart along the route, tracked wind speed, cloud formation, visibility, and fog density, all sent by wire to the two airstrips at either end of the flight path, then relayed by radio to receivers in the planes. Working with a federal committee to coordinate the system, Harry tapped Hoover's staff again to arrange for California's main telephone company to provide free transmission between the stations and the terminals.

Passengers swamped the new airline—within two years the equipment loans were paid back with interest. The impact of the service was soon felt. "Inspired by the prosperity of the Los Angeles-to-San Francisco route, other passenger air services, including the interesting combination of air and rail service between the coasts . . . began to spring up in various parts of the United States." Following the trial phase the fund turned over the weather service it had established to the U.S. government, who took over its operation.

III

By now Harry had set into motion many of the thirty-five aviation spark plugs, he had identified on the long steamer trip from Europe. One key challenge remained: blind flight, or flying by instruments only. This was the last great barrier to safe flying—achieving it would give pilots the ability to fly through most bad weather without becoming disoriented. It could make takeoffs and landings nearly foolproof.

Lindbergh's transatlantic flight offered some valuable lessons for Harry's plan to develop instrument-only navigation. Lindbergh could not have flown to Paris without his instrument panel, yet his gauges were at times unreliable. He brought two compasses, for example—an induction compass and magnetic compass. If one reading failed the other could compensate, he thought. Both failed simultaneously. Instruments of the day gave pilots the equivalent of educated guesses, at best. Altimeters were frequently inaccurate because the gears inside them weren't sensitive enough to produce an exact reading.

Imagine a pilot making a night landing, whose altimeter gauge says the plane is forty feet above the ground when it's actually ten feet. It's going to be a rough landing. As Harry was told when he was learning to fly: "See those instruments? Pay no attention to them!" But relying on visual cues, particularly in fog, could also be disastrous. A pilot's instinctual response to bad weather is to slow down. But when a plane's speed is too low, it loses lift (the force of the air under and over a wing). Result: the craft stalls and falls to earth.

There were still plenty of pilots who thought that planes would never overcome bad weather, nor should they be required to run on schedules. If travelers wanted transportation on a schedule, well, let them take a train. Harry thought such arguments absurd. He had watched his father place huge bets on mining properties based on coming technological solutions. There was a solution to blind flight and Harry bet technology could solve it.

At Cambridge Harry had studied the epic, decades-long struggle by astronomers, clockmakers and others to find the solution to the biggest challenge of marine navigation in the 18th century: plotting longitude. To arrive from point A to point B, using the ocean as a highway, ships needed to know their exact location. Not knowing one's position at sea caused hundreds of wrecks and cost thousands of lives over the centuries. "The scientific establishment throughout Europe—from Galileo to Sir Isaac Newton—had mapped the heavens in its pursuit of a celestial answer." The problem was solved by the invention of the marine chronometer. Harry contemplated an aviation version of such a device—one that could work with others in plotting an airplane's exact position in relation to the ground, in any weather.

The speed and performance of aircraft was being enhanced by the day, eclipsing the ability of pilots to respond quickly to conditions relying on visual cues. It was clear to Harry that as planes were getting faster and more maneuverable, pilots were still largely relying on their visual instincts to fly. This was dangerous. Harry's solution was to chart a different course for the fund in its final months: developing technology that would allow take-offs and landings using only instruments, or blind flight. Fund directors agreed to set aside $70,000 for a research center and staff it with the most talented test pilot and aviation experts available. Harry called it the Full Flight Laboratory.

Harry tapped his contacts in the army to "borrow" the best pilot they could afford for a project that could be of historic importance. They agreed and the choice was obvious: James "Jimmy" Doolittle. Everyone in aviation knew Doolittle. He was, after Lindbergh, perhaps the most famous aviator in the country. The press had pronounced him a "speed demon," a "daredevil flying ace," and a "smasher of air records." He was the first man to fly across the country in less than a day. He was a scholar, having been the first person to earn a doctorate in aeronautics at MIT. He possessed a methodical mind, a wry wit, and nerves of steel. He was a wiry 5' 6" with a broad smile, made prominent each time he broke into his hound-dog grin. His intensely competitive nature was once revealed during an international

air demonstration in Chile. The night before, he attended a cocktail party in Santiago and, a few pisco sours later, wound up breaking both his ankles in a freak accident. A few days later he piloted his plane anyway, hobbling to the aircraft on crutches, where he instructed his flight crew to strap his ankle casts to the rudder pedals.

Doolittle accepted Harry's job offer, arriving at Falaise for one of those long lunches, drinks, and cigars, at which they brainstormed the lab's approach. The two agreed that the Full Flight Lab would comprise: 1) two planes (a NY-2 for test flights and a Vought Corsair to make runs for parts and equipment); 2) a living quarters for Doolittle and his family; and 3) a hangar and workshop. It would all be based at Mitchel Field, the military airstrip named for former New York City mayor John Mitchel. (In a U.S. Army training flight during WWI Mitchel fell 500 feet from the cockpit of his scout plane, which had gone into a nosedive. He died instantly, having simply forgotten to buckle his safety belt.)

Doolittle liked the Corsair; it was faster than the NY-2, but had no blind flight instruments. Ironically it was a plane that demonstrated, in a hair-raising, near-death experience, exactly why instrument-guided flight was so necessary. It began one night after Doolittle took off in clear weather from Buffalo, New York. His plan was to fly to Mitchel Field using lighted landmarks and highways along the way. As recounted by Hallion:

"To avoid mountains he followed a cross-country route via Rochester, Syracuse, Utica, Schenectady, Albany, and then down the Hudson River. After Doolittle passed Albany, bad weather closed in on the plane. He had already used half of his fuel supply, and thus did not have enough to return to Buffalo where the weather was improving. Growing concerned, Doolittle resorted to following the lights of a southbound New York express train racing along the Hudson River Valley. When it disappeared from view, he began following the bank of the river. For a moment he thought of landing at the West Point parade ground, but decided to press on to Mitchel Field because the weather still remained flyable. Over New York City he broke

out into the clear, but fog completely shrouded the entire East River area; Doolittle realized that he could not go on to Mitchel Field. Governors Island was swathed in fog, and fog had now enclosed the Hudson river as well. Doolittle flew over the Battery, intending to crash-land in Battery Park, but a man ran out as the plane descended and waved him off. He climbed back into the night, decided to crash-land in the Hudson River, and then rejected this plan for 'the water looked uninviting.' He had one last chance: cross over to Jersey City and attempt a landing at Newark Airport. But here, too, fog had imprisoned the field. With the Corsair's gas gauge reading empty, Doolittle climbed through the fog into the clear night air, attempting to fly westward away from the urban areas until he could parachute over sparse countryside. At this point, near Elizabeth, New Jersey, the pilot spotted a revolving air route beacon light and a reasonable flat area next to it suitable for an emergency landing. Still uncertain as to whether it was a field or a lake, Doolittle flicked on the Corsair's landing lights and began a descent. He flew low over the area, snagging a tree top and tearing the fabric on the plane's left lower wing . . . Doolittle turned around, located the best-looking clear spot, and set the plane down 'by wrapping the left wing around a tree trunk near the ground,' completely wrecking the Corsair."

Doolittle walked away uninjured, but said, "The moral of the story is that with the NY-2 mounting blind landing equipment and the Full Flight Laboratory radio station alerted at Mitchel, this would have been a routine cross-country flight with 'no sweat.'"

IV

The lodgings at Mitchel Field for Doolittle, his wife Josephine (known as Joe), and their two young boys weren't exactly Gold Coast material. Doolittle affectionately called his temporary home "a long-vacant, termite-ridden wooden building." The Doolittles made the best of it, soon turning the

drafty structure into a major social hub, drawing "an eclectic menagerie of friends." Scientists, pilots, university professors, fund advisors, mechanics, and instrument makers would all come. Expats from Russian aviation visited, among them Sachinka Toochkoff, who had been Russian chief of naval aviation before fleeing the 1917 Revolution. Josephine Doolittle was a master beer maker whose latest brew was always on tap in the kitchen. New arrivals knew to bring an offering of hops to Joe if they expected a full glass. Not that anyone cared, but at the height of Prohibition. (Harry was in fact bankrolling a brewpub on government property.)

Harry and Doolittle agreed that enhancing the sensitivity of instruments and making them easier to use would be key. One afternoon Doolittle huddled with Elmer A. Sperry, one of the legends of instrument innovation. Sperry held over 350 patents and had invented the gyroscopic stabilizer, one of the instruments aboard the Curtiss flying boats Harry had trained on prior to the war. Sperry and Doolittle sketched and resketched prototype mechanisms that could create highly accurate, easy-to-read instruments showing the direction of heading and exact altitude, and which could also serve as a kind of artificial horizon, "showing if the aircraft is flying straight and level, climbing, diving or banking." Then Doolittle sketched out a final revision of the hybrid instruments he had in mind. Sperry said they could be done, assigning his son to design the new gauges. Two weeks later Sperry had the prototypes ready, two of the three based on gyroscopes.

To stage the test, Doolittle would need some bad weather. On a late September morning in 1929 a thick fog rolled in from Long Island Sound, completely blanketing Mitchel Field. It was the pea soup they had been waiting for. The facility's maintenance chief called Harry and Doolittle. By the time Harry arrived Doolittle had already been up in the air, taking a test run in the single-engine, two-seat biplane. Doolittle exited the craft and walked over to the hangar. "Good morning Harry," said Doolittle, shaking his hand. "I'm taking her up for a blind flight." The "her" referred to the Consolidated NY-2, the main test plane Doolittle had been using.

It had a full panel of instruments, but Doolittle would rely solely on three gauges developed at the lab. Also there that morning was Lt. Ben Kelsey, a fellow test pilot. Harry gave his immediate approval but seemed to have some hesitation. He was concerned about the fog—not that it was too thick, but that it was lifting, which might tempt another pilot nearby to take off.

"One suggestion," said Harry. "I want Ben to be in that second cockpit—just in case."

"In case of what?" asked Doolittle.

"In case anything goes wrong," said Harry. "If it does, Ben may have enough visual aids to land the plane."

Doolittle reluctantly agreed to have a "check pilot" sit in the front cockpit, keeping his hands off the controls while Doolittle flew the plane. If needed, the second pilot could instantly retake control. That settled, Harry hoisted himself onto the lower wing and wished Doolittle luck, pulling the heavy canvas hood over Doolittle's entire cockpit and fastening it closed. About fifty spectators had assembled. Doolittle scanned his instrument panel in the dark with the aid of a flashlight, checking his gauges: the tachometer, compass, air speed indicator, and rate of climb indicator, plus the three new gauges: a rebuilt altimeter, artificial horizon, and directional gyroscope. Kelsey kept his feet away from the rudder bars and placed his hands outside of the cabin for the spectators to see.

Doolittle thrust the engine and eased off on the brakes, powering the NY-2 in a perfectly straight line until it left the ground and disappeared into the mist. To locate the runway on his return, he relied on a "localizer beam," or radio signal, coming from the landing area. As historian Hallion recounted the flight: "Doolittle let the plane climb along the localizer path until it reached one thousand feet. Five miles from the field, he leveled off and initiated a 180-degree left turn, once again heading west on the localizer beam, now two miles away from Mitchel Field." A few minutes later, "He began a gradual descent from one thousand feet as he flew west along the localizer beam, peeled off at two hundred feet, and continued along the

localizer until he passed directly over the landing beacon. . . . Doolittle now began a steady descent at 60 mph and held this until touchdown." The landing was a little bumpy, but the flight was perfect. Doolittle rolled to a stop, greeted by Harry and raucous applause and cheering. Harry climbed back on the lower wing and pulled the canvas back. Harry was ecstatic—he immediately fired off a telegram to Orville Wright, noting that only three instruments were used to land safely. When Harry's press release was ready to go out, he took a copy for Daniel and Florence, writing in red ink across the top: "Dear Father & Mother. This is the story. Love, Harry."

The achievement of blind flight was one of Harry's most significant spark plugs boosting American aviation, and the fund's last major venture. Harry had guided the establishment of schools of aeronautics across the country; launched the Byrd and Lindbergh tours; held an influential safe plane competition; guided a nationwide rooftop marking campaign; underwritten a model passenger plane business and weather service; founded an air law institute; supported programs for aerial surveying and mapping and primary school aviation education; created a Guggenheim medal to recognize air pioneers; and given large grants to preserve the art and literature of aviation history.

In 1927, following the fund's first full year of operation, the number of applicants for pilots' licenses tripled; the number of licensed aircraft quadrupled. By the end of the decade the number of landing fields and airports would double. Numbers of passengers tell the story, too: in 1926 there were less than 6,000 passengers a year, jumping to 173,000 in 1929. By 1935 the number was close to 800,000. The business of flying was becoming a real business. In the late 1920s aviation stocks tripled. Harry could have invested in any number of these public companies, boosting the fortunes of friends and associates, making himself richer in the process. He was already rich, of course, and such a move would have destroyed his credibility as a promoter of aviation. In fact, Harry publicly warned against investing in aviation ventures he felt were unsound. Secretary Hoover was pleased with the progress. "During the next year we should surpass the whole

world put together with the impetus already gained," he said. "And all this is being done by private enterprise without government subsidy."

In the coming months there would be more good news, at least for Secretary Hoover: Coolidge would not run for reelection. The door opened to Hoover's presidential aspirations. The Guggenheims had high hopes for Hoover, too. Daniel was already a Hoover contributor; Harry an enthusiastic supporter and fundraiser. Commercial aviation, like the bull market of the 1920s, was exploding in growth, with no end in sight. Hoover campaigned on staying the course that two prior Republican administrations had set, all of which resonated with Harry. Carol got into the act, too, heading up a women's branch of the Hoover for President Committee in Long Island.

After Hoover clinched the Republican nomination and won the 1928 election, Harry could not contain his excitement. He wired the president-elect: "Your victory constitutes the greatest vindication of democracy in the history of the world." Harry's ebullient telegram was likely inspired by the fact that Hoover's dream might now result in Harry's own dream being realized: appointment to a major diplomatic post. It's the kind of job he had wanted following his Cambridge years, before he acquiesced to his father's wish that he help develop Chuqui. The fund was winding down and would soon close. Harry's notoriety as the "Godfather of Flight" made him a nationally known businessman and philanthropist. Hoover was made aware of Harry's diplomatic aspirations, if they weren't already known to him. Shortly thereafter an offer came: assistant secretary of commerce for aeronautics.

The offer hit Harry like a lead weight. A mid-level domestic government post? He wanted a perch on the world stage, preferably an overseas assignment. Politely, Harry declined the offer.

The president-elect was known to believe that the thorniest diplomatic issues facing the United States lay in Cuba and Mexico. Dwight Morrow was already improving U.S.-Mexico relations. But the Cuban post would not be easy to handle. That said, Hoover had seen Harry in action at the

aviation fund, marshaling the brightest minds in business, science, and the military, managing difficult egos. Lindbergh's air tour, funded and overseen by Harry, had captivated the nation. Hoover had watched Harry commission academic endowments and technological research with discernment. He knew Harry spoke Spanish and was conversant with Latin American commerce treaties. Harry clearly had competencies for the job. On top of this, developing commercial aviation in Central, South, and Latin America was a priority to Hoover. Most of the early airlines to South America traveled through Cuba.

Harry apparently had some back-channel help from another influential quarter, an elder statesman, Elihu Root, who had been an architect of U.S.-Cuba relations. (Root was then working with a group of U.S. senators, including the head of the Foreign Relations Committee, on matters related to the U.S. role in the League of Nations.) Root is believed to have made it known he backed Harry. (Root was also a board member of the aviation fund.) It took many more months, but the new president finally changed course and placed Harry's name in nomination for the Cuban ambassadorship before the Senate Foreign Relations Committee. Hoover knew what the risks were. The question was: Did Harry?

CHAPTER NINE

Tropical Mussolini

I

I f Harry were to be confirmed by the U.S. Senate, he would become, at age thirty-nine, one of the youngest U.S. ambassadors ever named. He would be the second most powerful figure in Cuba, after its mercurial leader, President Gerardo Machado y Morales.

Machado reigned during an era some consider a Cuban golden age, when Havana was called the Paris of the Caribbean. Its *macheteros* (sugarcane cutters) had made Cuba the world's largest supplier of sugar. Its *tabaqueros* (cigar workers) produced its finely made cigars. In the late 1920s the price of sugar had risen steeply, bringing wealth to the old colonial city. All around its fortresses, monuments, and cathedrals was booming new development. With the enforcement of Prohibition in the 1920s, the party was over in the United States, but just beginning in Cuba. American bars, speakeasys, and cabarets shuttered on the mainland, then reopened in Havana. Waves of unemployed bartenders migrated to Cuba, where they easily found work. Newly begun air service from Key West and Miami brought visitors to Havana in less than an hour. Pan American offered seven flights a day to Cuba. In the year of Harry's nomination a record 90,000 tourists visited Cuba, the vast majority from

America. English was spoken everywhere—casinos, nightclubs, restaurants, hotels, movie houses, golf courses, and yacht clubs.

To Americans, Cuba felt like an exotic, faraway place with all the American amenities. The island was essentially an American protectorate. What made it so was the Platt Amendment, part of a treaty between Cuba and the United States signed in 1903 laying out the means by which the United States could intervene in the internal affairs of Cuba, if deemed necessary. It had been drafted by Elihu Root, Theodore Roosevelt's secretary of state (and a director at the Daniel Guggenheim fund). Many Cubans considered the decree a Faustian bargain that compromised Cuban independence. Machado promised to repeal it.

But that was not to happen anytime soon. Machado needed U.S. backing to maintain his hold on the presidency. Less than a week after Harry's nomination came a United Press dispatch about the increasingly unpopular Cuban president. "Among the accusations against Machado are that he has suppressed opposition political parties, curtailed freedom of speech and of the press, nullified several sections of the electoral code devised for Cuba by Gen. Enoch H. Crowder, former American ambassador, violated American and Cuban property rights, and hampered the activities of labor unions."

Machado began his climb to power as a cattle rustler, a skill he learned from his father. He grew up in the central province of Villa Clara, later falling in with rebel forces at the start of the Cuban War of Independence in 1895. He became one of the youngest generals in the resistance. After the destruction of the U.S. battleship USS *Maine*, anchored in Havana Harbor during the conflict (killing 260 American servicemen), the United States allied with the Cuban opposition and entered the war, leading to Spain's defeat. But one of the conditions for the United States withdrawing troops was recognition of the U.S. Congress–passed Platt Amendment in Cuba's own constitution.

Machado went on to become the mayor of Santa Clara—one of his first acts was to burn the official records that had charged him and his father with

being cattle thieves. So began the remaking of a thuggish, ruthlessly ambitious man who became secretary of the interior before running for president in 1924. He promised to serve just one term and ran on a public works platform. After his election he commissioned the 700-mile-long Central Highway, spanning the entire length of the island. His signature project was the colossal El Capitolio, a building resembling the U.S. Capitol, but larger, where the Cuban legislature would reside. Constructed in the geographical center of Havana, its centerpiece sculpture is a fifty-foot-tall bronze, *Statue of the Republic*, a woman with a helmet, lance, and shield—inspired by Athena, the Greek goddess of wisdom. Cast in Rome and covered with twenty-two-carat gold, it was the second largest interior statue in the world at the time, after the Great Buddha of Nara.

All this conveyed upon Cuba cultural sophistication worthy of world admiration. Cubans felt a sense of optimism and renewal. They regarded Machado with buoyant admiration until he decided he would not leave after one term after all. Instead, he would run for reelection after rigging the system, engineering a change in the constitution that banned his opposition—namely his strongest political opponent, Carlos Mendieta, head of the National Union political party. Student groups and labor unions erupted in anger, holding demonstrations and rallies, many of which were broken up by excessive police violence. In 1928 Machado was reelected with no real opposition on the ballot. The result was a semipermanent public uprising against an increasingly repressive regime.

Harry's nomination came just as Machado's repressive tactics drew intense focus in American newspapers. The Senate Foreign Relations Committee considered invoking the Platt Amendment to intervene on the island. There was discussion over whether a special envoy should be sent—someone with real diplomatic experience. American companies held over $1 billion in investments in Cuba, half of those aligned with the sugar industry. The committee wanted to know: How would American interests be protected if Machado was toppled? Harry's nomination was placed on hold. This in

spite of strong backing from Elihu Root, Dwight Morrow, Secretary of State Henry L. Stimson, and the president himself. Harry was also backed by many editorialists of the day, not because they thought he'd be a check on Machado, but because he was seen as the right person to expand Cuba's role as the aviation gateway to Latin America. As one editorial noted: "Whether President Hoover had it in mind or not, aviation men say, the appointment of Mr. Guggenheim, generally regarded as America's foremost aviation backer, will do much to forward the already rapidly developing air traffic between the United States and the countries to the southward."

Harry's nomination remained in limbo for weeks until a flurry of editorials, appearing in the fall of 1929, argued that whether Harry was the right choice or not, the lack of having an ambassador would further hamstring U.S.-Cuban relations. As one noted: "Cubans threaten revolution as the only way to rid themselves of the Machado terror and restore their inalienable rights. Machado boasts that he has the enthusiastic support of Washington. We don't believe it. But the inaction of the United States government is hard to explain. That is where Guggenheim comes in. As ambassador he will report and interpret the dictatorship for Washington. If he sees clearly and reports fearlessly, there should be a reversal of the administration's policy toward Machado very soon."

Finally, Harry's nomination was approved Oct. 9 and moved out of committee, followed by ratification in the Senate. Harry and Carol got the good news while in Santa Barbara. For Harry, in a very real sense, it was the realization of a dream. Public service would now be his focus. Brimming with optimism, Harry said in an interview, "Life is a search for happiness, and a man is happiest when he loses himself in something bigger than his own individuality." He could not lose himself in business, he said, but believed public service might be his true calling.

Harry was Hoover's fourth key appointment—ambassadors to France, England, and Italy having already been named. The Cuba appointment was important enough for *Time* to put Ambassador Harry Guggenheim

on its Oct. 21, 1929, cover. That year Harry found time to write to the Old Man, Henry Gordon Comber, not to share news of his elevation but to convey a last-minute gift before he began his diplomatic service. It was at Cambridge that Harry's attraction to diplomacy seemed to really take hold. So it was to Cambridge he wrote. "My Dear Old Man," he began: "As I wrote in my last letter I have long been looking forward to the time when I should be able to express some small part of the gratitude that I feel for Pembroke in a really useful way. I have never forgotten the wholehearted reception that was given to me, an American, by you, Pembroke and Cambridge. I have always felt that because I was a stranger I was given more than my due because of that sporting spirit that is one of Cambridge's sacred possessions. My association with and friendship for Professor Hadley before and after he became Master until his death has been to me one of the real pleasures and benefits of my life." Harry then got to the point: "I would like to present to Pembroke 20,000 pounds ($1.5 million today), with a request that the Master and Fellows outline a plan for its most useful disposition. I have no restrictions to make whatsoever."

II

As planned, the fund would soon close, but Harry wanted aviation to remain part of his public identity. Ivy Lee sent out a headshot of Harry in profile, wearing his aviator's jacket and helmet, goggles perched on his forehead. Harry told reporters he would be traveling to many of his ambassadorial appointments by plane. He was immediately dubbed the "Flying Envoy." Daniel accepted this new direction in Harry's career, hosting a private gold-plated congratulatory dinner for his son at Hempstead House. Harry would soon be meeting with the president of a Latin American country in a presidential palace, Daniel said, just as Daniel had met with Mexico's president, Díaz, forty years earlier.

The announcement of the fund's closing appeared in newspapers on Oct. 24, yet proposals continued to come in. All of them received perfunctory rejections except one—a package from Lindbergh with details about a rocket scientist Harry had encouraged Lindbergh to visit some months earlier. With Harry at his new Latin post, Lindbergh wanted to approach Daniel and ask for funding for the professor's work. Harry, who had little time to evaluate Lindbergh's findings, gave his blessing to the request.

On the very day of the fund's closing came an ominous event back in the States—the stock market collapse of 1929. Share prices plummeted over consecutive days for nearly a week. Mining stocks took steep drops, wiping out extraordinary swaths of value in Guggenheim Brothers–held securities. As bad as the losses were, many Wall Street financiers shrugged their shoulders, believing the end of the bull market was an isolated event. When stocks began to recover, most investors, including Daniel and Harry's uncles, thought a general economic recovery was on the way. What was coming wasn't another bull market, of course—it was the Great Depression.

In November Harry took his own plane down to Washington, landing at Bolling Field, near the Capitol. That evening he attended a celebratory dinner with President Hoover, Charles G. Dawes, the new ambassador to Britain, and Secretary of State Stimson. The next day Harry and Carol climbed aboard their Pan American Airways flight for the forty-minute ride from Key West to Havana. They were chauffeured to the Presidential Palace, a massive building with neoclassical touches covering an entire block. Its towering interiors, decorated by Tiffany, were framed by sweeping Carrara marble staircases and Spanish statuary.

President Machado assembled his military attachés, executive office attendants, and cabinet members all in the palace's Blue Room. For Harry, it was time to meet "The Terror." To his surprise, Machado in the flesh appeared unimposing, and a bit disheveled. The Cuban president was of average height, his paunchy physique resembling a large avocado squeezed into an ill-fitting dinner jacket. He possessed a full head of silvery gray hair,

a broad nose, a thin mouth, and deeply weathered skin, his clean-shaven face defined by round tortoiseshell glasses. His left hand was generally out of sight, tucked into a jacket pocket. It was a famous hand, one missing its middle finger, blown off during the War of Independence.

The hours-long presidential reception would have exhausted most people, but Harry, fluent in Spanish and enjoying what had been a personal dream for so long, was in his element. The reception went on for the better part of the afternoon, after which he and Carol were driven to a three-story colonial mansion belonging to a wealthy Cuban widow, then living in Paris. Harry had arranged to look at the property as a prospective home for himself and Carol. The palatial residence was more than satisfactory—he signed a two-year lease on the estate.

Harry's model for his own ambassadorship took a page from Dwight Morrow, then ambassador to Mexico. Morrow spent his own money to hire economic experts to brief him; Harry would do the same. Like a shadow economic council, his advisors, specializing in finance and international law, began working up reports and spreadsheets on the state of the Cuban economy. Harry began meeting regularly with President Machado, taking lunch with the Cuban leader every week or so at the Presidential Palace. For public functions Harry donned the attire of his legislative counterparts, a dapper white suit and straw hat.

The Guggenheims settled into their new life with an ambitious social calendar. They were invited to tea with Cuban high society figures suggested by Machado functionaries and attended horse races at Oriental Park and dinner dances at the Havana American Jockey Club. Wealthy Cubans who owned *fincas*, or ranches, invited Harry to join them in shooting parties on their sprawling properties. Harry soon settled into a routine of weekly treks to such estates, walking as much as eight miles a day to hunt quail, guinea hens, and plovers. He would spend time, too, at the Havana Yacht Club, where he got mostly pro-Machado views from businessmen and rich plantation owners. As the Depression rolled on, Machado's acolytes contended

Machado was building goodwill with ordinary Cubans by making large investments in social programs. The truth was that most government expenditures were going toward the building of grandiose public works and interest on loans from American banks, which Harry knew because he was facilitating such interest payments.

Yet Harry may not have yet fully realized the depth of the political and economic problems brewing on the island. He was advised by the State Department to be circumspect in any public statements he made. Every word of the U.S. ambassador was dissected and held up to the light for interpretation. If the Hoover administration appeared sympathetic to the insurgency, that could trigger a coup. On the other hand, if the United States appeared to endorse Machado's tactics, it could further radicalize the forces opposing him.

In March Harry took an aerial tour of the eastern end of Cuba aboard his two-seater Vought Corsair, piloted by his own "aviation attaché." The *zafra*, or sugar harvest, was underway. From the air, a sea of lush green farms came into view, dotted by thousands of *macheteros* in their broad hats, stooped over, chopping stalks of sugarcane. Some assembled in groups, sharpening their machetes; others loaded the trimmed-down stalks of cane in great heaps upon two-wheeled oxen carts destined for railcars. A *machetero* could chop six tons of sugarcane a day. For those working the fields, the season would last perhaps four to five months; the harvest would have to be finished before the start of the rainy season in May.

A short time into the flight Harry noticed something peculiar: many farms had no *macheteros* at all; entire fields lay unharvested. Harry's economic team, free from influence by Machado apparatchiks, later told him why. Grinding mills played such a large role in local employment that communities dependent on their local sugar mill were essentially company towns. Like the copper works at Chuqui, if the mill closed it would wipe out the entire local economy. This is what was happening. In 1928 the price of sugar was 2.18 cents per pound; that dropped to 1.72 cents after the Crash; to 1.23 cents in 1930 and then to 1.09 cents in 1931. Farms were being

mortgaged and sugar mills, which had borrowed heavily from American banks over the past decade, were defaulting on their loans and going bankrupt. A visitor to the island, seeing all the dollars spent in Havana casinos, hotels, bars, and restaurants, would assume a thriving economy. Yet only a small percent of the island's population really benefited from business in the capital. Some 85 percent of Cuba's workforce was employed in the sugarcane industry. The result, noted one analysis, was "a lopsided export economy, in which foreign customers determined the degree of prosperity on the island."

Another factor pushing sugar prices down was the Smoot-Hawley tariff. Hoover had campaigned in 1928 with a promise to help farmers by raising tariffs on farm products. But when the bill, coauthored by Senator Reed Smoot and Congressman Willis C. Hawley, was taken up, other American business sectors got into the act. In the end tariffs were leveled on some 20,000 imported goods. Hoover thought the act would help the economy. The consensus today is that the tariffs worsened the Depression and caused a major drop in global trade. (Two years after it was enacted, Smoot and Hawley would retire from Congress.) For Cuba, the tariff was devastating, ultimately cutting Cuba's share of the American sugar market by half. Given the one-dimensional nature of the economy, when sugarcane workers lost their jobs, there were few other jobs to seek. What would all these thousands of workers who had lost their livelihoods do?

On the island, as on the mainland to the north, the disturbing economic news kept coming, but Harry and Carol kept up appearances. They did so in the spring of their first full year in Cuba at the *Maine* monument, the glittering blue waters of the Havana harbor as a backdrop, where Harry spoke before some 50,000 people attending the annual remembrance ceremonies for the sinking of the battleship. Harry looked every bit the diplomat, in top hat and coattails, speaking to an audience of Cuba's elite society, members of the government, and military. Cuban army aircraft buzzed overhead, dropping hundreds of roses on the monument. "The Star-Spangled Banner"

played, followed by a musket salute as American warships sat silent at their moorings in the harbor. The local press seemed to enjoy their flying envoy. In early 1930, when Harry clinched first place at a charity dance in the city, Havana newspapers affectionately called him *"aplatanado"*—a term for someone who, like a plantain, has taken root in their culture.

These public events were a welcome respite from the darkening clouds of the Depression and the bottom falling out of the sugar economy. Harry's first real assignment as American envoy came in April, when he spent several weeks preparing a legal analysis of a $9 million suit by a wealthy American against the Cuban government involving a dispute over ownership of a tract of real estate in the heart of Havana, once part of a Spanish land grant. The State Department followed Harry's recommendation that the U.S. government not take sides and that the dispute be settled in arbitration.

Carol lunched regularly with the spouses of other diplomats at Havana's famed Sevilla-Biltmore Hotel. Both Guggenheims spent a good deal of time at receptions at the U.S. Embassy in Havana. The office employed a dozen staffers, including the embassy's chargé, Edward L. Reed, and Military Attaché Joseph O'Hare, a former football star at West Point, plus two diplomatic secretaries, five stenographers, and a messenger. Harry threw so many receptions there that the sheer volume of alcohol required drew the ire of the U.S. press. One shipment, consigned directly to Harry from Bordeaux, weighed in at 5,632 pounds of liquor—2½ tons—including fifty-seven cases of wine, eleven cases of Champagne, nine cases of assorted wines and liquors, and five cases of whiskey. News leaked of the shipment, causing a minor diplomatic kerfuffle. At the height of Prohibition, it was illegal to ship alcohol to U.S. soil. A foreign embassy is considered U.S. territory, noted newspaper editorials in the United States, but the State Department seemed unconcerned. As one editorial concluded: "There will, therefore, be no issue raised over the 6,000-pound thirst of Ambassador Guggenheim. He knows what he's about as a diplomat and apparently can't get results on ice water alone."

One person who was probably imbibing too much was Carol, apparently battling both alcoholism and bouts of depression. She no doubt felt the pressure of one important fact she knew but had to keep under wraps: Harry was holding secret meetings between opposition leaders and Machado. What her husband was aiming for in the negotiations, apparently sanctioned by Secretary of State Stimson, was an agreement over the terms by which that year's elections would be held. Harry believed a grand compromise was in reach. But the discussions were poisoned by a wave of assassinations of anti-Machado activists, the murder of railroad union leaders, and brutality by Machado's police force against protesting Cuban university students.

III

The State Department and members of the U.S. Congress were watching Cuba carefully. The Depression was decimating economies in Latin America. Fascists had taken over Brazil. The governments of Peru, Bolivia, and Argentina had been overthrown. The revolutions in Mexico and in Russia continued to transform the governments and cultures of those societies. To Washington, Machado represented stability, but stability at a terrible price. After weeks of meetings with Carlos Mendieta and President Machado, Harry had a deal, or so he thought. A new law, which Machado said he supported, would reestablish free elections that November. It would allow Machado's political opposition, the Cuban nacionalista party, to appear on the ballot. But when it came time for Machado's rubber-stamp congress to vote on the measure, they overwhelmingly rejected the bill. Harry was shocked at this betrayal but had few options to force Machado to live up to his agreement.

In May Mendieta's party members held a meeting in the town of Artemisa. As the meeting began, soldiers attempted to stop the first speaker, causing chaos to break out. Machado's military forces rushed in and fired on

the crowd. Eight people were killed, several dozen badly injured. "The events of Artemisa mean that politics is no longer possible in Cuba, the answer to brutality must be rebellion," noted Ramón Zaydín, who had been the head of Cuba's House of Representatives.

It was an ominous statement. A feeling of impending doom pervaded Havana. Rumors of a civil war were all over the capital. Carol told Harry she wanted to return to the United States, and Harry gave her his blessing. Harry arranged for her to fly back to New York, where Carol decamped at a family home in Southampton, Long Island. Harry announced that he would be taking a two-month leave of absence, leading to immediate speculation he was quitting. Harry had no intention of leaving his post, but it was crucial he return to New York. On the morning of Sept. 28, 1930, Daniel Guggenheim lay seriously ill in his bed at Hempstead House. His heart disease had advanced. At around 11:00 A.M. that morning his condition worsened, and then he died. Those present at the moment of his death were his doctor, wife Florence, daughter Gladys, and Harry. (Older brother Robert was en route at the time from Washington, D.C.) The service at Temple Emanu-El would be simple. New York City mayor Jimmy Walker attended; among the pallbearers were Adolph S. Ochs, publisher of the *New York Times*, and Lindbergh. When Daniel died his estate was worth about $20 million ($1.2 billion in 2019 dollars). He left $2 million apiece to Harry and to sister Gladys and left $2 million in a trust fund for Robert. Most of the balance of his estate Daniel left to Florence.

Daniel had been preparing for Harry to replace him as family patriarch going back to Harry's Mexico days. Now that the time had come, Harry could not fully absorb the loss and what this leadership vacuum would mean to the family. Cuba was coming apart and he was a key catalyst in keeping it together. Less than a week after Daniel died Harry flew back to Washington, spending the next day focused on the situation in Cuba. He met with Secretary of State Stimson, then Under Secretary Cotton. He conferred with Francis White, an assistant secretary of state for Latin American

affairs, and with Dana Muro, chief of its Latin America Division. There were some in the U.S. Congress who felt that even if Machado's administration was unconstitutional, he was at least the devil they knew. The factions comprising the opposition frequently fought with one other. Were they to gain power, would Cuba's political system shatter into these competing power structures and plunge the country into a civil war? Harry was counseled to continue backing Machado but to keep him on notice that repression would only inflame his adversaries and undercut support from his allies.

In early 1931 government forces occupied newspapers, hundreds of political prisoners sat in jail, and riots were becoming commonplace. In February a bomb exploded in the Presidential Palace, one of a series of attempts on Machado's life. There were traitors in Machado's midst, probably members of the military. In a report to Stimson, Harry wrote: "hardly a night passes without the explosion of one or more small bombs in different parts of the city." He added, "President Machado replying to criticism of his administration in a speech on New Year's Day once more announced that he had no intention of resigning, declaring that 'presidents are not overthrown by scraps of paper.'"

Stimson cabled Harry, advising him to leave the country if he thought his life was in danger. If he remained, Stimson asked him to do so with the greatest of care. Harry elected to stay. Another State Department cable came in April, suddenly ordering Harry to break off negotiations between Machado and opposition forces. Harry ignored the order and continued talks, under the pretext that they were "informal" conversations. Still, he got nowhere with Machado.

Riots erupted at Cuba's main university, which had been closed by Machado. The turmoil spread and lasted three days. This triggered the Cuban Senate to grant Machado's request to impose martial law. It was later suspended. Later that year student demonstrations occurred throughout the country. Bombs went off in Matanzas, sixty miles east of Havana, and Machado declared martial law a second time. Hundreds of students were

arrested. Rumors flew in the capital, ranging from Machado's imminent resignation to the report that Harry had summoned two U.S. Navy cruisers from Guantanamo Bay (both rumors were false). Harry was called to attend a secret meeting of Machado and his cabinet in which emergency measures were discussed. Headlines in the United States proclaimed: CUBAN GOVERNMENT TOTTERS. Beyond martial law, Machado's congress granted the government a sixty-day period of media censorship. The draconian measure temporarily banned all rights of free speech and assembly and even rights to privacy in one's mail.

Editorials in some U.S. newspapers blamed Harry for the worsening conditions on the island. "Every realist in Washington knows that just one slender thread now holds President Machado in power. That is the support given him by the United States ambassador at Havana, Harry F. Guggenheim. Advised by Mr. Guggenheim, the state department has believed Cuba to be pacified, and has so told the newspaper correspondents. Today Cuba is again in eruption, and Mr. Guggenheim, as an adviser and a pacifier of Cuba, is himself hanging by a slender thread. A change of administration in Cuba, with or without physical armed intervention by the United States seems potentially imminent."

The Cuban opposition was critical of Harry, too, circulating manifestos that denounced Machado as a murderer and Harry as his accomplice. Machado shifted tactics, contending that the real source of political unrest in his country was the Communist menace. He referred to it in his public statements, while at the same time emphasizing his backing from Harry, a proxy for the military force that he could summon from the United States, if needed. As Machado said in one interview: "You have asked me why there is agitation in Cuba today—murmurs of revolution—echoes of rebellion. I will tell you why. It is because Russia is in Cuba. It is because the snake of Russian communism, having found a refuge among disloyal Cubans, is trying first of all to strike at Cuban national life with the principal object of spitting its venom at the United States. On my word as an officer and a

gentleman, on my word as the president of this republic, that is the truth, and your own American ambassador, Señor Harry F. Guggenheim, knows that it is the truth."

<div align="center">

IV

</div>

As Machado's paranoia grew, so did his acts of barbarism. Labor leaders and student protest leaders were disappearing, their mutilated bodies later found by the sides of roads. Those taken to the notorious Morro Castle suffered a worse fate. The Spanish-built fortress at the entrance to Havana Bay was rumored to have a trap door in the lower floor where prisoners were held. When the door opened their bound bodies would fall into the sea, dead or alive, where they were eaten by sharks. In one instance, a shark was caught and inside its belly was the arm of an opposition leader, identified by a shirtsleeve carrying the monogrammed initials of the deceased. After a number of such discoveries, Machado's harbormaster devised a simple solution: he banned shark fishing.

Later that year two key leaders of the insurrection were captured by Machado's forces. In custody they charged that Harry had "practically intervened in Cuban affairs in an effort to prevent the revolution." While Secretary of State Stimson had declared a "hands-off" policy of strict neutrality, Harry was working behind the scenes to allow Machado to continue in power, they said, in exchange for reforms. "Mr. Guggenheim then told our leaders that if they did not want to accept the program he had laid before them and the continuation of Machado in office for the 'short period' until 1933, his interest in bringing about a settlement was ended. Those of the opposition leaders who conferred with him declared that Mr. Guggenheim said he could not accept any proposal for the immediate resignation of President Machado because that would mean 'the defeat of my policy.'"

This heightened tensions between Secretary of State Stimson and his Cuban ambassador. Harry pointed out that Machado perceived that the Hoover administration gave his reign wide latitude, a perception that made Machado act with impunity. Harry suggested a strong signal be sent from Washington to Machado indicating that support for him was not unconditional. And at some point, Harry argued, the Platt Amendment should be abolished. Stimson disagreed, instructing Harry to convey no such sentiment to Machado. His orders were to maintain strict neutrality.

Once again, Harry was in a Latin country on the eve of revolution. Troops surrounded the U.S. Embassy. It resembled a military checkpoint. Incoming calls to the embassy were monitored by Machado's military attachés; all visitors had to be cleared by them. When Harry flew from Havana to Washington in his own plane, it would be escorted by two Cuban military aircraft part of the way, for security. It was all becoming overwhelming for Carol. She again wanted to leave Cuba and return to New York, where her young daughters were spending more time in the company of nannies and tutors than their own parents. Harry accompanied Carol back to Manhattan then returned to Cuba. A short time later he received Carol's doctors' reports describing her major weight loss and bouts of dizziness. One of her doctors termed Carol "emotionally unstable" and advised Harry that she not return to Cuba.

It was increasingly unsafe for President Machado to venture out in public, but he did anyway. Every Saturday he would stop by a park with a carousel, sitting in the back of his $30,000 armor-plated limousine. At the park was a sidewalk ice cream vendor selling tropical flavored cones of *tamarindo* and *guanabana*. One day, the ice cream vendor disappeared, his cart left behind. Machado found this odd and asked his driver to pull over. Luis Santeiro, Machado's great-grandson, described what happened next in a memoir: "They had barely gone half a block when this huge explosion sent the ice cream cart flying way up in the air. Cars parked nearby rocked like tin toys, and their windows were smashed to smithereens . . . Green

gobs of lemon ice cascaded down one man's forehead . . . Everyone around got splattered by those delicious island flavors that we all adored. Although to the disappointment of some, Papa Geradito was still very much alive."

Machado escaped yet another assassination attempt after Clemente Vázquez Bello, leader of the Senate and a Machado ally, was shot to death leaving his home—his car sprayed with machine gun fire, gangland style. At Bello's funeral a resistance group reportedly planted 300 pounds of dynamite in a tunnel next to where Bello was to be entombed, apparently hoping to wipe out Machado and his entire cabinet when they attended. Fortunately for Machado, Bello's family chose a different burial site at the last minute.

Harry knew his life was in danger—he apparently believed a price had been put on his head by one of the opposition groups. A few weeks after the Bello assassination Harry received a package from Lindbergh at the embassy. Inside was a .38 revolver, a shoulder holster, and a note. Harry termed the model a "quick draw" style pistol. Wrote Lindbergh: "I hope you never need this present."

Chronicling the increasing violence in the capital, U.S. Embassy dispatches from Harry's staff to the State Department now read like crime blotters: details of railroad derailments caused by striking unionists and murders by the *Porra*, Machado's secret police. Guards with bayonets and guns stood at every major government building, train station, and bridge. Back in the United States, President Hoover's reelection bid looked promising in the early months then ended in a landslide defeat by Franklin Delano Roosevelt. With Cuba in total disarray and a new Democratic administration, Ambassador Guggenheim would soon be out of a job.

Sumner Welles succeeded Harry in May of 1933 and was put to the task of forcing Machado out. Just as Harry had done, Welles began mediating between opposition groups, only now the conversations were to plan for a post-Machado government. As usual, the discussions went nowhere. Finally, a crippling general strike in Havana brought down Machado's government. An alliance organized by military officers, including future Cuban leader

Fulgencio Batista, took over. Machado fled to the Bahamas. All of the best-laid ideas of Harry and his advisors—plans for making Cuba a Latin American air hub, reconstructing the Cuban economy, reforming the tax system—lay scattered in boxes and file cabinets inside the U.S. Embassy. After Machado's chartered getaway plane reached Andros Island, the ex-president simply said, "I am very tired."

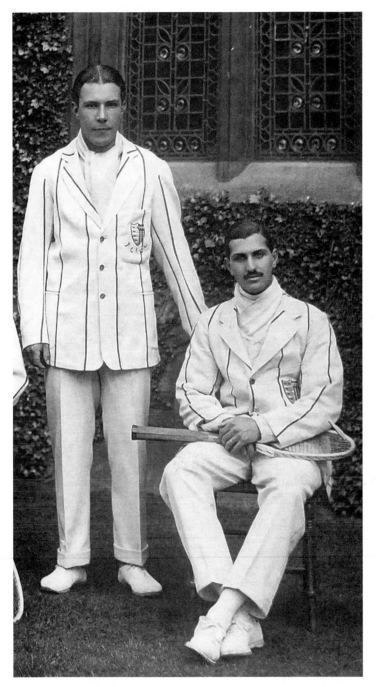

Harry and fellow team mate on the Pembroke College tennis squad.

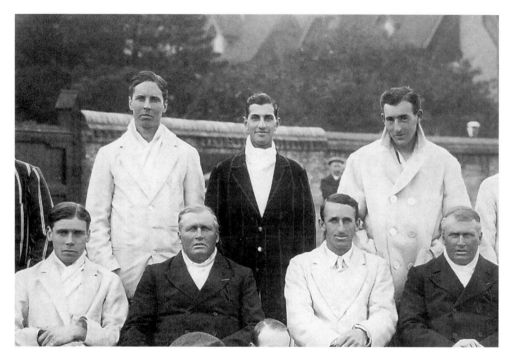

Cambridge, 1913: on the way to Wimbledon.

First wife Helen Rosenberg and daughter Joan in Cambridge.

ABOVE: Harry's parents, Florence and Daniel, with granddaughter Nancy, circa 1916.
BELOW: The well-dressed woodsman: Harry took up hunting early.

Harry with Charles Lindbergh after a test flight in California.

Illustration for *Popular Science*, who named Harry
the "Godfather of Flight" in the late 1920s.

Pointing to the future: (L to R) North Carolina Gov. O. Max Gardner, HFG, Virginia Gov. Harry F. Byrd at a 1929 military maneuver.

Safe skies: Harry made the case for commercial aviation in *Forbes* and other publications.

ABOVE: Inside Falaise, Harry's home for nearly fifty years. BELOW: Built in the style of a Norman manor, Falaise overlooks the Long Island Sound.

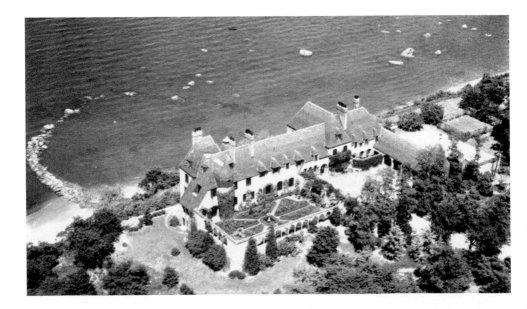

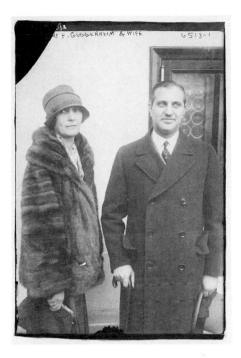

ABOVE: Harry and second wife, Carol Morton Potter.
BELOW: Cain Hoy, Harry's hunting retreat near Carleston, South Carolina.

REPÚBLICA DOS ESTADOS UNIDOS DO BRASIL
FICHA CONSULAR DE QUALIFICAÇÃO
Esta ficha, expedida em duas vias, será entregue à Polícia Marítima e à Imigração no pôrto de destino

Nome por extenso Harry Frank Guggenheim.
Admitido em território nacional em caráter TEMPORARIO, digo TRAN-SITO
(temporário ou permanente)
Nos termos do art. 6 letra — do dec. n. 7967, de 1945
Lugar e data de nascimento New Jersey, 23 / 8 / 1890
Nacionalidade norteamericana Estado civil casado
Filiação (nome do Pai e da Mãe) Daniel Guggenheim - Florence
Guggenheim Profissão Comerciante
Residência no país de origem New York, U.S.A.

	NOME	IDADE	SEXO
FILHOS MENORES DE 18 ANOS			

SÊL
CON

Passaporte n. 156236 expedido pelas autoridades de Depto. de
Estado, Washington na data 17-fevereiro-1948
visado sob n. 188.-

Consulado Embaixada do Brasil
em Santiago

ASSINATURA DO PORTADOR:
Harry F. Guggenheim

22 de março de 19 48
O CÔNSUL:

NOTA—Esta ficha deve ser preenchida à máquina pela autoridade consular, sendo as duas vias em original.

ABOVE: Foreign affair: Harry got to know his future wife, Carol Potter (then married to his boss) on business trips to South America. LEFT: Harry Guggenheim, Dr. Robert H. Goddard, and Col. Charles A. Lindbergh.

Harry in his WWII pilot uniform.

Daughter Joan enlists.

ABOVE: Alicia Patterson. BELOW: Alicia in the *Newsday* newsroom.

Formal portrait, circa 1930.

ABOVE: Dark Star wins the Derby.
LEFT: Hilla von Rebay: Solomon's
muse, Harry's headache.

Frank Lloyd Wright inside the rising Guggenheim Museum, now a U.N. World Heritage site..

The Guggenheim opens: (L to R) HFG, Henry Cabot Lodge, Jr. (U.S. Ambassador to the U.N.), Robert Moses, and Bernard Baruch.

Harry and Alicia take Empress Farah of Iran (a former art student) on a tour of the new Guggenheim.

ABOVE: Joan Miró and HFG next to Miró's sculpture commemorating Alicia.
BELOW: Lunch for 1,000 to welcome *Newsday*'s new publisher, Bill Moyers.
(L to R) U.S. Sen. Robert F. Kennedy, HFG, Bill Moyers.

CHAPTER TEN

Muzzle Velocity

I

Harry returned to Sands Point, his steamer trunks packed with trinkets from his *carrera diplomática*: boxes of decorative terra-cotta tiles to line the walls of the kitchen at Falaise; photos of himself on horseback hunting at the fincas of wealthy Cuban friends; a full set of china bearing his ambassador's crest.

Harry's exit from Cuba was but one of several existential challenges he now faced. At forty-two, it was a little early for a midlife crisis. But he must have wondered: Was his short-lived diplomatic career really over? Perhaps this would be a productive hiatus, a time to reflect on the previous decade, split between aviation and diplomacy. Daniel had been steward of the family's wealth. Harry was now steward of the family's reputation and its financial future. Yet the Guggenheims were a legacy brand and a mature business, hit hard by the Depression. What future did it really have?

His father had groomed him to be heir apparent, yet Harry's fractious departure from Guggenheim Brothers a decade earlier had set him on a different path. Harry took stock of his life: he was still the Godfather of

Aviation (and lucky to be alive, he no doubt told himself). He had cultivated relationships with two U.S. presidents. His relationship with Lindbergh was well known, with one newspaper suggesting Harry knew Lindbergh better than anyone in the country. He had held one of the most important U.S. ambassadorships. But now he was back at Falaise with no discernable career, no new job on the horizon, but many new obligations as Daniel's heir.

Harry was no longer a partner of Guggenheim Brothers, either, but his father's estate and his own interests were intertwined with family business interests. He began attending meetings again with his uncles. Of key concern at that moment was the political crisis in Chile. A socialist junta had taken over, threatening a government default of Guggenheim nitrate bonds held by the Guggenheims and thousands of other investors. Some in the business community still believed that a stock rebound was on the horizon. Not the Guggenheim's family financier, Bernard Baruch, who said: "You ain't seen nothin' yet. We're in for a real hurricane." The brothers wondered how they would ever raise the huge sums of capital required for new ventures as they watched capital markets dry up. Some of the family's wealth was threatened in other ways: Uncle Murray had been hit with a $3 million tax bill based on a $20 million trust he had set up for his heirs. Florence, too, faced a potentially huge tax hit for Daniel's estate. Harry and his mother began meeting with the family accountants to blunt the potential financial damage. Florence now lived at Milles Fleurs, a more modest-sized French country–styled estate constructed near Hempstead House after Daniel's death.

Newspapers carried alarming reports on the unfolding chaos in Cuba—murders by the *Porra*, aerial bombing of rebels in the countryside, a shootout in the Cuban House of Representatives. After Machado was overthrown, by one account, Sumner Welles was nearly assassinated before escaping back to Washington. In the summer of 1933 a series of front page stories appeared in the *New York Post* offering Machado's version of events, titled, "Fugitive Tells His Own Story." Harry refused to grant interviews with reporters asking for his views on the situation; he would

offer no transitory takes on the unrest. Instead he summoned Ivy Lee to help him compile a collection of his columns and speeches on Cuba. The compendium, *The United States and Cuba: A Study in International Relations*, chronicled U.S.-Cuban relations since the days of the Spanish and urged repeal of the Platt Amendment. It received generally positive reviews. Two weeks after the book was published the Platt Amendment was abolished.

Praised by critics, the good reviews were of momentary comfort for a man suddenly preoccupied with the future of the family finances in the middle of the Depression, the future of his career, and the future of his marriage. Carol had begun splitting her time between solitary hours in the tower studio at Falaise and keeping company with new friends at the First Century Christian Fellowship, also known as the Oxford Group. It was a kind of self-help association founded to grapple with problems like fear and avarice by building spiritual values in daily life. Members would meet at Bible studies and evangelical house parties. Some of the principles of the Oxford Group led to a famed offshoot—Alcoholics Anonymous. Imbibers at the Oxford Group who stopped drinking apparently helped Carol achieve her own sobriety. Harry recognized the positive role Oxford played in Carol's life, though it held no interest to him personally. "It has done her very much good but I cannot follow it myself," he wrote Lindbergh.

On Harry's mind, too, were events unfolding in Germany. Hitler had become chancellor just a few months before Harry returned from Cuba. Constitutional protections for Jews were quickly suspended, then a Nazi party–organized boycott of Jewish-owned businesses. Ominous edicts followed: the exclusion of Jews working in civil service and university positions; citizenship stripped from Eastern European Jewish émigrés; a ban on Jews from property ownership; a prohibition against Jews working as journalists. This touched off an exodus of German Jews, among them Albert Einstein, winner of the Nobel Prize for physics a decade earlier.

Harry conferred with his uncles on what the family position should be and what the Guggenheims could do to help émigrés. Simon had recently

attended a private New York dinner for Einstein hosted by New York governor Herbert Lehman and financier Felix Warburg. Both Lehman and Warburg were readying a drive to raise $2 million in relief aid to Jews suffering from Nazi persecution. It was agreed that Harry would preside at the campaign's official launch. At a fundraising kickoff dinner Harry delivered a rousing but elegiac speech to the 1,000 wealthy New Yorkers in attendance. Harry termed Hitler's state-sponsored violence as, "a battle of bigotry against reason, of the darkness of a night against the light of ages, of savagery against culture." He asked: "How will history record the reversion to barbarism of Hitler, the Nazi, in a day in which France produced a Briand, Great Britain a MacDonald, and India a Gandhi?"

II

Another matter weighing heavily on Harry was the nightmare that had descended upon the Lindberghs just a year earlier. The whole world had followed the story: In the spring of 1932 the Lindberghs' curly-haired twenty-month-old son had been kidnapped from an upstairs nursery while Charles and Anne ate dinner in their dining room. The child died, apparently from a fall during the abduction. When the body was found two months later in nearby woods, the entire country felt the Lindberghs' outrage and heartbreak. Solving the case became a serial page-one crime drama in the nation's newspapers, attention the Lindberghs found unbearable. Following the arrest of Bruno Hauptmann, a German émigré who worked as a carpenter in Brooklyn, hundreds of reporters swarmed the trial, attended by columnists like Walter Winchell and Damon Runyon. Will Rogers took particular interest—he had visited the Lindberghs and their son just two weeks before the kidnapping. Slim took the stand, as did Anne, answering questions about ladders, ransom notes, and late-night visits to cemeteries to meet the kidnappers. The Lindbergh baby's

garments, worn by the child when he died, were put on display. As the courtroom drama played out, H. L. Mencken termed it "the greatest story since the Resurrection."

After the kidnapping Falaise became a refuge for the Lindberghs. Slim and Harry began secretly discussing the possibility of the Lindberghs' building a home on Harry and Carol's property. The site Charles and Anne had chosen was near Falaise, not far from the sound. Lindbergh had some ideas about landscaping and some improvements to the waterfront. Depending on the tide at Falaise, a boat could be difficult to launch from the ramp at Harry's sloping beach. Lindbergh worked up a pencil-drawn diagram outlining his solution. It would be a modification to the existing ramp, requiring steel axles, brass pipes, and pneumatic wheels to release a boat like a slipway launches a newly built passenger ship. Harry had the land cleared and put in plantings, and took the new boat launch under consideration.

The idea of living on the Falaise estate was a dream that would have to wait. Lindbergh felt a growing agitation, and danger, from the onslaught of reporters' obsessive focus on him, Anne, and their second son, Jon. Newspapers piled up thousands of column inches a week on their lives. Every movement by the couple—where they traveled, what they ate, who they visited—was covered in excruciating detail. Slim confided to Harry he was considering a short-term solution: leave the country and wait for the media's preoccupation with the Lindberghs to cool off. Harry profoundly disagreed, setting off a heated argument one Sunday afternoon at Falaise. "As long as you do anything constructive in your life, you will have to meet it," said Harry, referring to the glare of publicity. "You can't get away from it. The only thing to do is to change your whole attitude. Conquer it inside of you, get so you don't mind. You've got to stop fighting it, stop trying to get away from it."

Lindbergh disagreed. "It isn't what they say—it's their physical presence in your life, not being able to step outside your door without having a flash(bulb) explode in your face." Anne concurred with her husband.

"Suppose you *do* give in to it," she said, "stop fighting, stop guarding your private lives, throw open your doors to them, let them do anything they want, take anything—then what? Will we have peace then?" she asked.

Of course not, said Harry, unless they were willing to live a life of "vegetating oblivion." Harry's "accept what you cannot change" advice was not a winning argument with Charles and Anne. When the Hauptmann trial ended and the defendant was found guilty, the verdict set off death threats against Jon. One day Jon and his teacher were riding home when their car was forced off the road by pursuing paparazzi, who sprang from their vehicles and used the opportunity as a photo op. It was the last straw. Late one night, just before Christmas, the Lindberghs secretly boarded a steamer, the *American Importer*, headed for England. A British journalist called Harry and asked him for confirmation of the Lindberghs' departure, to which Harry simply said: "Yes, the Lindberghs said goodbye to America for the time being and are well on their way across the Atlantic."

The Lindberghs landed at Long Barn, an estate in Kent owned by a member of Parliament, where they lived with their second-born son relatively undisturbed by the press. Slim had not abandoned his dream of living at Falaise. As he wrote to Harry: "We have been here (Long Barn) for over two weeks now, and the only place we like better is Falaise. I think you have, in Falaise, the most desirable home I have ever been in. It seems to be the best possible location one could find to embody sea and country within daily reach of the resources of a great city."

Harry, in turn, missed Lindbergh's presence: "Write to me often. Come back when you can. I need the comfort of your companionship and friendship." Harry and Slim exchanged dozens of letters in the coming months. The kidnapping and death of Lindbergh's son was rarely referenced, but Harry and Slim corresponded on almost everything else: crime in American cities, thoroughbred horses, politics, publishing, landscaping at Falaise, the future of aviation, life in England, dog breeding, and the

sale of Lindbergh's travel trailer (left behind at Falaise) to a buyer Harry knew in Cuba.

The most frequent topic of Harry and Slim's correspondence was the work of Dr. Robert Goddard, a physics professor at Clark University in Worcester, Massachusetts. The professor first came to their attention during one of the Guggenheims' weekend furloughs from Cuba. Harry and Slim enjoyed a hearty late breakfast one morning at Falaise, served as always by white-gloved attendants in the oak-paneled dining room. Afterward, Anne went upstairs and Carol, Harry, and Slim sat in the living room by the fireplace. Carol, glancing through a recent issue of the *New York Times*, suddenly said: "Listen to this," and read aloud excerpts of a story about a university scientist in Worcester, Massachusetts, Dr. Robert Goddard, setting off experimental rockets at his aunt Effie Ward's cabbage farm. For years the press had been having a field day with Goddard, chronicling his rocket tests, mocking them as an exercise in science fiction. After the latest cabbage-patch launch, one headline noted: MOON ROCKET MISSES TARGET BY 238,799 MILES.

Accounts of Goddard's trials read like preludes to Armageddon: "A flash of flame across the night sky, a roar like the trump of doom. And startled citizens for miles around here were aroused to what they at first thought was a rehearsal of the end of the world. A farmer had seen it shoot into the sky, cutting a track like a comet. Someone else said it was a meteor. Others were sure they had seen an airplane explode and fall in flames. The explosion had jarred houses for two miles and crowds quickly gathered, to mill about uncertainly." Goddard's latest test flight had indeed triggered reports of an airplane crash, causing a police car and two ambulances to rush to the scene.

Neither the Clark University campus nor its students were safe from Goddard's experiments. Upon hearing the latest explosion in the professor's lab, students would wonder if anyone had been killed. Among Goddard's assistants was Clarence Hickman, a Clark graduate student. An aspiring

magician and clarinet player, Hickman was handling a cartridge with nitroglycerin powder one day when it went off in his hand. "All the flesh and the bones showed bad," recalled Hickman. "I was absolutely sure they would cut the hand off." A talented surgeon worked on Hickman for hours. He lost a thumb and two fingers on his left hand and half a finger on his right. Hickman was back twenty-four hours later, missing just one day on the job. Such was the devotion Goddard commanded from his students.

Lindbergh made calls to his contacts in aviation research to ask what they knew about Goddard. The consensus: Goddard's work was dangerous but visionary, and thoroughly grounded in research. Some days after the discussion at Falaise, with Harry and Carol back in Cuba, Lindbergh called Goddard at his office to request a visit. Goddard paused, as if to convince himself the conversation wasn't a hoax—the most famous man in the world wanted to discuss his experiments?—then accepted.

Lindbergh drove to the professor's lab at Clark University, where Goddard's students observed his physics lectures from the safety of their seats. The slightly stooped, string bean–thin professor, always in a twill-weave woolen suit, high starched collar, and four-in-hand tie, neatly wrote his calculations on the blackboard. On the far left, for example, would be a large circle, within it the word EARTH. On the far right a smaller circle with the word MOON, his balding head floating between the circles like a celestial body. Next came a flurry of computations estimating the force and speed required to move one pound of matter to the lower atmosphere of the Earth. "Limit of atmosphere; 200 miles" and "Limit of balloon; 20 miles." Goddard had, in fact, developed proposals that would send humans to the moon and on interplanetary travel. But the more immediate purpose of rockets ascending to heights beyond sounding balloons was to carry scientific instruments that could collect data and take meteorological readings in the lower atmosphere.

III

Goddard first became fascinated with space at age sixteen, when he read H. G. Wells's *War of the Worlds*. As a boy he climbed a cherry tree, as if to get closer to the sky, and dreamed about traveling to the moon. His childhood was filled with scientific discovery—kites, magnifying glasses, microscopes, telescopes and a subscription to *Scientific American*. In high school he wrote an essay, "The Navigation of Space," describing various means of launching spacecraft, including the use of magnetic forces, and discussed how such spacecraft could avoid meteors. He dreamed of having it published and sent the essay to *Scientific American*. It was rejected. In college he wrote papers suggesting the use of gyroscopes for balancing and steering airplanes and the idea that a train floating on electromagnets would someday travel at a speed of 12,000 miles per hour.

But Goddard's key fascination was rocket-propelled flight. His first patent for a rocket was issued in 1914 when he was still a junior physics instructor at Clark College (later merged with Clark University), where he taught a course on electricity and magnetism. The patent, titled, "Rocket Apparatus," envisaged a multistage projectile fueled by charges that would fire in succession (a concept that later became the central design for sending astronauts to the moon). A second Goddard patent described a liquid fuel system powering his rocket, which would allow projectiles to ascend far higher than sounding balloons.

During that first meeting with Lindbergh, Goddard outlined his attempts to transition from solid fuel to liquid fuel rockets. His prototype was an ingenious design: an open rectangular frame holding a motor in place at the top, beneath it an open space for the exhaust, and below that small tanks of liquid oxygen and gasoline at the base. The long sides of the frame were actually transport tubes conveying the air and gas from the bottom and combining them at the top, igniting inside the rocket motor. When fired, propulsion from the top of the frame would pull the entire apparatus

upward. Goddard later used this design to fire his first liquid-fueled rocket. It went up forty-one feet at about sixty miles per hour. Goddard's wife Esther documented the flights on film. Goddard screened these home movies for Lindbergh during his visit. Later that afternoon Goddard invited Lindbergh to his home to show him more of the records of his research.

When they arrived, Esther was in the kitchen preparing a snack. Over chocolate cake and milk, Goddard and Lindbergh continued the conversation. The professor had begun his experiments just a few years after the Wright Brothers flew at Kitty Hawk. After filing his initial patents Goddard succeeded in winning research funding for his work from a succession of backers: Clark University, the Smithsonian, the Carnegie Institution for Science, and the Army Signal Corps during World War I. But the sums were not great and most were short-term grants. Believing the military would be a potential source of funding, Goddard designed what was called the first "portable infantry rocket" (later considered the prototype for the bazooka) The military showed only cursory interest in Goddard's work.

Lindbergh, who named his famous plane after his funders in St. Louis, knew how difficult it was to raise money for experimental ventures. He saw in Goddard his own doppelgänger, of sorts. Both Lindbergh and the professor were introverted perfectionists who preferred working alone. Both felt misunderstood and misrepresented by the press. Lindbergh saw something of himself in Goddard's binary nature: "On one day he would be a conservative scientist, confining the objective of his 'high-altitude research project' to measurements relating to the earth's upper atmosphere," wrote Lindbergh. "On another, he would let his mind run freely through fictional accounts of interplanetary warfare, or put down in writing new ideas for human emigration to distant areas of space." In Goddard, Lindbergh saw a kind of scientific Renaissance man—Goddard knew his physics but could deploy principles of aerodynamics, thermodynamics, metallurgy, and structural engineering into his work. To Lindbergh, Goddard's high-altitude

objectives were exactly the kind of upward extension of aviation that he and Harry had dreamed about since Lindbergh's reliability tour.

The Guggenheim Fund had been shut down and Harry was preoccupied with the turmoil unfolding in Havana. Mindful of this, Lindbergh knocked on other doors to find funding for Goddard. The results weren't promising. So Lindbergh sent Harry a confidential package of documents in support of Goddard's work and notes on his visit with the professor. The package arrived at the embassy in Havana with an "ask": Would Harry give his blessing to Lindbergh approaching his father Daniel to fund Goddard's work?

Nine days after Harry received Slim's package, Harry wrote back. "I felt, in a general way, that now that the Fund has been liquidated that it would be unwise for him (Daniel) to become involved in all sorts of aeronautical experimental projects . . . The Fund has been wound up under such very favorable circumstances that it would seem to be too bad to do anything to mar this record. However, I feel that, on account of your personal sponsorship and interest in this project, it is an exception and, in answer to your inquiry, I see no reason why you shouldn't talk it over with my father."

Lindbergh went to see Daniel at Hempstead House in the spring of 1930. The pair sat before the great hearth as Lindbergh recapped Goddard's experiments. In Lindbergh's opinion, rockets were the next stage of aviation and Goddard was the best man to build them. Lindbergh told Daniel that Harry had encouraged the visit with Goddard, and that he had come to Daniel to discuss possibly funding Goddard's work. "You believe these rockets have a real future?" asked Daniel. "And this professor of yours, he seems capable?"

Lindbergh replied yes to both questions, adding: "As far as I can tell, he knows more about rockets than anybody else in this country."

"How much money does he need?" asked Daniel. Lindbergh replied that Goddard thought that he could make significant advances within a four-year window, but that would require $25,000 a year. It was a risk—and highly unusual—to put that much money behind a solitary, private scientist. Daniel

was willing, but with one condition: he would set aside $50,000 for Goddard for the first two years, but for the third and fourth, another $50,000 would be offered only if an advisory committee set up to monitor Goddard's work deemed another installment warranted. That committee would be guided by Harry. Lindbergh called Harry and recapped the conversation then phoned the Goddards with the good news. The couple was elated. They made a beeline to their favorite Chinese restaurant, ordering wonton soup, chicken chow mein, and egg rolls to celebrate. The citizens of Worcester could be grateful, too—with this new funding Goddard would find a new location for his rocket tests, no longer terrorizing his aunt's neighbors.

Harry directed Ivy Lee to issue a press release on the project, likely expecting little response. The reaction was staggering—some 3,000 newspaper stories noted the Guggenheim grant to Goddard. The volume of stories on Goddard in that single year exceeded the total number of articles written on Goddard in the entire prior decade. More importantly, the credibility conveyed by the Guggenheim funding recast the narrative around Goddard. With this very public nod from the Guggenheims, few stories subsequently referred to Goddard as a crackpot. The grant was one small step in Harry's support of the rocket age, one giant leap for Goddard.

IV

Robert Goddard could now build his own shop and hire his own crew at a location more suitable for rocket testing. He canvassed colleagues at Clark to help choose a new site for the launches, considering meteorological data and weather maps, terrain, wind speeds and temperatures. Goddard needed clear skies and high visibility. He eventually found a location on a high plateau near the town of Roswell, New Mexico, home to a U.S. Weather Bureau station. He and Esther, along with a team of technicians, were soon on their way to southwest New Mexico, bringing with them an entire railcar

filled with Goddard's shop equipment—lathes, welders, calipers, wrenches, and drills.

At the time, Roswell, a community of about 12,000 residents, was a classic western town. Willow trees lined its wide dirt streets. Surrounded by open prairies, farms, and ranches, this was cattle country. On the weekends its main street filled with cowboys in broad-brimmed hats, old prospectors, and ranchers walking livestock through town. Three miles northeast of Roswell, at the end of a dirt road, was Goddard's new work site, the Mescalero Ranch. The land was named for the Mescaleros, a branch of the Apaches who once lived on the dry, sandy-clay soil. At the center of the property was a run-down adobe ranch house, surrounded by rickety sheds, a detached Mission-style cottage, and an artesian well.

Soon, beginning at 7:30 A.M. each day, the sounds of drilling and hammering filled the air as Goddard's six-person staff built various components of test rockets. Goddard would sit at a bench soldering together strips of metal cut from tin cans to form prototype rocket designs for his work crew to follow.

When design changes were agreed upon the machinists would begin building his rockets in stages. The engines, the pumps and valves, and the fuel tanks were then subjected to static tests—essentially running the machine in place, hundreds of pounds of weights keeping it from blasting off. If results were positive, the rocket would be taken to a launch tower for the real test. In the early days the tower was simply an abandoned windmill with its top sawed off.

After several misfires, followed by modifications, tests, and retests, Goddard prepared for his first major experimental flight on Dec. 30, 1930. His "mission control" was a nearby shack and observation post made from corrugated tin and plywood procured from a Roswell hardware store. Goddard ignited his liquid oxygen–driven rocket and watched in astonishment as it rose 2,000 feet, then veered off its vertical path and fell back to earth. The rocket clocked a speed of about 500 miles per hour, "perhaps the greatest

obtained by a man-made contrivance up to that time." Goddard reported this early success to Harry and Slim; both sent congratulations.

Over the next eighteen months Goddard's tests produced a mixed record. Engine propulsion improved but was marred by a series of launch failures. When it was time to ask for the second two years of funding he was confident it would be approved. But many things had changed in the short time since Harry, Carol, and Lindbergh first discussed Goddard at Falaise. Daniel had died; Goddard's champion, Charles Lindbergh, was deeply involved in the investigation of his son's death; Harry was consumed with events unfolding in Havana; and the Depression showed no signs of lifting, diminishing the Guggenheim family wealth.

So when Goddard arrived in Washington, hat in hand, to make his case to the advisory committee headed by Harry, who could not even attend, he received a chilly reception. The committee listened politely, then gave Goddard their reluctant endorsement for renewal. Then came the real meeting—and a candid exchange with Henry Breckinridge, Harry's attorney. At Harry's direction, Goddard was told that the Depression had "badly shrunk the Guggenheim estate" and his grant would have to be indefinitely suspended. Dejected but still optimistic funding would be renewed at a later point, Goddard closed up shop in Roswell and returned to teaching at Clark University, for now.

In the following months Goddard resumed his physics classes, delivered lectures, and continued rocket experimentation at his university lab. He again offered some of his ideas on military applications of his work but was turned down both by the U.S. Army and the Navy's Bureau of Ordnance.

The lull in funding did not deter Goddard in the least. "His mind was restless with ideas. His notebooks of affidavits bulged with plans for pumps, igniters, and fuel injection devices; for solar motors, ion motors and nose cones; for glide patterns to protect a spaceman from cremation as he reentered the earth's atmosphere." In spite of the pause in funding, Goddard continued to draw interest in his work from fellow rocket enthusiasts. One

was G. Edward Pendray, a reporter at the *New York Herald Tribune* and president of the American Rocket Society. Pendray was besieged by queries about Goddard's work from amateur rocket builders in Germany, which he relayed to the professor, who never revealed much about his experiments but enjoyed the attention. Pendray often had his own questions for Goddard; the two carried on a lively correspondence. A jovial character with a husky build and a Van Dyke beard, Pendray chronicled his own amateur experiments in rocketry. In his spare time he and his cohorts fired off seven-foot rockets on a beach on Staten Island, New York.

Pendray was closely following German rocket research, in particular a community of private sector enthusiasts carrying out their work at the Raketenflugplatz, a field where prototype rockets were launched, leading to the first successful firing of its own liquid-fuel rocket in May 1931, nicknamed the Repulsor. Goddard did not know it at the time, but the Germans were designing projectiles with features nearly identical to those of Goddard's models, including the future V2 rocket. The German military, which had begun its rearmament following WWI, believed rocketry would be of strategic value in any coming military warfare. In fact, Germany allocated $50,000 in its military budget for new rocket weapons in 1930.

When Harry returned from Cuba, he and Lindbergh resumed their conversations about Goddard. In mid-1934 Harry invited the Goddards and the Lindberghs for a weekend stay at Falaise. Before dinner, Goddard was accustomed to fixing his own dry martini, but this was a cocktail Harry took pride in executing himself, on the potent side. As always, it was a Falaisian menu and nothing quite like the Chinese dinners the Goddards were accustomed to. Over multiple courses and a parade of vintages from Harry's cellar, the conversation went on for hours, some of it involving what secrets of the upper atmosphere might be discovered by rockets bringing measuring devices to higher altitudes. The Goddards stayed in an upstairs guest room, where butler Walter Moulton came to

collect his slips of paper for breakfast orders. They all reconvened in the morning, the Goddards later departing for Massachusetts to await word. Goddard got it the following month—Harry sent a telegram informing him that funding would be forthcoming to begin flight tests again for the coming year, totaling a little over $20,000 ($400,000 today). The Goddards were back in business.

CHAPTER ELEVEN

Rockets and Rackets

I

Robert Goddard unlocked the door to his abandoned machine shop at Mescalero, spotting an old hat he had left on a workbench. He picked it up, smacked the dust from it and looked around. Boarded up for two years, its tenants were now desert centipedes and black widow spiders. His old writing desk sat undisturbed.

Everyone on the team resumed their old roles. Esther did the bookkeeping, cashed the Guggenheim checks in town, picked up supplies, and tracked purchases of equipment and materials. In the early days Esther would stand patiently near the launchpad holding a bucket of dirt to extinguish small blazes caused by fiery liftoffs. At Roswell Esther became chief documentarian for each flight. She used a still camera and built a darkroom at the ranch to develop launch photos. Esther also documented her husband's work with a movie camera, capturing rocket liftoffs and their slow, graceful return to earth (when the parachute worked).

The test site for Goddard's rockets was Eden Valley, about ten miles north of the Mescalero Ranch, an area of wide-open, flat scrub dotted by mesquite

and juniper. It was owned by a local rancher intrigued by Goddard's work who granted him free use of his land. Goddard's projectiles were becoming heavier and taller, some standing fifteen feet. Each new model was referred to as "Nell," a generic nickname bestowed by a shopworker. With renewed funding from Harry, Goddard soon began his A-series tests. These were a turning point in his work, marking the first flights of a rocket that maintained its own straight trajectory.

Goddard made this possible with a device similar to Sperry's gyroscopic stabilizer. It guided the rocket's position by controlling tail vanes pivoting against the blast of ejected gases. "Before launching, the gyroscope was set in motion, spinning on an axis parallel to the axis of the rocket as it stood upright in the launcher. If the rocket veered from its vertical course, the gyroscope opened a valve which worked a piston which, in turn, forced the pair of vanes into the rocket blast, causing the device to correct any deviation." This gyroscope-valve-piston-weathervane device was the second Goddard patent underwritten by Guggenheim funding: No. 1,879,187, "Mechanism for Directing Flight."

With this ingenious system Goddard reached higher elevations in the spring of 1935. In one trial, Nell lifted gracefully out of the launch tower, wobbled left, then right, each time correcting itself, climbing to 4,800 feet before dropping back to the dry scrub of the prairie. "It was like a fish swimming upward through water!" proclaimed Esther. That summer came another impressive launch, this one reaching 7,500 feet, or about a mile-and-a-half, Goddard's highest elevation yet.

Goddard took notes on each flight and sent reports on his progress to Harry and Lindbergh. Finally it was time to invite his benefactors to Mescalero to witness a test, he thought. Lindbergh planned a return trip to the United States that fall. Harry would be in the South around that time, so a plan was made for Lindbergh to pilot his plane to South Carolina, pick up Harry on the way and continue to New Mexico.

Harry alerted reporters of the trip and prepared a three-page statement for news organizations. On the afternoon of Sept. 22, Slim and Harry landed

at the Roswell airstrip. A handful of journalists had waited hours for them to arrive, but upon clambering out of the two-seat plane Lindbergh was his usual reticent self, releasing no information on how long they would stay or what they would be doing. A short time later Harry issued the handout to reporters. He noted that since the initial Guggenheim funding six years earlier, Goddard had carried out thirty rocket flights. "The object of this work is to obtain meteorological, astronomical, magnetic, and other data at altitudes greatly exceeding those which can be reached by balloons of any type." He explained, "It is of the utmost importance to science to obtain data in regions exceeding thirty miles in height, where electrical phenomena, including ionization and the reflection of radio waves, take place."

Harry and Slim settled into their spare quarters at Goddard's adobe ranch house, turning in early. At dawn a convoy assembled, Goddard driving his Ford truck behind a trailer towing the sixteen foot rocket. With the heat of the day rising, the caravan headed north out of Roswell to Eden Valley, passing abandoned wells and hills of rolling, low scrub. Finally, they arrived at an observation shack, a large wooden shed whose exterior walls were lined with corrugated tin. Attached to the shack's doorframe was a metal arm, a telescope bolted to the end of it which, when pivoted, could be swung to chin-height, for observation. Another arm held a rectangular control console, with separate wires descending from each dial. Some 200 feet beyond the shack stood the launch tower. Goddard and his team wheeled the rocket to its embarkation point.

In due course Goddard returned to the shack with his technicians and began adjusting dials, priming the ignition system. There were clicking sounds in the distance, apparently from the base of the rocket itself. Goddard, his head now covered with a broad sun hat, anxiously turned another dial and stooped over slightly as he peered through the spyglass, his eyes darting up and back to the launchpad. It was ready to fire. Goddard punched the remote control ignition button. A flame erupted at the base of the rocket, flickering for some fifteen seconds. Then nothing. Everyone waited a few moments

more, but the rocket sat motionless. Goddard described the problem in his notes: "Apparently the oxygen gas, which during the filling of the oxygen tank passed down through the chamber, had caused premature burning of the string holding the igniter in the chamber before the run. After ignition, the propelling charge burned entirely outside the rocket." In other words, it was a dud.

All was not lost, thought Goddard. He had prepared a backup Nell. Goddard told his crew to take the failed rocket back to the shop and return with its replacement. On their way back to the test site a flash rainstorm drenched the prairie around them, including the backup rocket. The professor thought it was too risky to launch in anything less than fully dry conditions, so he scratched the second test. Before leaving the test site, Goddard showcased the properties of liquid oxygen to Harry, pouring it onto a giant tumbleweed and igniting it, creating a massive fireball, while Lindbergh wandered out on the prairie, a loaded Colt revolver in his hand. He uncovered a sidewinder rattlesnake, then a large tarantula, blasting the spider with a round.

Two days later Goddard tried again. Harry hadn't slept well the night before, apparently concerned about the pace of Goddard's progress not just in reaching higher elevations, but in taking off at all. Harry rose early and helped Esther prepare a large breakfast for the group. Filled with high hopes, the caravan returned to the launch site. The skies had cleared—a good omen? Esther stood ready with her movie camera. Goddard worked through his countdown procedure. Then he punched the ignition key. This time flames erupted from several points on the engine, spitting fire dramatically. But once again the rocket would not rise. He quickly surmised that the problem this time was excess oxygen burning through a valve, throwing off the timing of ignition. As disappointed as they all felt, Slim and Harry could see the meticulous planning that went into Goddard's launches and his quick analysis pinpointing the cause of the failures. They offered Goddard their sympathy but said they could not stay for any further attempts.

Goddard noted in his diary that day: "Mr. Guggenheim and Col. Lindbergh left soon afterward, after having a hurried lunch at the ranch house. At lunch Col. Lindbergh said that the work was just about where aviation was in 1912. The writer (Goddard) drove them to the airport, where they took off at about 11am. The colonel flew to the tower, circled it twice and dipped his wings in salute . . . had nap."

Before he left, Harry reassured Goddard the visit was in no way a failure. "Goddard's faith in the ultimate success of his work was contagious," said Harry. "I promised I would come back." Esther's films of Nell climbing to successively higher elevations was evidence enough of Goddard's progress, Harry decided. The press also seemed to have faith in Goddard. Some 600 newspapers across the country carried stories about Harry and Slim's four-day visit to Roswell, most describing it in glowing terms. Virtually none of the journalists holed up in Roswell appeared to be aware that both launches failed.

In the coming months Goddard redesigned Nell with stronger motors and more robust fuel pumps, in turn requiring engineering adjustments that added long delays between test flights. Harry set renewals of Goddard's funding on a yearly basis, instead of the two-year block of support originally granted by Daniel. Soon it was time for Goddard to request another year of funding at a time when Harry was being lobbied by numerous other potentially worthy grantees for projects in aviation and rocket science.

Lindbergh offered his advice, writing to Harry: "I am thoroughly convinced that rockets will be sent to altitudes measured in the hundreds of miles in the fairly near future. I believe also that Goddard will probably be the first man to make flights of really high altitudes and to make observations of definite scientific value if he is financially able to continue his work. I think this is an instance where extremely important results will probably be obtained with comparatively small expenditure . . . It seems to me that this is the logical continuation of the interest you took in aviation at the time of the War, as President of the Daniel Guggenheim Fund, and

in many other ways. Of course, it is impossible to foretell such things, but I believe it is quite probable that Goddard's developments will eventually be comparable in a way with those of the Wright brothers, and of Langley. As far as the transport of material is concerned, Goddard is a pioneer and the present leader in the last and most advanced method which the human mind has been able to conceive. I believe it is quite probable that the research and development related to rockets will take somewhat the same position during the next 50 years, that aviation has during the past 50." Lindbergh's influence again held sway: Harry approved $20,000 for another year.

In continuing his relationship with the professor, Harry hoped to harmonize Goddard's efforts with those of rocket initiatives he was underwriting in California. Harry asked Goddard to visit Dr. Robert Millikan in Pasadena. He was president of the California Institute of Technology, then making the organization a leader in aeronautical science by forming its own rocket research group. Of course, "Goddard dreaded the encounter with Millikan, and with reason," notes historian Milton Lehman. "It brought one more reminder that the rocket might not remain his exclusive preserve." Goddard nonetheless complied with Harry's request. He began his visit to Pasadena echoing Harry's suggestions about sharing research and collaborating with scientists at the Institute—perhaps subcontracting aspects of Goddard's work to speed up his test flights. It was a pleasant enough visit, everyone in hypothetical agreement with the concept of sharing research. But Millikan's institutional approach indeed turned out to be abhorrent to Goddard. The professor had no desire to share virtually any of his nearly thirty years of research. Goddard left and nothing came of the plans.

Back at Roswell Goddard began testing his "L" series rocket, designed with a new cooling system and a "clustered" motor. In March 1937, Goddard celebrated an extraordinary milestone—his highest altitude yet, sending Nell to a height approaching 9,000 feet. In the coming months, however, Goddard was unable to repeat the feat. Elated at first, Harry later wondered whether the flight was a fluke. The following year Goddard enhanced the

moveable tail section at Nell's base and improved flow to the fuel nozzle. Yet in subsequent tests not a single flight cleared much over 2,000 feet. Harry's disappointment again set in, but he renewed Goddard's grant for another year. Harry and Lindbergh had placed their bets on the professor. They would not give up on him now.

II

After Daniel's death in 1930 Harry grew closer to his Uncle Solomon. Uncle Sol often had Harry down to "Big Survey," his hunting and riding retreat in Yemassee, South Carolina. Nearby was Bernard Baruch's compound, "Hobcaw Barony," where Baruch had wintered each year since 1905. Even brother Robert was on the hunt for his own preserve in South Carolina, eventually buying a large retreat called "Poco Sabo."

Depression-era prices made land in the area a good buy. Harry decided to acquire his own expanse of woods in South Carolina and eventually pay off some of the purchase price by starting a timber and cattle business on the land. The location he chose was likely on advice from lumberman Victor C. Barringer and Tom Byrd, Admiral Byrd's younger brother. Tom was a partner in the Byrd family's apple business in Virginia and knew much about land values in the South. He accompanied Harry on his property search, helping him acquire large tracts of mostly undeveloped acreage in South Carolina's Lowcountry, northeast of Charleston. The area was closer to New York than Florida or Santa Barbara, where Harry and Carol rented homes in the winter months. The land Harry found was filled with great swaths of timber and wetlands, crisscrossed by old sand roads.

On a train ride down to South Carolina in February 1936 Harry sent good news to Lindbergh about his site search, writing in longhand: "I have just closed negotiations for the most important parcel of the timber tract near Charleston. Tom Byrd, who has been south with me, and I spent about

a week going over the property. I am very pleased with its possibilities. I am starting timber operations at once as I hope to earn the greater part of my investment back in a few years' time. It is a very interesting property of about nine or ten thousand acres (when I get a few more parcels) surrounded by salt rivers on three sides and a national forest on the fourth side. There is a house site where I hope to put up a hunting lodge, approached by one of the loveliest live oak drives I have ever seen . . . The property consists of long leaf, short leaf, and loblolly pine forests . . . The young pine growth is about the best in the country I am informed by experts. It is a natural habitat for quail, deer and turkey." Harry called his new development Cain Hoy, once explaining that the term referred to a type of local plant known as cain hay. Cattle ate the leaves; the stalks were used to make rattan baskets. The name evolved phonetically over time to Cain Hoy.

Harry reportedly bought the first 7,500 acres for $90,000 ($1.7 million today) then snapped up more land totaling about 15,000 acres. The area once comprised rice plantations and the site of a kiln that produced bricks for some of the earliest buildings in Charleston. Harry again enlisted Polhemus & Coffin, architects for both Falaise and Florence's home, Milles Fleurs, to build Cain Hoy. Construction costs in this remote part of the state were about the same as Falaise ($250,000, or $4.7 million in today's dollars).

Cain Hoy was built in the style of a plantation home, its portico framed by four white columns. Inside the well-appointed hunting lodge were four rustic guest rooms. Paneled walls on one side of the living room concealed a bar and a storage closet for firewood (an exterior door conveniently allowed delivery of firewood directly from outside). The dining room sat ten people comfortably around a long banquet-style table made of white glass on a copper base. Above it, terra-cotta fixtures shaped like lotus leaves lit the room in a warm glow. A large patio constructed of old English brick fronted the marsh and boathouse. The gardens were laid out by Noel Chamberlin, a landscape architect whose famed clients included Charles Schwab and Harry's mother, Florence (who commissioned Chamberlin to design the

gardens at Hempstead House). Harry entertained guests at outdoor lunches on picnic tables overlooking the Cooper River, serving whatever the hunting party took down that day. Carol fabricated works of woodland art for the preserve: two turkey sculptures topping a pair of brick columns at the foot of the entrance road and a copper-tinged mirror above the lodge's fireplace, wild turkeys etched into the glass. Cain Hoy soon became Harry's second home, a hub for family gatherings and social events, and a regular gathering-place of ex-military brass for annual hunts and dinners.

Besides construction of the main house, Harry cultivated some goodwill with nearby locals by funding the restoration of an Anglican church on his land, the St. Thomas and St. Denis Parish Church. The walls of the vestry house had fallen in, a herd of goats living in the ruins. It was hallowed ground to many, being the site of the 1876 Cainhoy Massacre, which left seven people dead. Harry evicted the goats and reconstructed the vestry house with new walls and a new roof. (The restoration is likely responsible for the church being placed on the National Register of Historic Places.) In the coming years, Harry's visitors to Cain Hoy included master builder Robert Moses and wife Mary; H. L. Stoddard, a leading conservationist who helped create the profession of wildlife management; U.S. Navy Admiral John Dale Price, commander of all naval air forces in the Pacific after WWII; and Hoyt Vandenberg, a U.S. Air Force General who was the second director of the CIA (for whom Vandenberg Air Force Base is named). One of the most frequent visitors was U.S. Senator Harry F. Byrd (yet another brother of the famous aviator).

<center>III</center>

Tracking Goddard's work, developing Cain Hoy and building his thorough-bred racing stables absorbed much of Harry's time and energy in the late 1930s, as did raising money to aid the exodus of Jews from Nazi Germany.

Harry had begun raising private capital for Jewish settlements abroad, doing so as a founding director of the Refugee Economic Corporation (REC). The REC funded an important multiyear Johns Hopkins study of resettlement of European refugees. The research was key to identifying countries where Germany's hundreds of thousands of Jewish émigrés might live. In one case the REC funded settlements in the Philippines, securing enough ranchland in Mindanao to take as many as 10,000 refugees. As a director Harry raised funds toward the $250,000 plan to resettle Jews in Palestine's Huleh Valley, where a vast area of swamps was drained to build farms for settlers. The project ultimately made the region "one of the most prosperous, wealthy and fertile areas in the state of Israel," stated one study.

Lindbergh, too, would do his part to subvert the Nazi menace—or so Harry thought. Slim complied with a request from Col. Truman Smith, the American military attaché in Berlin and a leading authority on German rearmament. Fluent in German, he had interviewed Adolf Hitler a decade earlier in Munich, before his climb to power. But Smith lacked reliable intelligence on the state of the Luftwaffe, the German air force. Smith wanted to arrange a visit by Lindbergh to Germany to assess its air power. Would Hermann Göring, chief of the Luftwaffe and a WWI flying ace, entertain a visit by Lindbergh to tour the German Air Ministry and review the much-revered German air force? Sensing a potential PR coup, Göring accepted.

The announcement of the visit provoked a mixed reaction among the Guggenheims, including Harry's brother-in-law, Roger Straus, who cabled Lindbergh: I AM CONVINCED THAT THE GERMAN PROPAGANDA DEPART-MENT WILL TRY TO INTERPRET YOUR VISIT AS AN APPROVAL OF THEIR REGIME. Indeed, Göring capitalized on every minute of Lindbergh's trip, giving him a hero's welcome from the very beginning of the nine-day visit. Lindbergh toured factories producing the Reich's most advanced fighters and bombers. He witnessed aerial shows by the top guns of the Luftwaffe. Lindbergh was impressed at the speed and precision of these state-of-the-art war machines. He delivered a luncheon speech at the Berlin Air Club,

a cautionary message on military air power. "Unlike the builder of the dugout canoe, we have lived to see our wings of fabric turn into carriers of destruction even more dangerous than battleships and guns." The trip culminated with Charles and Anne's attendance at the opening day of the 1936 Olympics in Berlin, sitting next to Göring, in his box.

When Lindbergh returned he described the Reich's military airpower as superior in every way to its counterparts in the United States, France, and Britain. "Germany now has the means of destroying London, Paris, and Prague if she wishes to do so," he reported. "England and France together have not enough modern war planes for effective defense or counterattack." Roosevelt, acting in part on Lindbergh's assessment, ordered a huge increase in the production of U.S. military aircraft.

Press reaction to Lindbergh's visit, interpreted as a military mission to gather air intelligence, received mostly praise in the press, but also some criticism that his visit conveyed legitimacy to the Nazi regime. As Harry wrote to Lindbergh: "I was fishing on a salmon river on the Gaspé Peninsula for three days just before the event and so was spared overtures from Jewish leaders who feared your visit would be an indication of your approval of Nazi anti-Semitism and would aid the enemy at home and abroad. The day you were due to fly to Berlin I was asked to contact you and call attention to this please. It was too late and furthermore I had no doubt that you had considered it. I stated that I had every confidence that you would conduct yourself as to give no aid to anti-Semitism."

Lindbergh was fascinated by what he perceived to be the new Germany; a disciplined, orderly society, one that lacked poverty and social decay, he thought. And best of all, Germany kept its journalists in check. His judgment was perhaps colored by what he perceived to be the efficiently run, regimented nature of German society. This was in contrast to France and Britain, legacy empires whose civilizations were on the decline, he believed. These were of course the very nations that offered Lindbergh refuge during his darkest years. Historian Lynne Olson noted that Lindbergh's opinions

of Hitler's Germany were formed by someone who was rarely without a military escort and who saw exactly what Göring and his minions wanted him to see. Lindbergh didn't speak German; he and Anne relied on translators everywhere they went. It's true, they had little to fear from the German press. As Olson asked: What journalist would be foolish enough to criticize a VIP guest of the German state?

During their time abroad the Lindberghs finally abandoned their plans to build a home at Harry and Carol's estate. Lindbergh apologized and insisted on covering the cost of the plantings Harry had put in. What Harry didn't know at the time was that the Lindberghs were so enthralled by German society that they had secretly begun looking for a home in Berlin. Their house-hunting in the German capital was reportedly assisted by Albert Speer, Hitler's chief architect, then at work transforming much of Berlin in the image of the new Reich.

Harry told family members who questioned Lindbergh's favorable views of Germany that he was impressionable, but in no way anti-Semitic. Even so, as time went on Harry and Slim's letters made no further references to the growing Nazi menace or Lindbergh's glowing assessments of the Luftwaffe, either because they suspected their mail might be read, or these matters were too uncomfortable to discuss via letter. They instead debated Professor Goddard's latest problems, like a recent windstorm that had leveled the rocket tower. Harry assessed Goddard's test flights over the past year and wrote Lindbergh that he would approve another round of funding. As always, Slim approved: "I am glad that you have again decided to continue with the Goddard project. Goddard is extremely fortunate in having someone to back him, who understands the problems of research as well as you do. There are very few people who would hold interest over such a long period of time, and without more concrete results."

Lindbergh was right. Without Harry's continued backing, Goddard would likely have returned to his Aunt Effie's farm. Harry was again betting on the future, expecting that Goddard's work would someday

have monumental payoffs. Yet in personal moments he would express frustration that while the Goddard project was fulfilling, it was not enough to keep him occupied. In spite of the violent last months before he left Havana, Harry missed the cachet of his diplomatic post, shuttling between Cuba's presidential palace and the White House. He saw no way to reclaim it until an opportunity came one day, one that thrust him back into the public eye.

IV

In the 1920s rum runners and booze traffickers ran their illegal operations like well-organized businesses. When Prohibition ended in 1933 they applied their organizing principles to new enterprises—gambling, prostitution, and racketeering. Among their most lucrative was the Fulton Fish Market in lower Manhattan, one of the largest wholesale fish exchanges in the nation. Fishmongers had to pay racketeers thousands of dollars in protection money each year. An editorial noted: "Every tug that lands at the docks has to pay a fee; every truck that enters the market also had to pay . . ." Racketeers exacted their tolls "in an efficient and business-like manner, staging a theft now and then, and returning the loot immediately afterward, to demonstrate the dealers' need of their services."

The profiteering went well beyond fish. Racketeers demanded protection money from businesses of all kinds: poultry sellers, trucking companies, bakeries, restaurants, garment makers. There were limited prosecutions of those involved because witnesses and juries were often bribed or intimidated by crime families.

New York Governor Lehman appointed Thomas Dewey as a special prosecutor to investigate and uproot these mob operations. Dewey had been an assistant district attorney with a sterling record prosecuting organized crime. Shortly after he was appointed, Dewey hauled in Charles (Lucky)

Luciano, the first boss of the Genovese crime family, winning a conviction against him for running a prostitution racket. Over the next two years Dewey racked up seventy-two convictions and one acquittal.

Police commissioners and district attorneys come and go with election cycles. Dewey wanted a permanent entity to monitor law enforcement. He proposed forming a committee of leading New York business figures who could act as a permanent adjunct to New York's criminal justice system. "In my judgment," said Dewey, "it could prove to be the solution of the problem of organized crime."

This watchdog group would be modeled after similar associations in Chicago, Baltimore, Cleveland, and Philadelphia. But who would lead it? Dewey discussed the question with New York's recently elected mayor, Fiorello La Guardia, who made smashing organized crime a key plank in his 1933 campaign. La Guardia thought of Harry, who had briefly campaigned for La Guardia in his winning race for New York City mayor. (La Guardia ran for mayor as a progressive Republican on the fusion ticket, promising to demolish the corrupt Tammany Hall political machine.) Politically, La Guardia was to the left of Harry (a moderate Republican), but Harry and La Guardia shared a passion: aviation. At a campaign dinner, the two met again. "So you're the guy who put it over on me in Italy," cracked La Guardia.

Harry was asked to head the group, and he accepted. Its official title was the "Citizens Committee on the Control of Crime in New York"; unofficially it was known as the Guggenheim Committee. Harry described its role in an interview: "We are neither a group of vigilantes nor reformers. We are not a 'shoot 'em from the hip' squad nor are we a group dealing in theories and abstractions," he said. Rather, the association would seek to "break down the organization of crime and improve the administration of criminal justice in this city." Harry headed up its launch in 1937 with an annual budget of $50,000, raised from the thirty other committee members. Harry's associates included prominent bankers and financiers, along

with his lawyer, Henry Breckinridge; Gold Coast neighbor Herbert Bayard Swope, editor of the *New York World*; Lee Thompson Smith, president of the Grand Jury Association; Artemus Gates, president of the New York Trust Company; and C. C. Burlingham, architect of the Fusion political movement in New York.

Heading the crime committee didn't quite match the cachet of an ambassadorship, but Harry saw a unique niche to be filled in public service, where his analytical skills could make an impact. It was also an opportunity, he later admitted, to boost the political fortunes of Dewey, whose rising political star perhaps twinkled opportunity to Harry down the road should Dewey seek higher office, as everyone thought he would.

Whatever Harry's motivations, he believed that policymaking around crime was hindered by a lack of rigor in understanding not how and where crime was happening, but what happened to perpetrators after they were arrested. To understand this, Harry employed a kind of *Moneyball* approach to tracking and analyzing crime data over the prior twelve months. He theorized that the right numbers, like a well-documented balance sheet for a Guggenheim mine, would reveal patterns. In the coming year Harry and his staff produced 9,000 file cards tracking every category of crime—loan sharking, robbery, murder, prostitution. Committee staff spent hours tabulating street arrests with demographics and geographical locations of those committing crimes, and the levels of bail they received. They looked at the life cycle of each case: arrest, bail, prosecution, sentencing. They amassed summaries of the backgrounds of jurors and tracked sentences issued in every major case brought before each of the five district attorneys' offices in New York.

Eventually the Guggenheim Committee amassed enough data to make borough-by-borough correlations. Harry looked hard at the Brooklyn district attorney's office, long suspected of systemic corruption (and a bastion of the Democratic Tammany Hall political machine). The numbers showed that bail for certain repeat offenders in Brooklyn was often suspiciously low,

and suggested that grand juries were being fixed, a conclusion based in part on information coming from jury deliberations on those being investigated.

Making their case with spreadsheets and flowcharts, Harry and his committee members requested a special prosecutor be appointed to investigate. Governor Lehman agreed, naming John Harlan Amen, who had just won a jail term for mobster Lepke Buchalter. Amen's New York investigation went on for the next four years. Finally, Amen was able to expose both a corrupt bail bond office and an elaborate system of payoffs to police from gambling proceeds. Two senior attorneys in the DA's office were disbarred and one assistant district attorney was sent to Sing Sing. The results gave a boost to Dewey's political future, just as Harry had hoped.

V

One person unimpressed by Harry's new crimebuster career was his wife. Less than a year after Harry was named head of the rackets committee, Carol moved out of Falaise. Her primary residence became their apartment on E. 57th Street. From Carol's point of view, they were already living separate lives. Besides being immersed in crime committee meetings, Harry was frequently coming or going from Cain Hoy, tending to his 800 cows and bulls; buying and breeding his expanding stable of thoroughbred horses; analyzing progress on Goddard's experiments and regular reports on the aviation programs he and Daniel had established a decade earlier; raising money for Jewish aid; and frequently on the road delivering speeches on aviation and rocketry. Carol had her art and her friendships at the Oxford Group. But she no longer had a husband, she felt.

In early 1937, after spending their first New Year's apart, Carol and Harry stopped seeing each other altogether. Instead they jousted by mail over questions like who would pay the help. Carol wrote Harry: "About two weeks ago I asked you if Floreka and the Chef and Augusta would be

available for the apartment. You could not tell me when and said 'get my own cook.' I have done so and gave you every opportunity to cooperate with me. I can't keep changing cooks constantly. I have already had four in the past two months and am not willing to change again . . . it is very unfair to expect me to pay two sets of servants under the circumstances." Was an affair among the circumstances? "After all marriage is a fifty-fifty contract, not a harem," wrote Carol, later explaining she could no longer tolerate a relationship consisting of "Marriage for me, freedom for you."

Later that year Carol formalized their separation by moving out of the E. 57th St. apartment, triggering a bitter letter from Harry, who wrote: "you abandoned our home." Carol responded a few weeks later, on Valentine's Day, contending she had no choice. "Do you really think that it was possible for me to continue living at your apartment in view of your conduct and unwillingness to assume the essential obligations of marriage?"

Most of their arguments revolved around money. Carol revealed to Harry that, from the beginning of their marriage, living in a world of opulence was a personal sacrifice. She would have preferred the frugal life of a simple artist without the trappings of wealth. Carol made these complaints to her husband from the comforts of her elegant apartment overlooking the East River at 10 Gracie Square. The irony was not lost on Harry: "You assured me that your one desire was to shake off all luxury and live without financial sycophants in a small studio on a few thousand a year, or better on your own earnings. Now, your new environment speaks for itself."

A particularly contentious issue was the investment account Harry had created, with holdings worth some $3 million and delivering $100,000 in annual income, intended for their combined household expenses. Harry complained: "Little by little you have been using the income from the money that I gave you less and less for our joint expenses. You have now reached the point where you are spending it entirely for your own purposes. I don't think this is fair." At issue, too, was Carol's use of funds from a trust created for Diane. Harry's second daughter from his first marriage, Nancy,

was living with Harry and Carol's only daughter, Diane, at the Manhattan apartment. Over the previous few years, Diane, then attending Brearley, was essentially being raised by Carol and a series of nannies. After the split, Harry cut off Carol's access to the trust. As their marriage neared an end, Harry and Carol worked out an amicable financial settlement, driven largely by their concern for the girls.

<div align="center">VI</div>

In 1938 Lindbergh made another trip to Germany, this time causing an uproar and a major shift in public opinion against the most famous aviator in the world. Just weeks after the Munich agreement, Lindbergh and Anne were again guests of Göring. They were invited to a dinner party in which Göring awarded Lindbergh the Verdienstkreuz der Deutscher Adler (Service Cross of the German Eagle), one of the nation's highest honors. Speaking in German, Göring explained that Hitler himself had asked that Lindbergh be given the honor. Göring handed the medal to Lindbergh, who apparently had no idea of its significance. It was to commemorate the aviator's 1927 flight, Lindbergh was told by a translator.

Lindbergh played down the unexpected gift, but the U.S. press had a field day with the story, asserting that by not refusing it, or returning it, Lindbergh showed his true admiration for the Nazi state. Lindbergh would have done well to follow the path Harry took in a similar circumstance. A few years earlier the Cuban dictator Machado attempted to bestow upon Harry the Order of Carlos M. de Céspedes, the Cuban government's highest honor. Harry declined to accept such an award from the country's unpopular dictator. He knew the optics would be terrible. Harry later accepted the award, but only after Machado had been deposed. Lindbergh never returned the German Eagle, shrugging it off as a "teapot tempest." But Anne understood the danger, referring to it as "the albatross."

Soon after came the horrors of Kristallnacht, two days of riots, murder, and massive property damage instigated nationwide by the Nazi party against Jews, concluding with the rounding up of 30,000 Jewish citizens to be sent to concentration camps. Condemnations of the Reich came in from capitals around the world. Asked for his reaction to this "orgy of hate and destruction," Slim said: "They have undoubtedly had a difficult Jewish problem, but why is it necessary to handle it so unreasonably?"

After Kristallnacht the Lindberghs abandoned their plans to move to Berlin. Reich Minister Albert Speer wasn't surprised. "Imagine an American planning to bring his family to live in Berlin in 1938–39!" Speer later said. "He must have been very naive."

When Harry Met Alicia

I

In the 1930s most Americans were broke, or close to it. But social life on the Gold Coast carried on, oblivious to the ravages of the Depression or gathering war clouds in Europe. Harry, a soon-to-be bachelor, was never short on social opportunities. Invitations arrived daily: formal dinners, informal lunches, afternoon teas, garden parties, croquet matches, golf outings. Harry joined Uncle Sol and Aunt Irene often. The social interplay at Sol and Irene's gatherings in the city or on Long Island was never boring, though Harry professed to have little in common with the modernist painters and sculptors who came calling at their Plaza Hotel suite in Manhattan or at Trillora Court.

A fixture on the Gold Coast social circuit was the Sands Point home of artist Neysa McMein. Tall and slim, with wide-set, grayish-green eyes and high cheekbones, McMein was a commercial illustrator—the highest paid in the United States—known for her "pretty girl" covers for *McCall's*, *The Saturday Evening Post*, and *Liberty*. Neysa created the first image of Betty Crocker, giving the fictional housewife high Nordic brows and a

strong nose, a kind of demigoddess in disguise. Her parties in the city, already legendary, drew members of the Algonquin Round Table—Mary Pickford, F. Scott Fitzgerald, Noël Coward, Dorothy Parker. They came to Neysa's studio for drinks, poker, piano playing, and most of the time Neysa would be at her easel working on a portrait, her long, molasses-brown hair loosely pinned up. Often she was in an old blue smock colored by the smudges of her pastels. Some of her composite illustrations were based on the young female models Neysa recruited to pose naked in her studio for hours (one girl to sketch the arms, another for the legs, and another for the face).

Neysa lived in an open marriage with husband John Baragwanath, a mining engineer (everyone called him Jack). In the 1930s she and Jack invited their city friends out to their summer home, just down the road from Falaise. It was built in an old English style with whitewashed bricks, some twenty rooms, overlooking the sound and surrounded by giant oaks and dogwoods. The Gold Coast elite usually had many outposts, say a ranch out west, a hunting lodge in the South, a camp in the Adirondacks. Jack and Neysa had no such trinkets; they were the Gold Coast poor. Nonetheless, their home was a social magnet for A-list playwrights, actors, and writers. There were always new and interesting people to meet at a Neysa fete. At one such bash Neysa invited two recent arrivals to the neighborhood: Alicia Patterson (to whom Neysa had rented a nearby smaller home she owned) and husband Joe Brooks.

Alicia was a slender, auburn-haired woman of thirty-four, the daughter of Joseph Medill Patterson, founder of the New York *Daily News* and scion of Chicago's Medill publishing empire. Joe Brooks was a pleasant but unambitious man, an insurance executive at the *Daily News* and a hunting and fishing partner of Alicia's father. Patterson had recently bought the couple a wedding present, a Raymond Hood–designed home near Neysa and Jack's. Brooks was a gambler and an alcoholic, and over a decade older than Alicia. It was, in a very real sense, an arranged marriage. Joe was

devoted to Alicia, but shortly after their move to the Gold Coast she was coming to think of their troubled relationship as a mistake.

Alicia often confided her apprehensions about her husband's failings to Neysa. The topic tended to put Alicia in a foul mood. One late-summer afternoon Neysa apparently conjured a solution: a ride over to the home of Herbert Bayard Swope, then editor of Joseph Pulitzer's *New York World* (and Neysa's croquet partner). Neysa gathered up Alicia, Jack, and the Broadway playwright George Abbott, a houseguest that summer. The four of them hopped into Jack's Packard V-12 and, pulling onto the road, picked up speed as it began to drizzle. Tooling along in the Packard, Neysa would have announced the agenda along the lines of: "We have a party to join and then we're going to see a man about a bowling alley!"

Arriving at their first stop, it was no surprise to find the enormous colonial-style mansion filled with partygoers. The usual Swopian excess. Inside, a live band entertained young men in their summer suits and panama hats, drinks held loosely in their hands, gathered around slender women in elegant party dresses, hair piled high on their heads. Outside, a game of croquet was underway until a sudden downpour caused everyone to bolt for shelter. Neysa and company apparently ran back to the car and, seeing no letup, abandoned the affair and continued down the road. Eventually they approached a bluff above Long Island Sound, dominated by a vast expanse of gardens, winding paths, thickets of woods, and in the distance, grazing horses. The massive estate seemingly took up the entire horizon, at one end anchored by a Norman-style manor house and a medieval tower.

They passed through open black iron gates, each marked by a gold "G," pulling up to a cobblestone courtyard dotted with earthenware pots blooming with lilies and azaleas. The rain had nearly stopped, the skies clearing as they clambered slowly out of the Packard. The arched wooden entrance door opened and a man in a white linen suit emerged. His lightly bronzed face was set off by a Roman nose, thinning, dapple-gray hair, and pale blue eyes. Harry had entered middle age, to be sure, but he was still

handsome. He stepped forward to greet Neysa; the two had apparently met at one of Neysa's infamous bashes, where Harry half-joked to Neysa that she should come tour the latest addition to his estate, a bowling alley.

Neysa knew all about Alicia's passionless marriage and had heard the rumors that Harry and Carol had separated. The visit was apparently a matchmaking trip (though it's possible Alicia had met Harry once before at a horse show). Harry led his visitors to the terrace overlooking the sound, no doubt gently touching Alicia just at the elbow, like a gentleman.

In the waters below Harry had enjoyed many days of boating and fishing with Lindbergh, away from the scrutiny of reporters and photographers. Harry liked to point to a patch of ocean, the fishing grounds of a local angler who rowed to this hallowed spot several times a week. The fisherman would display his best catch to Harry, who looked down from his terrace atop the cliff, raising his arms in victory, signaling approval to the fisherman, who delivered the fish to Falaise for that evening's dinner. Alicia was charmed by it all—the Norman castle, the sweeping views of the sound, and the man in the white linen suit. As Michael Arlen recounts in his masterful biography of Alicia: "She couldn't remember whether they actually went to the new bowling alley or not . . . But she always remembered how Harry looked that night, and how he looked at her, and surely she at him."

Some weeks later Harry met Alicia again at the Saratoga Race Course in upstate New York, where horse people on the Gold Coast migrated for a few weeks each summer. Buying and breeding thoroughbreds was beginning to take up a good deal of Harry's time. Harry had bought his first horse, Nebraska City, for $400 in 1934, but didn't win big until placing third at the Belmont Stakes with a colt named Vamoose. At Saratoga he wasn't a hard man to find, holding court with guests in his private box or huddling with clockers in the barns. When Harry and Alicia made eye contact, her mischievous Celtic grin said more than words. Harry smiled back, no doubt issuing a gracious invitation: "I've got some yearlings to look at, will you come help me size them up?" Of course she would. Alicia had grown up

with thoroughbreds; she understood sire ratings and could ask jockey agents the right questions, which impressed Harry no end.

They had other things in common: Alicia was a huntress. (While on safari in Indochina, she brought down a water buffalo with a single shot.) She was an aviator, having earned her transport pilot's license, the tenth woman in the country to do so. She was also a decent angler, having learned to fly-fish from her father on trips to the Adirondacks. She had her own hunting retreat—about 1,800 acres along the St. Marys River in Kingsland, Georgia. On hot afternoons she would climb down a wooden ladder on the riverbank to take a swim. Sometimes there'd be a snake or two on the rungs of the ladder; barefoot, she would just kick them aside.

There was a lot of tomboy in Alicia, but she would turn meek in the company of her newspaper publisher father, a domineering force whom she described as having a "hypnotic influence" on her. "I would have died rather than fail him," she once said. Alicia was a surrogate son to a father who wanted a boy, but got three girls instead.

At age eighteen Alicia was kicked out of finishing school in Rome. (She and five other girls hired a car to cruise around the city in the middle of the night, stopping for cocktails on the Corso before returning at 3:00 A.M.) When she was twenty she took a typing course and went to work in New York at her father's newspaper. During the day she clipped out "filler items" from rival newspapers for the *Daily News* to use. At night she resumed her playgirl lifestyle, visiting speakeasies with a succession of young paramours. One romantic interest was Adlai Stevenson, member of another family newspaper dynasty. The city editor at the *Daily News* began assigning Alicia stories and she pursued them with vigor, until making a careless mistake. For a story about a divorce, she mixed up the names of those involved, triggering a libel suit. Her father invited her out to a restaurant for lunch and fired her before they got to dessert.

The setback didn't cause Alicia to abandon journalism. She married young and on her honeymoon in England wrote an article about fox hunting

for a magazine started by her father. Her first marriage didn't last, and she continued to write about hunting and learning to fly a plane. She flew everywhere with her second husband, Joe Brooks, himself a pilot. Alicia had plenty of shared interests with Joe, but a key failing of his, apparently, was his lack of respect for her brains and aptitudes. There was very little Betty Crocker in Alicia Patterson, something Joe did not understand, she thought.

Harry told Alicia he found a woman with wit, talent, and intelligence attractive. That deeply flattered her. Harry was sixteen years older than Alicia, but before long she embraced the notion that her disintegrating marriage might be eased by this new relationship. There were a few issues—Harry's controlling personality, for one, and his obsession with social protocol. But Alicia found such traits tempered by a charming humility and an edgy wit and, of course, Harry's enormous fortune. For all his riches, he was unpretentious and self-deprecating, she thought. Harry was a wealthy feudal lord, yes, but a man admired by fishermen.

Harry didn't contest the divorce initiated by Carol. Joe Brooks, on the other hand, took the breakup from Alicia hard, as did his hunting partner, Joe Patterson. Alicia's father viewed the divorce as a disaster and a personal repudiation of a relationship he himself had arranged. He was infuriated with Harry but could do little about it. With both marriages dissolved, Harry and Alicia were wed by a justice of the peace on July 1, 1939, in Jacksonville, Florida. Harry had a unique honeymoon in mind, involving the setting off of giant rockets in the desert.

II

The newlyweds flew west to the Mescalero Ranch in a new plane Harry had recently acquired. Along the way Alicia no doubt got an earful about Goddard. The professor's progress was inching along at a moment when time was of the essence. The war was spreading in Europe and Harry believed, via

reports from Lindbergh, that the Germans were investing heavily in rocketry, which they thought would someday be of strategic value. To counter this threat would require interest by the U.S. military in Goddard's work. To be taken seriously by the military establishment, Goddard's rockets needed to reach higher altitudes, and soon. Goddard was spending too much time on static tests, Harry thought, making little effort to farm out development work that could be done by others. Goddard understood Harry's fixation on hitting high altitudes, but the professor was more interested in perfecting the reliability of his rocket engines. Engine reliability was what ensured Lindbergh's success on his New York to Paris flight. A reliable engine—one that continues to run as the air grows colder and thinner in the higher atmosphere—will be one that can reach any altitude, said Goddard.

When Harry and Alicia landed at the Roswell airstrip the Goddards were there to greet them. The professor congratulated the couple on their nuptials, reminding his benefactor that he had only taken one plane flight in his life, with Harry at the controls. (Goddard later called the trip a hair-raising experience he would never repeat.) Harry and Alicia's honeymoon suite was a crumbling adobe cottage at Mescalero. On their first day at the ranch Goddard entertained his guests with a tour of the machine shop, a lunch of cold cuts, and sightseeing in town. In the evening Harry mixed the martinis and Esther served a roast leg of lamb. Later they assembled on the screened-in porch to watch Esther's films documenting her husband's rocket launches, narrated by Goddard. Then came some musical entertainment from the professor, sitting at his living room piano, banging out waltzes and operettas by Strauss. The next day, Goddard attempted a test launch. It failed.

Harry and Alicia hiked out to the nearby Rio Ruidoso river, camping and fly-fishing. They had plenty of time to talk about their future together. Alicia told Harry that, in spite of her early disaster in journalism, her father planned to bequeath her a position of some authority at the *Daily News*. Harry thought buying a paper for Alicia would give her the experience

she'd need to take on the future job. Plus, he thought, it was a project that would keep his wife busy. Alicia saw the wisdom of the idea. They agreed that Harry would underwrite the purchase if a newspaper could be found within driving distance of Falaise. Max Annenberg, circulation director at the *Daily News* and a friend of Alicia's father, was tasked to find one and soon did.

Back at the ranch, Harry sat down at the kitchen table, laying out Goddard's expense ledgers for the past year. It would soon be time to decide whether to renew funding. Alicia, outside smoking a cigarette, marveled at the satisfaction Harry seemed to take from analyzing the pile of financial logs spread before him. He thumbed through each page in deep focus, as if searching for some larger mathematical truths. Just then, she saw a car approach in the distance. When it arrived, out trotted a young man from the Western Union office in Roswell. He bore a telegram, which said: SUITABLE NEWSPAPER PROPERTY AVAILABLE. NEED RESPONSE SOONEST. MAX.

Alicia reacted with euphoria, then revulsion. This could be her own rocket liftoff, she thought. Or it could be a crash-and-burn disaster. She wanted to prove to her father she indeed had newspapering talent. Could she really launch a newspaper, hire and manage a staff of reporters, editors, typographers, and cartoonists, not to mention an advertising team and whatever size fleet of delivery trucks and delivery boys such a paper would require? Alicia expressed her doubts to Harry. The reality of the opportunity suddenly sunk in and it overwhelmed her. On second thought, she wanted out. Harry countered with a pep talk, urging her not to pass on this chance. The price was right, the paper was close to Falaise and the swelling exodus to Long Island by city dwellers suggested a growing market. Harry urged her to reconsider. Alicia thought it through, then changed course and agreed. Harry underwrote the purchase, minus a small participation fee Harry loaned to Alicia, which she contributed as her share in acquiring a newspaper that would later be named *Newsday*.

III

After Germany invaded Czechoslovakia in early 1939, the Lindberghs returned to America. They found a rental home in Lloyd Harbor, New York, just east of Falaise. Lindbergh arrived on the *Aquitania* (Anne and their two sons returned on a later ship) where over one hundred reporters awaited him on the docks, a sea of flashbulbs going off as he disembarked, raining shards of broken glass on the path to his waiting car. Two days later Lindbergh attended a secret meeting at West Point with Gen. Henry "Hap" Arnold, chief of the Army Air Corps. Arnold wanted to know every latest detail Lindbergh knew about Hitler's Luftwaffe, which Lindbergh gladly provided.

Like Harry and Lindbergh, Hap Arnold was a passionate believer in aviation. He was taught to fly by the Wright Brothers. Arnold believed that air power was the military force of the future. He was alarmed at the dilapidated state of the U.S. military's air defenses. As one estimate put it: "Ranked twentieth in size among the world's air forces and still under Army control, it had a few hundred combat planes, many of them obsolete, and fewer than nineteen thousand officers and enlisted men." Arnold planned to change this. He asked Lindbergh to visit U.S. aircraft manufacturers and research centers to assess their potential for mass production of planes. In the coming weeks Lindbergh did so, finding that while holding great potential, U.S. capabilities in air power were far behind the Germans.

Lindbergh returned to active military duty and joined the boards of aviation companies developing production of bombers and fighter aircraft. As Olson recounts: "For a cause like this, Lindbergh—as Arnold had hoped—was not averse to using his celebrity. He became the Air Corps' point man, involving himself in countless discussions with members of Congress, bureaucrats, diplomats, business executives, scientists, and engineers about what needed to be done—and spent—to make America No. 1 in air power."

As Lindbergh traveled across the country he was blitzed with speaking invitations. The experience reminded him of the weeks on the road and the dozens of speeches on aviation he had made during Harry's reliability tour. Lindbergh felt dead certain America should stay out of the European conflict, a sentiment many citizens agreed with. Some 50,000 Americans lost their lives in WWI. As Olson put it: "Britain, France and the rest of Western Europe had repeatedly demonstrated an inability to settle their own disputes. If those countries had refused to stop Hitler when they could have, why should we bail them out again?" Even General George Marshall, who became head of all U.S. forces in Europe, didn't favor U.S. entry into the war at the time. Neither did many other public figures, among them Ernest Hemingway, Herbert Hoover, and Frank Lloyd Wright. In fact, Wright congratulated Lindbergh's blunt embrace of neutrality, quipping: "We all knew you could fly straight. Now we know you can think straight."

Public solidarity with Lindbergh's views on the European war emboldened him to speak out. Hap Arnold did not object—he felt Lindbergh was perfectly free to express his noninterventionist views on radio addresses and public appearances. Besides the building audiences for his public addresses, he wrote articles for *Reader's Digest*, the *Atlantic Monthly*, and others advocating neutrality. A strong German state was necessary to check the influence of communist Russia, he contended. The greatest threat to Western civilization, wrote Lindbergh, was Communism. "Germany alone can either dam the Asiatic hordes or form the spearhead of their penetration into Europe." The European war was not America's fight.

The overwhelming public support for Lindbergh's passionate embrace of neutrality worried the Roosevelt administration. After learning of what would perhaps be Lindbergh's most widely heard address yet, carried across multiple radio networks and reaching millions of Americans, a clandestine offer came from Roosevelt via Truman Smith. If Lindbergh agreed to ease up on his isolationist pronouncements he would be offered a newly created post in the cabinet: Secretary of Air. Lindbergh valued the creation of

such a position but had no interest in holding it. The last thing he wanted was a government job.

When Congress introduced Lend-Lease legislation, allowing the United States to provide war materiel to any ally if deemed to be in the nation's interests, congressional hearings took up the matter. Lindbergh was invited to speak before a House committee. He made the case for neutrality forcefully and deftly deflected questions about his patriotism. Newspapers ran stories exploring the potential of a Lindbergh candidacy for president. Lindbergh received the ultimate compliment from U.S. Senator William Borah, the Idaho Republican who had pushed through Harry's appointment as Cuban ambassador. Borah suggested Lindbergh run for president, to which Lindbergh replied, "I prefer intellectual and personal freedom to the honors and accomplishments of political office—even that of president." (Years later novelist Philip Roth, a Guggenheim fellow, imagined a Lindbergh presidency in his classic novel *The Plot Against America*.)

Harry, an anglophile who considered Britain the cultural guardian of Western civilization, listened to his old friend Slim's speeches with apprehension. He deeply disagreed with Lindbergh's neutrality views but believed they grew out of a belief they did share: that Communism was the most dangerous threat to democracy. Still, their once voluminous correspondence slowed to a trickle. Harry was now receiving some very different kinds of mail: heart-wrenching letters from desperate Jewish families trying to flee Europe. Jews with last names like Guggenheimer or Guggenstern claimed to be distant relatives, enclosing photos of their children and appealing for help for passage to America. Harry discussed the matter with Florence. With Harry's encouragement, Florence loaned Hempstead House to the Committee for the Care of European Children, some of them Jewish boys and girls who had made it to Britain. About one hundred children, ranging from one to ten years old, came to live at Hempstead House (a nursery and playground was added to the property) while they awaited placements in

foster homes. Considering the scale of the human catastrophe underway, it wasn't much, but it was something.

The few notes Harry and Lindbergh exchanged over this period center around Goddard's work. In May of 1940 Harry arranged a meeting with Goddard and officials of the Navy Bureau of Aeronautics, Army Ordnance, and Army Air Corps. Harry and Goddard offered Goddard's research data and use of patents to develop military preparedness. All three agencies took a pass on Goddard's offer except the Air Corps, who expressed interest in the use of rockets in jet-assisted takeoffs of aircraft.

Harry and Slim continued to correspond on the crime committee, which was winding down, in part due to Harry's trouble in raising funds for it just before the war. Both continued to share their disdain for President Roosevelt, whom they blamed for the sad state of U.S. military aviation.

<div align="center">IV</div>

In the prior two presidential elections Harry had supported Roosevelt's rivals (Herbert Hoover, Alf Landon). This third time around, the election of 1940, Harry and Lindbergh both backed Wendell Willkie, Roosevelt's opponent, a former Democrat who just prior to the convention switched parties to become the Republican nominee. In the first of many schisms to come between Harry and Alicia, *Newsday* endorsed two candidates for president that year. Alicia, a Democrat, backed Roosevelt, and Harry, as publisher, backed Willkie.

In August the Republican National Committee announced Harry would chair the "Wings for Willkie" aviation committee. Harry worked for the RNC organizing aviation clubs and lobbied airplane brokers around the country to campaign for Willkie, who, like Roosevelt, wanted to add a cabinet position representing military aviation. Harry wrote an opinion piece appearing in newspapers nationwide, noting that Italy's air power had crushed Ethiopia

and Hitler's Luftwaffe had conquered Poland. Yet in 1940 America had but 500 planes ready for combat. Harry contended that the air forces of Hitler and Mussolini combined numbered about 20,000. "The plain truth is we will be fortunate if, by January 1, 1942, we have a total of a few thousand planes suitable for first-line fighting." When the Roosevelt administration announced a plan to train student pilots for air service, amounting to a thirty-five-hour course, Harry ridiculed the idea. "Should ever the time come when this nation is forced to defend itself in the air, it would amount to mass suicide to send thirty-five-hour pilots up to combat the experienced aviators which would be sent against them."

On election day Roosevelt vanquished Willkie, winning his third presidential race, though by a much lower margin. That year Nazi Germany, having invaded France, Belgium, Luxembourg, and the Netherlands, and already at war with Britain, declared a naval blockade around the British Isles and unleashed a vicious bombing campaign of central London, killing or injuring thousands of people and damaging or destroying hundreds of thousands of buildings. Calls for the United States to enter the war mounted in Congress, but a sizeable slice of public opinion continued to favor neutrality. Lindbergh felt it was more important than ever to make his case for staying out of the war. Britain didn't have a chance, he said. People listened and agreed. His radio addresses now drew more mail than radio addresses made by FDR.

That summer a peacetime draft was imposed, setting off anti-war demonstrations on college campuses. College students held anti-war rallies and formed campus organizations to fight the draft. Just before the election, one group at Yale, started by law school students, invited Lindbergh to speak at their rally. They called themselves the Committee to Defend America by Aiding the Allies, later known as America First.

America First organizers believed in staying out of the war in Europe, and that giving aid to any side weakened the national defense. The organization grew quickly, attracting a cross-section of Democrats and Republicans

and a strong following from American business interests. Among its early members: Gerald Ford, Potter Stewart, Kathleen Norris, Eddie Rickenbacker, John F. Kennedy, and prominent Jewish figures like Sears, Roebuck and Co. heir Lessing Rosenwald. In America First, Lindbergh found his political doppelgänger—and America First found that the most famous man in the world was championing their cause. In the coming year Lindbergh spoke to thirteen America First rallies, packing Madison Square Garden and the Hollywood Bowl, delivering addresses later recounted on the front pages of newspapers everywhere. The organization soon grew to 800,000 members.

The rallies angered Roosevelt. The president called Lindbergh a "copperhead," a reference to Yankees who were sympathetic to the Confederacy during the Civil War. Secretary of the Interior Harold Ickes went further. At a Bastille Day meeting Ickes observed: "No one has ever heard Lindbergh utter a word of horror at, or even aversion to, the bloody career that the Nazis are following, nor a word of pity for the innocent men, women and children who have been deliberately murdered by the Nazis in practically every country in Europe. . . . I have never heard this Knight of the German Eagle denounce Hitler or Nazism or Mussolini or Fascism."

Lindbergh countered with a ratcheting up of his own rhetoric. For several months he planned what he knew would be a bombshell speech that would draw a bull's-eye on the forces he blamed for leading America toward war. The venue would be an America First rally in Des Moines, Iowa, in September 1941. As Anne Lindbergh surmised as soon as she read a draft of his remarks, the reaction would be incendiary.

Addressing a packed meeting hall of 7,500 attendees, Lindbergh said: "The three most important groups who have been pressing this country toward war, are the British, the Jewish and the Roosevelt administration . . . I can understand why the Jewish people wish to overthrow the Nazis. The persecution they have suffered in Germany would be sufficient to make bitter enemies of any race. No person with a sense of the dignity of mankind condones the persecution of the Jewish race in Germany. Certainly I and my friends do

not. But, though I sympathize with the Jews, let me add a word of warning. No person of honesty and vision can look on their prowar policy here today without seeing the dangers involved in such a policy, both for us and for them. Instead of agitating for war, the Jewish groups in this country should be opposing it in every possible way, for they will be among the first to feel its consequences . . . Their greatest danger to this country lies in their large ownership and influence in our motion pictures, our press, our radio, and our government."

Of course, Jews in Europe were already feeling the consequences of political leaders who appeased Hitler. Asserting that Jews controlled the media was one of the first Nazi arguments made to justify Jewish persecution. In fact, less than 3 percent of U.S. newspapers were held by Jewish owners at the time.

If the German Eagle was an albatross, the Des Moines speech was a lead weight. Reaction was swift. A group of 700 Protestant leaders—bishops, deans, presidents of theological colleges—signed a statement denouncing the speech. "Catholic and Protestant alike will tremble to read these words of the Lindbergh they have loved," wrote the clergy members, who termed the remarks anti-Semitic propaganda. "This Lindbergh speech is the beginning of the last phase of a definite plan to destroy democratic government in this country. It marks a dire threat to our way of life, our humanness, our very existence as an independent free people."

A less elegant response came in a Western Union telegram from Cornelius Vanderbilt Jr.: WHAT AN UNPATRIOTIC DUMB BELL YOU ARE. Libraries removed *We* from their shelves. Streets named after Lindbergh were renamed. When Lindbergh appeared on newsreels in movie theaters he was booed.

Harry was distressed over Lindbergh's stridency but did not comment publicly on the speech. He believed Lindbergh was being influenced by some of the new, extreme elements that had joined America First, some of them anti-Semites and Anglo-haters. Yet as the unending German aerial raids on Britain continued, Gallup polls showed overwhelming public belief

that the war was not winnable. This too, angered Harry. There were nightly German air attacks on London. Among those taking shelter underground was Alicia's niece, Madeleine Korbel, the future Madeleine Albright, U.S. secretary of state. The Luftwaffe was also attacking outlying cities, including Cambridge. They dropped firebombs on homes just south of Pembroke's Trumpington Street. Civilian targets near the Cambridge train station were hit with oil bombs then strafed by machine guns from German planes, killing dozens of civilians.

Lindbergh continued his neutrality tour around the country. Guggenheim friends and family, like Henry Breckinridge and Anne Morrow's mother, expressed their disgust with Lindbergh in private. Rumblings from members of the Guggenheim family were getting back to Harry. How could he still consider Charles Lindbergh a friend? In public, Harry maintained a Delphic silence over the national uproar. In private, he would argue that Slim was not an anti-Semite, that he was criticizing a subset of Jews who were agitating for war, not Jews as a whole. The argument seemed unconvincing to those around Harry, some of whom floated theories about his rationalizing. Was his defense of Lindbergh somehow linked to his own ambivalence about his Jewish identity? Neither Harry's second wife, Carol, nor his third, Alicia, was Jewish. No Shabbat candles or menorahs were ever seen at Falaise. The question of Harry's relationship to his faith—that is, whether he had one—had been raised before by the Jewish press. After Harry's nomination to be Cuban ambassador, a column in *The Modern View*, a Jewish weekly, wondered how Jewish Harry really was: "Does Lindbergh know that Guggenheim is a Jew? Does Hoover?" It concluded, "Guggenheim has not been interested in Jewish affairs, and can hardly be recognized as such. In other words, the first Jew to be appointed as ambassador since the war is not much of a Jew."

And yet: Harry delivered harsh speeches attacking anti-Semitism prior to the war and raised enormous sums to help Jewish refugees from Europe. Harry was a member of Temple Emanu-El and gave generously to Jewish charities. Regardless of Harry's true feelings about Lindbergh, or Lindbergh's

true feelings about Jews, these questions became moot on December 7, 1941. After the Japanese attacked Pearl Harbor and Roosevelt declared war on Japan and Germany, Lindbergh went silent and America First was disbanded. The debate was over.

V

At the beginning of the war the nation's supply chain for military aviation was in bad shape. There were shortages of propellers, engines, radio equipment, instruments, and landing gear. Pearl Harbor caused a rethinking of this, giving Harry's crusade on behalf of military air power a new lift. He spoke at government hearings and at academic conferences, asserting that American air power had been "shackled" by such neglect. "We gave birth to the airplane; our commercial aviation is greater than that of the rest of the world combined; we are a country of mechanics; we can build the greatest air power in the world in a few years' time, if airmen are cut loose from traditional military curbs." By "curbs" Harry meant the relegation of air power as a secondary force, a kind of military stepchild split between the Army and Navy, a mere auxiliary to ground forces. Britain had its Royal Air Force, Germany the Luftwaffe. It was time for the United States to create a third service branch—a U.S. Air Force.

In fact there was already plenty of acceptance of the idea in many parts of Washington. Hap Arnold and mid-ranking officers in the army shared Harry's sentiment. But many felt such a realignment should be done strategically, in peacetime. Either way, air power was about to face its first test of the war: secret plans were in the works for a bold retaliatory air strike against Japan for Pearl Harbor. The man chosen to lead the mission was Jimmy Doolittle, the flying ace Harry recruited to pilot the first instrument-only flight for the Guggenheim Fund. In the spring of 1942 Doolittle, then a lieutenant colonel, took off from an aircraft carrier in the Pacific, guiding sixteen bombers (each with a five-man crew) on an air raid over Tokyo,

raining destruction down upon Japanese steel mills and military bases. The "Doolittle Raid" was a success, boosting morale in the United States and demonstrating that the Japanese mainland could be hit by U.S. forces at sea. The raid also caused the Japanese Imperial Navy to speed up its military objectives in the Pacific (igniting the Battle of Midway, where Japan lost half of its aircraft carriers). When Doolittle returned to Washington he and Josephine were whisked to the Oval Office. A beaming Roosevelt, accompanied by Hap Arnold and Gen. George Marshall, congratulated him. Doolittle received the Medal of Honor and was promoted to brigadier general.

Harry sent congratulations to his former test pilot, not only on the raid but for the credibility it brought military aviation (much like the boost Lindbergh's tour gave to commercial aviation). Harry was now fifty one, but conveyed his intention to reenlist to those he knew among Navy brass, and lobbied for a senior-level assignment. His commission was renewed, and Lt. Commander Guggenheim began a nine-month officer's training. During this first assignment he learned much about military administration and leadership, enough to prepare him for a substantial posting: command of the Naval Air Station at Mercer County Airport near Trenton, New Jersey.

Mercer Field was a 525-acre aviation depot, the terminus for new bombers arriving off the assembly line for final equipment checks and test flights. Most would be based on aircraft carriers in the Pacific. The compound housed three barracks, a mess hall, officers' quarters, a dispensary and firehouse, two of the largest plane hangars in the country, and three concrete landing strips. At opening ceremonies in July of 1943 Vice Admiral John S. McCain (father of the late U.S. senator) came to Mercer Field to wish Harry and his military staff well, reminding them, "There are pilots and crews—and a place on a carrier—for every plane you can turn out."

Harry congratulated navy personnel on their new assignment at Mercer Field, addressing them over a loudspeaker: "We are the last link in the supply chain of aircraft for pilots," he said. "Failure of that last link could cost lives of American pilots and crews—or lose battles, or even a war."

Mercer Field was part of a big bet the navy was making on its latest torpedo bomber: the TBM Avenger. Harry had to quickly gain working knowledge of every mechanical, structural, and engineering aspect of the Avenger. It was built to sink surface vessels and submarines, but could do far more damage. At the bottom of its boxy fuselage were two giant bomb bay doors. Avengers could drop torpedoes, lay mines, scatter depth charges, or unleash 2,000-pound bombs. Each plane had hydraulic-powered folding wings and a crew of three: pilot, bombardier, and turret gunner. Its canopy resembled a cylindrical greenhouse with a bubble of glass in the rear for the turret gunner, whose Browning .50-caliber machine gun faced backward to defend against enemy pursuers. A pane of bulletproof glass in the bubble offered partial protection to the gunner.

The business culture of the boardroom, which Harry knew so well, requires negotiation and compromise. Military command structure requires unquestioning execution of orders. Despite this culture clash Harry seemed to thrive at Mercer Field. When directives came down to modify the Avengers' instrument navigation and engineering systems, Harry ironed out changes with assembly-line managers at the nearby GM Avenger plant and modified testing protocols. As he had done in WWI, Harry worked up risk assessments for his planes: How many hours could their Curtiss-Wright engines run before one failed? If the hydraulic-powered wings froze, how could the source of the jam be identified and fixed? Avenger crews were outfitted with Switlik parachutes, manufactured locally in Trenton. Volunteers leaped off a jump tower to test them (an idea suggested years earlier to the parachute maker by Amelia Earhart). Among the planes passing through Harry's flight checks at Mercer Field was the Avenger flown by then twenty-year-old George H. W. Bush. The future U.S. president was shot down in his Avenger and rescued after a bombing mission. Years later, Bush wrote a book about the flight and sent a copy to Richard Switlik, founder of the parachute company, inscribed: "With thanks for my life."

Harry had subscriptions to his favorite publications come to Mercer Field—*Thoroughbred Record, The Blood-Horse,* and the *Federal Reserve Bulletin.* (The latter tracked Depression-era indicators in American business—department store inventories, commercial loan rates, bond yields, movements of gold.) One of the perks of being base commander was off-site sorties. He made trips to Falaise, some ninety minutes away by car, to see Alicia, who gave her husband the latest headlines on the rollout of *Newsday.* There was frequent correspondence to answer from Goddard and Lindbergh, and constant stacks of expense requests for his thoroughbred racing stables. Harry's posting at Mercer Field lasted nearly two years. During a review of his command he asked for his next assignment to be in the Pacific Theater, where he could see his torpedo bombers in action.

Soon he was on his way as an observer aboard the USS *Nehenta Bay,* an escort carrier (also known as a baby flat-top). When Harry arrived the battle for Okinawa had been raging for weeks. The *Nehenta Bay* and its carrier group were 375 miles to the south, off the Sakashima Islands, which kamikaze pilots were using as bases to defend Okinawa. Kamikazes were difficult to defend against, typically coming in at 45° dives from 10,000 feet, visible for just moments before hitting their targets. To stop this threat, Avengers from the *Nehenta Bay* and its sister ships were tasked to destroy kamikaze airfields and their support structures on the Sakashimas.

Baby flat-tops like the *Nehenta Bay* were smaller than a full-size carrier; the ship held perhaps one-quarter the number of crew members of a standard-size aircraft carrier. Because the flight deck was so short, Avengers required a catapult takeoff and a tailhook landing. Occasionally an Avenger would return damaged by Japanese pursuit fighters, the turret compartment shot up so badly that the body of the gunner was unrecognizable. Upon landing, crews would run to the back of the plane, throw a tarp over the remains, and remove them. As the man who had been in charge of quality control for these Avengers, Harry was well aware that their bulletproof glass offered protection in name only.

Even so, Harry expressed his strong desire to serve in a future mission as a tail gunner, convincing a duty commander to let him do so. All five of the key airfields in the Sakashimas had already been hit; this was a presumably low-risk assignment. Yet on the day of Harry's first mission, two kamikaze planes successfully targeted nearby sister ships in the *Nehenta Bay*'s carrier group, causing serious damage. Before Harry and his fellow crewmen took off, they would have sat down in the ship's briefing room, their mission explained by an intelligence officer. The flight plan and targets were drawn up on a chalkboard, along with the return route (following the correct path back was crucial to avoiding the embarrassment of returning to the wrong carrier, as some pilots did). Weather conditions were discussed and a tail number for their designated plane was issued. From there they headed topside to the flight deck. Harry climbed into his Avenger's cramped tail gunner compartment, knees nearly up to his chest. To his left was the machine gun, swiveling easily with the help of power steering, its barrel poking through a slot in the glass dome. With his flight suit on and the metal of the heavy plane absorbing the blistering June sun, it would be a hot ride.

Flying in close formation, Harry's Avenger and its sister planes climbed to a safe altitude and headed to the target area. Once over the islands the plane descended at an angle, approaching the sweep zone. As the land-based targets came into range, possibly radar installations and ammunition dumps, Harry fired away. During multiple runs Harry's crew reported no enemy aircraft or antiaircraft fire. Harry's plane returned safely to the *Nehenta Bay*. He made several such missions, receiving a commendation letter for his first. As believers in military aviation had predicted, U.S. air power, from Normandy to the Sea of Japan, had been decisive. Two years after signing the peace accords in Tokyo Bay, the U.S. military finally acknowledged what the backers of military aviation had been lobbying for all along: establishment of the U.S. Air Force.

CHAPTER THIRTEEN

Horsepower

I

During the war years, while Harry was at Mercer Field, Alicia made Falaise a *Newsday* satellite office. Low on writers, she talked friends into writing stories for the paper. Her fledgling staff would come to Falaise and enjoy the best business lunches of their lives. Men were in short supply, having headed off to war, so Alicia brought a wave of talented women to work at *Newsday*. Far from the failure Alicia feared her newspaper would be, *Newsday*'s circulation was surging. This was the job she told Harry she wanted to back out of because she believed she had no talent to do it. Harry refused to let her change her mind. Alicia poured her heart and soul into the tabloid, traveling to see big-name advertisers, assigning stories, hiring new staff, and it was working. Of course, another reason it was working was that Harry, its majority owner, poured some $750,000 into the paper before *Newsday* become profitable.

When she needed a break, Alicia went off to visit Neysa and Jack at their home down the road, where some guests became Neysa's lovers. Jack took a slightly different approach in their open marriage. He obtained permission

from Neysa, while she was away in the early summer, for an annual tradition he called Freedom Week. Jack invited actresses, models, and call girls out to their home for several days of swimming and croquet. In the evenings, drinking games involved young women, and men, losing their clothes. Famed Broadway director and semipermanent houseguest George Abbott attended Freedom Week but always claimed it was just fun and games (as if everyone played croquet with prostitutes on the weekend). Abbott marveled at the unique marital union that made all this possible. "Perhaps the unconventional marriage of Jack and Neysa will be a model for the marriage of the future," said Abbott, without a touch of irony.

Harry apparently skipped Freedom Week, but during the war Harry and Alicia's relationship took on some of the fluidity of Jack and Neysa's marriage. At one point Alicia rekindled her youthful love affair with Adlai Stevenson. They saw each other often, at political events and at Kingsland. They corresponded continuously. Whatever dalliances Harry had at the time, he kept them well under the radar, though he appears to have had an affair with his female driver at Mercer Field, apparently a very good dancer.

Harry was fond of George Abbott, the erudite, courtly Broadway director who spent fifteen summers with Neysa and Jack on Sands Point. As writer, producer or director of shows like *Damn Yankees* and *A Tree Grows in Brooklyn*, Abbott was possibly connected to more successful productions than anyone in theater history. His string of hits included, at one point, four shows running simultaneously on Broadway. Alicia was fond of George Abbott, too. During the war Abbott and Alicia often traveled together to Kingsland, a smaller, simpler spread than Cain Hoy. Alicia's main lodge was a one-story building made of cypress. At Kingsland Alicia would swim across the river wearing her wide straw hat, keeping her head above water until reaching a sand bar, where she stretched out in the sun. Abbott would be inside, working on plays. Abbott and Alicia spent hours talking to each other, like a married couple.

II

For Alicia, *Newsday* was a dream come true; it consumed most of her waking hours. Harry's uncle Solomon had a dream, too: a permanent museum for the modern art collection he had amassed over the past twenty years. It was the focus of conversation when Harry and Alicia visited Solomon at Big Survey, or lunched with him at Trillora Court (Sol's Gold Coast home), or came for drinks at Solomon and Irene's massive suite at the Plaza. Occasionally Harry would see Solomon at 120 Broadway, where Harry settled back into his father's old office on the 35th floor after the war. The chairs around the boardroom's mahogany table sat empty. Meyer's gilded portrait was still there, a reminder of what was possible for immigrants in America (with a little luck from a Colorado silver mine). Harry's mother, Florence, had died in 1944 at the age of eighty-one. A short time before her death she and Harry finalized the donation of Hempstead House to the Institute for Aeronautical Sciences to create a research center in Daniel's memory. Another major loss, this one at the end of the war, was Robert Goddard, who died in 1945 at the age of sixty-two. Upon his return Harry developed a plan to memorialize Goddard's research (preserving, too, the long track record of Guggenheim support for his work). Esther Goddard and Edward Pendray agreed to document Goddard's experiments in a multivolume opus.

Solomon, the last surviving Guggenheim brother, remained chairman of the family business. In his late eighties, he still looked dapper and fit. One day he paid a visit to Harry at 120 Broadway, with much to talk about. Nephew and uncle sat down to make plans for the future of the family firm and the future of Sol's Museum of Non-Objective Painting, as it was then known. Frank Lloyd Wright had been selected as the architect, but things were moving slowly. At this rate, Sol was unsure whether he would ever live to see the first day of his museum's construction, much less its opening.

This was the late 1940s—patriarchal bias still guided conversations over family succession. Sol had three daughters and few nephews to choose from.

Only one nephew, in Sol's eyes, was up to the job. Over the years Harry had impressed Solomon—the showdown at the Partners table over Chuqui; the relentless work he did for the aviation fund; his loyalty to Robert Goddard; the admirable care he took in protecting the family brand; his knack for making money in horse racing and publishing; his ability to stay alive in Cuba in the midst of a revolution.

Agreements were struck: When the last Guggenheim brother died, Harry would reorganize the family firm with trusted outsiders and family members. When Solomon was gone, permission would be granted for the newly organized firm to use the name Guggenheim. Harry would join the museum's board of trustees. The museum would be a groundbreaking and controversial work of architecture in Manhattan, ushering in a new experience of art in the future, Solomon would say. Harry didn't fully comprehend Sol's meaning but sensed that the museum would be a defining feature of the family's identity in the future. Harry perhaps imagined his responsibilities would not arrive for some time. But soon they did—Sol died in the fall of 1949 at age eighty-eight.

Two years after Sol's death Harry reorganized Guggenheim Brothers—among the new directors were Albert E. Thiele (company veteran and director of Kennecott Copper) and Albert C. Van de Maele (daughter Joan's husband). Betting on technology had been the calling card of Guggenheim Brothers—Harry would attempt to revitalize the firm with an eye toward new refining methods in oil and nitrates. As he geared up to assess the most immediate steps needed to advance the museum—poring over the copious correspondence between Sol and Hilla Rebay, the museum's director—he remained involved in Republican politics.

Dwight Eisenhower was exactly the kind of centrist Republican Harry admired. In the 1952 campaign, Harry endorsed Ike on the pages of *Newsday* and the two began a correspondence. Harry was a frequent visitor to White House "stag parties" and to lunch conferences with Eisenhower and Secretary of State John Foster Dulles. One idea Harry pitched to

Eisenhower was a kind of envoy to Latin America, signaling to the region of some twenty countries that the United States takes their collective interests seriously. If created, Harry might be persuaded to take the job. Ike liked the idea. Dulles opposed it, believing the State Department would never agree to such a power shift. Instead, in August 1953 Eisenhower pitched Harry to take the position of assistant secretary of state for inter-American affairs. Harry was flattered but turned down the offer.

Besides relaunching Guggenheim Brothers, running the business side of *Newsday* and studying plans for Sol's museum, Harry spent time on another passion: thoroughbred horses. He would fly or take the train at every opportunity to watch his colts train in Florida, South Carolina, or Kentucky. When three of his horses, Nebraska City, War Dog, and Vamoose, began winning purses, he invested more time in his hobby. Horses were a family tradition—riding, showing, and breeding them had been a pastime enjoyed by many Guggenheims, starting with Meyer and his trotters. Harry initially raced his horses under the banner of Falaise Stables (soon changed to Cain Hoy Stable, possibly to avoid confusion with his brother Robert's Firenze Stables). Before going to auctions he studied the bloodlines of the thoroughbreds for sale. He was fascinated by their ancient histories, going as far back as the early 1700s. Around that time English nobles returned from the Middle East with three Arab stallions. They sought to fuse the power of English warhorses with the speed of the Arabian breeds. Since then, every thoroughbred traces its lineage to these three horses.

Harry's focus on the thoroughbred business came at the dawn of a golden age of horse racing. The sport had suffered shrinking attendance during the Depression years and World War II. After the war it captured the public imagination when horse races, for the first time, were televised. Viewership boosted racetrack attendance. Each week 700,000 Americans visited the nation's 130 racetracks. By 1952 more people were watching horse racing than baseball.

Harry built up his stable to about a dozen horses in training and a handful of brood mares. He stabled them in Kentucky, in Florida, at Cain Hoy, and at Falaise. He struck up a friendship with bloodstock agent Humphrey Finney, who procured colts and fillies at auction for Harry and taught him how to find stallions worthy of breeding. Time at the stables had a restorative effect on Harry; he seemed to feel at home roaming around the paddocks and tack rooms, the training tracks and the horse barns.

Harry recruited the best trainers and stable hands he could find. Most of his competitors ran far bigger breeding operations. The Whitneys, Mellons, and Vanderbilts spent lavishly on their horse farms, as did lifelong turfmen with massive spreads like Robert Kleberg's King Ranch in Texas. None of them could match the winning record of the already legendary Calumet Farm in Kentucky, owned by Warren Wright (heir to the Calumet Baking Powder empire). Calumet dominated racing in the 1940s and '50s, having won the Triple Crown twice with Citation, a bay colt ridden by master reinsman Eddie Arcaro. In 1948 Citation won nineteen out of twenty races (fifteen of them in a row).

Compared to Calumet Farm and King Ranch, Harry's Cain Hoy Stable was at best a boutique underdog. To compete with bigger operators Harry would have to punch above his weight. How? For one thing, as fascinated as he was with bloodlines, he apparently felt many owners over-relied on them as predictors of champions. Harry focused on a handful of alternative metrics to identify and cultivate promising horses. He tracked pregnancy rates among his mares, analyzing the size and weight of foals to judge their mothers' fertility. He obsessively documented the gait of his horses, allowing early correction of movements like "rotary gallop" (a kind of cross-canter). Harry insisted his horses always run in dry conditions, not mud, to keep assessments of their progress consistent. In the early morning one could find Harry at the training track with his clocker, listening intently to the horse's breathing as it flew by at full gallop. Was it light or labored? This was one way to gauge how efficiently the horse's lungs infused oxygen

into its bloodstream. The more oxygenated blood routed to a horse's legs the greater its speed and staying power.

On the path from prospect to contender, there are many factors outside a trainer's or owner's control. Jockeys can have a bad day. Or they may not be the best match for a horse at all. Road trips can affect a colt or filly before a race (some didn't travel well by rail car). The prior day's weather always affects turf—a rain-saturated track is like galloping through chewing gum, as one trainer put it. These X factors made Harry skeptical of conventional wisdom. As he said, "There are so many variables and imponderables in the racing and breeding of thoroughbred horses that any owner, breeder, trainer, or jockey can make a strong argument to prove almost any case he wants to make."

It came as a pleasant surprise one day when Harry arrived at the training track in Kentucky and learned that a colt that had been foaled at Cain Hoy was posting some exceptional times. As the months went by Harry asked his trainer, Moody Holley, to work with the horse, Battle Morn, with an eye toward the season's coming championship races. Working with Holley, Battle Morn began finishing in the money immediately. The horse went on to win the Grand Union Hotel Stakes in Saratoga, then the famed Hialeah Park Stakes in Florida, setting up Battle Morn as a qualifier for the 1951 Kentucky Derby. Racing reporters took notice, but questioned Battle Morn's tendency to drift from competitors, sometimes finishing near the track's outside railing. The colt didn't like running between other horses and galloped wide at turns. Yet still he managed to win.

Part of the Kentucky Derby's mystique was its respect for tradition. The race had been held every year, around the same time and same place, since 1875 (just a few years before Meyer struck it rich in Colorado). Harry was heading to the Derby with a horse now judged to be the favorite. But Battle Morn didn't have a rider yet. Eddie Arcaro, then the best jockey in the business and a free agent, might be available. He had won the Kentucky Derby four times and the Triple Crown twice. He also had a bad boy reputation

as a drinker and a womanizer, and a killer instinct, literally. He was temporarily banned from racing a decade earlier after a bumping match concluded with Arcaro literally knocking the competing jockey off his horse at full speed. Arcaro later admitted that, yes, he was trying to kill him.

Arcaro's antics didn't overshadow his immense talent. He was in such demand that he could choose to ride almost any horse at the Derby in 1951. Harry repeatedly approached Arcaro, knowing a great jockey could improve a horse's finish by one or two lengths. Harry made Arcaro a series of lucrative offers, Arcaro remained noncommittal. A week before the race, Harry's lobbying finally paid off. Arcaro would ride Battle Morn. Harry was thrilled, but also knew it was a crowded field: A total of twenty horses had qualified for the 1951 race. That said, Harry also knew he had the best jockey in the business, and the horse that was favored to win.

Or so he thought. At the beginning of the two-minute race, Battle Morn got a bad start out of the gate. Harry, watching in horror though his binoculars, saw Battle Morn float wide of the pack, trying, but failing, to make up for the drift. He finished sixth, out of the money. A bitter result, but the experience taught Harry another truth about racing, reminiscent of the mining world. Even with a good trainer, the best horse, and the right jockey, it's tough to win without a little luck.

III

Harry took the loss not as a blow, but an affirmation. He went back to work and hired a new trainer. He had his eye on a brown colt he had purchased for $6,500 at auction from a Kentucky breeder. Harry named the horse Dark Star. This colt, too, stood out from the rest by bolting like a bullet at the start of a training run, sustaining an unrelenting pace. Dark Star's breathing was perfect. He didn't stray from other horses; he ran as if they weren't there. As a two-year-old, the horse competed in six races,

winning three, including Hialeah and Belmont Park. The following year, as a three-year-old, Dark Star did even better at Gulfstream Park and Keeneland, qualifying for the year's championship races.

Two years after his defeat, Harry was on a return trip to the Kentucky Derby. This second time around he felt more at ease, perhaps more confident. Harry debated strategy for the race with his new trainer, Eddie Hayward, and his new jockey, twenty-four-year-old Henry Moreno, son of a Chicago barber. Harry's first Derby loss had led him to be a better student of strategy. There were several approaches, including *speed* (burst to the front, hold the lead); *stalking* (hold back on speed, then move to the front in the backstretch); or *closing* (hold a strong position in the backstretch, then unleash the horse in the homestretch). Harry and Hayward settled on a plan: the jockey would open up Dark Star just enough to clinch the third place slot, hold the position, then punch the colt into full speed at the stretch. Harry and Hayward trusted their jockey. Moreno was given discretion to change up strategy if the moment called for it.

That year the Derby would be watched by some twenty million Americans on CBS and another 100,000 in attendance. Nearly three-quarters of all American television sets in use at the time would be tuned to the Derby. Jockey Eddie Arcaro was back, this time riding Correspondent. Coming into the 1953 race, Arcaro had just won the Derby again in the prior year, making a total of five Derby victories. Neither Harry's jockey nor his trainer had ever won the Derby. Yet Arcaro and Correspondent weren't what worried Harry. A far more dangerous threat was that year's overwhelming favorite to win, the first equine star of the television age: Alfred Vanderbilt's Native Dancer.

The horse possessed a quality of invincibility. Native Dancer won most of his races in a nail-biting, come-from-behind finish. Children organized Native Dancer fan clubs; adults sent the colt postcards and letters. Racing analysts called Native Dancer a "wonder horse" and "horse of the decade, perhaps of all time." What also set Native Dancer apart was its gray coat, a rare color among thoroughbreds, earning it the nickname Gray Ghost.

Entering the 1953 Derby, Native Dancer was undefeated, having won eleven races in a row. Bettors knew this and gave Harry's colt no encouragement: Dark Star's chances at winning were set at 25–1. The Associated Press polled fifty newspaper reporters on the race. Only one in fifty believed Dark Star would finish first.

On race day, the morning was cool, then turned brilliantly hot in the afternoon, "the blue sky dotted with clouds resembling cotton candy." Beneath the famous twin spires of Churchill Downs, thousands of spectators pushed through the spinning turnstiles, making beelines for the betting counters. On the far side of the track were the Derby barns, where crowds swarmed around the stalls of Native Dancer and Correspondent, the two favorites. Harry's colt looked on impassively at the stream of visitors to the other horses.

The Derby wasn't just a race, it was a grand social stage. It drew a who's who trifecta from business, politics, and entertainment. In the lead-up to race day in 1953, Judy Garland and Bob Hope came to Louisville to perform. In the boxes, not far from Harry's and Alicia's seats, was U.S. vice president Alben Barkley (Truman's running mate in 1948); J. Edgar Hoover, director of the FBI; Sen. Joseph McCarthy, then at the height of his anti-Communist crusade; a handful of governors; and a newly elected senator who would become minority leader that year, Lyndon Baines Johnson. Baseball Commissioner A. B. "Happy" Chandler was there, so was actor James Coburn, a horse owner, sitting high up in the boxes wearing a monocle and sipping a mint julep. Flaunting wealth was part of Derby tradition. No one did that better than "Diamond Jim" Moran, a New Orleans restaurateur, who walked around signing autographs, bespectacled in $40,000 diamond-rimmed glasses; a clip-on tooth bridge fastened with 9½ carats of diamonds; a stickpin in his lapel with 5½ carats of diamonds; and even lines of diamonds running down each side of his pants zipper. Around his neck was a pair of gold-plated binoculars.

Harry and Alicia enjoyed the glitzy excess. They mingled with their fellow blue blood socialites at the Downs' elegant clubhouse and the mirrored Matt

Winn Room, named for the late Churchill Downs president. Women's fashions at that year's Derby were a marvel, as always—broad straw hats topped with roses, orchid corsages pinned to brightly colored dresses. Hats everywhere would tilt this way and that as the ladies sneaked glances at the nearby luminaries, all the while sipping watered-down mint juleps, at a pricey $1.25 a glass.

When it was time to begin, a brass band in the infield played "The Star-Spangled Banner." The starting gates were rolled into position. A call came from the paddock judge, "Riders up!" followed by the line of jockeys atop their horses approaching the starting gate as the band struck up "My Old Kentucky Home," a Derby tradition. Eleven horses assembled into the starting gates, Dark Star the last to arrive. Moreno could see the heads of his fellow jockeys drop forward, the wide open dirt track in front of them, their horses snorting and shifting in anticipation. Dark Star, whose starting position was far to the outside, seemed impatient. A moment later the gates opened and Dark Star exploded ahead like one of Goddard's rockets, hitting 35 mph in seconds. Moreno heard only the deafening roar of the crowd and the galloping thunder around him. The horse beneath him moved beautifully, his legs firing like pistons.

Right out of the chute, Correspondent and Native Dancer burst into first and second place, as expected. Both had been bumped. (Ace Destroyer nudged Correspondent; Money Broker shouldered Native Dancer.) Moreno glanced left to assess his position. Native Dancer and Correspondent, while in front, weren't moving as fast as expected. "I can take them," he thought. Moreno made a zero hour change. The jockey ditched the stalking plan, brought his whip down sharply on Dark Star and went to full speed. From an outside position, Dark Star crossed laterally ahead of the pack, ahead of Native Dancer and Correspondent, taking the lead inside position, near the left rail. Moreno had showed his hand. Could Dark Star hold the lead? Harry, through his binoculars, realized instantly that their plan had been junked. He took a breath—other riders had tried this move against Native Dancer. All of them had failed.

Along the backstretch Dark Star maintained his position. Native Dancer trailed several lengths behind. Around the last turn, Correspondent faded back. Arcaro could not rally his horse; Correspondent was done. But Native Dancer picked up steam. This was it. This was what Native Dancer always did, thought Moreno. Fifty yards to go. Holding tight to Dark Star, he yelled through the wind, "Go, baby. Go, baby!" Native Dancer continued his approach. The stallion pulled ahead second on the inside of the pack. Now it was a two-horse race. Native Dancer continued to gain, a half-length behind Dark Star, closer, then a quarter-length, then almost parallel with Dark Star, but not quite. The finish line appeared. As the two powerhouse colts crossed it the result was clear: It was Dark Star by a head. Native Dancer hadn't come from behind fast enough. In an instant, the king had been dethroned. Dark Star came in at 2:02, the fifth fastest time in Derby history, winning Harry $90,050 (of which jockey Henry Moreno got $9,080 and trainer Hayward $3,000).

Some in the crowd, and many at home watching, burst into tears. The Native Dancer legend, an unbeaten champion, had finally been wrecked. Moments after Dark Star's win, reporters began writing the story they had never expected. Dark Star's victory was one of the biggest upsets in Derby history.

Harry was in a state of shock and only vaguely aware of the sea of outstretched hands around him and shouts of congratulations. Fans looked up from the lower grandstands, cheering in Harry and Alicia's direction. A small phalanx of Louisville police and racetrack ushers suddenly arrived, escorting Harry down to the track for the championship ceremony. Moreno sat astride Dark Star, his horse barely winded, waiting in the Winner's Circle, his arms cradling a giant rose bouquet, the famous garland of roses already draped over Dark Star's shoulders. Harry arrived and walked up to Dark Star, yelling a congratulatory exchange with Moreno, then clutched Dark Star's bridle just long enough for the wall of photographers in front of them to take their photos. As soon as Moreno

dismounted, a young blond woman in pearls stepped forward—Marilyn Monroe—who had graced the cover of that year's debut issue of *Playboy*. She planted a victory kiss on Moreno's cheek as flashbulbs popped. Harry got no such affection but beamed with satisfaction as he held up the Derby's golden cup. From there the Guggenheim entourage made its way back to the north wing of the Churchill Downs grandstand, rejoining Alicia for a private buffet dinner to honor the champion. First to greet Harry was Alfred Vanderbilt, offering an unconvincing smile and outstretched hand, saying, "I'm glad it was you, Harry," repeating, "I'm glad it was you."

Among journalists covering the festivities was a reporter for the hometown paper, the *Louisville Courier Journal*. Harry turned to the writer, ever conscious of the family reputation, saying quietly, "Now, please don't put any intimate stuff in your story." Alicia, a lover of intimate stuff, took pity on the journalist and gave him some on-the-record quotes. Alicia confided to the reporter that most Guggenheims don't attend races or bet much. They come to the races when they have one of their horses running. Racing was more or less a hobby for Harry, she said. "It's not a career with him, it's his pleasure."

That evening Harry and Alicia returned to the home of their longtime friend Mark Ethridge, then editor of the *Louisville Courier Journal*. Ethridge's wife arranged for the garland of roses to be hung over their front door when the Guggenheims arrived. The 1953 Derby inspired Alicia to ask John Steinbeck to write a piece on the race for *Newsday*. The story became a classic on the Derby, "one of the most beautiful and violent and satisfying things I have ever experienced," he wrote.

Newspaper stories about Dark Star's victory pointed out the bump that Native Dancer received. This annoyed Harry no end. Even Dark Star seemed to resent the best-horse-didn't-win controversy. A columnist claimed to have interviewed the horse himself on the matter. The colt said that he was so confident he'd win that he tried to bet on himself: "I tried to bum a couple of bucks off my owner, Mr. Guggenheim, Saturday morning so I could put

it on my nose. I even offered to go without oats for the weekend in exchange for the deuce. 'Guggy'—he hates that—gave me that Native Dancer look and sympathetically patted me on the rump." Dark Star concluded: "Sure I know that Native Dancer is the better horse. And that only means it took a better horse than the better horse to double cross the bettors."

Sadly, Dark Star wasn't the better horse for long. A few weeks after the Derby, Dark Star suffered a career-ending torn tendon during the Preakness. (Though Harry did well on stud fees. Dark Star would sire many future thoroughbreds.) The Gray Ghost got the last word. In 1954 *Time* ran a horse on its cover—Native Dancer—naming Vanderbilt's colt "Horse of the Year."

The House that Harry Built

I

Just a year before Solomon died, the Baroness Hilla Rebay von Ehren-
wiesen sat with a guest in Sol's suite at the Plaza Hotel ladling split
pea soup from a silver tureen. The walls around them were adorned with
paintings of swirling geometric shapes, triangles and ovals in jewel-like
shades of indigo and lime green, yellows and earthy browns, all tumbling
into one another. Rebay was Solomon's longtime artistic advisor. Her guest
was Cynthia Lowry, an Associated Press reporter, whose frumpy, slightly
disheveled appearance was no match for the elegantly dressed baroness,
a lover of tailored skirt suits, her blond hair in a German braided crown.
The paintings all around them were examples of "nonobjective" art, the
genre forming much of Solomon's personal collection, soon to be housed
in a new, permanent museum. How did one understand such work? "It is
like trying to explain music in words," said Rebay, sprinkling croutons
into her soup. "It is cosmic, it is order, balance and it is rhythm," she said
with her clipped German accent, waving her soup spoon at the canvases
almost violently.

Rebay was a minor German aristocrat who grew up in Strasbourg and became a painter, an art collector, and a passionate believer in nonobjective work, the term Wassily Kandinsky used to describe art "reduced to its essential elements—in the case of painting, to color, form, and line." Rebay idolized Kandinsky and fellow nonobjective painter Rudolf Bauer, convincing Sol to underwrite Bauer, whose canvases of trigonometric shapes were likened to advanced calculus equations. Sol struck a deal with Bauer similar to the way Hollywood studios signed their contract players. Bauer (who also happened to be Rebay's lover) would be paid handsomely to create his works, later becoming property of the museum.

Beyond nonobjective painters like Kandinsky and Bauer, the baroness advised Sol on purchasing other modern and contemporary artists—Fernand Léger, Marc Chagall, Robert Delaunay, Albert Gleizes, Amedeo Modigliani, Ladislaus Moholy-Nagy, Paul Klee, Georges-Pierre Seurat, Edward Wadsworth. The walls of Solomon's Plaza suite were getting very crowded. Sol's foyer was tinted a pale blue; the walls and ceiling of his study were lined with cork—neutral backdrops for his boldly colored acquisitions. Sol developed a unique affection for his paintings. "I can't stay away from them very long," he said. "So I decided to make my home my own museum where my friends and I can spend as many hours as we choose just sitting and feeling my pictures. Sometimes you get to think you know one of the pictures, and then after you have looked at it for a long time again you get an entirely different conception."

Solomon and Irene Guggenheim first met Rebay in 1927 through a mutual friend. Sol commissioned the baroness to paint his portrait, which he was pleased with. Rebay introduced them to her expansive network of painters, thinkers, and collectors of nonobjective art. These were the game-changers of the avant-garde, the artists of the future, she would say, and in some measure she was right. At sixty-six Sol was nearly thirty years older than Rebay, but he and Irene found the baroness congenial company and the three of them traveled across Europe on art-buying binges, visiting painters

at their ateliers. Besides becoming Sol's art advisor and spokeswoman, some were convinced the baroness and Sol were also carrying on an affair, though no evidence ever surfaced to confirm this. Letters they wrote each other were always typewritten by secretaries; no personal correspondence between the two has ever emerged suggesting their passions extended beyond art.

Solomon began collecting art at the turn of the century, just as the brothers were making a mint. Back then his tastes were in the Old Masters, Dutch and Flemish landscape paintings, the French Barbizon school. When Solomon talked up abstract artists like Kandinsky, friends and business associates laughed and called it "bunk." This made Sol determined to collect even more of it, eventually growing his collection beyond 1,000 pieces. He founded the Solomon R. Guggenheim Foundation in 1937 to eventually become the legal holder of his collection and operate a museum to exhibit it. The museum was founded two years later at a temporary location, a former auto showroom at 24 E. 54th St. in Manhattan, which the baroness christened the Museum of Non-Objective Painting. It would be a temple of worship: walls were hung with heavy, pleated gray draperies, rectangular ottomans sat in the center of the rooms, the air smelled of burning incense, Bach and Chopin played endlessly during visiting hours. Canvases were mounted within extra-wide silvery frames and hung so low they nearly touched the baseboards. The idea was that patrons would sit back on the ottomans and experience the paintings in a state of relaxation. A brochure for the museum advised patrons: "Attach your eyesight to the visionary rhythm and do not search for the materialistic delusion of matter."

A few years later, as Sol and Rebay searched for an architect to build the permanent museum, Sol's niece, Peggy Guggenheim, opened her own gallery three blocks north of Sol's collection. Peggy was being advised by Marcel Duchamp and collecting some of the same modern artists as her uncle. Peggy considered Rebay a manipulative charlatan and thought her ideas about nonobjective art were overblown. The strain in their

relations hit a crescendo when the baroness responded to a suggestion Peggy sent her uncle, to buy a certain Kandinsky painting Peggy had acquired, accusing Peggy of abusing the reputation of her own family name by crass commercialization. By this logic, it was fine for Rebay's European dealer friends to make a profit from Sol's money, but not Solomon's own niece. Yet another rift opened over a former employee of Rebay's who went to work for Peggy. The baroness employed artists as security guards and custodians at the museum, among them Jackson Pollock. After being largely ignored by Rebay, Pollock walked over to Peggy's modernist gallery and was given a one-man show and a monthly contract. As Pollock's work brought him superstardom, Rebay never accepted Pollock as a legitimate artist, calling his work "meaningless scribbles and scrawls."

Besides Bauer and Kandinsky, Rebay sought to promote another artist—Hilla Rebay. She organized a one-woman show at the museum, mounting no less than 255 of her own watercolors and collages. The exhibit's catalogue conveyed much of what Rebay thought about herself: "The versatility of this great artist is astounding," her work "an avalanche of talent," her style "has never been done before" which most likely "can never be rivalled" because she is not only a "virtuoso" but possibly "the greatest woman painter" and without question "the foremost art figure of our day." To some this was simply laughable hyperbole, harmless self-promotion. But after Sol died, criticisms of Rebay and the museum began to surface, causing concern among the close family members who had been named trustees to the foundation, including its president, son-in-law Arthur Stewart, a British nobleman (married to Solomon's daughter, Eleanor), and its chairman, nephew Harry. After an interim period of leadership by Stewart, who lived in West Sussex, England, it became obvious that leading the foundation from abroad during this crucial period was not tenable. By board agreement it was decided that Harry should be the one to manage the growing Rebay controversy and guide Solomon's vision to fruition.

The criticisms of Rebay came not only from art reviewers who objected to the immodest showing of so much of her own work at the not-for-profit museum, but from artists themselves who were uncomfortable with Rebay's "mystic double-talk" and condescending pronouncements about the work the museum exhibited. Stories surfaced that new artists were having their work "tampered with." In one instance, a young artist attended a Rebay museum opening and was shocked to find that a section of his painting had been repainted by Rebay's staff. He lodged a complaint with the museum, who returned his art with the paint "clumsily removed," rendering the painting "ruined." When the artist threatened a lawsuit, Rebay sent him a check for $450. There were complaints about the awards the museum had begun bestowing, notably an arts scholarship, apparently chosen haphazardly and biased in favor of Rebay's favorites. Works by Miró or de Kooning were said to be "taboo" while other examples from Sol's collection, like early Picassos and Chagalls, were collecting dust in storage. "Presumably they cannot be shown together lest the representational art contaminate the other!" observed the *New York Times*. Beyond personal prejudices, some believed Rebay held racial animus. A German art magazine ran an interview with Rebay in which she lauded nonobjective work as the only true art, making a bizarre reference to WWII: "It is really a shame that the bombs did not work harder to destroy the old (art) so that finally our own time could fulfill itself."

Some of the criticism spilled over to the foundation itself, which came under fire for ignoring reporters' questions about Rebay's antics and the question of when construction would begin on the new museum. The foundation issued vague press releases filled with "doubletalk" said the *Times*. The newspaper reminded readers that, as a nonprofit organization receiving federal and local tax breaks, the foundation was obligated to serve the public interest and employ professional standards in doing so.

Harry could see the reputational damage these controversies were wreaking on the museum and to the Guggenheim brand itself. But he found

himself in a bind—Solomon's affection for nonobjective art was clear; it was the focus of his collection. Rebay, to her credit, had steered Sol's collecting habits in the direction of some of the greatest modern artists of the century. She also gave a voice to up-and-coming female artists by showing their work. Harry would have to figure out a way to placate the critics and rein in Rebay, whose talents as an art advisor seemed not to extend to managing artists or museum programs. He had little time to do this. In April of 1951 the *Times* published a scathing critique of the museum, making an unprecedented suggestion: "Perhaps the foundation would better serve the public interest if it would place the new Wright building and the Guggenheim collections and monies under the jurisdiction of one (or perhaps jointly of two) of the existing museums of modern art."

Harry had seen onslaughts of criticism of the family many times over the decades, but to have the *New York Times* suggest that the Guggenheim family was too incompetent to run its own museum was unprecedented. High up on the 35th floor at 120 Broadway, Harry fielded phone calls from family members astonished at the situation, asking him what he intended to do about it. Harry consulted with board members—at least one still held Rebay in high regard. The majority seemed indifferent to the situation. Harry seemed to have a clear vision of what needed to be done. First, the museum would no longer focus exclusively on nonobjective art. Instead it would take a broader approach, showing the work of modernists and contemporary artists. Harry reasoned that before the war, when Sol began collecting nonobjective painters, they represented the experimental fringe. Since then, new artists and subgenres worthy of collecting and exhibiting had emerged. Second, recognizing this, the museum would change its name from the Museum of Non-Objective Painting to the Solomon R. Guggenheim Museum. ("Memorial Museum" was the initial wording, the word "memorial" later dropped.)

Third, Harry arranged a meeting with Arthur Stewart and the *Times* art critic, Aline Louchheim, who had written the story blasting Rebay. In

a lengthy meeting Harry listened to a replay of the banquet of indictments leveled in the story. Harry outlined the changes in progress and laid out the causes for the delays in starting construction, which owed largely to the complicated, slow-moving process of closing Solomon's estate. Solomon left $2 million to build the new museum and another $6 million as an endowment, but tax complications had slowed the transfer of these bequests. It's likely there was also discussion of the fact that Solomon himself had delayed breaking ground on the museum, believing an economic downturn would follow World War II, expecting construction costs would be cheaper. No such downturn occurred. The delay instead wound up costing the foundation money as costs rose.

The meeting with the *Times* ended the paper's criticism. Under Rebay, even Harry admitted the museum had become "ridiculous." Later he issued a detailed public statement on its new direction. In a largely positive follow-up story, the *Times* applauded Harry's course correction: "Refreshingly free of the double-talk which has colored so many previous statements, this one inspires trust in the board's sincerity, honesty and good will," stated the *Times*. "The news that the great Seurats, Chagalls, Delaunays, Klees . . . will be exhibited to the public (despite their 'representational' character) is heartening. And artists will be encouraged to learn that something is being done to change the awards of scholarships from the disorganized, personal basis of the past to something as objective and commendable as the system used in awarding Simon Guggenheim Fellowships."

Harry's new approach was simple: redouble the family's commitment to Wright's design, but expand its mission—something Rebay strongly opposed. That was irrelevant to Harry; he wanted Rebay out, if for no other reason than her behavior represented a risk to the family's reputation, something Harry had spent much of his life protecting. After the changes were instituted Harry asked her to resign, which she did in April of 1953, citing health reasons.

II

These developments caused Frank Lloyd Wright some anxiety. It was Rebay who first contacted Wright in 1943 to ask him to design Solomon's museum (although Wright once confided that the idea to hire him originated with Irene Guggenheim). Wright and Rebay had worked closely on plans for the museum during a relationship that grew tempestuous, but retained mutual respect. From their first meeting in New York, the architect was charmed by the curator; they were soon on a first name basis and discovered some shared quirky interests, among them alternative medicine. Rebay "believed that much of human sickness was due to bad teeth, and within six weeks of their acquaintance she got Mr. Wright to remove his teeth and get dentures." In early correspondence with Wright, Rebay's enthusiasm for the future museum resembled a religious quest: "I want a temple of spirit, a monument!" she said, urging him to move with dispatch. "Mr. Guggenheim is 82 years old and we have no time to lose."

The next summer, with his first sketches in hand, Wright traveled to Crawford Notch in the White Mountains of New Hampshire, where Solomon and Irene summered at the grand Crawford House. Wright presented the drawings to Sol, who looked them over carefully, without a word. Wright titled the proposed building "Ziggurat," given its spatial dimensions resembled an inverted version of the temples of Assyria and Babylon, whose entranceways were something akin to ramps. Sol was astounded at the concept; it was a kind of building he had never imagined for a museum, or anything else. Solomon teared up looking at the sketches. "Mr. Wright, I knew you would do it," he said. "This is it."

In the coming years Wright made countless design modifications to reduce growing costs as the perimeter of the museum site expanded. The Ziggurat would be built on a parcel of land acquired by the foundation on Fifth Avenue, with later additions to the site forming a one-block stretch between East 88th and 89th Streets, overlooking the Central Park reservoir.

Up until the moment Sol died, all the components seemed to be in place. Now, from Wright's perspective, there would be two unsettling "X factors": Harry, the man chosen to replace Solomon; and James Johnson Sweeney, the man Harry chose to replace Rebay.

Harry's first task in his relationship with Frank Lloyd Wright was to address rumors that the changing of the guard signaled the possibility that Wright's Ziggurat would not be built at all. There was talk about ditching the design and moving Sol's collection into a preexisting building at the site. Sweeney, it was believed, thought Wright's conception was a poor way to display art. Harry put the rumors to rest, conveying to Wright that the gossip was likely coming from an embittered Rebay, and that Sol's wishes for Wright's version of the museum would be honored and built as planned.

The first time Wright and wife Olgivanna came to dinner at Falaise, Wright felt an instant rapport with Alicia, who in turn become a passionate supporter of Wright's vision. In time Alicia joined the museum board and Wright would write to her as a means of lobbying Harry, who he often addressed with a German salutation, "Lieber Harry!" and Harry would address Wright as "Querido Francisco" (Dear Frank). Harry and Wright soon became amicable antagonists over a range of forthcoming design and construction matters. When Wright wanted his way, he invoked the memory of beloved Uncle Sol, insisting Harry's uncle would have sided with Wright's version of affairs.

Finally, in 1952, with Solomon's estate largely settled, the foundation applied for its long-awaited building permit. The response arrived quickly: application denied. Wright's unorthodox design violated thirty-two building codes, all of which would have to be rectified. Wright prepared an appeal with a cover letter stating, "Architecture, may it please the court, is the welding of imagination and common sense into a restraint upon specialists, codes and fools." Wright showed the draft to Harry, who suggested he remove the word "fools." Wright complied.

The appeal apparently made little headway, so Harry and Wright cultivated an ally: master builder Robert Moses, then a New York City planning commissioner (one of seven offices he held at the time). Moses disliked the building, hated modern art, and didn't care for the location of the future museum, yet he was on good terms with both Wright and Harry. (Moses and wife Mary had once been Harry's guests at Cain Hoy.) Years earlier Moses had taken a drive with Wright and Rebay to a hilltop in Riverdale, the Bronx, just north of Manhattan. Moses thought the location was ideal (naturally, he envisioned a park on the site). Wright and Rebay thought the locale was perfect, a Temple Mount for art. Solomon nixed the idea, insisting it was too far from Manhattan.

Moses eventually went along with the Fifth Avenue site and apparently offered guidance to Wright as the architect received approvals, one by one, for the required changes: altering floor payloads, widening stairways, adding fire exits, redesigning the dome, modifying plumbing and ventilation. The process moved with glacial speed—revising plans, revising the revisions, consulting with multiple city departments, presenting the modified plans at permit hearings. After four years of bureaucratic ping-pong, Wright and Harry appealed to Moses for more direct intervention, and Moses reportedly responded with an "iron fisted ultimatum" to the head of the Planning Commission: "Damn it, get a permit for Frank. I don't care how many laws you have to break. I want the Guggenheim built!" Moses arranged the hiring of a special inspector, costing $3,000. Harry "grumbled, but paid." In the spring of 1956 the building permit was issued.

Ground was broken that year at the Fifth Avenue site, just after Wright turned eighty-nine. He showed no signs of slowing. The architect now thought the time was right to resurface an idea he had already run by Harry, a new description of the museum: "Archeseum"—a term combining the words architecture and museum. Harry was unpersuaded. Wright stepped up his lobbying campaign until Harry had had enough, hurling a friendly rejoinder to Wright: "Querido Francisco . . . please lay off for all time this 'Archeseum' stuff. The family do not want it." Harry predicted: "I have no

doubt, as time goes on, that the museum will be known as 'The Guggenheim,' just as the Whitney Museum is known as 'The Whitney' and the Frick Museum is known as 'The Frick.'"

III

As construction got underway Harry and Wright faced another small challenge. A group of some twenty artists, among them Robert Motherwell and Willem de Kooning, cosigned a letter objecting to the interior design of the museum, complaining it was "not suitable" for displaying art and criticizing the slant of the ramp. Based on drawings they had seen in New York newspapers, they concluded, "The basic concept of curvilinear slope for presentation of painting and sculpture indicates a callous disregard for the fundamental rectilinear frame of reference necessary for the adequate visual contemplation of works of art." As one artist put it: "We shall be compelled to paint to suit Mr. Wright's architecture."

For a man with no teeth, Wright's correspondence could bite. He wrote a rebuttal to the dissidents: "Dear Fellow Artists . . . there is no 'rectilinear frame of reference' whatever for the exhibition of a painting except one raised by callous disregard of nature, all too common to your art." He accused his "fellow artists" of knowing "too little of the nature of the mother art: architecture." Wright's design called for sloping walls, where paintings would tilt slightly toward the natural light, the same light the artist had used to paint, all in defiance of what he called "a picture-dealer's artificiality." Harry publicly supported Wright, noting that the ramp's grade was just 3 percent. The protest went nowhere. But Wright believed Sweeney had a hand in the letter.

That's because Wright and Sweeney had been feuding for months, starting nearly from the first day of new director's appointment, mostly over the interior color scheme of the museum and the very issue of how to display paintings. This put Harry in the awkward position of mediator. He began

spending a great deal of time refereeing "quarrels between an architect who wanted to dictate the art displays and a director who wanted a hand in the architecture."

Sweeney was a formidable character in the art world. He had lectured widely on contemporary art and European Modernism; his booming voice matched an imposing presence—tall, balding, and muscular. Growing up in Brooklyn, the product of an old Irish family, Sweeney was a Georgetown graduate who had been curator at the Museum of Modern Art (MOMA) for a decade. He lived in a penthouse apartment near the East River, its cavernous rooms a stage for his Calder sculptures, his Mirós and Picassos, and his stylish Le Corbusier furniture, set off by stark white walls. He was a man with fanatical views on how art should be displayed. As one visitor, Peggy Guggenheim, wrote, "The interior of his home resembled a Mondrian painting."

When Sweeney replaced Rebay, he gave the museum, still in its temporary quarters, a curatorial remake. He took down the heavy draperies, snuffed out the incense, turned off Bach and removed paintings from the extra wide wooden frames, which even Wright denounced as "a hideous lumberyard." Sweeney remounted Sol's paintings against milk-white walls, without frames, under powerful light. Fine for the old Guggenheim museum. But when Sweeney attempted to convince Harry and the trustees that these forms of display should be adopted in the new museum, Wright reacted as if the Ziggurat itself were under attack. The curator and the architect battled each other, lobbing broadsides, mostly through letters to Harry.

Throughout 1958 Sweeney leveled arguments against three fundamental elements in Wright's design of the Guggenheim: 1) the museum's sloping walls; 2) the cream-white tone the architect had selected for the interior; and 3) reliance on natural lighting. Wright returned fire from his command post at the Plaza. On May 7: "Harry—Lieber! Why do you think the walls of the Solomon R. Guggenheim Museum are gently sloping outward? They gently slope because the donor and his architect believed that

pictures placed against the walls slightly tilted backward would be seen in better perspective and be better lighted than if set bolt upright. This is a chief characteristic of our building and was the hypothesis upon which the museum was fashioned."

In another letter Wright condemned Sweeney's desire to use a bright hue of white (the same shade as his apartment), likening the color to the "toilets of the Racquet Club." That was a mistake—Harry had friends who were club members. Harry wrote to Wright: "You seem to have an unpleasant association of ideas with white. Why conjure up the toilets of the Racquet Club? Why not let your fancy image the snows of Kilimanjaro or the breast of the Trumpeter Swan? Now, Querido Francisco, cooperate with me as I have with you to build the most beautiful and functional museum for a living and growing Art foundation."

Harry would have no such luck. In a May 10 letter, Wright condemned Sweeney as a creative deadweight and a paladin for the old orthodoxy: "True, the new reality knocks him out. But were he a man he would be in on the beginning of an organic idea of what constitutes the more liberal painting and its presentation in future. But Jim (regardless of years) has not youth and I know now he is a millstone where the new life of the Solomon R. Guggenheim is concerned."

In the summer of 1958 Sweeney threatened to quit over Wright's insults and intransigence. Harry talked his director out of resigning, assuring him that he had the full backing of the board. Harry reminded Wright that it was Solomon who once cautioned that "the paintings must not be subjugated to the building." In over-the-top, waggish language, Harry brushed off Wright's digs at Sweeney, ordering Wright to "cease your diabolical maneuvers because your building is for the angels. Stop causing everyone, including yourself, quite unnecessary bile and labor. Let us finish this job that your cussedness would have killed aborning without your help, and help us dedicate in harmony your beautiful and ingenious pile to an eager world."

Wright was unmoved; he appealed twice more. On November 28: "Dear Harry, I am fully aware that but for you the Museum would never have been built. It is because of that I plead with you now not to fail me in completing this work as it was originally conceived . . . I deeply wish that you stand by me at this most crucial moment of a perfect expression of a museum to present the paintings in the most perfect way possible." And again on Dec. 27: "Lieber Harry . . . You are now *the* Guggenheim who will decide the fate of the original Guggenheim bequest . . . Why the opus as designed so greatly matters is because as designed and originally approved probably means a new kind of museum, a more broad and enjoyable one."

Harry tried to reassure Wright that the Ziggurat was safe. "The architectural integrity of your building will be preserved," he wrote, but "the technique of exhibiting the art of the museum is the function of the Director of the museum." In another missive, Harry took a sharper tack (no longer "your building," now "our museum"): "If this were an architectural matter, we would bow to your genius. We can't accept you as a universal genius who can put on superior art shows and administer our Museum."

With the concrete spiral set to rise, Harry conceived of a global awards competition for groundbreaking artists, connecting the New York art world to artists abroad, calling it the "Guggenheim International." The award structure resembled Harry's safe plane competition three decades earlier: a $10,000 grand prize and a range of secondary prizes for artists from different countries for works of "outstanding merit." It was the highest cash award given in the arts at the time. Harry wanted it to be presented by a world-renowned painter. He found one in the White House—Dwight Eisenhower—who relaxed by painting New England landscapes in a tiny art studio under the White House stairs. Harry, a frequenter of Ike's "stag dinners," convinced Eisenhower to present the inaugural award in 1956, won by British abstract painter Ben Nicholson, and the second award, two years later, to Spanish painter Joan Miró. Harry accompanied Miró and his wife, Pilar Juncosa, to the White House for the presentation. Juncosa wore

a scarf painted by her husband, which she removed and handed to First Lady Mamie Eisenhower as a gift. Eisenhower showed Miró and Harry a collection of his oil paintings, to which the Spaniard noted solemnly, "very sensitive."

IV

It would be nearly sixteen years between the moment the Guggenheim's first sketches were presented to Solomon and opening day of the museum. Solomon's original budget was $250,000 for the land and $750,000 for the building. The final numbers were closer to $480,000 for the land and $3.7 million for the museum. Frank Lloyd Wright lived long enough to see the scaffolding come down on the exterior of the museum in January 1959, his creation finally brought to life. But he died a short time later, six months before the museum was fully completed.

At a pre-opening dinner that autumn for the press, artists, and architects, Harry addressed questions lingering over just how true the museum was to the architect's vision. "I believe Mr. Wright to be a great man, a great genius," said Harry. "I did my best to preserve the integrity of his building." Raising his hand to his chest, he said, "And in my heart . . . I feel in clear conscience that I have done it. The building is exactly the way Mr. Wright created it. I worked for it and I fought for it." This was artful wording. The museum—that is, the building—did in fact conform to Wright's vision. It's also true that Sweeney got his concessions—a milk-white color for the walls, mountings for paintings that allowed them to float, not tilt, and fluorescent light supplementing natural light, illuminating each work uniformly.

The building's design had been publicly debated for years before it opened—now that people could see it in three dimensions, there was really something to talk about. Everyone in New York had an opinion, and they were usually different. Neither could the city's two principal newspapers

agree. The *New York Times'* John Canaday said the museum was "a war between architecture and painting in which both come out badly maimed." The *New York Herald Tribune*'s Emily Genauer wrote it has "turned out to be the most beautiful building in America."

On opening day about 10,000 people queued along Fifth Avenue; only 6,039 could enter, each paying a fifty-cent admission ($4.50 today). There was no end to visual interpretations of the museum, described as a beehive, a child's spinning top, a chambered nautilus, an upside-down bowl of oatmeal, a Martian space ship, a bobsled course, a giant Jell-O mold, a runaway washing machine. Architect Philip Johnson considered such allusions nonsense, describing the museum's soaring atrium as "one of the greatest rooms created in the 20th century."

The opening show, with 134 pieces selected by Sweeney, was an impressive pageant of modern art—Cezanne, Kandinsky, Braque, with pieces by Klee, Chagall, Léger, de Kooning, and Pollock. Not a single work by Bauer appeared. This was not lost on Rebay. After the opening, which she refused to attend, Rebay sent a Western Union telegram to Sweeney, stating that the inaugural exhibit consisted of "aftermath trash" which "insults Solomon R. Guggenheim(')s name while his collection is hidden away."

Just weeks after opening Harry wanted to know more about who his customers were and what they thought of the Guggenheim. He commissioned the Gallup organization, who interviewed some 700 patrons, discovering that 38 percent came to the museum to see the building. The typical visitor was a college-educated woman, age twenty-one to thirty-four. Many indicated a preference for visiting during the evenings, so Harry extended the hours one day a week until 9:00 P.M.

Polling patrons was anathema to Sweeney. The museum should showcase art to lead public sensibilities, not follow them, he thought. The poll reflected a new receptiveness Harry was developing for the Guggenheim, one that would gauge public tastes and emphasize art educational programs. Harry also sought a more professional staff structure that separated the art and

business functions of the museum. Sweeney and Harry bitterly clashed over these new directions and soon weren't on speaking terms. In time Harry concluded Sweeney was no longer the man for the job and told him so.

Sweeney resigned in July 1960, expressing no bitterness, at least in public. Harry complimented Sweeney on his eight years of service to the Guggenheim, having brought to the collection Russian avant-garde artists, Alexander Calder's mobiles (Sweeney had known Calder since the 1930s), and sculpture by Giacometti and Brâncuşi. Sweeney, in turn, had Harry to thank for backing him when Wright attempted to become curator as well as architect.

After the Guggenheim opened Harry surmised that he still had little understanding of modern art. One thing he did understand was the immense satisfaction he felt guiding the construction of the museum. As he told one family member, he realized that the happiest moments of his life had come from building things of consequence, that would endure, as a foundational entrepreneur in the air age or as foundation chairman of a new museum. It not only made him happy, it convinced him that the key to carrying forward the family legacy was building institutions that would last.

<p style="text-align:center">V</p>

Alicia, too, was building something of consequence. She awoke at Falaise each morning at around 8 A.M., reading the New York papers over breakfast in bed, often taking a call about the day's schedule from her secretary, Dot Holdsworth. She would then drive her Oldsmobile coupe to the *Newsday* office, about twenty minutes away. In 1954 *Newsday* was the most profitable U.S. daily paper begun in the past two decades. The postwar boom brought New Yorkers to Long Island to live and work in their own cities and towns, giving *Newsday* a homegrown readership. "We're a big city paper that just happens to be published in the suburbs," she said. At the core of *Newsday*

was a tabloid sensibility, a brash, bumptious slant on the news. It took a while for Alicia to settle on this approach. In the early days arguments over the direction of the paper boiled over. One editor asked Alicia what exactly she wanted *Newsday* to be. She shouted out, half-jokingly, "Dogs! Cats! Murders!" After the war, the paper's investigative journalism elevated its reputation and made it a magnet for journalistic talent. This attracted young journalists like Robert Caro, today perhaps the greatest biographer in America, whose landmark work, *The Power Broker*, began as a series of articles in *Newsday*.

Harry covered hundreds of thousands of dollars in losses until the paper broke even in its seventh year. After the war, as he juggled responsibilities at Guggenheim Brothers, the museum, his horses at Cain Hoy and in Kentucky, and more grants for aviation research centers, Harry found time to come to the *Newsday* office each week and manage the paper's business operations and negotiate with unions. Much of the tension in Harry and Alicia's relationship sprang from the heated discussions they had over budgets and expenses. Alicia would "spend every nickel if it meant getting a good story"; Harry was a cost-cutter and a budget hawk. Harry's financial management apparently led to the paper cycling through four general managers. One noted: "It was like being nibbled to death by ducks."

A more serious bone of contention was the resentment Harry felt over the fact that Alicia generally gave him very little credit for his role in funding and comanaging their joint venture. In interviews she offered but faint recognition of her husband's contributions. When the topic of *Newsday* came up with new acquaintances, it was often assumed that *Newsday* was Alicia's paper and Harry had little, if anything, to do with it. Harry bitterly resented this lack of acclamation and frequently complained to Alicia about it. Given the multitude of Harry's other business involvements, it's astonishing this issue got so deeply under his skin, but it did.

In 1954, as circulation reached 210,000, *Newsday* won its first Pulitzer Prize, landing Alicia on the cover of *Time*. The achievement did little to

replenish their marriage. Even *Time* chronicled Harry and Alicia's contentious relationship. During one dustup, "Alicia fixed her husband with a glare and challenged: 'You have 51 percent of the stock. You can fire me anytime you want.'" As their marriage broke down Alicia spent less time at Falaise, at one point moving in for a few weeks with close friend Phyllis Cerf and husband Bennett Cerf, cofounder of Random House. Harry and Alicia began to communicate mostly through lawyers. Around the time of the museum opening, they reconciled, in their own way, or perhaps it was an agreement casting their marriage in new terms along the lines of friends Neysa and John. Alicia now made little effort to keep her affair with Adlai Stevenson a secret.

Tabloid Titan

I

I ndian prime minister Jawaharlal Nehru visited the United Nations in 1960, but what he really wanted to see was the new Guggenheim museum. Harry arranged for Nehru's visit on a Saturday afternoon, escorting him down the circular ramp as they talked over art and architecture. Nehru lingered over the modernist works, finding the museum "perfectly fascinating." Soon came another world leader, Empress Farah of Iran, wife of the shah, then just twenty-four. Harry and Alicia escorted her imperial majesty down the ramp with a contingent of thirty. The empress had been an architecture student, the Guggenheim was the first Wright building she had ever visited. "I like it," she said, calling its curving galleries "a good idea." So good, the empress later used Iran's staggering oil wealth to build her own subterranean version of the Guggenheim in Tehran. Its curving walkways spiraled deep underground, connecting galleries that held some 200 masterpieces, today worth $3 billion.

The Guggenheim was a global fascination and the symbol of a new, modern sensibility toward contemporary art. Practically overnight it

commanded a stature on par with its New York rivals, MOMA and the Whitney. Harry, as head of the museum, presided as a kind of unlikely ambassador for a new world of modernism. He knew much about his own art at Falaise, the medieval tapestries and ancient relics of continental Europe. But what did he really know about Pollock, Kandinsky, or Mondrian? Harry had no shame in proclaiming his ignorance. In fact, he looked forward to learning much from the director who would replace Sweeney. In spite of Harry's organizational reforms, there was no search committee for a new director. Harry simply consulted with the board member he trusted most, Daniel Catton Rich, former director of the Art Institute of Chicago. Rich offered but one recommendation: Thomas Messer, a Harvard grad and director of the Institute of Contemporary Art in Boston.

Although they were thirty-one years apart (Messer was forty-one at the time), Harry felt an instant rapport with his new director. Born in Prague, Messer conversed in a thick Czech accent and comported himself like a European aristocrat, an erudite gentleman with impeccable manners. Every few weeks Harry invited Messer over for lunch at the 74th Street townhouse, where they discussed personnel and budget matters. On Saturdays Messer took Harry to gallery openings, introducing him to the work of American surrealists, German expressionists, Italian futurists. When it came to understanding, say, a three-dimensional box by Joseph Cornell, Messer could deconstruct such works in an instant, revealing an incongruous jumble of found objects to be the mythical history of a Renaissance princess. Messer knew the life stories of these artists—Cornell began making boxes to amuse his brother, who had cerebral palsy, and for all of Cornell's references to Europe's high culture, he had never left the country. Cornell created his mysterious boxes in the basement of his mother's home in Queens.

On weekend tutorials with Messer, Harry frequently reminded his new director of the huge sums of money behind the museum's acquisition costs. Harry wanted to fully understand what he was buying. He asked Messer

to explain every piece—"and no double talk, please," he joked. Messer benefited from these visits, too. They were an opportunity to win early approval for pieces he had found and wanted to buy, but would need Harry's approval before he went before the Acquisition Committee. As Messer recalled in an interview, "I knew that if Harry gave his nod, nobody would oppose it." Messer expanded the staff and, with Harry's blessing, recruited British art critic Lawrence Alloway, the man credited with coining the term "pop art." Among the new jobs Alloway took on was curating Harry's biannual International, begun under Sweeney.

II

Alicia continued to serve on the museum board, but spent more time advancing another passion: Adlai Stevenson's political career. In the presidential campaign of 1960 Stevenson was a dark horse candidate for the Democratic nomination. Even after being twice defeated by Eisenhower, Stevenson considered running a third time as the Democratic Party's nominee, facing Ike's vice president and certain Republican party nominee Richard Nixon. *Newsday*'s readership was heavily Republican. It would be a coup for Kennedy to clinch the paper's backing. So a young Jack Kennedy came calling on Alicia that spring, arriving at the *Newsday* offices. He and Alicia strolled (accompanied by campaign staff and *Newsday* editors) to a private dining room at nearby Nino's restaurant, where they spent the afternoon together. Kennedy knew how close Alicia was to Stevenson—might she suggest to him that the time had come to abandon unrealistic dreams for a third run and back the candidate who was favored to win, Jack Kennedy? Not yet, said Alicia. But she promised Kennedy that if Stevenson was not nominated at the convention, Kennedy could count on her. "If anything ever happens, you're my second choice," she said, grinning.

At the Democratic convention that summer, efforts to advance Stevenson failed to gain steam, yet he refused to publicly back Kennedy. An unlikely but possible scenario was Stevenson flipping Illinois delegates his way, triggering a brokered convention. Alicia considered the idea quixotic. She instead tried to cut a deal on her paramour's behalf in which, if elected, the new Democratic administration would name Stevenson secretary of state in return for his support at the convention. Alicia sent a note through an emissary to Robert Kennedy, who replied with an encouraging response, but no commitment. Alicia relayed the response back to Stevenson, who remained unmoved and uncommitted.

After Kennedy clinched the nomination Alicia endorsed JFK on *Newsday*'s editorial page. Harry naturally wrote an opposing opinion piece backing Nixon. Kennedy appreciated the support from Alicia—a poll in late 1960 showed 694 daily U.S. newspapers endorsed Nixon; only 194 backed Kennedy. After the election, Alicia published an open letter to Kennedy, asking him to spell out what Americans should do in response to the admonition made in his inaugural address, "Ask not what your country can do for you . . ." Kennedy wrote back to Alicia laying out his ideas, which *Newsday* reprinted in full-page format. A *Time* magazine story termed the president "Alicia's Pen Pal."

Alicia lost no time capitalizing on the publicity. She asked the White House whether a visit might be possible to discuss a range of issues, some specific to Long Island. For five years she had been advocating for the closure of a nearby Air Force base, Mitchel Field, where there had been a series of plane accidents (in one case, a Martin B-26 bomber crash near the home of a *Newsday* staffer). Alicia thought the land should be used to expand two nearby colleges. Harry opposed the idea, backing a business group that wanted to convert the base to a civilian airport.

To her great satisfaction, Alicia received an immediate lunch invitation from Kennedy. A few days later she found herself sitting down with the president at the family quarters of the White House. The lunch started

with Bloody Marys and ended with ice cream cake. They talked about Jackie Kennedy's coming trip to India and the political future of younger brother Teddy Kennedy. Then Alicia laid out her case for closing Mitchel Field and barring any plans to convert it to a commercial airport. Pushing himself from the table, Kennedy picked up the phone and said, "Get me Jeeb Halaby." A moment later, Halaby, his Federal Aviation Agency chief, was on the line. "Jeeb, we don't need Mitchel Field, do we? Let's shut the damn thing," said Kennedy. The president put the phone down. "It's closed," he said matter-of-factly.

Alicia was ecstatic. Harry, of course, was not. The "Godfather of Flight" had been outflanked by his own wife using his own newspaper, with help from Jeeb Halaby, a former test pilot who had served on the Daniel and Florence Guggenheim Foundation advisory board. On top of that, Mitchel Field was where Jimmy Doolittle had conducted the first blind flight in U.S. history for the Guggenheim fund. It was yet another contentious bump in the road that *Newsday* always seemed to produce for Harry and Alicia.

Of course, it was no more than a bump considering other successes and recognition Harry was earning at the time. In 1959 Robert Goddard, whose work Harry financed for a decade, was posthumously awarded the Congressional Gold Medal. That year the National Aeronautics and Space Administration (NASA) renamed its Maryland center the Goddard Space Flight Center, home to Project Mercury, the first American effort to send humans into space. At the same time Harry and his father's influence on aviation was felt every day—by then, most of the senior aerospace engineers in America were graduates of Guggenheim aviation schools. Harry's horses continued to bring him good news. In 1959, the year the museum opened, Cain Hoy Stables became the highest earning thoroughbred horse farm in America. (In 1963 it produced yet another star colt, sending Harry to his fourth Kentucky Derby appearance.) *Newsday*, profitable for over a decade and with a circulation of 350,000, was the most successful suburban daily in the nation.

There was much for Harry to celebrate, indeed—until the summer of 1963.

III

Even in her mid-fifties, Alicia kept a trim figure and possessed the energy of a teenager. In May of 1963 she told Harry she was heading to California to become a godmother, attending the christening of Adlai Stevenson's newest grandchild. Adlai and Alicia shared a suite at the Fairmont Hotel atop San Francisco's Nob Hill, and then a road trip along the spectacular scenery of Highway 1 to Big Sur, site of the christening.

The following month, back for a stay at Kingsland, Alicia didn't feel quite like herself. Her drinking, smoking, high-stress lifestyle, and constant feuding with Harry was taking a toll on her physically. Her doctor advised that she ease up on smoking and boozing; it would add years to her life. But without such daily vices, what kind of life would that be? she asked. Alicia waved off the concerns. George Abbott was also becoming alarmed about her health. Alicia was unwell, he said. She "didn't take good care of herself." Alicia's staff was also noticing a change in her behavior. At Kingsland she appeared listless for several days and at one point suffered a dizzy spell. When she returned to Falaise things did not improve. Alicia repeatedly called in to *Newsday* to say she wasn't feeling up to coming in. Later that month her symptoms grew more pronounced—waves of dizziness and nauseousness began to overwhelm her. Alicia's secretary, Dot Holdsworth, called the doctor, who arrived and witnessed Alicia in her bathroom heaving up a large volume of blood. Her doctor said she needed to get to a hospital immediately. Holdsworth called Alicia's chauffeur, Noel Dean—the three of them drove to Doctors Hospital in Manhattan. Alicia went into shock as she arrived, having lost about one-third of her blood.

Alicia's doctors diagnosed her with a serious ulcer. To prevent the need for an operation would require a drastic change in her lifestyle, certainly a major reduction in her consumption of alcohol and cigarettes. Her doctors gave Alicia two choices: "She could alter her way of life or she could have surgery." She chose surgery, meaning a gastric resection, in which a portion of her stomach would be removed. Harry apparently did not oppose her decision and monitored her situation during visits to the hospital and by doctors' reports by phone at his townhouse. Adlai Stevenson came to the hospital to see Alicia. Harry was there at the time and barred him from visiting. The operation went smoothly, or so her surgeon thought. In fact the procedure failed to stop her internal bleeding. The doctors conferred, attempting to reduce Alicia's loss of blood by irrigating her stomach, but that did nothing. They operated a second time, attempting to alter a nerve pathway to stop the blood flow. This also failed. A final surgery was performed, the third in twenty-four hours. They suspected Alicia's spleen may have been playing a role in the source of bleeding, so they removed it. This too was unsuccessful. Hours later, on July 2, Alicia died. She was fifty-six. An examination later led doctors to theorize that the source of her bleeding was the virtual disappearance of her stomach lining, a condition associated with alcoholism.

The physicians called Harry with the terrible news first; Harry called Dot Holdsworth. Among those who came to stay with Harry the night Alicia died were Holdsworth, Josephine Patterson (Alicia's sister), and Harry's grandson Dana Draper (Nancy's son). They described Harry as "shattered," his face ghost-white. For all the bad blood between him and Alicia, the constant feuding over the management of *Newsday*, Harry now felt a cascade of sorrow and remorse. He turned over in his mind their last few conversations. He had revised his will just weeks earlier, granting to Alicia, after his death, the 2 percent interest in *Newsday* which she had sought for so many years. It would have given her the controlling stake. "I was supposed to die first," said Harry to Dana. Instead, the opposite had occurred, something that "wasn't supposed to happen."

About 800 people attended Alicia's service that month at the Episcopal Cathedral in Garden City, Long Island. Telegrams of condolence arrived from President Kennedy, New York governor Nelson Rockefeller, Averell Harriman, Adlai Stevenson. Lindbergh, then in France, sent some poignant thoughts to Harry: "I have known you now for so long and Alicia now for so many years, that it seems to me almost a loss in my own family. I wake at night thinking of you and her, and I cannot accustom myself to the fact that she is no longer here with us—at least in the sense of the past." A few months later, in a ceremony arranged by Harry, Alicia's ashes were left beneath an oak tree near the river at Kingsland. Harry inscribed a simple plaque of remembrance: "A beautiful and spirited lady lived on this land, and under this oak tree she watched the river that she loved." Harry would also commemorate Alicia with two works of art, commissioning a life-size bust by artist Laura Ziegler and a large ceramic mural by Joan Miró to be permanently installed at the Guggenheim.

Harry had not let Adlai Stevenson visit Alicia prior to her surgery, nor would he allow him to attend the funeral. Harry had tolerated Alicia's relationship with Stevenson, but now his true feelings emerged. This was apparent after Harry came across a letter from the former governor to his wife, hidden in papers at her *Newsday* desk. The discovery enraged him. Harry called Dot Holdsworth and asked her to clean out the desk and all its paperwork, letter included. Unbeknownst to Harry, Alicia had instructed Holdsworth, in the event of her demise, to gather all the letters Stevenson had written her, stored in Alicia's office safe, and return them to Stevenson, which Holdsworth faithfully did.

When Alicia was alive, the battle lines were clear: she commanded the editorial side of the paper, Harry its business operations. Alicia would arrive in the newsroom, glasses perched on her head, puttering around the jumble of desks and file cabinets, engaging reporters in arguments, sometimes lighthearted, other times heated. At the morning news meetings Alicia opened up discussions to freewheeling debate, often joined by

her golden retriever, Sunbeam. Once, in a contentious conversation over coverage of physical fitness, Alicia ordered everyone in her office to drop to the floor and do pushups. As *Newsday* chronicler Robert Keeler put it: "Under Harry, there was a tight agenda, but there were no dogs, no calisthenics, and little debate."

The man now running *Newsday* would arrive at the office impeccably dressed in his three-piece suits, amid a sea of reporters in rumpled, short-sleeved white shirts. *Newsday* had grown to a 252-person editorial staff—section editors, beat reporters, feature writers, sports columnists, copy editors, photographers, graphic artists. Harry's management style was reminiscent of Mercer Field: he preferred to be addressed as Captain and moved to centralize decision-making among his top editors. He immediately established a new system by which data-driven research reports were required before major policy positions were taken on the editorial page. It's not clear what improvements came from any of this. "In trying to impose Guggenheim order on Pattersonian chaos, Harry was at a serious disadvantage, he had all the fiscal and analytical skills of a successful businessman, but none of the talents of a journalist," said Keeler.

Just a few weeks after Alicia's death he asked his editorial director to send around a two-page memo to editorial writers summarizing his opinions on issues. Harry's views on the executive branch of government, for example, were clear: "The President and his advisors are in the best position to know our defense needs (regardless of which party) and we must accept their estimates rather than listen to a lot of sour grapes from embittered ex-generals and admirals."

In fact, the Captain expressed not-so-veiled contempt for reporters. He held vivid memories of the ink-stained wretches and photographers trailing Lindbergh's every move, intruding into every moment of his family life, exposing the Lindberghs to visibility that some thought played a role in the kidnapping and death of their son. Harry remembered his frustration

in the early days of aviation, when most stories about airplanes tended to be about crashes. (Daily auto accidents killed far more people, he would remind anyone who cared to listen.) He recalled the many column inches skewering his performance as Cuban ambassador. He also remembered the early press coverage of Goddard—many journalists treated every rocket test failure as a debacle and likened Goddard to a mad scientist. This was perhaps why, as Harry explained to *Newsday* staffers at one of his first general meetings with them, he often found journalists to be dishonest, untrustworthy people who "frequently lied." But these were *his* reporters now, journalists who had won the paper a Pulitzer Prize and whose work resonated with readers, driving up circulation, in turn producing enthusiastic advertisers who poured money into Harry's pockets.

After officially taking over his wife's position, Harry issued a generous one-time bonus to all employees in Alicia's memory. Sometime later he established a thirty-five-hour work week. He brought in Alicia's nephew, Joseph Medill Patterson Albright, as assistant to the publisher. This was a signal to *Newsday* employees of his respect for the Patterson legacy. Of course, Albright was just twenty-six and had been working out of *Newsday*'s Washington, D.C., bureau. He was too green to be editor anytime soon, but maybe Albright would take Alicia's place someday? That was the widely felt expectation.

Harry signaled another change, hiring his old Kentucky friend Mark Ethridge, a giant in American journalism, to temporarily take over Alicia's job as editor. Ethridge was transitioning to retirement after many years as publisher of the respected *Louisville Courier Journal*. He was a proponent of the New Deal and had received public service appointments by both Roosevelt and Truman, one of which was to chair a committee investigating racial discrimination in government. His appointment sent the unmistakable message to staff that *Newsday*'s editorial agenda would stay progressive and independent, in spite of Harry's well-known Republican leanings.

IV

In the fall of 1963 word apparently reached Harry from White House press secretary Pierre Salinger that, just as President Kennedy had met with Alicia, he would be open to doing so with Harry. Would Harry be available to discuss hemispheric relations soon at the White House? At the time the president's foreign aid budget was under attack in Congress. It included nearly $1 billion for the Alliance for Progress, a signature Kennedy program that had been likened to a Marshall Plan for Latin America. Harry sent a note to Salinger, suggesting: "If the President seriously wants to talk about Latin America, I should like to see him."

In the letter Harry reminded Kennedy of his bona fides: "My family has undertaken large mining and metallurgical operations in many Latin American countries. I am the third of four generations working there. After leaving college I lived in Mexico for three years. I lived in Cuba as ambassador for nearly four years . . . President Eisenhower asked me to take the position of Assistant Secretary of State for Inter-American Affairs in August, 1953. I begged him to reconsider because I thought that with the present organization for Latin America in the Department of State it would be impossible to accomplish what was needed. For what I had in mind required the creating of a new job and the appointment of someone of far greater international prestige and certainly no one whose family had large interests in many countries in Latin America. I have no ulterior motive except to be helpful. I am in my seventy-third year, with a warning to slow down. I could not take on any job even if it were desired, and I have no candidate for any job."

An invitation soon arrived. Harry would meet privately with Kennedy at the White House on the evening of Sept. 5, and be a guest at a state dinner that night. At 6:30 P.M. Harry was ushered to the Oval Office, where the president greeted him "with warmth and charm," recalled Harry. "He said that he had not realized that Alicia had been so ill. I explained briefly her

operations that ended so tragically." Harry asked Kennedy about the health of his own father. The situation wasn't good, he said, stating that Joseph Kennedy had lost his speech and could no longer write. The two talked about changes at *Newsday* since Alicia's demise and its new leadership under Mark Ethridge.

The Oval Office was filled with nautical touches evincing Kennedy's navy career, model clipper ships and oil paintings of schooners at sea. "You must know this room well," said Kennedy, stretching all the way back to "Mr. Hoover's time." Harry gently corrected the president, noting that he had first visited the White House during the Coolidge administration, just after launching the fund for aviation. Harry said that he remained a close follower of aeronautics, his current interest being supersonic passenger planes. Prototypes were being developed by England and France—Harry said the United States should produce its own version. To his surprise, Kennedy agreed. In fact, Jeeb Halaby had sent Kennedy a private memo on developing a supersonic prototype just three months earlier.

The conversation turned to Latin America; Kennedy asked for Harry's views. Harry said he was convinced, "that a basic difficulty in dealing with our Latin American affairs was organizational." What we need is "either an ambassador or undersecretary of state to have overall charge of Latin America, or this hemisphere if preferred." A single envoy for some twenty countries could escalate attention required to deal with individual nations or the region as a whole. As bad as U.S.-Cuban relations were at that moment, they were a worse headache thirty years before, when Hoover told Harry that the two biggest trouble spots in the world were south of the border. Kennedy showed interest in the concept of creating such a position. Then he asked Harry whether he could publicly use the reference by Hoover. Of course, Harry was happy to oblige. Outside, the temperature was cooling off; JFK invited Harry for a walk to see the Rose Garden, landscaped recently by a Kennedy family friend. They discussed Kennedy's Alliance for Progress, which Harry respectfully but candidly termed, "too little, too late."

Kennedy held firm on the level of funding he wanted for the program. Would Harry support it anyway? Harry agreed, but noted that on a per capita basis, the aid would be nowhere near enough to solve the problems of Latin America.

At the state dinner that evening Harry joined 200 guests and dignitaries for filet of beef, salmon mousse, and foie gras, and a 1955 Dom Perignon. In a brief toast, Kennedy said, "One of our guests here this evening, Ambassador Guggenheim, told me . . . that when he went to Cuba as our ambassador in the administration of Herbert Hoover, that President Hoover said to him that the United States had two problems in foreign policy: Cuba and Mexico. We still have one of those problems." The dinner guests laughed and Harry appreciated the reference, even if it served only as fodder for a punchline. The Cuban Missile Crisis and Bay of Pigs disaster were still fresh in everyone's minds.

Just ten weeks following Harry's visit, on a warm afternoon in Dallas, Kennedy was assassinated. Like the entire nation, Harry was shocked and dumbfounded by this act of violence. Most of *Newsday*'s edition that day had already run off the presses. The circulation department made an expensive suggestion: run a late edition, an "extra" without advertising. Harry agreed. Harry also ordered a temporary ban on gun advertisements, a small but symbolic measure.

V

Harry continued to expand *Newsday*, launching a national syndicate to sell *Newsday* content (an idea first suggested years ago by Alicia). Some big-name writers were brought on, among them: Pulitzer Prize winner Marguerite Higgins and Robert Moses, who would write a weekly column, "From the Bridge." The biggest name Harry reeled in was John Steinbeck, winner of both the Nobel and Pulitzer Prizes, a friend of Harry and Alicia's for a

decade. Steinbeck's assignment would be Vietnam, sending his reflections on the war in the form of dispatches to *Newsday*.

In 1964 it would have been natural for *Newsday* to endorse the Republican nominee, Barry Goldwater. But Goldwater made Harry uneasy, particularly his seeming openness to the idea of using nuclear weapons in Cuba and in Vietnam. Johnson was a Cold Warrior, too, but a stable one. In October Harry wrote the *Newsday* editorial endorsing Johnson, who won in a landslide.

After the election Harry used an intermediary at *Newsday* to open a line of communication with the White House. He made the same offer to Johnson to present his thoughts about Latin America as he had to Kennedy. The contact inside the White House was Johnson's press secretary, Bill Moyers. A visit by Harry to see Johnson would be welcome, said Moyers, who set up a meeting.

Harry was back at the White House again on a cold February day in 1965. Latin American affairs was the agenda, but he also planned to make an extraordinary recommendation to Johnson, an idea possibly hatched at one of Harry's hunts with ex–military brass at Cain Hoy. He wasn't sure how much time he'd get with the president, but would wait until the moment was right. Harry's appointment with Johnson was at 5:15 P.M. that day, but Moyers suggested he get to the southwest gate fifteen minutes early so they could talk beforehand. Harry arrived early and was escorted to the Cabinet Room. Moyers was in a meeting and running late—in his place appeared Jack Valente, Johnson's speechwriter and closest confidant.

Valente and Harry chatted until 5:15 P.M., when Valente was called in to see Johnson. A moment later Valente returned and walked Harry into the Oval Office. Harry took a seat and observed Johnson to be "in a perturbed state of mind." A butler brought a tray with coffee for Harry, while Johnson took a phone call—Johnson was always on the phone. When the president hung up, Johnson told Harry that he had earlier discussed the war with Eisenhower, who assured him that "there was absolutely no one to negotiate

with and if negotiations were carried out there would be no one to enforce their conclusions." Suddenly, Johnson reached into a jacket pocket and pulled out a wad of paper, perhaps twenty folded sheets, extracting one. The document was a "highly confidential cable" Johnson had just received confirming the disarray in the Viet Cong leadership, indicating that Eisenhower's statements were true, and that "negotiation was impossible."

Harry moved the conversation toward Latin America, asking whether he had read Barbara Ward's *The Rich Nations and the Poor Nations*. Johnson said he had. Harry told Johnson he "could not agree with her thesis that governments of rich countries should loan taxpayers' money to governments of poor countries for normal development. That loans for dire need and essential purposes were in quite a different category from those of normal venture capital." Harry and the president compared notes on Johnson's Latin American appointments, with Harry yet again bringing up the need for a pan-Latin diplomat who could act with dispatch when political hotspots flared up.

Harry saved his most unconventional comment until the moment he felt the end of his conference with Johnson was near. Twenty years after the end of WWII, American troops were still stationed in large numbers in Europe and Asia. About 270,000 U.S. troops were still in Germany. In the midst of an increasingly dangerous Cold War, a grand gesture might be called for. As Harry recounted: "I asked the president whether he had considered a world message at the appropriate time suggesting the withdrawal of all military forces to within national borders and all naval forces to within territorial waters. I conjectured that an evaluation would indicate that the United States would be in a very good situation vis-à-vis the rest of the world under such circumstances."

One can imagine Johnson looking up at Harry through his thick, rimless glasses, perhaps wondering if he was serious. Not missing a beat, the president replied, "Well of course nothing can be done at the present time until this present situation (Vietnam) is cleared up."

Johnson told Harry he was due at another meeting in the Cabinet Room; it was yet another emergency session on a development in Vietnam. Johnson asked Harry to come along to meet some of the members of the Cabinet. Harry shook hands with Secretary of State Dean Rusk, Secretary of Defense Robert McNamara, Undersecretary of State George Ball, and National Security Advisor McGeorge Bundy.

It's unknown whether Harry had really thought through the implications of his idea. (What would be the impact of withdrawing thousands of American troops keeping the peace between the Koreas?) However practical or impractical the suggestion, a related concept had been turning over in his mind for some time. This one was also related to global conflict and what he called "man's relation to man." It would be far more feasible and did not require the cooperation of a U.S. president.

Destiny of the Dynasty

I

Harry's quixotic suggestion to Johnson paralleled the out-of-the-box deliberations Harry was having with some close associates over the future of the small family foundation he had begun with Carol, later known as the Harry Frank Guggenheim Foundation. It began with a conversation at Cain Hoy in early 1959. After an afternoon hunt, Harry's retired military pals sat down for a round of drinks. Talk turned to the subject they knew most about—military battles. The world did not stop fighting after the Second World War. The war in Korea, still fresh in everyone's minds, caused the death of 3 million, mostly civilians, and the destruction of nearly every major city on both sides. The war ended right back where it began, with the country divided between north and south. The impulse for violence respected no borders and transcended all languages, observed Doolittle, a gifted raconteur who usually did much of the talking. "Harry, there's got to be a way to stop all these damn wars we're having," he said. "You're the only one with any money, why don't you start a foundation to do something about it?"

That year Harry began a series of meetings with Doolittle and Lindbergh to explore the question of "man's relation to man," that is, why humanity so frequently turns on itself with savagery and barbarism, in all its forms. The consequences of violence and war are well understood, but what were the causes? As Harry later wrote Lindbergh: "My premise is that men throughout history with great ability to dominate and exert power have abused that power. In pursuit of that primary urge to dominate their fellow man they have decimated him and caused incalculable destruction to the accumulated works of beauty and utility that man has created. I suggest that we have such dominating characters in the world today and constantly developing more who are harmful to the better relations of man to man. Unless we can find means to recognize these qualities and control them they will continue to cause holocausts of destruction."

Harry drew on many confidants to sharpen the focus of the problem and scope out an approach to addressing it, among them: Harry's younger cousin Peter O. Lawson-Johnston (then a vice president of the Guggenheim-owned Pacific Tin Consolidated); Charles Lindbergh; Edward Pendray (consultant to the Daniel and Florence Guggenheim Foundation); Dr. Paul Fitts, professor of psychology at the University of Michigan; and Henry Allen Moe, recently retired from the John Simon Guggenheim Memorial Foundation, where he had overseen the awarding of some 5,000 fellowships in the arts for nearly forty years. The project would be a "long and difficult journey," Harry wrote to Dr. Fitts. It was crucial they chose the right "explorers" to undertake it.

As Harry and this circle of advisors brainstormed the foundation's new direction, he buttoned down other matters, like the fate of Falaise. During his forty-plus years at Falaise, Harry had watched the grand estates of the Gold Coast disappear, their land subdivided by developers. He wished no such fate for his own home, so he willed the entire estate to Nassau County, with the stipulation that it would maintain the property as a public museum. It would be one more platform for people in the future to understand the

Guggenheim legacy, he reasoned. Harry worked up detailed instructions on how every item in every room would be arranged, which portraits of friends and family would be seen in the living room, how his top hats and military uniforms would be visible through the open closet door in his bedroom. He conducted walk-throughs of his home to experience what future visitors would see. In preparing to make Falaise a museum, Harry mounted a bronze plaque near the corner of the living room fireplace. It read:

> *Goddard: America's Father of the Space Age. Sitting before this hearth, in 1929, Carol Guggenheim noticed and read aloud to Harry Guggenheim and Charles Lindbergh the New York Times article about Robert Goddard's abortive rocket experiment at 'Aunt Effie's farm' in Massachusetts. Soon thereafter, Lindbergh arranged a meeting with Goddard, which was the first step in the Guggenheim financing of Goddard's pioneering developments in astronautics.*

Goddard scored more recognition of his genius that decade: a $1 million settlement by the U.S. government in a patent infringement case brought by Esther Goddard and Harry, whose parents' foundation owned the rights to Goddard's patents. It was a joint settlement by the army, navy, air force and NASA, the largest collective government settlement in U.S. patent history. Then there was the biggest vindication of all: the moon landing in 1969, which owed part of its success to Robert Goddard's early concepts of liquid-fueled, multistage rockets.

In the 1960s, as Harry entered his seventies, he was beset with the lingering effects of a back injury and some significant loss of hearing, likely from his proximity to the roaring engines of Avengers at Mercer Field. His tennis days were over, replaced by short laps in the pool at Falaise. No one his age piloted planes, given the quick reflexes required by instrument-only flying (an innovation Harry himself was in part responsible for).

Harry was slowing down, but what had not dimmed within him was his determination to find the right person to succeed him. He had added tens of millions in value to the family enterprises. The question was: Who could sustain the family legacy? As he wrote in a letter accompanying his will, "The Guggenheim family has helped to develop the natural resources of the world," pioneered the "air age and rocket age," and spearheaded ventures in education and the arts. "In planning the distribution of my estate," he wrote, "one of my primary objectives has been to arrange matters in such a way that one of the members of the Guggenheim family would have the opportunity . . . of carrying on the Guggenheim family tradition in the constructive use of the funds available to him."

What qualities would such a person possess? "The initial requirements for one to carry on such a tradition are those of character, integrity, a capacity for leadership, innate ability, preferably a superior education, and an urge to work and a determination to succeed." This was a Pygmalion concept, of course—these attributes sounded suspiciously similar to, well, Harry Guggenheim. Then there was the small matter that the Guggenheim family had, over the years, been "daughtering-out." Harry, along with uncles Solomon, Isaac and Benjamin collectively had twelve daughters and no sons.

II

Harry perhaps thought he found a successor in Oscar Straus II, one of his sister Gladys's sons. Harry made Straus a senior partner at Guggenheim Brothers, head of the firm's resurrected exploration division, praising him in a memo announcing the promotion. Straus would advance new mining ventures around the world and strike joint ventures with new partners. But Straus failed to bring back the glory days of the empire. He instead ended up in bitter arguments with his uncle, presumably over the fact that the

world had changed since the heyday of Guggenheim mining, when John Hays Hammond traveled with bodyguards and discovered one bonanza after another. Developing nations had since learned to be far more protective of their own mineral wealth. Soon Harry and Strauss were no longer talking. "After a while the two men could not even remain in the same room together."

No matter, Harry had another horse in the race: his grandson Dana Draper daughter Nancy's son. Harry had been cultivating Dana as the family's potential future patriarch since he was a teenager. Of keen interest to Harry was Dana's education. To prepare for running the Guggenheim empire Dana would have to attend the best schools, which at that time, according to Harry, were in the East. This caused sparks between Harry and Nancy, who preferred to let Dana choose his own school, preferably on the West Coast, where the family lived.

Dana was a quiet young man in his early twenties, always in jeans and T-shirts, a bandana around his neck and a satchel slung over his shoulder. His wavy blond hair reached his shoulders. Dana's interests were sculpture and photography, and he cared deeply about environmental causes. He was trying to figure out his way in life, considering a career as a doctor or possibly an educator. Ambivalent about his grandfather's overtures, Dana wrote to Harry about his bouts of despondency and indecision. Harry offered him philosophical advice: "You write of 'depressions and anxieties' in your search for understanding. Excessive introspection will not solve the problem, but, on the contrary, may blur your vision. Continue to read what the philosophers and brilliant analysts have written, but try to correlate their conclusions with the facts of life as you see them without you, rather than too much within you."

There was nothing courtly or erudite about Dana, but Harry believed he could guide his hipster grandson in the right direction. Dana simply needed structure and purpose in life. Such virtues could be derived from working for the family business, thought Harry. Dana agreed to give it a go. Harry

sent Dana down to Chile to study the family's nitrate interests, then a tour of duty at Cain Hoy, where he undertook a report on cattle operations, then on to the museum for a research assignment. All three stints seemed to go well.

When Dana agreed to attend school in the East, Harry was incredibly pleased and let Dana know it: "This is a birthday greeting on your 21st. I wish you a very happy and constructive life. We all owe the latter to humanity and I think it is the best way to achieve the former. I have learned that happiness comes from the 'ecstacy' [sic] of creation . . . This is the striving for completion that is the basic urge of life. On this occasion I wanted to give you a good car, but I hesitate to do so right now because most colleges deny the use of cars to freshmen." Harry settled on a more modest gift: "I am sending you a rather useless watch for the atomic age but it is a souvenir of the past." Harry went on to offer Dana a trip to Europe, and to pay for a friend to accompany him. He concluded: "I congratulate you on your perseverance to get a top educational foundation. Anything I can do to help, of course I shall do with real promise."

Dana took two summer school courses at Columbia in 1961, scoring a B in Psychology and a C in History. His application to Columbia was denied, but Harry used his influence to get Dana into Columbia's School of General Studies. After Dana posted better grades and graduated, Harry rewarded Dana with a trust fund and made him a trustee at the museum foundation, the Daniel and Florence Guggenheim Foundation, and the HFG Foundation. When Dana graduated Harry bought his grandson a Porsche.

Soon it came time to get to know the world of newspaper publishing. Harry asked Dana to take on a mini-apprenticeship at *Newsday*, providing him a guest room at Falaise. Dana felt somewhat overwhelmed by it all—the liveried servants insisting they take his clothes to be laundered and pressed; Walter arriving at the dining room with a multicourse breakfast; riding to the office by limousine. In his first week at *Newsday* Dana filled out paperwork, misspelling his alma mater, Columbia, then flunked an incoming reporter's test. He was paired up with a couple of the toughest editors at the

newspaper, who tried to show him the ropes. His copy was marked up so extensively that his typewritten words disappeared under the corrections. One thing soon became clear to everyone: Dana had absolutely no future in the newspaper business.

Seven weeks later, Dana broke the news to his grandfather: he was quitting. It was a gut punch to Harry, who said nothing at the time. After Dana left Falaise, Harry sent his grandson a letter: "I have ever tried to convince you—but am afraid I failed—that all the preparation I had attempted to give you was not in my interest but yours, so that you would lead a full, fruitful and dedicated life to your fellow man in our family tradition." That tradition must be carried on, wrote Harry, "by those who consider it a privilege and a rare opportunity, and not merely an obligation or for one's special benefit. I hope with greater maturity you will come to that conclusion, and try to find some way to retrieve the opportunity you have discarded, and serve." To Harry's credit, he did not ask for the Porsche back.

III

Along came a third possible successor, a dark horse candidate, another bright young man who showed promise. As early as a decade before her death, Alicia had been thinking about who might take her place at *Newsday*. She wanted it to be her nephew, Joe Albright. He became Alicia's surrogate son; she began referring to him as her likely successor when he was only a teen. Joe was the visual antithesis of Dana. With close-cropped dark hair and thick-framed black glasses, a hint of stubble on his face, he was a man in his early twenties who resembled a teenager in a suit. But Patterson journalism was in his blood. After attending Williams College, he spent the summer covering the police beat for the *Denver Post*, then became a general assignment reporter at the *Chicago Sun-Times*. When Joe turned twenty-three, Alicia asked her nephew to come to *Newsday* as a kind of paid

apprenticeship. *Newsday* historian Keeler recounted a meeting Joe attended with staff and union reps. A note was silently circulated, asking "Who's he?" The answer, scribbled back: "The heir apparent."

Joe Albright and his wife Madeleine, the future U.S. secretary of state, found a home in Garden City and visited Falaise often. Uncle Harry took Joe and Madeleine, then studying for her master's degree at Columbia, to the horse races. Harry invited them to Sunday lunches of roast beef and Yorkshire pudding and introduced the Albrights to their Gatsby-like circle of friends—George Abbott, Neysa McMein, publisher Bennett Cerf, socialite Marietta Tree.

Joe got to know the business side of the paper, working in ad sales (where he ventured off on sales calls, sometimes returning with the ad but not the check) and the circulation department (tracing delivery routes in his cherry-red Mercedes). Then it was on to the copy desk, and then a job at the paper's Washington bureau covering the State Department. Joe learned of his aunt's death while he and Madeleine were in Washington. He inherited 12 percent of *Newsday*'s shares from Alicia, who left her stake in *Newsday* to her four nieces and nephews. The day before the funeral Harry sat down with Joe on the terrace at Falaise and read a letter from Alicia asking Harry to give her nephew a chance to succeed her. It was an emotional moment. All signs indicated that Harry would give Joe a chance to succeed.

In the beginning, he did. Harry made Joe assistant to the publisher, allowing him a range of big and small assignments. He and Madeleine continued to spend time at Falaise. There was dinner one Saturday night with novelist John Steinbeck and *New York Times* publisher Arthur O. Sulzberger. There were gifts from Harry when they moved to a new home—homemade jams, an elegant fire screen, and later a salary raise and Christmas bonus for Joe. A generous check arrived over the holidays to cover the costs of a vacation to a Rockefeller-owned resort at St. John in the Virgin Islands. "Dear Uncle Harry, what a truly marvelous spot this is," wrote Madeleine. "It feels a million miles away, and you made it all possible for us."

The honeymoon did not last. Joe was a good reporter, but not much of a manager. Staffers found him to be indecisive and unsteady on the assignment desk, which some simply chalked up to a lack of experience. Whatever his failings, he did not instill confidence among the editor corps. "He was striving to please Uncle Harry," said Madeleine, "but it is questionable whether he ever had a chance." Although Joe was paired up with senior staff to learn the ropes, no one ever came forward to mentor him, she said. As Madeleine Albright biographer Michael Dobbs put it: "The quiet and unassuming Joe Albright lacked the glitz and gravitas that Harry regarded as essential qualities for running a newspaper."

In 1964 Harry ended Joe's assistant to the publisher position, naming him editor of a new weekend magazine (the editorial kiss of death). The following year Harry announced that Ethridge was leaving and that he, Harry, was taking over as editor (adding to his titles of president and publisher). If Joe Albright wasn't destined for leadership at *Newsday*, he certainly wasn't Guggenheim successor material. Harry's search for an heir among kith and kin had hit a wall, again.

But there was still hope: As Harry's confidence in Joe faltered, it rose in the talks he was having with yet another bright young man, Bill Moyers, special assistant and press secretary to LBJ, who had set up Harry's meeting with Johnson. Moyers's role at the White House went far beyond official titles. He wrote key speeches for Johnson and was a confidant of Kennedy's brother-in-law, Sargent Shriver, and therefore a trusted link between the Kennedy and Johnson camps (before and after the assassination). Johnson could rely on Moyers having an unusually good read on political machinations on the Hill, filling in Johnson by phone on who was delivering as promised and who needed to be called.

Moyers was a familiar face to American television watchers, his jet-black hair combed back perfectly, jacket always buttoned, a pair of black horn-rimmed glasses conveying the look of a character from *Mad Men*. Behind the White House podium Moyers disarmed reporters with his Southern

charm, self-deprecating jokes, and his sanguine intellect. He was erudite, likeable, and well-spoken. Bill Moyers had both glitz and gravitas.

What Moyers didn't have was the role he really wanted, a position out of the spotlight on the policy side of the administration. When two such opportunities opened up (national security advisor, undersecretary of state), Moyers had let his interests be known, yet failed to clinch either post. This caused tension between Moyers and his boss—Johnson was annoyed Moyers wanted to leave his job so soon.

In 1966 LBJ escalated U.S. combat operations in Vietnam. Over 6,000 American servicemen were killed that year, another 30,000 wounded. The number of American soldiers in Vietnam, on land and offshore, had reached 445,000 troops. Moyers was a liberal Democrat who deeply opposed the war, yet had to defend a war hawk president every day, in front of the world.

That year Harry asked Moyers to lunch at the Metropolitan Club in Washington. Moyers had been an assistant news editor for Johnson-owned broadcast stations in Texas. Would his future plans envision a return to the media world? If so, Harry had an opportunity. Why not come to work for *Newsday*? Moyers recalled the conversation to Robert Keeler: "I said, 'Captain, I know about your editorial policies, and I'm on the other side of the fence philosophically.'"

Harry replied, "But you have supported the president on the war."

"Yes, I have had some doubts, though," said Moyers.

"We all have doubts about it," said Harry reassuringly.

The job Harry had in mind would be to fend off potential competition in Long Island and oversee an expansion at *Newsday*. The position would entail taking over as publisher when Harry retired. Moyers was flattered and interested, but turned Harry down. Two weeks later a family tragedy caused Moyers to reconsider. His older brother, James Moyers, was diagnosed with cancer and killed himself. Moyers felt obligated to support his brother's family, at least for a while. It would be impossible to do this and support his own family on a White House press secretary's salary. Harry's

offer to Moyers was more than double that salary. Moyers called Harry back. After a second meeting at the Metropolitan Club, the terms were set: Moyers would get a five-year contract, at $75,000 a year, rent-free living at a *Newsday*-owned home in Garden City, and a company car.

IV

In December 1966 the White House announced that Moyers would soon leave the Johnson Administration to become publisher of *Newsday*. "I believe Bill Moyers is a kindred spirit who thinks, as I do, that newspapering should be a profession dedicated to public service," said Harry in an interview. "We share the common belief that integrity is the armature around which a newspaper must be built." At the time of Moyers's hiring, Harry was editor, publisher and president of *Newsday*. Moyers would become publisher while Harry remained president and became editor in chief.

When Moyers, just thirty-two, arrived for his first day on the job in Garden City, the printing plant stopped the presses for ten minutes to honor him, "like a twenty-one-gun salute." Later, naturally, Moyers held a press conference and fielded questions. Landing Moyers, one of the most visible faces of the Johnson administration, was a master move for Harry. "I've got a star" he told Leonard Hall, a friend and former chair of the Republican National Committee. To John Steinbeck, Harry wrote, "Bill Moyers at long last is on the job and is already everything I anticipated."

Two days after Moyers started Harry threw him a mammoth celebratory lunch at the Garden City Hotel, on the outskirts of the Gold Coast. On the guest list were 1,000 of the biggest names in New York media, business, and politics—*New York Times* publisher Sulzberger; county executives from Suffolk and Nassau; Sen. Robert F. Kennedy; Sen. Jacob Javits; New York governor Nelson Rockefeller. Inside the hotel's Georgian Room, tables were set with gold linen and crystal. Some eighty reporters from newspapers,

wire services, radio, and television came to cover the event. The last time that many journalists had converged on Long Island was the day Harry saw Lindbergh off on the reliability tour. Following some good-natured ribbing and testimonials from Harry, Kennedy, and Javits, Moyers took the podium and offered some thoughtful takes on the press and public policy. "A newspaper, in fact, is like politics, universal in its reach, yet always rooted in the people who live in a specific place at a specific time."

The people Moyers referred to were readers on Long Island, but Harry and Moyers agreed that the newspaper itself was too parochial. Readers across the island were increasingly sophisticated and cosmopolitan. *Newsday*'s identity should be more aligned with the city itself. Moyers said to Harry, "We're going to have to spend $1 million over the next three years to improve the editorial product, to hire people." This included expanding coverage of Vietnam. All this was in alignment with the larger national recognition Harry sought for *Newsday*. The budget for editorial improvements ultimately rose to $3 million. "The Captain never said a word about the cost," said Moyers.

In the coming months Moyers oversaw a format redesign, broader business news coverage, and deep-dive stories on poverty and race. He hired writers from the New York *Daily News* and the *Wall Street Journal*, dedicating one acclaimed columnist to solely cover New York City. Harry had sent John Steinbeck to Vietnam—Moyers hired novelist Saul Bellow to cover the Arab-Israeli war. Recognizing the lack of diversity in the newsroom, Moyers later set aside funds to hire ten journalists of color, including Les Payne, who later won a Pulitzer Prize for his reporting. Still, some editors didn't trust their star publisher, suspecting he took the job as a platform to launch a political career. He was getting plenty of advice to do just that. Lyndon Johnson suggested to Moyers he should come back to Texas to seek public office. Former New York governor Averell Harriman told Moyers he should run for a U.S. senate seat. Sen. Robert F. Kennedy asked Moyers to head his campaign for president.

Moyers waved off the political overtures but continued his association with leading Democrats. When Martin Luther King Jr. was assassinated,

Moyers flew down with Kennedy to the funeral. Harry blamed Moyers, in part, for the endless rumors about his political future. Moyers reassured Harry, telling his boss, with a touch of humor: "If you can shoot quail at Cain Hoy with all these right-wingers, I can surely take one trip with Bobby Kennedy to a funeral."

Grumblings aside, Harry was now considering Moyers as the man who could fulfil his elusive quest for an heir. Harry brought Moyers into his discussions of the business of Guggenheim Brothers and appointed him to the boards of the museum and the HFG Foundation. As Moyers recalled, "he wanted me to do more for him than *Newsday*." The job of Guggenheim museum trustee had its perks—one weekend Moyers jetted to Paris to dedicate the loan of a museum-owned Jackson Pollock painting to the U.S. Embassy. He cohosted some of the museum's famous themed dinners, like the one celebrating "Master Craftsmen of Peru." The fourth floor dining room at the Guggenheim resembled a tropical jungle in the sky—palm trees, grapevines, and ferns were beside every table. A flock of exotic birds was rented for the occasion, some of which escaped their cages, setting off a hunt for cockatiels, myna birds, and parakeets flying and walking around the Guggenheim's upper floors. All were apparently rounded up before the arrival of some one hundred dinner guests, including the Peruvian ambassador, who brought with him a dozen cases of brandy (ensuring no shortage of pisco sours that evening).

V

To Harry, second only to the future of *Newsday* was the future of his horses. He had become royalty in the sport of kings, part of an elite, small circle of owner-winners, the first Jewish member of the Jockey Club and a cofounder of the New York Racing Association. (*An account of Harry's formation of the NYRA with its first chairman, John Hanes, appears in this book's Source Notes.*) Over the course of thirty-five years Cain Hoy horses had won about 1,000 races and made it to five Kentucky Derbys.

Those days ended after Harry's final Kentucky Derby appearance with Captain's Gig in 1968. Harry saw no point to passing his horses on to any heir. The following year Harry visited Barn 48 at Belmont Park, making a final visit to see his favorite racehorses. He walked slowly beneath the hay-lofts, leaning slightly on his cane for balance. The walls of the Cain Hoy office were chockablock with framed photographs of some of Harry's leading horses: Turn-to, Bald Eagle, Armageddon, Battle Morn, Ack Ack, Dark Star, Anchors Aweigh, Bimini Bay, Hushaby Baby. Soon their track records would appear in Harry's 180 page catalogue, *Cain Hoy Dispersal*. Printed on glossy, heavy stock paper, its cover was embossed with the textural feel of fine leather, like those old offering documents at Guggenheim Brothers. The first photo of the booklet wasn't a horse, but a full-page close-up of Harry himself, wearing a confident master-of-the-realm expression, taken perhaps ten years earlier. The image reminded readers that these were Guggenheim horses—thoroughbreds owned by a family with its own pedigree. Harry's old English bloodstock agent, Humphrey Finney, handled the sale. In auctions at Keeneland and Belmont Park, Finney sold Harry's mares, weanlings, yearlings, and stallions for a record $4,751,200 ($35 million today).

Back at *Newsday*, the 1968 season of the paper's softball league drew players from across *Newsday*'s departments. Moyers batted .425 in the slow-pitch league and was a solid second baseman (though his team finished last). Harry and Moyers talked about everything—baseball, football, tennis, crime coverage, horse racing, costs of newsprint, Guggenheim museum business, the man's relation to man project. By all accounts Moyers's tenure at the paper was a rolling success. That year, at a circulation of 425,000, *Newsday* was among the top twenty newspapers in the country and physically one of the largest, an average 158 pages. It had become the largest suburban daily newspaper in the United States and was still growing.

A good year for Moyers, but a very bad one for Lyndon Johnson. The welfare, housing, and urban renewal programs of the Great Society, the creation of Medicaid and Medicare, and the Voting Rights Act were undeniable

triumphs for Johnson and the country. But there was never any positive news in the relentless daily coverage of the Vietnam War. In the midterm elections of 1966, Democrats lost forty-seven seats in the House. Inflation was climbing, and Johnson's approval ratings were plummeting. Johnson abandoned plans to run again. Harry endorsed Nixon on the editorial page; Moyers published a dissenting opinion piece endorsing Hubert Humphrey.

This decision by Moyers was no surprise to longtime readers and watchers of *Newsday*; Harry and Alicia had conveyed differing political endorsements on the editorial pages for years. But Harry was annoyed by press coverage terming the split "confusion" at *Newsday*. Another tiff with Moyers emerged on election eve, when Moyers and a group of editors gathered in Harry's office to watch the returns, until Nixon's victory was clear. Harry said, "Well, now it's over, he's president of all of us." To which someone in the room cracked, "He's not my president." No one seemed to pay much attention to the comment, but Moyers got a memo from Harry the next day. It read, in part: "The reaction of the people in my office last night confirms my worst suspicions . . . their deep-seated hostility toward him (Nixon) was obvious in the dismay on their faces and in their comments. They will never give him a chance . . . I am sure you will find a way to free *Newsday* from the clutches of propagandists and polemicists who are so deeply prejudiced that they cannot see what is right for their country."

Moyers pushed back sharply with a rebuttal memo defending his staff's right to voice political opinions. Around this time Harry had the first of a series of health scares. He was diagnosed with prostate cancer, prompting Moyers to write another memo to Harry, this one a recap of medical research on the subject from the Mayo Clinic. While Harry had lashed out at Moyers over liberal bias in the newsroom, he showed no signs of abandoning Moyers, either as the future leader of *Newsday* or potential heir apparent.

After the election *Newsday* editorials on the new administration were conciliatory toward Nixon, stating that the new president should be given the chance of finding a way out of the war. The paper's editorials had

generally been soft on Nixon only because the editorial page editor, Stan Hinden, was Harry's handpicked arbiter of the section. Following Harry's cancer surgery, he was spending almost no time at *Newsday*, so Moyers assumed more control at the paper and thought it an opportune time to replace Hinden with David Gelman, a former journalist whom Moyers had known in the Peace Corps, banishing Hinden to the Washington bureau. A funny thing happened on Hinden's way to Washington: he stopped at Falaise to see Harry, no doubt encouraging Harry's belief that his newsroom was becoming a hotbed of liberals. Hinden described Harry as "distressed," asking Hinden, "What is it that Moyers is trying to do?"

Newsday editorials now reflected increasing public skepticism of Nixon's war strategy in Vietnam. Harry was deeply irritated not just by this, but by the sea change he perceived on the news side, particularly of the anti-war movement. *Newsday*'s sympathetic coverage of Vietnam Moratorium Day in the fall of the following year, for example, made Harry irate. As Harry wrote in a memo to Moyers: "*Newsday* was sucked into the deception perpetrated by the organizers of the Moratorium to the effect that overwhelming numbers of people supported their efforts." In truth, said Harry, "Our left-wing city room accepted the propaganda without question."

Nothing could have prepared Moyers for the next row with his boss. Moyers came to lunch at Falaise one afternoon and found Harry sitting at a table off the terrace, a book beside him with a rearview photo of a curvaceous woman on the cover. The woman was naked and on her knees, long blond hair reaching the small of her back. Harry was reading reviews of the book, with tears in his eyes, and said bitterly to Moyers when he arrived, "They would never have done this to Alicia."

Moyers knew all about the book, *Naked Came the Stranger*, by Penelope Ashe. It was an instant *New York Times* bestseller—and a complete hoax—written by twenty-five journalists at *Newsday*. The mastermind behind the prank, *Newsday* television critic Mike McGrady, said he was fed up seeing the runaway success of insipid works by writers like Jacqueline

Susann and Harold Robbins. So, he compiled a collection of the most god-awful, purposely bad prose, lacing it with carnal debauchery. The guidelines he issued to writers contributing chapters were clear: "There will be an unremitting emphasis on sex. Also, true excellence in writing will be quickly blue-penciled into oblivion." The novel explored infidelity as a means to restoring marriage. Its plot revolved around husband and wife talk show hosts. When the wife, Gillian, catches the husband carrying on with a production assistant, she decides to teach him a lesson by having an affair with every man, and one woman, that crosses her path. She has sex with a rabbi, a mob boss, and many others at familiar venues on Long Island, and one encounter on the upper level of a double decker bus. Written with a "perfectly realized awfulness," the book sold 20,000 copies before readers discovered it was a literary hoax. Profiled in 600 newspaper stories that year, the novel went on to sell 400,000 copies and was turned into a softcore movie even worse than the book.

Naked had started long before Moyers arrived—he was asked to contribute a chapter, which he quietly declined to do. This made little difference to Harry, who believed the entire episode brought shame and ridicule on the *Newsday* brand and indirectly, on the Guggenheim family reputation. The book became yet another battle over the rights of *Newsday* journalists to express themselves. As Moyers told Robert Keeler: "I wound up in a series of meetings defending their right to do this, and therefore, becoming more in Harry's mind on the other side. Harry Guggenheim believed that I should have prevented that, that I could have prevented that . . . He never forgave me for them."

VI

Oscar, Dana, Joe, Bill Moyers—Harry saw in each of them what he wanted to see, rather than who each of them was. As Dana told Robert Keeler: "So

much of it had to do with his fantasies." Harry projected the attributes he desired onto those he tried to anoint, whether they possessed them or not. That said, in spite of the contretemps with Moyers, Harry had settled on a new leadership model, one in which Moyers would run and eventually take over *Newsday*, while Harry's younger cousin, Peter Lawson-Johnston, would someday head Guggenheim Brothers.

Peter was yet another dark horse in Harry's succession regatta. He had not really known Harry until the early 1960s. Peter was a son by the first marriage of Uncle Sol's daughter, Barbara. After Barbara divorced Peter's father, Sol became a kind of surrogate father to Peter. For some years he attended school in Florida while living on Solomon's yacht, a converted U.S. destroyer. Lawson-Johnston spent time with his grandfather at Trillora Court and Big Survey in South Carolina. Harry once suggested Peter take a job down at the family's nitrate fields in Chile, but Peter's wife Dede laid down the law, stating she had no interest in living in the Atacama Desert. Peter went on to work at other family businesses within the U.S., that "poor first impression" lingering until Peter came to see Harry one day at 120 Broadway. Peter says he requested to see Harry simply to ask to be put on the mailing list for the museum, but the two seemed to hit it off. Like Harry, Peter practiced a gracious formality. He was a dapper, well-mannered, and well-educated man in his early forties, easygoing and likeable. Before long Harry had Peter installed on the museum board and made him a partner at Guggenheim Brothers.

In late 1968 Harry added a codicil to his will stipulating a $100,000 bequest to Moyers and a four-way split of Guggenheim mining shares to Moyers, daughter Joan, Lawson-Johnston, and John Peeples, chairman of the Guggenheims' Anglo Lautaro Nitrate Corp. Some months later Harry is believed to have suffered a stroke. This latest health problem stoked Harry's paranoia. He cut himself off from Moyers and began to communicate only by notes and memoranda. "That was the dividing line," said Moyers. "I've read a lot about strokes . . . They make you a different person in the same body. And that's

what happened to Harry Guggenheim." After that, Harry's lawyer, Leo Gottlieb, described him as "crotchety," "unreasonable," and "suspicious of everybody." Harry was becoming particularly leery of Moyers, who he believed was usurping his power at *Newsday*.

While Harry was being treated at Memorial Sloan Kettering in Manhattan, he called his personal secretary, George Fontaine, asking him to place a certain document into a manila envelope, seal it, give it to Peter Lawson-Johnston, and ask Peter to bring it to Harry's hospital room, unopened. Peter recalled he had no idea what to make of this, expecting it could be very good or very bad news. When Peter arrived Harry was sitting up in bed, looking pale and much smaller than he had in earlier days, having lost weight. He spoke very softly. "Is that the envelope I asked George Fontaine to give you?" asked Harry.

"Yes, would you like me to open it?"

"Yes, please, and read what's in it. I think it may interest you."

Peter's heart started to pound as he opened the envelope and read the document, his eyes welling up in tears. It was not bad news, it was very good news: the document was Harry's will and it stated that Peter would be Harry's principal heir. Peter would be chief trustee of an estate worth perhaps $50 million ($350 million today). His inheritance would include land on the Falaise estate; Harry's 74th St. townhouse; a quarterly income equal to 5 percent of the assets of Harry's trust; use of Cain Hoy for his lifetime (to revert to the HFG foundation after that); a 40 percent share in Guggenheim mining interests, and more.

"Harry, I'm in a state of shock," said Peter. "I'm overwhelmed. Why me?"

"Peter, I have been watching your progress over the past several years and there is no one else to whom I could comfortably entrust this responsibility. Also, you have a fine family of your own. And you are a gentleman." Making Peter principal heir made the will a very unequal distribution of wealth. Harry believed that only by centralizing his assets with a single

actor could the family's business legacy and social impact investing be carried on.

Harry surprised Peter again on an early Sunday morning in February 1970. Harry called him from a beachfront cabin in Golden Beach, Florida. As Peter recalled the conversation:

"Peter, I need your help with a problem at *Newsday*."

"Do you want me to fly down to see you?"

"That's the general idea."

Peter arrived at the cabin the next day. Inside the dark beachfront bungalow, Harry sat on an overstuffed couch beneath a copy of van Gogh's *Sunflowers*. He was deeply tanned, setting off those pale blue eyes, but he had lost more weight, his small head resembling a skull. "Excuse me for not rising," he would say to visitors. "My legs have been giving me a little trouble." Peter sat down and Harry pulled out a handful of *Newsday* editorials, most of which criticized Nixon over the war. With the surf crashing in the distance, Harry's voice rose, telling Peter he was "ashamed" to have his name on the masthead of his own newspaper. He wanted his paper to continue on in the hands of someone who shared his views—meaning a moderate Republican. "I've made up my mind to sell it to my friend Norman Chandler." Chandler owned Times Mirror, publisher of the *Los Angeles Times*. Peter was shocked, but agreed to help Harry with the plan, which called for Peter and John Hanes to surreptitiously gather the latest financials from *Newsday* to prepare it for a sale. Harry did not want Moyers or the Albrights to know. They might try to sabotage his plans or find a more liberal buyer.

Harry wanted a direct sale—no brokers or third parties. To do this he would offer *Newsday* to Chandler for a very attractive price. Finally, after the data was collected and a deal was in place, Harry called Joe Albright. Upon hearing the news, with Harry on the other end of the line, he replied with alarm, "What do you mean, you're selling *Newsday*? You can't do that. You can't. My family owns 49 percent!"

As Madeleine Albright recalled: "Joe and Bill Moyers had never been close, but now they scrambled to put together enough money to bid on the 51 percent Harry Guggenheim owned. They succeeded, but Harry would not sell to them." Moyers apparently shopped around for other buyers. When Harry discovered this he was livid. It was a final betrayal by Moyers, the last straw, he thought. Harry removed Moyers from the museum board and added another codicil to his will, canceling the cash bequest he had planned to give his publisher and striking Moyers as a beneficiary of his estate.

The Chandlers bought *Newsday* for $75 million, a staggering return on investment considering Harry had put less than $1 million into buying the paper and covering its losses for the first seven years. As Madeleine Albright noted, by holding out and attempting to find another buyer, "Joe and his family ended up with more cash for their minority share than Harry received for the majority, but money was beside the point."

A minor detail Harry failed to comprehend was that the person setting editorial policy at Times Mirror wasn't Norman Chandler, but his son, Otis, who was every bit as liberal as Moyers. Harry in fact sold his newspaper "to the wrong company, ideologically speaking," said Peter. No matter—when the sale of *Newsday* was consummated in May 1970, Moyers resigned, with two years left on his contract. Harry bought him out for $300,000 and allowed his former publisher to remain in his *Newsday*-owned Garden City apartment for some time.

Later that year, in August 1970, while at Saratoga with daughter Joan, Harry had a major stroke (his third). It left him almost unable to speak and barely able to move. An ambulance took him to Falaise, where he spent the last few months of his life. A bed was set up for him in the downstairs book room, clusters of prescription bottles soon covering nearby tabletops, a copper bracelet sitting on one, a gift of John Hanes to help Harry manage his pain. Those who came to see the old man were a small group of his most loyal friends and family: Peter, Joan, John Hanes, Thomas Messer

on occasion, and the most frequent visitor, Charles Lindbergh. In the old days Lindbergh would have flown in and landed at a nearby horse pasture. Instead, he drove down to see Harry from Connecticut in his Ford Falcon station wagon.

In the very early hours of Jan. 22, 1971, Harry Guggenheim died at the age of eighty. Like everything else, Harry's demise appeared as if he had planned that, too. A few years earlier, Peter recalled, he and Harry were sitting by the fire at Cain Hoy. Peter asked Harry whether he was afraid of death. Said one heir to the next: "Peter, if I should die in my sleep tonight I could think of nothing more beautiful."

EPILOGUE

O n a cold, overcast day in late February 1971, a private service was
held for Harry at Manhattan's Temple Emanu-El. A chief rabbi and
a navy chaplain presided, all three daughters and sister Gladys attending.
(Harry's older brother Robert, after a short stint as ambassador to Portugal,
had died a decade earlier.) From there the entourage traveled to Salem Fields
Cemetery in Brooklyn, arriving at the Guggenheim family mausoleum,
an imposing chamber modeled after the octagonal "Tower of the Winds"
clocktower in Athens. With a thin layer of snow on the ground, an out-
door tent had been erected, inside of which Harry's coffin lay draped in an
American flag. After a multigun salvo from a U.S. Navy honor guard, the
flag was folded and presented to the family. The doors to the mausoleum
opened, revealing a pitch-dark shaft leading to Harry's final destination,
near Meyer and Barbara, Daniel and Florence.

Harry's 48-page will named two chief beneficiaries: Peter Lawson-
Johnston and the HFG Foundation. Harry gave the foundation $12 million
and another parcel of land he had bought in South Carolina, Daniel Island,
a 4500-acre peninsula bordering Cain Hoy, used for his cattle business. To

each of his daughters he gifted $250,000. To the outside world it appeared that Harry had snubbed Joan, Nancy, and Diane. But each had already received some measure of family wealth, through trust funds created for them and financial help over the years. Harry forgave loans to relatives, like the one he had extended to his favorite granddaughter, Carol Langstaff (daughter of Diane), to buy her home in Vermont. She was among the small handful of visitors who came to see Harry at Falaise in his final days.

Harry's longtime butler, Walter Moulton, received his bequest a few years earlier, upon retirement. Harry wrote to him: "You have been with me for nearly 42 years. In all that time there has never been an unpleasant word between us, unless there has been an impatient one on my part on some rare occasion. You have been the best and most loyal of friends. I am most grateful to you. You have looked after my welfare so very efficiently and loyally all these years . . . I shall look after your welfare in so far as I can do that for the rest of your life." Harry became Walter's informal investment advisor and made suggestions on changing some of his retirement holdings, giving Walter a monthly stipend of 62 percent of his regular salary. The letter ended, "With every good wish, Your long time and sincere friend, Harry."

The Falaise in which Walter had worked for four decades opened as a Nassau County museum two years after Harry's death. Curators carefully followed Harry's sequenced tour instructions—its rooms and furnishings arranged just as they looked when Harry and Alicia lived there. The dining room table was set with six place settings using the Ambassadorial china and Cuban crystal. Among framed photos in the living room: Bernard Baruch, Herbert Hoover, Gladys Strauss, Charles Lindbergh, Robert Goddard, Jimmy Doolittle, Alicia Patterson, George Abbott, and Carol Langstaff. Above the massive fireplace mantle, an ancient tapestry given to Harry by Florence depicted a Swiss landscape, a reminder from his mother of his Swiss roots. Among other works of art: a Giacometti sculpture; Paul Gauguin's "The Black Venus"; a statue of St. John the Baptist by Florentine sculptor Andrea della Robbia.

Upstairs, the northeast bedroom had become known as the Lindbergh guest room. On one wall Harry had placed a framed sheet of handwritten text by Lindbergh, a page from the manuscript for *We*. Down the hall, in Harry's bedroom, two French porcelain lions sat on either side of the fireplace, next to his open closet door, Harry's military uniforms on display. On the wall opposite his bed was a Renaissance-themed Spanish oil with a motto in Latin, roughly translated, "They have elected me, will you follow?" Down a narrow staircase, visitors came upon the trophy room, appointed with Chippendale furniture in rich mahogany. A glass case commemorated the triumphs of Cain Hoy thoroughbreds—silver cups and plaques, the 1953 Kentucky Derby gold cup along with a painting of Dark Star vanquishing Native Dancer. Harry wanted the tour to end at the swimming pool—at each corner is a 600-year-old marble sculpture of a carp (a wedding present from Alicia's side of the family).

Lindbergh's last visit to Falaise was during a preopening lunch there in May of 1973. He and Anne lunched with Guggenheim family members and others, among them Robert Moses. Lindbergh addressed the lunch gathering, thanking the county for letting him see his "second home" again. "The halls, the rooms are almost identical to when I saw them in 1927." Joan was the only daughter to attend; Diane was in Europe at the time. Tragically, Nancy ended her own life just four months earlier from an overdose of sleeping pills after a raft of devastating health problems. Today, Harry's Cadillac is in storage, but Lindbergh's Ford station wagon sits off the courtyard entrance, its blue paint fading. "It may be Lindbergh's way of saying, 'I'll be back,'" said historian and Falaise curator Ken Horowitz on a recent tour.

After the war Harry and Slim resumed their friendship and expansive correspondence, much of it related to Lindbergh's interests in preserving wildlife in Africa and protecting the blue whale. Several times a year, Harry came to visit the Lindberghs at their Connecticut home on Scott's Cove, always in jacket and tie, no matter what the occasion, recalled Reeve

Lindbergh, the aviator's youngest daughter. After lunch—usually buffet style from a sideboard—Harry would lean back in an armchair and light up his billiard pipe, signaling the start of many hours of conversation. The controversies that engulfed Lindbergh in the years just before the war—his passionate defense of noninterventionism, his dissentious America First rallies, the Des Moines speech—continue to be debated. As daughter Reeve put it, "When I read my father's statements today, I can understand why people called him antisemitic." The Des Moines speech was like "throwing a match onto a powder keg. I don't think he understood that. I don't know why. There was an absence of understanding of what certain words and phrases meant to people. My mother had it by instinct. She was a diplomat's daughter." Harry, a former diplomat himself, also understood this. "Harry didn't agree with many of the things my father said in speeches," said Reeve, "but it did not destroy their friendship."

One thing Lindbergh well understood was Harry's contributions to developments of both the air and the space age. In the 1960s Lindbergh wrote: "It can be said without doubt that Guggenheim contributions played a major role in achieving for the United States its mid-20th century position of world leadership. By training scientists and engineers, they heightened our military power," and by accelerating "perfection of aircraft design" prior to WWII, Harry and Daniel "helped us to destroy our enemies, and saved unknown thousands of American lives."

Some forty years later the former dean of the Harvard Business School, Nitin Nohria, came to a simlar conlcusion. A 2009 study on business leadership in the early years of aviation, coauthored by Nohria, found that Harry likely had a greater impact on the growth of the air age than the Wright Brothers, because he believed in disseminating technology, not sequestering it as the Wright brothers had.

Harry backed Robert Goddard's work for over a decade, but it took years for Goddard's rocket research to be recognized by the U.S.

government. A biographical history of Goddard by NASA calls him the "father of modern rocketry," noting, "Goddard didn't live to see the age of space flight, but his foundation of rocket research became the fundamental principles of rocket propulsion." The leaders of the new space race—Jeff Bezos, Richard Branson, and Elon Musk—owe much to Goddard's work.

❖

In the spring of 1971 the Guggenheim museum trustees met and discussed Harry's legacy at the Guggenheim. They lauded him for laying the groundwork in acquiring two of the Guggenheim's foundational collections —one from Justin K. Thannhauser (some 75 works forming the core of the museum's impressionist holdings, including 32 Picassos); the other from Peggy Guggenheim (over 300 works of Cubism, Surrealism, and abstract expressionism, all residing in her 18th century Palazzo Venier dei Leoni, on Venice's Grand Canal, now operated by the New York Guggenheim). After decades of estrangement, Harry welcomed cousin Peggy back into the family fold by organizing her first show at the Guggenheim in 1969. Peggy's impact on the world of modern art has since been chronicled in books, plays, and the groundbreaking 2015 documentary by Lisa Immordino Vreeland, "Peggy Guggenheim: Art Addict."

The trustees recognized that, "more than any other person," it was Harry who brought the museum into being. The Guggenheim's current director, Richard Armstrong, agrees: "By temperament, it was a big stretch for Harry Guggenheim to take over the building of the museum. He was an impatient person interested in clarity and execution, attributes that aren't often associated with an art museum. But he felt an enormous responsibility to get the museum built."

Apart from building the museum, Harry's greatest impact on the Guggenheim may have simply been to rename it. Changing its title from

"Museum of Non-Objective Art" to the Solomon R. Guggenheim Museum was one of the most consequential branding decisions in business history. Fusing the art of the future with Wright's architectural masterpiece created an institution with cultural credibility. Or in Armstrong's words, "The single most powerful art brand in the world." Since then, museums themselves have become works of art, designed by celebrated architects like Frank Gehry, I.M. Pei, Zaha Hadid and Santiago Calatrava.

The power of the family brand helped the Guggenheim Bilbao become a driver of economic growth in the small town, as it was designed to do. Peter Lawson-Johnston admits he was initially skeptical of the idea. In the early 1990s the Basque government approached the Guggenheim board, proposing a joint venture to build a Spanish sister museum. "I had never heard of Bilbao," says Peter, "but I visited the city with a friend and board member, Robert 'Stretch' Gardiner, and met with the mayor of Bilbao to talk about the proposal." City authorities put on a gracious welcome, but neither Peter nor Stretch was convinced that opening a second museum in an economically depressed Spanish port town was a good idea.

Peter asked Stretch, "What do you think we should do?"

"I would make an impossible demand that'll cause them to back off the idea, then no one's feelings will be hurt."

So Peter made what he thought was an outlandish offer, telling the Basques they would have to agree to a $100 million budget, including a $50 million acquisitions fund and a $20 million fee for the Guggenheim foundation. "I thought, well, we'll never hear from them again." Three weeks later the Basque government agreed to fund the Frank Gehry–designed building. Peter and the board have since welcomed potential partnerships in other cities. Richard Armstrong says the Guggenheim Abu Dhabi, long in the making, is on track to open by 2026.

Museums require a unique alignment between art and money. Their reputations are built on getting the balance right. In his letters to Frank

Lloyd Wright, Harry reminded the architect that the art must not be sub-jugated to the building and that the museum is, in part, an educational platform whose credibility rests on serving the public interest. Near the end of Sweeney's reign, Harry realigned the entire administrative staff, separating business and curatorial functions. Harry was obsessed with conveying a sense that the museum operated with integrity and competence, qualities critics had earlier charged the museum lacked. Harry largely succeeded at this. All of this imbued the Guggenheim brand—both the family and the museum—with exactly the kind of attributes required to launch a company in a very different sector of business: Wall Street.

In the late 1990s, in the middle of the dotcom boom, Peter's son, Peter Lawson-Johnston II, known as LJ, was looking to raise capital for a family real estate fund. This led to a conversation with a friend and Connecticut neighbor, Todd Morley, then head of a broker-dealer, Links Securities. Through a Morley associate they met Mark Walter, who with partners had recently formed a commercial paper outfit, Liberty Hampshire, and were looking to grow their business. The idea surfaced to unite these three entities—LJ's real estate assets, Morley's broker-dealer, and Walter's Liberty Hampshire—under a single brand. The partnership was essentially a real estate roll-up with a powerful new name. "We talked a lot about what this could become," said LJ. The result of those conversations is Guggenheim Partners, a global financial services firm. The company reached $100 billion in assets under management (AUM) in its first ten years. Today that has risen to over $300 billion in AUM and some 2,400 employees. (The author was chief content officer at Guggenheim Partners for six years.) "A powerful brand enhances the tangible value of a company," says LJ.

One trait the company shares with so many of Harry's early ventures: punching above its weight. Guggenheim Partners was a lead advisor on the 2013 Verizon-Vodafone merger (then the third largest business deal in history). The company's growth has made its chief executive, Mark Walter,

a multibillionaire. Walter formed a group of investors, among them Magic Johnson, to buy the Los Angeles Dodgers for $2.2 billion.

One of the first questions new clients often ask is: "How are you related to the museum?" Board members have debated how closely aligned, from a brand perspective, the two institutions should be. LJ, a managing partner, answers the question in regular PowerPoint slide-shows to senior staff and others at the firm. Besides chronicling over 100 years of Guggenheim family business, much of it related to Harry, LJ describes the "family formula" for success and its Steve Jobsian approach: acquire great talent, not so you can tell them what to do, but so they can tell you what to do.

LJ remembers meeting Harry when LJ was a child and watching horseraces with Harry from his box overlooking the finish line at Saratoga. In Guggenheim Partners' New York offices, Harry's gold Kentucky Derby trophy, once at Falaise, is displayed on the 32nd floor. Nearby is the gilt-framed portrait of Meyer and his mutton-chops, his eyes fixed in a magisterial gaze.

❖

As a navy pilot in both world wars and a witness to the brutality of the Cuban revolution, Harry had seen the consequences of violence firsthand, on a vast scale. With input from Lindbergh and Doolittle, social scientists and academics, he set his own foundation on a course to explore the root causes of human violence.

The year 2021 marks five decades since Peter Lawson-Johnston succeeded Harry as chair. The foundation's early studies looked at the human instincts of violence and aggression through the lens of neurobiology and evolutionary biology. Later came a focus on criminology and political science. One thing that has not changed is the far-reaching, almost intractable

scope of Harry's mandate. "We are a modest size foundation with the most ambitious of agendas," said its new president, Daniel Wilhelm, a criminal justice reform veteran.

Known for its rigorous scholarship, the foundation's work is well recognized within the academic community. What it has done less well is to convey the fruits of that scholarship to policymakers, says Wilhelm. "Where we find ourselves now is with a new challenge, which is to do a more purposeful job of trying to identify research that can speak directly to contemporary issues of violence, and to suggest ways to prevent that violence to people in the world of policy and practice."

Crime and justice issues have come into sharp focus in the Biden era. Among the areas of research Wilhelm says the foundation will tackle: mass shootings, policing and race, violence and the Covid-19 pandemic, violent threats to democracy via uses of disinformation, the catalytic role media plays in relation to violence, loss of a shared concept of nationality, and direct attacks on democratic norms.

One high-profile event the foundation sponsors each year is a two-day symposium on crime in America at New York's John Jay College of Criminal Justice. The conference's highlight is the Justice Trailblazer Award, administered by the Center on Media, Crime and Justice and headed by prize-winning journalist Stephen Handelman. Bill Moyers won the 2018 Trailblazer Award for his documentary on Riker's Island. During his acceptance speech, Moyers noted his connection to the foundation's namesake and the fact that Harry had hired him as publisher of *Newsday* in 1967. "That was one big favor he did for me," said Moyers. "He did me a second one four years later, when he fired me." It was a sacking with serendipity. Bill Moyers spent the next 45 years building a legendary career in broadcasting, earning 36 Emmy Awards and 9 Peabodys.

❖

A final Harry Guggenheim legacy is yet another business the Guggenheims had never been known for: real estate. The community of Charleston, South Carolina, whose streets resemble snapshots in time from the antebellum South, recently became the largest city in South Carolina. That milestone was driven, in part, by the creation of two new communities on land Harry once used for timbering, hunting, and cattle ranching.

One is Daniel Island, a peninsula of about 4,000 acres on the southern border of Cain Hoy. Harry left the land to the HFG Foundation. Daniel Island is just across the Cooper River from Charleston, yet it has always been difficult to reach, requiring a forty-minute car ride via a circuitous route coming from downtown Charleston. That changed in the early 1990s, as the I-526 Expressway was extended across the river to connect Daniel Island to North Charleston, thereby making the airport five miles away and downtown Charleston just fifteen miles away.

The city incorporated the land, and LJ (with a real estate degree from Columbia University) went to work capitalizing on the rising land values on behalf of the foundation. He commissioned a master development plan for Daniel Island. The low-country forests Harry used for cattle ranching and hunting now include several thousand units of housing, two golf courses, a tennis stadium, markets, banks, churches, and schools, all surrounded by twenty-three miles of rivers, marshes and waterways. Daniel Island's growing population includes one member of Congress, Rep. Nancy Mace. The peninsula has its own newspaper, the *Daniel Island News*, published weekly by Sue Detar, one of the first residents on the island. Naturally there's a Guggenheim-themed restaurant, "Harry's"; its walls hold photos of HFG with Lindbergh, Goddard, and Vice Admiral John S. McCain.

To the north, Harry's second major parcel, Cain Hoy, is undergoing a similar transformation. Some 9,000 housing units will be built, many of them on land purchased by a real estate investment unit within Guggenheim Partners. LJ is applying lessons learned from Daniel Island to Cain Hoy.

"Years ago the number one amenity people wanted was golf. Now it's open space and walking trails, so Cain Hoy will reflect that." Roughly half of its acreage—about the size of the entire Charleston peninsula—is set aside for conservation. LJ plans to connect family history to the area with street names. Under consideration: Seven Sticks Road and Lindbergh Boulevard.

Harry placed Cain Hoy in a charitable remainder trust, giving Peter Lawson-Johnston the use of it for his lifetime. The income from its real estate investments will someday benefit both the HFG Foundation and the Guggenheim museum.

❖

In the current debates about the future of capitalism, driven by a shrinking middle class and the rising wealth gap, it's worth considering the older ethos of capitalism that Harry represented. The titans of capitalism in the last century weren't any less ruthless or exploitative than those of the present era. But many of them, like Harry, felt an obligation, even a duty, to improve the society that made their wealth possible in the first place.

As Harry once wrote to Nancy: "I believe there is a responsibility to use inherited wealth for the progress of man and not for mere self-gratification, which I am sure does not lead to a happy life." As a businessman and a philanthropist, Harry strengthened that progress through passionate, sometimes obsessive engagement. To dole out money without a strong connection to that which you're funding is to become an "absentee landlord."

"The gift isn't worth much," said Harry, unless "the giver goes with it."

Notes

MANUSCRIPT COLLECTIONS

Center for Research in the Humanities, New York Public Library.

Charles A. Lindbergh Papers, Sterling Memorial Library, Yale.

John Hays Hammond, Sr. Papers, Sterling Memorial Library, Yale, Edward Pendray Papers, Princeton.

Harry Frank Guggenheim Archive, Harry Frank Guggenheim Foundation.

John F. Kennedy Presidential Library and Museum,

Harry Frank Guggenheim Papers, Library of Congress, Washington, D.C.

Pembroke College Archive, University of Cambridge.

Solomon R. Guggenheim Museum Archives.

The Papers of John Maynard Keynes, Kings College Archives, University of Cambridge.

1—BANDITS AND BULLION

p. 1 "Bandits and Bullion" is the title of chapter 12 in *Metal Magic*, Isaac F. Marcosson's classic history of the American Smelting and Refining Company (New York: Farrar, Straus and Company, 1949).

p. 2 "Nearly every president of Mexico" Mark Wasserman, *Everyday Life and Politics in 19th Century Mexico* (Albuquerque: University of New Mexico Press, 2000), 53.

p. 3 "some $1.2 billion in foreign investment flooded into the country" Friedrich Katz, *The Life and Times of Pancho Villa* (Redwood City, CA: Stanford University Press, 1998), 15.

p. 3 "Streets were poorly cobbled and unpaved" Gatenby Williams (alias for William Guggenheim), *William Guggenheim* (New York: Lone Voice Publishing Co., 1934), 75.

p. 3 "The men of the town" Edwin P. Hoyt Jr., *The Guggenheims and the American Dream* (Funk & Wagnalls, 1967), 84.

p. 3 "Ore taken from the mines was spread across shallow pits" "Mines Yield Marvelous Wealth," *Mojave County Miner*, March 25, 1911, 1.

p. 4 "He set up his living quarters" Williams, *William Guggenheim*, 81.

p. 4 "construction proceeded as planned until late one moonlit night" Williams, *William Guggenheim*, 82.

p. 4 "His assailants, who had gained access to his room" Williams, *William Guggenheim*, 83.

p. 4 "At that time the train only ran to the town of Monclova" Williams, *William Guggenheim*, 105.

p. 5 "wild with commotion" Williams, *William Guggenheim*, 105.

p. 5 "On the evening prior" Williams, *William Guggenheim*, 105.

p. 5 "His young son" Williams, *William Guggenheim*, 105.

p. 5 "confessed that they had slain the wrong man" Williams, *William Guggenheim*, 105.

p. 5 "On the rare occasion when Hammond's wife traveled with him" Interview with John Jay Hammond in B.C. Forbes, *Men Who Are Making America* (New York: B.C. Forbes Publishing, 1917), 184.

p. 5 "Traveling on behalf of the Guggenheims one summer" John Jay Hammond, *The Autobiography of John Jay Hammond, Volume 1*, (Farrar and Rhinehart, New York, 1935), 117.

p. 5 "These skills came in handy" Hammond, *Autobiography of John Jay Hammond, Volume 1*, 117.

pp. 5–6 "A band of about one hundred revolutionaries" Hammond, *Autobiography of John Jay Hammond, Volume 1*, 117.

p. 6 "Undeterred, the colonel warily eyed" John Jay Hammond, *Autobiography of John Jay Hammond, Volume 1*, 117.

p. 6 "Nearby Yaquis were in the midst" Hammond, *Autobiography of John Jay Hammond, Volume 1*, 118.

p. 6 "Who would be first" Hammond, *Autobiography of John Jay Hammond, Volume 1*, 118.

p. 6 "Our appearance was, indeed, formidable" Hammond, *Autobiography of John Jay Hammond, Volume 1*, 118.

p. 7 "Under a five-year contract" Harvey O'Connor, *The Guggenheims: the Making of An American Dynasty* (New York: Covici Friede, 1937), 129.

p. 7 "With Hammond's expertise, Guggenex" O'Connor, *The Guggenheims*, 133.

p. 7 "Our government is very foolish" O'Connor, *The Guggenheims*, 88.

p. 7 "In a stately, high-ceiling room in the old Palace" Marcosson, *Metal Magic*, 51.

p. 8 "The Guggenheims received their concession from Diaz" Marcosson, *Metal Magic*, 51.

p. 8 "By the turn of the century, Guggenheim-owned smelters" Thomson Gale, Profile of ASARCO, Grupo Mexico, International Directory of Company Histories, 2006.

p. 9 "The area was populated by the Pennsylvania Dutch" Hoyt, *The Guggenheims and the American Dream*, 18.

p. 9 "The Quakers and Swedes who lived there" Hoyt, *The Guggenheims and the American Dream*, 18.

p. 9 "Their top seller: stove polish" Hoyt, *The Guggenheims and the American Dream*, 18.

p. 9 "Investing several hundred dollars" Hoyt, *The Guggenheims and the American Dream*, 19.

p. 10 "He bought the railroad stock cheap" Irwin Unger and Debi Unger, *The Guggenheims: A Family History* (New York: Harper Perennial, 2005), 18.

p. 10 "Meyer sent sons Daniel, Murray, and Solomon" Unger and Unger, *The Guggenheims*, 21.

p. 11 "It began as a loan request" Unger and Unger, *The Guggenheims*, 24.

p. 11 "A counteroffer was made" Unger and Unger, *The Guggenheims*, 25.

p. 11 "Another partner wanted out" Unger and Unger, *The Guggenheims*, 27.

p. 11 "Meyer hired an engineer" Unger and Unger, *The Guggenheims*, 27. Historians disagree over whether the mines were flooded before or after Meyer acquired his interest in them.

p. 11 "RICH STRIKE, FIFTEEN OUNCES SILVER" Unger and Unger, *The Guggenheims*, 27.

p. 12 "My boys, I can see great things coming in this country" O'Connor, *The Guggenheims*, 77.

2—THE APPRENTICE

p. 13 "roamed the globe in search of profitable holdings" Bernard Baruch as quoted in *Seed Money: The Guggenheim Story* by Milton Lomask (New York: Farrar, Straus and Co., 1964), 26.

p. 13 "Between the years 1880 and 1890" Bernard M. Baruch, *Baruch: My Own Story* (New York: BN Publishing, 1965), 215.

p. 13 "Meyer gathered his sons around the meeting table" Irwin Unger and Debi Unger, *The Guggenheims: A Family History* (New York: Harper Perennial, 2005), 34.

p. 14 "textile factories and chemical plants" Horace J. Stevens, *The Copper Handbook, A Manual of the Copper Industry of the World* (Houghton, MI: Houghton Mifflin Harcourt, 1903), 67–68.

p. 14 "So it is with you" Unger and Unger, *The Guggenheims*, 34.

p. 15 "a cartel-like entity" International Directory of Company Histories, Profile of ASARCO.

p. 15 "After declining to join ASARCO, Daniel turned the tables" International Directory of Company Histories, Profile of ASARCO.

p. 16 "At the birth of the 20th century" Harvey O'Connor, *The Guggenheims: the Making of An American Dynasty* (New York: Covici Friede, 1937), 140.

p. 16 "Inside, the enormous foyer" Barr Ferree, "Notable American Homes: 'Firenze Cottage,' the Summer Home of Daniel Guggenheim," *American Homes and Gardens* 6, (September 1909): 337.

p. 17 "There were Pompeiian-style bronzes" Ferree, "'Firenze Cottage'," 337.

p. 17 "Red silk damask" Ferree, "'Firenze Cottage'," 338.

p. 17 "Nearby was Solomon's estate" "Wreckers Razing Jersey Landmark," *Courier-Post*, Camden, New Jersey (Sept. 20, 1940), 17.

p. 17 "A second-floor parlor room" "Wreckers Razing Jersey Landmark," 17.

p. 17 "Not to be rivaled" "The Googs Built Competing Houses," *Asbury Park Press*, January 22, 1996, 4.

p. 17 "the ugliest place in the world" Peggy Guggenheim, *Out of This Century: Confessions of An Art Addict* (London: Andre Deutsch Ltd, 1979), 15.

p. 18 "When Harry was ten" O'Connor, *The Guggenheims*, 80.

p. 18 "For months the youthful partners" O'Connor, *The Guggenheims*, 80.

p. 18 "After two years of sales" O'Connor, *The Guggenheims*, 80.

p. 18 "Harry later wrote" O'Connor, *The Guggenheims*, 80.

p. 18 "But Meyer and Barbara" Lomask, *Seed Money*, 34.

p. 18 "Meyer felt orthodox Jewish practices" Lomask, *Seed Money*, 34.

p. 19 "Harry and Edmond were too young to yet play a role" O'Connor, *The Guggenheims*, 158.

p. 19 "In the evenings Harry and Edmond found perverse pleasure" Lomask, *Seed Money*, 33.

p. 19 "Eventually Meyer had enough" Lomask, *Seed Money*, 33.

p. 19 "As the huge funeral procession" Lomask, *Seed Money*, 36.

p. 20 "'falcon-eyed' gentleman with a 'terrifying exterior'" McDonald Sullivan and Ross Dixon, *A Great New York City Institution: Independent and Proprietary, Columbia Grammar School, 1764–1964, A Historical Log* (New York: Columbia Grammar School, 1965), 42–43. Columbia Grammar and Preparatory School's graduates include Oscar Straus, Felix Adler, founder of the Ethical Culture movement, and Nobel Prize winners Murray Gell-Mann and Rainer Weiss.

p. 20 "He had done well in the stock market" Sullivan and Dixon, *Columbia Grammar School, 1764–1964*, 44.

p. 20 "Campbell wore the same Victorian coat and beat-up hat for years" Sullivan and Dixon, *Columbia Grammar School*, 43.

p. 20 "every scrap of paper was saved, every piece of string small or large was carefully rolled up for future use" Sullivan and Dixon, *Columbia Grammar School*, 43.

p. 20 "Apparently Campbell required such privacy" Sullivan and Dixon, *Columbia Grammar School*, 43.

p. 20 "Harry thrived in his years at Columbia Grammar" HFG appears in several editions of *The Columbia News*: 1904–05 and 1906–07. He is listed among debate society members on the affirmative side of an April 8, 1904, debate that resolved, "The Tories were treated cruelly by the Americans after the Revolution." Later, he is listed as "President" of the "Lowell Literary and Debating Society, Class of '07"; on the roster of the school's hockey and football teams, 1907; ranked first place, twelve-pound shot, in a "Summary of Events and Winners, 26th Annual Field Day, April 27, 1907"; and on a list of student members of the school's "Automobile Club" and "Motor Cycle Division," 1905–06. Columbia Grammar and Preparatory School Archives.

p. 21 "At fifteen Harry was arrested" "Guggenheim Boy Held for Speeding," *NY Daily Tribune*, July 23, 1906, 12.

p. 21 "that the legal limit was 8 mph" "Automobile Notes," *Wilkes-Barre Times*, October 30, 1907, 10.

p. 21 "One winter day, when Harry was seventeen" "Guggenheim Auto Wrecked," *New York Times*, January 25, 1907, 6.

p. 22 "After Harry's high school graduation" "Edward [*sic*] and Harry Guggenheim Off for Their Ranch in Idaho," *New York Times*, August 6, 1907, 7.

p. 22 "He joined the cross-country track team" References to HFG's time at Yale are noted in the campus newspaper, the *Yale Daily News*, and in Yale's academic records for 1907.

p. 23 "The town's oldest thermal springs" Reau Campbell, Entry on Aguascalientes, *Campbell's New Revised Complete Guide and Descriptive Book of Mexico* (Chicago: Rogers & Smith Co., 1909) 158–159.

p. 23 "Over each door" Campbell, *Complete Guide and Descriptive Book of Mexico*, 158.

p. 24 "Next to each apostle" Campbell, *Complete Guide and Descriptive Book of Mexico*, 158.

p. 24 "a young boy" Ida Dorman Morris and James Edwin Morris, *A Tour in Mexico* (New York: The Abbey Press, 1902), 93.

p. 24 "The residents of Aguascalientes" Campbell, *Complete Guide and Descriptive Book of Mexico*, 158–159.

p. 24 "lay agricultural lands rich" Campbell, *Complete Guide and Descriptive Book of Mexico*, 158.

p. 24 "Notwithstanding the great wealth of his father" "Rich Youth Shovels Ore," *Long Beach Telegram*, February 11, 1908, 2.

p. 24 "On his first day" "Rich Youth Shovels Ore," 2.

p. 24 "He brought dinner with him" "Rich Youth Shovels Ore," 2.

p. 24 "He watched" "Rich Youth Shovels Ore," 2.

p. 25 "William C. Potter" "The New Personnel in Charge of Aircraft Program," *Aerial Age Weekly*, May 6, 1918, 393.

p. 25 "Potter was fifteen years Harry's senior" "The New Personnel in Charge of Aircraft Program," 393.

p. 25 "I appreciate the gift, but not the book" Lomask, Seed Money, p. 60

p. 25 "Nights wasted" Ibid.

p. 25 "I am expecting you to relieve me" Lomask, Seed Money, p. 61.

p. 27 "The climb down" Mark Wasserman, *Everyday Life and Politics in 19th Century Mexico* (Albuquerque: University of New Mexico Press, 2000), 194.

p. 27 "Wherever the veins of silver ran" Wasserman, *Everyday Life and Politics*, 195.

p. 27 "Laborers used steel-tipped" Wasserman, *Everyday Life and Politics*, 195.

p. 27 "The sacks of rock" Wasserman, *Everyday Life and Politics*, 195.

p. 27 "His float on wheels" "First Children's Carnival a Brilliant Success," *The Daily Record*, Long Branch, New Jersey, August 27, 1909, 1.

p. 28 "The extended wings waved majestically" "First Children's Carnival," 1.

p. 29 "The late afternoon wedding" "H.F. Guggenheim Is A Bridegroom," *New York Times*, November 10, 1910, 11.

p. 29 "Daniel had an English friend" Lomask, *Seed Money*, 81.

3—A PROPER EDUCATION

p. 31 "Pembroke, a constituent college of Cambridge, was founded" Aubrey Attwater, *Pembroke College Cambridge, A Short History* (Cambridge University Press, 1936), 7.

p. 31 "house of scholars" Attwater, *Pembroke College Cambridge*, 7.

p. 30 "for the salvation of her soul" Attwater, *Pembroke College Cambridge*, 7.

p. 31 "At that time there were but four colleges" Attwater, *Pembroke College Cambridge*, 7.

p. 31 "A garden and a meadow" Attwater, *Pembroke College Cambridge*, 8.

p. 31 "Pembroke's first scholars" *Pembroke College Cambridge, A Celebration*, ed. A. V. Grimstone (Pembroke College Cambridge, 1997), 9.

p. 31 "Medieval education focused" Grimstone, *Pembroke College Cambridge*, 10.

p. 31 "refrain from murmuring" Grimstone, *Pembroke College Cambridge*, 9.

p. 31 "producing twenty-two bishops in its first 300 years" Grimstone, *Pembroke College Cambridge*, 33.

p. 31 "and one of the most influential clerics in England" Attwater, *Pembroke College Cambridge*, 39.

p. 31 "he termed the Princesses Mary and Elizabeth" Attwater, *Pembroke College Cambridge*, 39.

p. 32 "where they were chained to a stake" John Foxe, "The Execution of Ridley and Lattimer," *Foxe's Book of Martyrs* (John Day, 1563), 323.

p. 32 "curiosity" and "stranger from another land" Harry Guggenheim, Speech before Pembroke College Society Dinner, July 13, 1959, Box 107, Harry Guggenheim Papers, Manuscript Division, Library of Congress, 5–6.

p. 33 "Mr. Guggenheim, there are two types of people in this world" Guggenheim, Speech before Pembroke College Society Dinner, 6.

p. 33 "Hadley was known" Biosketch, William Sheldon Hadley, *Pembroke College Cambridge Annual Gazette* 2 (1928), 5–7.

p. 33 "Comber had taken three years off" Biosketch, Henry Gordon Comber, *Pembroke College Cambridge Annual Gazette* 10 (1936), 13–15.

p. 34 "Students at that time" Interview, Jayne Ringrose, Pembroke College Honorary Archivist, October 18, 2018.

p. 34 "It was built in the 1880s" John Drake and Charles Malyon, "Leckhampton House and Garden," *Cambridgeshire Garden Trust Newsletter*, September 19, 2005, 3. One year after Harry received his M.A. from Cambridge, two royal visitors, Prince Albert and Prince Henry, came to visit Leckhampton House. They would soon attend Trinity and were shopping for a royal campus residence. A note to Eveleen Myers soon arrived from Buckingham Palace, stating that the whole decision turned on the upstairs bathroom, which was "not fit" for His Royal Highnesses. It seems Prince Albert, the future King George VI (father of Queen Elizabeth II) was "very keen" on his "bathing arrangements." For that reason, the royals took a pass on Leckhampton and chose a smaller residence, Southacre, with its larger and more princely privy.

p. 34 "Leckhampton was built in the style of a Cotswold manor" Drake and Malyon, "Leckhampton House and Garden," 4.

p. 35 "the London architect who designed Leckhampton" Cambridge University Real Tennis Club and Professionals House, Historic England, https://historicengland.org.uk/listing/the-list/list-entry/1422000.

p. 35 "according to Gwen Raverat's biting memoir" Gwen Raverat, *Period Piece: A Cambridge Childhood* (London: Faber and Faber, 1952), 16.

p. 36 "In those days Keynes" Ringrose Interview, October 18, 2018.

p. 36 "Tutoring was a lucrative side business for Keynes" Robert Skidelsky, *John Maynard Keynes, Hopes Betrayed—1883–1920, Volume 1*, (New York: Viking Penguin, 1986), 208.

p. 37 "Money . . . is, above all, a subtle device for linking the present to the future" Skidelsky, *John Maynard Keynes*, 208.

p. 37 "probably as a guest of Henry Carlyle Webb" Interview, Tim Ellis, Chairman, Hawk's Company LTD., August 23, 2019.

p. 38 "1,700-volume personal library" Biosketch, William Sheldon Hadley, *Pembroke College Cambridge Society Annual Gazette* 2 (1928), 5–7.

p. 38 "Hadley's expansive interest" Tom Stammers, "The French Revolution and Pembroke: The Hadley Collection," European Collections blog, January 27, 2014, https://europeancollections.wordpress.com/2014/01/27/the-french-revolution-and-pembroke-the-hadley-collection/.

p. 38 "In the evenings Harry attended" Ringrose Interview, October 18, 2018.

p. 38 "Frederick and Eveleen Myers had left behind one of the most impressive" Drake and Malyon, "Leckhampton House and Garden," 6.

p. 39 "If you were an intellectual" Interview, John David Rhodes, Warden of Leckhampton, October 18, 2018.

p. 39 "but was not persuaded" Drake and Malyon, "Leckhampton House and Garden," 7.

p. 40 "John Maynard Keynes's appointment books" The Papers of John Maynard Keynes, Engagement Diaries, 1902–1946, Kings College Library, Cambridge.

p. 40 "On April 9, 1912, Harry met Benjamin for lunch" Edwin P. Hoyt Jr., *The Guggenheims and the American Dream* (Funk & Wagnalls, 1967), 217.

p. 40 "Over lunch" Hoyt, *The Guggenheims and the American Dream*, 217.

p. 40 "Upon arriving in Le Havre" John H. Davis, *The Guggenheims: An American Epic* (New York, William Morrow and Co., 1978), 238.

p. 41 "By one account" Davis, *The Guggenheims*, 239.

p. 43 "It was a blisteringly hot day" Accounts of the elimination rounds come from Cambridge University student publications, excerpts of which appear in HFG's personal photo album, owned by Ingrid Butler, wife of Dana Draper, HFG's grandson. The account of Harry's Wimbledon matches is drawn from tournament drawsheets and press coverage of that year's competition.

p. 43 "the steadiest Continental performer ever seen at Wimbledon" "The Lawn Tennis Championships," *The Guardian*, June 28, 1913, 12.

p. 43 "He was a power hitter" "The Lawn Tennis Championships," 12.

p. 43 "his academic exposure had included" Second Special Examination in Political Economy, December 6, 1913, 102–103.

p. 43 "He had studied Adam Smith" Second Special Examination in Political Theory, December 6, 1913, 100–101.

p. 43 "In his chemistry exams" Special Examination in Chemistry for the Ordinary B.A. Degree, Part II, May 31, 1913, 675.

p. 44 "Harry graduated from Pembroke" Ringrose Interview, October 18, 2018.

p. 44 *"Auctoritate mihi commissa admitto"* (translated from the Latin by Jayne Ringrose) Ringrose Interview, October 18, 2018.

4—ORES OF CHUQUI

p. 45 "some 500 in all" Among them was U.S. Steel heir John Shaffer Phipps, owner of Westbury Gardens, a botanical wonderland of two hundred acres, at the center of which was an 18th-century Georgian-style residence, and William Vanderbilt II's Eagle's Nest, a Spanish revival mansion, with its own boathouse and wharf.

p. 46 "$7 million for Chapultepec Castle" "Chapultepec Castle," *Sterling Weekly Champion*, March 24, 1892, 3.

p. 46 "Nirvana" A partial description of the estate appears in "Brokaw Quitting Nirvana," *Times Union*, April 13, 1918, 8.

p. 47 "Business associates of the brothers" The descriptions of Harry's uncles come from Bernard Baruch and John Hays Hammond.

p. 47 "Right after my return from Cambridge" Milton Lomask, *Seed Money: The Guggenheim Story* (New York: Farrar, Straus and Co., 1964), 57.

p. 47 "Meetings were often impromptu, announced at the last minute" *The Autobiography of John Jay Hammond, Volume 2*, (Farrar and Rhinehart, New York, 1935), 503.

p. 47 "He recalled a meeting one day" *Autobiography of John Jay Hammond, Volume 2*, 503.

p. 47 "Good Lord! . . ." Hammond, *Autobiography of John Jay Hammond, Volume 2*, 503.

p. 48 "J.H.H. certainly has a temper!" Hammond, *Autobiography of John Jay Hammond, Volume 2*, 503.

p. 48 "Why did Daniel once spend $6 million" "Interview with B.C. Forbes," in B.C. Forbes, *Men Who Are Making America* (New York: B.C. Forbes Publishing, 1918), 177. Daniel had little patience for fractional ownership in the brothers' mining ventures. As he once said: "It was absolutely necessary we should control the whole business . . . Our experience is that the small stockholder on the outside can be very pestiferous and very annoying, and usually is." "The Attitude of the Guggenheims," *Salt Lake Mining Review*, October 15, 1913, 41.

p. 48 "If we can't discover scientific methods" Forbes, "Interview with B.C. Forbes," 177.

p. 48 "a marvel of typographical beauty" Garet Garrett, "As Others See Guggenheims," *Collier's Weekly*, January 6, 1912, 24.

p. 49 "heartless, soulless exploiters" Harvey O'Connor, *The Guggenheims: The Making of An American Dynasty* (New York: Covici Friede, 1937), 322.

p. 49 "a bonus system for consistent work attendance, a social infrastructure of housing and education" O'Connor, *The Guggenheims*, 338.

p. 49 "He was earnest in his sympathy" O'Connor, *The Guggenheims*, 322.

p. 50 "You have reached the summit" Lomask, *Seed Money*, 66.

p. 50 "Newspapers covered the incident" "Masked Burglar Failed to Scare Financier's Wife. Only Got $100 Before Mrs. Guggenheim Drove Him Away," *Philadelphia Inquirer*, November 17, 1915, 1; "Her Cry Routs Robber. Mrs. Guggenheim Scorns Pistol in Hands of Masked Thief," *Washington Post*, November 17, 1915, 2; "Mrs. H.F. Guggenheim Sees Burglar Flee," *New York Tribune*, November 17, 1915, 14.

p. 51 "It was a neo-Italian Renaissance gem" Christopher Gray, "Back in Manhattan: A Full Block of Elegant Houses," *New York Times*, July 27, 2008, 5. The Guggenheim residence was modest compared to the homes erected by other captains of industry in the neighborhood. Around the corner was steel pioneer Henry C. Frick's $5 million limestone mansion, overlooking Central Park, spanning the entire block between E. 70th and E. 71st.

p. 51 "closer to her own family" Helen's parents were Heyman and Paulina Rosenberg. Heyman Rosenberg was a silk manufacturer. The 1910 census records Helen, her brother, and their family as living on W. 78th St.

p. 51 "Every wealthy family" Lomask, *Seed Money*, 44.

p. 51 "Gladys had abandoned" Irwin Unger and Debi Unger, *The Guggenheims: A Family History* (New York: Harper Perennial, 2005), 191.

p. 52 "In 1914 nearly half of all U.S. foreign investment" Thomas F. O'Brien, "Rich Beyond the Dreams of Avarice," *Business History Review*, Harvard University Business School, March 22, 1989, 2.

p. 52 "comprising a vertical depth of about 1,000 feet" History and Description of Mine and Plant, Chile Copper Company and Chile Exploration Company (New York, undated) Box 30, Harry Frank Guggenheim Papers, Manuscript Division, Library of Congress.

p. 53 "In 1910 industrialist and mining magnate Albert Burrage bought the mining rights" Janet L. Finn, *Tracing the Veins: Of Copper, Culture, Community from Butte to Chucquicamata* (Oakland: University of California Press, 1998), 86.

p. 54 "But the high levels of chlorine in the rock" Isaac F. Marcosson, *Metal Magic*, (New York: Farrar, Straus and Company, 1949), 92.

p. 54 "The latter raised $95 million in stock" O'Brien, "Rich Beyond the Dreams of Avarice," 126.

p. 54 "As in Mexico, labor costs in Chile were cheap" O'Brien, "Rich Beyond the Dreams of Avarice," 126.

p. 54 "Massive caches of dynamite" History and Description of Mine and Plant, Chile Copper Company and Chile Exploration Company (New York, undated) Box 30, Harry Frank Guggenheim Papers, Manuscript Division, Library of Congress.

p. 54 "A detonation like this could break down a million tons" Chile Copper Company and Chile Exploration Company, 15.

p. 55 "Water was so scarce" Chile Copper Company and Chile Exploration Company, 12.

p. 56 "At the core of his responsibilities" Harry F. Guggenheim, "Building Mining Cities in South America," *Engineering and Mining Journal* (EMJ) 110, no. 5 (July 31, 1920): 206. A discussion of the infrastructure build-out at Chuqui can be found in History and Description of Mine and Plant, Chile Copper Company and Chile Exploration Company (New York, undated) Box 30, Harry Frank Guggenheim Papers, Manuscript Division, Library of Congress.

p. 56 "Harry and Colley settled on the idea of creating two towns" Guggenheim, "Building Mining Cities in South America," 206.

p. 56 "The community would have three *pulperias chilenas*" Finn, *Tracing the Veins*, 99.

p. 57 "Blood ran often . . ." Alvear Urrutia, as quoted in Finn, *Tracing the Veins*, 97.

p. 58 "In 1915 the family's refinery" O'Connor, *The Guggenheims*, 362.

p. 58 "several memos arrived" The complaints from Albert Burrage were summarized and discussed in three memos: F.A. Collins to Daniel Guggenheim, May 31, 1915; Daniel Guggenheim to Harry Guggenheim and Edmond Guggenheim, June 30, 1915; F.A. Collins to Harry Guggenheim, July 7, 1915; Box 30, Harry Frank Guggenheim Papers, Manuscript Division, Library of Congress.

p. 59 "To placate upper management" Guggenheim, "Building Mining Cities in South America," 206.

p. 59 "pampa dust and cement" Guggenheim, "Building Mining Cities in South America," 206.

p. 59 "Chuqui's population soon topped 12,000 residents" Finn, *Tracing the Veins*, 90. Finn's unique labor history took a comparative look at the lives of copper mine workers in Butte, Montana, and Chucquicamata in Chile.

p. 60 "Some twenty languages were spoken by residents" Finn, *Tracing the Veins*, 90.

p. 60 "Chinese and Japanese émigrés ran groceries and barber shops" Finn, *Tracing the Veins*, 90.

p. 60 "Instead of the ragged" Guggenheim, "Building Mining Cities in South America," 207.

p. 60 "Why should some workers enjoy well-known U.S. brands" Finn, *Tracing the Veins*, 90.

p. 60 "Even the most vocal critics" Finn, *Tracing the Veins*, 108.

p. 61 "In his ignorance" Finn, *Tracing the Veins*, 90; Eulogio Gutierrez and Marcial Figueroa, "Chuquicamata, Sus Grandeza y Sus Dolores," Imprenta Cervantes (Santiago, Chile, 1920) 7.

5—SHOWDOWN

p. 62 *"Here in the very maelstrom of commerce"* Advertisement for the Equitable Building, *New York Times*, October 6, 1913, 5.

p. 62 "The Equitable was" "Biggest Office Building is Nearing Completion," *Owensboro Messenger*, May 23, 1915, 5.

p. 63 "a secret door" John H. Davis, *The Guggenheims: An American Epic* (New York, William Morrow and Co., 1978), 130. Elegant as it was, the new headquarters for Guggenheim Brothers was modest in décor compared to fellow tenants like Harry Payne Whitney, heir to the Whitney fortune, whose garish office was wainscoted with elephant hide.

p. 63 "Forbes came up one day" This interview was the basis of a profile of Daniel in a book by in B.C. Forbes, *Men Who Are Making America*, (New York: B.C. Forbes Publishing, 1918), 173. Among others profiled by Forbes in the book: Alexander Graham Bell, Henry Ford, Thomas Edison, and John D. Rockefeller.

p. 62 "How did you manage to get this interview with me? Forbes, *Men Who Are Making America*, 175.

p. 65 "he had crossed the Atlantic seventy times" Forbes, *Men Who Are Making America*, 178.

p. 65 "He worked up an analysis" Memo from Harry F. Guggenheim to Partners, Guggenheim Brothers, October 20, 1921, Box 30, Harry Frank Guggenheim Papers, Manuscript Division, Library of Congress.

p. 65 "You will be interested to know" Memo from Harry F. Guggenheim to Partners, Guggenheim Brothers, October 20, 1921, Box 30, Harry Frank Guggenheim Papers, Manuscript Division, Library of Congress.

p. 66 "eight Wright airplanes" "Says Villa Has Use of Many Millions," [sic] *Montgomery Daily Times*, March 21, 1916, 7.

p. 67 "removing some $2 million" "Says Villa Has Use of Many Millions," 7.

p. 67 "The cache was sold for $1.5 million" "Says Villa Has Use of Many Millions," 7. The massacre of American mining engineers is recounted in three page-one stories in the *New York Times* and a fourth on American travel in Mexico, *New York Times*, January 13, 1916, 1.

p. 68 "older brother Robert would enlist" Davis, *The Guggenheims*, 293.

p. 68 "Cousin Edmond signed up" Edmond Guggenheim Draft Registration Card, Abstract of WWI Military Service, 1917–1919, Ancestry.com.

p. 68 "Even the OId Man" Remembrance: A Part of Pembroke" (undated) Kit Smart's Blog, Pembroke College, https://www.pem.cam.ac.uk/kit-smarts-blog /remembrance-part-pembroke.

p. 69 "Then came news of Carlie Webb" "Capt. H.C. Webb (killed)," *The Guardian*, September 28, 1916, 14.

p. 69 "At the time the U.S. Navy" "Fund Started to Buy Aeroplanes for U.S.," *Evening Sun*, May 22, 1915, 4. Just a few years prior, the stepchild status accorded to aviation by the Taft administration was laid bare in the *New York Times*. "Congress will be asked by Secretary of War Dickinson to buy five or ten aeroplanes for the army. The secretary said to-day that he would devote a paragraph of his annual report to the subject of flying machines." "Dickinson Will Ask Congress to Buy Air Craft for Army," *New York Times*, November 10, 1910, 11.

p. 69 "As a statement from the Aero Club put it" "The National Airplane Competition," *Montgomery Advertiser*, May 30, 1915, 6.

p. 70 "Inspired, Harry acted quickly" Irwin Unger and Debi Unger, *The Guggenheims: A Family History* (New York: Harper Perennial, 2005), 145.

p. 70 "Its legendary maker, Glenn Hammond Curtiss" An aviation pioneer, one of Curtiss's most famous flights was from Albany, New York, to Governor's Island in 1910, at the time the longest flight in U.S. history. The wings were made from fabric used in hot air balloons; its airframe carried bags filled with champagne corks in case of a water landing on the Hudson River. The flight is artfully recounted by New York historian Cole Thompson, who describes how an oil leak caused Curtiss to make an emergency landing in northern Manhattan's Isham Park. "Inwood in Aviation History," My Inwood, May 28, 2015, https://myinwood.net/inwood-in-aviation-history/

p. 70 "See those instruments?" Harry F. Guggenheim, *The Seven Skies* (New York: GP Putnam's Sons, 1930), 151.

p. 71 "there were some thirty-eight naval aviators in the country" Capt. W.H. Sitz, USMC, A History of U.S. Naval Aviation, U.S. Navy Department, Bureau of Aeronautics, U.S. Government Printing Office, 1930. http://www.worldwar1.com/dbc/pdf/navalaviation.pdf.

p. 71 "Harry banged out a letter" Letter from HFG to Master Sheldon Hadley, April 11, 1917, Pembroke College Archives, Cambridge.

p. 72 "Dear Master, I have just received" Letter from HFG to Master Sheldon Hadley, September 18, 1917, Pembroke College Archives, Cambridge.

p. 73 "He went on to England and Italy to help organize such operational hubs" "The Godfather of Aviation," *NY Herald Tribune*, September 23, 1928, p 12.

p. 73 "In Brest and Moutchic he inspected air stations" Record of Officers, U.S. Navy, Harry F. Guggenheim, National Archives and Records Administration, 1917–1918.

p. 73 "His next stop was Pauillac to help set protocols" Record of Officers, U.S. Navy, Harry F. Guggenheim, National Archives and Records Administration, 1917–1918.

p. 73 "From there it was on to Lacanau" Record of Officers, U.S. Navy, Harry F. Guggenheim, National Archives and Records Administration, 1917–1918.

p. 73 "followed by an assignment" Record of Officers, U.S. Navy, Harry F. Guggenheim, National Archives and Records Administration, 1917–1918.

p. 73 "Harry's Italian mission required a visit to Rome" Milton Lomask, *Seed Money: the Guggenheim Story* (New York: Farrar, Straus and Co., 1964), 82.

p. 73 "The future New York mayor" Lomask, *Seed Money*, 82.

p. 73 "A neat stratagem, but it didn't work" Lomask, *Seed Money*, 82.

p. 74 "On Dec. 2 the RMS Mauretania" "Mauretania Lands 4,000 U.S. Soldiers; First to Get Home," *Brooklyn Daily Eagle*, December 2, 1919, 3.

p. 74 "The staggering death toll" *Pembroke College Cambridge, A Celebration*, ed. A. V. Grimstone (Pembroke College Cambridge, 1997), 139.

p. 74 "The high number of those who perished" Grimstone, *Pembroke College Cambridge*, 140.

p. 74 "Harry's uncle William had bought" Davis, *The Guggenheims*, 138.

p. 76 "'Nitrates,' proclaimed Daniel, 'will make us rich beyond the dreams of avarice!'" Thomas F. O'Brien, "Rich Beyond the Dreams of Avarice," *Business History Review*, Harvard University Business School, March 22, 1989, 2.

p. 76 "his split from Helen" Helen Rosenberg, Harry's first wife, went on to marry a wealthy stockbroker, Harold Matzinger. They lived in a palatial villa on Florida's Indian Creek Island, which daughter Joan visited frequently.

p. 77 "as an unchallenged fiefdom" Unger and Unger, *The Guggenheims*, 160.

p. 77 "Anaconda was offering $70 million" Unger and Unger, *The Guggenheims*, 161.

p. 78 "Angry arguments made by the juniors" Davis, *The Guggenheims*, 132.

p. 78 "Pounding his fist" Davis, *The Guggenheims*, 132.

p. 78 "There's no choice but to sell" Davis, *The Guggenheims*, 132.

p. 79 "The gift would include $250,000" Davis, *The Guggenheims*, 156.

p. 79 "Falaise" In the 1920s the term Falaise was also in the news when the Marquis Henri de la Falaise, a French flying ace in WWI who had received the Croix de Guerre for heroism, married film star Gloria Swanson. Her married name became Gloria La Bailley de La Falaise.

p. 80 "Harry and Carol visited art and antiques dealers" Box 154, "List of Foreign Addresses for the Use of Mr. Harry While Abroad," undated, Harry Frank Guggenheim Papers, Manuscript Division, Library of Congress.

p. 80 "I had expected" Letter draft from Daniel Guggenheim to HFG, June 1, 1923, Box 54, Daniel and Florence Correspondence, 1918–30, Harry Frank Guggenheim Papers, Manuscript Division, Library of Congress.

p. 81 "Dear Father" Letter from HFG to Daniel Guggenheim, June 6, 1923, Box 54, Daniel and Florence Correspondence, 1918–30, Harry Frank Guggenheim Papers, Manuscript Division, Library of Congress.

6—GODFATHER OF FLIGHT

p. 82 "had ranked Daniel" The *Forbes* 1918 ranking of the richest people in America placed Daniel Guggenheim as thirteenth, in a tie with J.P. Morgan Jr., Charles M. Schwab, James Stillman, and Thomas F. Ryan. Chase Peterson-Withorn, "From Rockefeller to Ford, See Forbes' 1918 Ranking of The Richest People in America," September 19, 2017, Forbes, https://www.forbes.com/sites/chasewithorn/2017/09/19/the-first-forbes-list-see-who-the-richest-americans-were-in-1918/#4d86c2b54c0d.

p. 83 "through massive doors" "Hempstead House," Sands Point Conservancy, http://sandspointpreserveconservancy.org/

p. 83 "A description at the time" John H. Davis, *The Guggenheims: An American Epic* (New York, William Morrow and Co., 1978), 156.

p. 83 "His two early ideas" Richard P. Hallion, *Legacy of Flight: The Guggenheim Contribution to American Aviation* (Seattle: University of Washington Press, 1977), 23.

p. 84 "In the coming years the Wrights would spend $152,000 in legal fees" David T. Courtwright, *Sky as Frontier: Adventure, Aviation and Empire*, (College Station: Texas A&M University Press), 27.

p. 84 "The stubbornness with which the Wrights" Anthony J. Mayo, Nitin Nohria, and Mark Rennella, *Entrepreneurs, Managers, and Leaders: What the Airline Industry Can Teach Us About Leadership* (New York: Palgrave MacMillan, 2009), 7.

p. 84 "At New York University (NYU) a four-course experimental program" Hallion, *Legacy of Flight*, 27.

p. 85 "So NYU decided to establish" Hallion, *Legacy of Flight*, 28.

p. 85 "Its members proposed" Hallion, *Legacy of Flight*, 28.

p. 85 "He instead offered to gauge" Hallion, *Legacy of Flight*, 28.

p. 85 "Harry brought the chancellor's note home to his father at Hempstead House" Davis, *The Guggenheims*, 159.

p. 85 "Dan looked at the letter" Davis, *The Guggenheims*, 159.

p. 85 "Daniel arose in the morning" Davis, *The Guggenheims*, 159.

p. 85 "It would underwrite a propeller laboratory" Hallion, *Legacy of Flight*, 29.

p. 85 "That October" Hallion, *Legacy of Flight*, 30.

p. 86 "Were I a young man" "An Endowed School of Aeronautics," *Philadelphia Inquirer*, June 16, 1925, 10.

p. 86 "The dream of aviation" "An Endowed School of Aeronautics," 10.

p. 87 "Why can't we just buy one airplane and have all the pilots take turns?" Richard Norton Smith, "The Underestimated President," *Wall Street Journal*, August 1, 1998, p3.

p. 87 "If you keep dead still" Alan Brinkley and Davis Dyer, *The American Presidency*, (Houghton, MI: Houghton Mifflin Harcourt, 2004), 330.

p. 88 "Hoover, be at the White House" Milton Lomask, *Seed Money: the Guggenheim Story* (New York: Farrar, Straus and Co., 1964), 85.

p. 88 "What's the use of getting there quicker if you haven't got something better to say when you arrive?" Lomask, *Seed Money*, 85.

p. 88 "Hoover, show Mr. Guggenheim to the elevator" Lomask, *Seed Money*, 85.

p. 88 "pretty high-handed with his office help." Lomask, *Seed Money*, 85.

p. 89 "Among those who accepted the invitation" Hallion, *Legacy of Flight*, 32–33.

p. 89 "The average aircraft engine possessed" *Aerial Age Weekly*, July 17, 1918, 671.

p. 89 "I am not an expert on aviation" "Air Ports Great Need of Cities," *Salt Lake Tribune*, August 30, 1925, 25.

p. 90 "He obtained a relic" Davis, *The Guggenheims*, 160.

p. 90 "The greatest inspiration" "World Is Entering an 'Air Age,' Guggenheim Fund Director Says," *Christian Science Monitor*, September 15, 1927, 1.

p. 90 "By 1925 it was probable that Harry Guggenheim knew more about" Edwin P. Hoyt Jr., *The Guggenheims and the American Dream* (Funk & Wagnalls, 1967), 292.

p. 90 "As of 1926" Press Release, Box 54, Daniel Guggenheim Fund for the Promotion of Aeronautics; Hallion, *Legacy of Flight*, 35.

p. 91 "They set off for three months" Hallion, *Legacy of Flight*, 37.

p. 91 "When added to the forward edge of a plane's wing" Hallion, *Legacy of Flight*, 39.

p. 91 "A 1926 biplane" Hallion, *Legacy of Flight*, 39.

p. 91 "At a time when American airline passenger service was virtually nonexistent" Reginald M. Cleveland, *America Fledges Wings: The History of the Daniel Guggenheim Fund for the Promotion of Aeronautics* (New York and Chicago: Pittman Publishing, 1942), 19.

p. 92 "Geographic boundaries" Hallion, *Legacy of Flight*, 38.

p. 92 "much of Europe's air traffic consisted of aging WWI aircraft" Hallion, *Legacy of Flight*, 38.

p. 92 "thirty-five financial spark plugs" Hallion, *Legacy of Flight*, 38.

p. 92 "Harry steered a series of discussions" Hallion, *Legacy of Flight*, 39.

p. 92 "During World War I, while in the Austrian air service" Hallion, *Legacy of Flight*, 50.

p. 94 "Any plane that meets the acid test of these requirements" Gove Hambidge, "The Godfather of Aviation," *New York Herald Tribune*, 6.

p. 94 "The contest drew" Cleveland, *America Fledges Wings*, 68. While the planes were in the air, lawsuits were also flying. The designer of the Ford Leigh plane sent a complaint to Orville Wright threatening legal action over his claim that another competitor, British aviator Handley Page, had stolen his "auxiliary wing" design. The argument would have been familiar to Wright, who years earlier had sued Curtiss over a similar patent dispute. Meanwhile, Handley Page was suing Curtiss for using Handley's "leading edge slot" on his own plane, the very design (by a different name) Page was being sued over by the Ford Leigh designer.

p. 94 "In the end" Cleveland, *America Fledges Wings*, 77.

p. 94 "Harry asked Bennett" Hallion, *Legacy of Flight*, 153.

p. 94 "Traveling state to state, it would bring the reality of air travel to towns in dozens of cities" Hallion, *Legacy of Flight*, 153.

p. 94 "Bennett agreed" Hallion, *Legacy of Flight*, 154.

p. 94 "An average of 12,000 people came out" Cleveland, *America Fledges Wings*, 89.

p. 94 "Bennett gave interviews in each town" Hallion, *Legacy of Flight*, 154.

p. 94 "I think it a remarkable demonstration" Cleveland, *America Fledges Wings*, 89.

p. 95 "One of the great satirists of the day, and a fan of the coming air age" Will Rogers, "No Novelty Anymore to be Killed in Auto," *Star-Gazette*, November 1, 1927, p 1. Ironically, eight years later Rogers died in a plane crash.

p. 95 "Harry tried to reframe press coverage" Harry F. Guggenheim, *The Seven Skies* (New York: GP Putnam's Sons, 1930), 103.

p. 95 "In other words" Guggenheim, *The Seven Skies*, 104.

p. 95 "the need for a clearinghouse" *Journal of Air Law*, quoted in Hallion, *Legacy of Flight*, 76–77.

p. 96 "a recommended reading list" Hallion, *Legacy of Flight*, 73.

p. 96 "Called the Daniel Guggenheim Medal" Hallion, *Legacy of Flight*, 152.

p. 96 "arriving aboard the RMS *Aquitania*" Hallion, *Legacy of Flight*, 83.

7—LORD OF THE WINGS

p. 99 "Near the base of it was a sad pile of sandwiches" Leonard Mosley, *Lindbergh, A Biography*, (New York: Dell, 1977), 108.

p. 99 "Through the left window was what the pilot called his 'periscope'" Harry F. Guggenheim, *The Seven Skies* (New York: GP Putnam's Sons, 1930), 74.

p. 100 "When you get back from your flight" Irwin Unger and Debi Unger, *The Guggenheims: A Family History* (New York: Harper Perennial, 2005), 253.

p. 100 "He's doomed" Unger and Unger, *The Guggenheims*, 253.

p. 100 "For several days, the pilot, Charles Lindbergh, waited for weather to clear over the eastern seaboard" A. Scott Berg, *Lindbergh* (New York: Berkeley Books, 1998), 114.

p. 100 "It was early in the morning" Berg, *Lindbergh*, 114.

p. 100 "He banked north toward New England" Berg, *Lindbergh*, 117.

pp. 100–101 "He soon settled into a sequence of checking gauges Donald E. Keyhoe, *Flying with Lindbergh* (New York: G.P. Putnam's Sons, 1928), 51–52.

p. 101 "A few hours later he was over the Atlantic" Berg, *Lindbergh*, 119.

p. 102 "Lindbergh received about $5 million in business offers" Berg, *Lindbergh*, 163.

p. 102 "He was pitched a $300,000 contract from Adolph Zukor" Berg, *Lindbergh*, 144.

p. 102 "He turned both down" Berg, *Lindbergh*, 162.

pp. 102–103 "People behaved as though Lindbergh had walked on water" Berg, *Lindbergh*, 170.

p. 103 "Mountains, lakes, parks" Berg, *Lindbergh*, 169.

p. 103 "epoch making event" Harry F. Guggenheim, *The Seven Skies* (New York: GP Putnam's Sons, 1930), 102.

p. 103 "godsend to aviation" Berg, *Lindbergh*, 164.

p. 104 "*The Spirit of St. Louis* is 'blind,' and someone might get in front of you" Keyhoe, *Flying with Lindbergh*, 190.

p. 104 "Lindbergh disagreed" Keyhoe, *Flying with Lindbergh*, 190.

p. 104 "I don't want all the pilots to think" Keyhoe, *Flying with Lindbergh*, 190.

p. 104 "Probably you could" Keyhoe, *Flying with Lindbergh*, 191.

p. 104 "I've seen a propeller kill a man" Keyhoe, *Flying with Lindbergh*, 12.

p. 104 "The Colonel is right" Keyhoe, *Flying with Lindbergh*, 12.

p. 104 "Keyhoe, as the Colonel's aide" Keyhoe, *Flying with Lindbergh*, 12.

p. 105 "But when Lindbergh received the draft" Berg, *Lindbergh*, 165.

p. 105 "It was called *We*, a reference Lindbergh said" Berg, *Lindbergh*, 166.

p. 105 The book came out just a few weeks later" Berg, *Lindbergh*, 167.

p. 105 "Colonel Lindbergh is the commanding officer" Keyhoe, *Flying with Lindbergh*, 13.

p. 106 "I am completely satisfied" Letter to HFG from Charles Lindbergh, August 3, 1927, from William Penn Hotel, Pittsburgh, Pennsylvania, Box 90, Harry Frank Guggenheim Papers, Manuscript Division, Library of Congress.

p. 106 "From Milwaukee, Wisconsin" Letter to HFG from Charles Lindbergh, August 20, 1927, on "Lindbergh Reception Committee" stationery, Box 90, Harry Frank Guggenheim Papers, Manuscript Division, Library of Congress.

p. 106 "Aboard 'Spirit of St. Louis' On Tour" Ev Cassagneres, *Ambassador of Air Travel* (Matoon, Illinois: United Graphics Inc., 2006), 2.

p. 107 "Come on now, Colonel" Keyhoe, *Flying with Lindbergh*, 39.

p. 107 "His collar and tie were pulled badly out of shape" Keyhoe, *Flying with Lindbergh*, 18.

p. 107 "Somebody hit me on the head" Keyhoe, *Flying with Lindbergh*, 18.

p. 107 "Where is it?" Keyhoe, *Flying with Lindbergh*, 18.

p. 107 "In regard to the press stories concerning my health . . ." Letter to HFG from Charles Lindbergh, August 27, 1927, from Sioux Falls, South Dakota, Box 90, Harry Frank Guggenheim Papers, Manuscript Division, Library of Congress.

p. 108 "Lindbergh's rest days" Cleveland, *America Fledges Wings* 100.

p. 108 "Hundreds of thousands of people" "Lindbergh's Unhappy Lot," *Minneapolis Daily Star*, August 29, 1927, 14.

p. 108 "I do not believe that these complaints" Letter to HFG from Charles Lindbergh, September 1, 1927, Pierre, South Dakota, St. Charles Hotel, Box 90, Harry Frank Guggenheim Papers, Manuscript Division, Library of Congress.

p. 108 "Marion Davies and Mary Pickford hosted a party" Cassagneres, *Ambassador of Air Travel*, 183.

p. 108 "The next day Louis B. Mayer picked up Lindbergh" Cassagneres, *Ambassador of Air Travel*, 183.

p. 108 "Before leaving L.A." Cassagneres, *Ambassador of Air Travel*, 183.

p. 109 "Lindbergh took questions from reporters" Cassagneres, *Ambassador of Air Travel*, 183.

p. 109 "30 million Americans" Cleveland, *America Fledges Wings*, 99.

p. 109 "Lindbergh tallied some key metrics from his journey" Cleveland, *America Fledges Wings*, 99.

p. 109 "Nonstop press coverage kept *We* at the top of the best sellers list" Berg, *Lindbergh*, 167.

p. 110 "As everyone prepared for a dinner of beef Wellington" Interview with Ingrid Butler, wife of Harry's late grandson, Dana Draper, March 20, 2019.

p. 110 "Would you please go upstairs" Butler Interview, March 20, 2019.

p. 111 "Walter would be back again, beckoning guests" Alice Arlen and Michael J. Arlen, *The Huntress: The Adventures, Escapades, and Triumphs of Alicia Patterson: Aviatrix, Sportswoman, Journalist, Publisher* (New York: Pantheon, 2016), 157.

p. 111 "I was astonished at the effect my successful landing in France" Charles A. Lindbergh, *Autobiography of Values* (Boston: Mariner Books, 1978), 310.

p. 112 "Harry loved the Sound" There are at least two variations of this quote, one appearing in Earl Kimser, "Guggenheim Mansion to Open," *New York Times*, May 13, 1973, 101.

p. 112 "once bringing her a collection of dollhouse furniture" Letter from Carol Guggenheim to Evangeline Lindbergh, December 14, 1928, Box 90, Harry Frank Guggenheim Papers, Manuscript Division, Library of Congress.

p. 113 "Lindbergh disappeared into the woods with a bearskin" Keyhoe, *Flying with Lindbergh*, 165.

p. 114 "For the newly founded Northwest Airlines" Northwest Airline Files, Northwest Airlines History and Biography, https://airlinefiles.com/american-airlines/84-legacy-airlines/330-northwest-airlines-history-and-biography.

p. 114. "Tabloid reporters went through the Lindberghs' garbage" Lynne Olson, *Those Angry Days* (New York: Random House, 2013), 10.

p. 114 "In coming years Anne would say" Olson, *Those Angry Days*, 10.

8—EYES IN THE SKY

p. 115 "The Guggenheim aviation fund office" Description of the fund offices comes from newspaper accounts during the years it operated.

p. 116 "he wanted the city's principal airport" "House Bill Provides Air Terminal," *Sunday Star*, Washington, D.C., February. 3, 1929, 9.

p. 116 "The map depicted" "Large Detail Map of Airport Points Under Preparation," *The Standard Union*, August 10, 1927, 1.

p. 117 "Its dedication drew some 25,000" "Floyd Bennett Field," Wikipedia, https://en .wikipedia.org/wiki/Floyd_Bennett_Field.

p. 118 "Just as the automobile would be very greatly handicapped without signposts" "Harry F. Guggenheim Surprised at Changes Over Past 20 Years," *El Paso Times*, February 6, 1929, 11.

p. 119 "Airmail carriers made so little money" Cleveland, *America Fledges Wings*, 104.

p. 119 "Early railroads in the United States" George C. Werner, "RAILROADS," Handbook of Texas Online, Texas State Historical Association.

p. 119 "universal condemnation" Cleveland, *America Fledges Wings*, 104.

p. 120 "If an accident occurred" Cleveland, *America Fledges Wings*, 104.

p. 120 "It had been founded just a few years earlier" "Western Air Express," One Nevada Encyclopedia Online, http://www.onlinenevada.org/articles/western-air-express.

p. 120 "Stay to the right of the railroad tracks" "Western Air Express," One Nevada Encyclopedia Online, http://www.onlinenevada.org/articles/western-air-express.

p. 120 "The air-line distance between Los Angeles and San Francisco" Cleveland, *America Fledges Wings*, 108–109.

p. 120 "Lunch will be served" Cleveland, *America Fledges Wings*, 109.

p. 121 "The data was made available" Richard P. Hallion, *Legacy of Flight: The Guggenheim Contribution to American Aviation* (Seattle: University of Washington Press, 1977), 94.

p. 121 "Each of the stations" Hallion, *Legacy of Flight*, 94.

p. 121 "Inspired by the prosperity" Cleveland, *America Fledges Wings*, 110.

p. 122 "Altimeters were frequently inaccurate" Hallion, *Legacy of Flight*, 115.

p. 122 "See those instruments?" *The Seven Skies*, Guggenheim, 151.

p. 122 "If travelers wanted transportation on a schedule" Gen. James H. "Jimmy" Doolittle, *I Could Never Be So Lucky Again* (New York: Bantam Books, 1991) 122.

p. 123 "The scientific establishment" Dava Sobel, *Longitude* (New York: Walker and Co., 1995), front flap.

p. 123 "Harry tapped his contacts" Hallion, *Legacy of Flight*, 112.

p. 124 "The night before" Carroll V. Glines, USAF, An American Hero, Air Force Magazine, https://www.airforcemag.com/article/1193doolittle/.

p. 124 "Mitchel fell 500 feet" "Mitchel Killed by Fall from Aero," *New York Tribune*, July 17, 1918, 1.

p. 124 "Doolittle liked the Corsair" Hallion, *Legacy of Flight*, 119.

p. 124 "As recounted by Hallion" Hallion, *Legacy of Flight*, 120.

p. 125 "The moral of the story" Hallion, *Legacy of Flight*, 120.

p. 125 "a long-vacant, termite-ridden wooden building" Doolittle, *I Could Never Be So Lucky Again*, 126.

p. 126 "an eclectic menagerie of friends" Jonna Doolittle Hoppes, *Calculated Risk*, (Santa Monica Press: 2005), 104.

p. 126 "Scientists, pilots, university professors" Doolittle, *I Could Never Be So Lucky Again*, 126.

p. 126 "Among them Sachinka Toochkoff" Hoppes, *Calculated Risk*, 104.

p. 126 "showing if the aircraft is flying straight" Hoppes, *Calculated Risk*, 103.

p. 126 "two of the three based on gyroscopes" Milton Lomask, *Seed Money: the Guggenheim Story* (New York: Farrar, Straus and Co., 1964), 101.

p. 126 "I'm taking her up for a blind flight." Hoppes, *Calculated Risk*, 111.

p. 127 "Harry hoisted himself onto the lower wing" Hallion, *Legacy of Flight*, 122.

p. 127 "Doolittle scanned his instrument panel" Lomask, *Seed Money*, 101.

p. 127 "As historian Hallion recounted the flight" Hallion, *Legacy of Flight*, 123.

p. 128 "the fund's last major venture" One of the aviation fund's final bets was $250,000 for an airship institute in Akron, Ohio, close to where Goodyear was building its blimps. The four-story institute held a two-ton revolving arm which hurled miniature zeppelins through the air at 200 mph to test the greatest stress points on a blimp during a storm.

p. 128 "In 1926 there were less than 6,000 passengers a year, jumping to 173,000 in 1929" U.S. Centennial of Flight Commission, The Pioneering Years: Commercial Aviation 1920–1930, https://www.centennialofflight.net/essay/Commercial_Aviation/1920s/Tran1.htm.

p. 128 "by 1935 the number was close to 800,000" Hallion, *Legacy of Flight*, 99.

p. 128 "In the late 1920s aviation stocks tripled" U.S. Centennial of Flight Commission, The Pioneering Years: Commercial Aviation 1920–1930, https://www.centennialofflight.net/essay/Commercial_Aviation/1920s/Tran1.htm.

p. 128 "During the next year" Owen L. Scott, Aviation Developments, *Racine-Journal News*, December 31, 1927, 16.

p. 129 "Your victory constitutes" Harvey O'Connor, *The Guggenheims: the Making of An American Dynasty* (New York: Covici Friede, 1937), 439.

9–TROPICAL MUSSOLINI

p. 131 "a record 90,000 tourists" Tony L. Henthorne, *Tourism in Cuba: Casinos, Castros, and Challenges* (Bingley, England: Emerald Publishing: 2018), 12.

p. 132 "What made it so was the Platt Amendment" Entry on Cuba, *Funk and Wagnalls New Encyclopedia*, Volume 19, 188.

p. 132 "Among the accusations against" "Serious Charges Against Machado," *Altoona Mirror*, September 19, 1929, 1.

p. 133 "His signature project was the colossal El Capitolio" El Capitolio and the Statue of the Republic are described on "El Capitolio," Wikipedia, https://en.wikipedia.org/wiki/El_Capitolio.

p. 133 "American companies held over $1 billion in investments in Cuba" Ramon Eduardo Ruiz, *Cuba: The Making of a Revolution* (Amherst: University of Massachusetts Press, 1968), 49.

p. 134 "Whether President Hoover had it in mind or not" Associated Press, "New Ambassador to Cuba Known as Aviation Booster," *Wilkes-Barre Leader*, September 18, 1919, 21.

p. 134 "Cubans threaten revolution" "Guggenheim Meets the Terror," *Pittsburgh Press*, September 19, 1929, 18.

p. 134 "Life is a search for happiness" Harry F. Guggenheim Approved for Ambassadorship in Cuba, *New York Herald Tribune*, September 15, 1929, 1.. p. 135 "My dear Old

Man" Letter from HFG to H.G. Comber, March 15, 1929, Pembroke College Archive. The legacy of Harry's gifts to Pembroke College include a three-year research fellowship and the annual Harry Frank Guggenheim Dinner.

p. 137 "took a page from Dwight Morrow" Tax collections had dropped, and the price of sugar had plummeted. The small group of advisors Harry hired to work with him included Philip C. Jessup, a brilliant economic advisor who later was part of the diplomatic team that founded the United Nations; Edwin Seligman, an expert on tax policy; and Grosvenor Jones, former chief of the finance division at the Department of Commerce.

p. 138 "In 1928 the price of sugar" Luis E. Aguilar, *Cuba 1933* (New York: W.W. Norton and Co., 1972), 98.

p. 139 "a lopsided export economy" Ruiz, *Cuba: the Making of a Revolution*, 45.

p. 139 "For Cuba, the tariff was devastating" Clifford L. Staten, *The History of Cuba* (Westport, CT: Greenwood Press, 2003), 56.

p. 140 "The State Department followed Harry's recommendation" "No Cause for Interference," *Dayton Herald*, May 14, 1930, 10.

p. 140 "The office employed a dozen staffers" United States Department of Commerce, 1930 Census.

p. 140 "One shipment, consigned directly to Harry" Associated Press, "Envoy to Cuba Imports Booze," *The Capital Journal*, February 12, 1931, 13.

p. 140 "A foreign embassy is considered U.S. territory" Associated Press, "Envoy to Cuba Imports Booze," 13.

p. 140 "There will, therefore, be no issue raised over the 6,000-pound thirst of Ambassador Guggenheim" "Our Wet Embassies," *The Tennessean*, February 17, 1931, 4.

p. 141 "But when it came time for Machado's rubber-stamp congress" William Hard, "Cubans May Ask Intervention," *Evening Star*, Washington, DC, August 14, 1930, 1.

p. 142 "Eight people were killed, several dozen badly injured" Ruiz, *Cuba: the Making of a Revolution*, 100–101.

p. 142 "The events of Artemisa mean that politics is no longer possible in Cuba" Aguilar, *Cuba*, 101.

p. 143 "In a report to Stimson" The Ambassador in Cuba (Guggenheim) to the Secretary of State, Havana, January 8, 1931, Papers Relating to the Foreign Relations of the United States, 1931, Volume 2, https://history.state.gov/historicaldocuments /frus1931v02/d70.

p. 143 "with the greatest of care" Herminio Portell-Via, *La Nueva Historia de la Republica de Cuba, Santo Domingo* (Dominican Republic: La Moderna Posea, 1986), 371.

p. 143 "Harry elected to stay" Portell-Via, *La Nueva Historia de la Republica de Cuba*, 371.

p. 143 "Harry ignored the order" Portell-Via, *La Nueva Historia de la Republica de Cuba*, 372.

p. 143 "Another State Department cable came in April" Portell-Via, *La Nueva Historia de la Republica de Cuba*, 372.

p. 144 "Cuban Government Totters" Associated Press, "Cuban Government Totters," *Spokane Chronicle*, December 11, 1930, 1.

p. 144 "The draconian measure temporarily banned all" Associated Press, "Censorship Once More is Clamped Down in Havana," *Montana Standard*, December 13, 1930, 1.

p. 144 "Every realist in Washington knows" "Men and Affairs," *St. Joseph Gazette*, November 16, 1930, 4.

p. 144 "You have asked me why there is agitation" "Machado Charges Soviets Behind Cuban Disorder," *Dayton Daily News*, February 26, 1931, 2.

p. 145 "The Spanish-built fortress" "Beals Charges Machado Ruled with Murder," review of *The Crime of Cuba* by Fanny Butcher, *Chicago Tribune*, August 19, 1933, 8. These and other atrocities were recounted by Carleton Beals, former correspondent for the *New York Herald-Tribune*. Ironically, Beals had, just a few years earlier, been awarded a Guggenheim fellowship to write a book on Mexican President Diaz by the namesake foundation of Harry's uncle Simon.

p. 145 "practically intervened in Cuban affairs" "Junta Says Revolt Will Be Continued, Guggenheim Is Assailed," *New York Times*, August 15, 1931, 1.

p. 145 "Mr. Guggenheim then told our leaders" "Junta Says Revolt Will Be Continued" 1.

p. 146 "Every Saturday he would stop by a park" Luis Santiero, *Dancing with Dictators: A Family's Journey from Pre-Castro Cuba to Exile in the Turbulent Sixties* (New York: Amazon, 2017), 188.

p. 146 "They had barely gone half a block when this huge explosion" Santiero, *Dancing with Dictators*, 188–89.

p. 147 "Harry received a package" Note from Charles Lindbergh to HFG, November 3, 1932, Box 90, Harry Frank Guggenheim Papers, Manuscript Division, Library of Congress.

p. 148 "I am very tired" "Machado in Nassau with Aides; Exile Says He Still Loves Cuba," *New York Times*, August 14, 1933, 12.

10—MUZZLE VELOCITY

p. 150 "You ain't seen nothin' yet" John Baragwanath, *A Good Time Was Had* (New York: Appleton-Century-Crofts, Inc, 1962), 136.

p. 150 "a shootout erupted in the Cuban House of Representatives" "Cuban Leaders Duel in House," *Spokane Chronicle*, June 1, 1933, 1.

p. 150 Reports coming from Cuba indicated that there were plans in the works to assassinate Harry's successor, Sumner Wells. While Machado was held at the airport by his own military troops, Wells reportedly managed to get him released. "The Daily Washington Merry Go Round," *The Daily American*, August 31, 1933, 4.

p. 151 "It has done her very much good" HFG Letter to Charles Lindbergh, August 1, 1936, Box 13, Incoming Correspondence, Charles A. Lindbergh Papers, Sterling Memorial Library, Yale University.

p. 151 "Ominous edicts followed" Timeline of Events, 1933–38, US Holocaust Museum, https://www.ushmm.org/learn/timeline-of-events/1933-1938.

p. 152 "Both Lehman and Warburg" "Corporation Formed to Aid Nazi Refugees," *Philadelphia Inquirer*, July 22, 1935, 5.

p. 152 "a battle of bigotry against reason" "Drive to Aid Jews Opened by Lehman," *New York Times*, June 15, 1933, 1.

p. 153 "Lindbergh worked up a pencil-drawn diagram" Drawing by Charles Lindbergh, date unknown, Box 2, Harry Frank Guggenheim Papers, Manuscript Division, Library of Congress.

p. 153 "As long as you do anything constructive" Anne Morrow Lindbergh, diary entry, June 12, 1932, *Hour of Gold, Hour of Lead, 1929–1932* (New York: Harcourt Brace Jovanovich, 1973), 271.

p. 153 "It isn't what they say" Lindbergh, *Hour of Gold, Hour of Lead*, 271.

p. 154 "Suppose you *do* give in to it" Lindbergh, *Hour of Gold, Hour of Lead*, 272. The following day, the Lindberghs' maid, upon learning that she was to be questioned by police again on the death of the Lindbergh baby, committed suicide by poisoning herself at the Hopewell home.

p. 154 "One day Jon and his teacher were riding home" Olson, *Those Angry Days*, 11.

p. 154 "Yes, the Lindberghs said goodbye" "Extra Police Will Protect Lindberghs," *Lexington Leader*, December 24, 1935, 1.

p. 154 "We have been here (Long Barn) for over two weeks now, and the only place we like better is Falaise" Letter from Charles Lindbergh to HFG, March 25, 1936, Box 2, Harry Frank Guggenheim Papers, Manuscript Division, Library of Congress.

p. 154 "Write to me often. Come back when you can" Letter from HFG to Charles Lindbergh, December 11, 1936, Box 13, Incoming Correspondence, Charles A. Lindbergh Papers, Sterling Memorial Library, Yale University.

p. 155 "Listen to this" "To Explore Skies with Moon Rocket," *New York Times*, July 21, 1929, 11.

p. 155 "A flash of flame" Blazing A New Trail in the Upper Spaces," *St. Louis Post-Dispatch*, August 18, 1929, 88. Today a granite obelisk marks the spot where the rocket was launched on March 16, 1926. It is on the ninth fairway of the Pakachoag Golf Course in Auburn, MA.

p. 156 "Hickman was handling a cartridge with nitroglycerin powder" Hickman describes the accident in an oral history project, Engineering and Technology History Wiki, https://ethw.org/Oral-History:Clarence_Nichols_Hickman.

p. 157 "His childhood was filled with scientific discovery" David A. Clary, *Rocket Man: Robert H. Goddard and the Birth of the Space Age* (New York: Hyperion Books, 2003), 10.

p. 157 "The Navigation of Space" Clary, *Rocket Man*, 16.

p. 157 "He dreamed of having it published" Clary, *Rocket Man*, 17.

p. 157 "In college he wrote papers" Clary, *Rocket Man*, 26.

p. 157 "Rocket Apparatus" Clary, *Rocket Man*, 44.

p. 158 "portable infantry rocket" Clary, *Rocket Man*, 76.

p. 158 "On one day, he would be a conservative scientist" Milton Lehman, *This High Man: The Life of Robert Goddard* (New York: Farrar, Straus and Co., 1963), xiv.

p. 159 "I felt, in a general way" Letter from HFG to Charles Lindbergh, May 28, 1930, from U.S. Embassy in Cuba, Box 13, Incoming Correspondence, Charles A. Lindbergh Papers, Sterling Memorial Library, Yale University.

p. 159 "You believe these rockets have a real future?" Lehman, *This High Man*, 173.

p. 159 "As far as I can tell" Lehman, *This High Man*, 174.

p. 159 "How much does he need?" Lehman, *This High Man*, 174.

pp. 159–160 "Daniel was willing, but with one condition" Lehman, *This High Man*, 174.

p. 160 "They made a beeline for their favorite Chinese restaurant" Lehman, *This High Man*, 174.

p. 160 "He and Esther, along with a team of technicians" Lehman, *This High Man*, 185.

p. 161 "Goddard would sit" Clary, *Rocket Man*, 182.

pp. 161–162 "perhaps the greatest obtained by a man-made contrivance" Lehman, *This High Man*, 186.

p. 162 "badly shrunk the Guggenheim estate" Lehman, *This High Man*, 196.

p. 162 "His mind was restless with ideas" Lehman, *This High Man*, 201.

p. 163 "A jovial character" Lehman, *This High Man*, 170.

p. 163 "Pendray was closely following German rocket research" Lehman, *This High Man*, 168.

p. 163 "In fact, Germany allocated $50,000 in its military budget" Lehman, *This High Man*, 167.

11—ROCKETS AND RACKETS

p. 165 "Esther did the bookkeeping" Clary, *Rocket Man*, 153.

p. 165 "She used a still camera" Clary, *Rocket Man*, 153.

p. 166 "Before launching, the gyroscope was set in motion" Lehman, *This High Man*, 194–95.

p. 166 "In one trial, Nell lifted gracefully out of the launch tower" Lehman, *This High Man*, 208.

p. 166 "It was like a fish swimming upward through water!" Lehman, *This High Man*, 208.

p. 167 "The object of this work" Statement by Harry F. Guggenheim, September 24, 1935, 3 pages, Box 13, Incoming Correspondence, Charles A. Lindbergh Papers, Sterling Memorial Library, Yale University.

p. 168 "Apparently the oxygen gas" Lehman, *This High Man*, 210.

p. 168 "He had prepared a backup Nell" Lehman, *This High Man*, 210.

p. 168 "Before leaving the test site, Goddard showcased the properties of liquid oxygen" Lehman, *This High Man*, 211.

p. 168 "He uncovered a sidewinder rattlesnake" Lehman, *This High Man*, 211.

p. 168 "Harry rose early" Lehman, *This High Man*, 211.

p.168 "He quickly surmised" Lehman, *This High Man*, 211.

p. 169 "Goddard noted in his diary" Lehman, *This High Man*, 212.

p. 169 "Goddard's faith in the ultimate success" Lehman, *This High Man*, 211.

p. 169 "I am thoroughly convinced" Letter from Charles Lindbergh to HFG, April 6, 1936, Box 2, Harry Frank Guggenheim Papers, Manuscript Division, Library of Congress.

p. 170 "Goddard nonetheless complied with Harry's request" One design element Harry nudged the professor on was fuel injection pumps. Designing these pumps was time consuming—Harry wanted Goddard to farm out work on the pumps to the California Institute of Technology. Ideally, Goddard, Von Karman, and Clark Millikan would collaborate on such work. As Harry wrote to Lindbergh on September 19, 1938: "It is quite hard, as you know, to get the prima donnas of science working together." In the end, Goddard refused to collaborate.

p. 171 "I have just closed negotiations for the most important parcel" Letter from HFG to Charles Lindberg, February 11, 1936, Box 13, Incoming Correspondence, Charles A. Lindbergh Papers, Sterling Memorial Library, Yale University.

p. 172 "Harry called his new development Cain Hoy, once explaining" Associated Press, "Guggenheim One of Track's Top Sportsmen," *Ogden Standard Examiner Sun*, May 17, 1953, 9.

p. 172 "Harry reportedly bought the first 7,500 acres" Robert Shelton Converse, "The St. Thomas and St. Dennis Parish Church: An Anglo-Franco Alliance in the Low Country," (graduate thesis, Clemson and the College of Charleston) Tiger Prints Publishing: Clemson University, May 2011, 32.

p. 172 "the site of a kiln" Jackson Turner Main, *Political Parties Before the Constitution* (Chapel Hill: University of North Carolina Press, 1973).

p. 172 "Cain Hoy was built in the style" "Well-Appointed Dwelling Is Reached by Oak Avenue from Woodland Road," *News and Courier*, March 14, 1937, 1. The description of Cain Hoy comes from the *News and Courier* story and the author's visit to the home.

p. 173 "The walls of the vestry house" Converse, "The St. Thomas and St. Dennis Parish Church," 31.

p. 173 "the 1876 Cain Hoy Massacre" Converse, "The St. Thomas and St. Dennis Parish Church," 31. https://tigerprints.clemson.edu/cgi/viewcontent.cgi?article=2129&context=all_theses

p. 173 "Harry evicted" Converse, "The St. Thomas and St. Dennis Parish Church," 48. https://tigerprints.clemson.edu/cgi/viewcontent.cgi?article=2129&context=all_theses.

p. 173 "visitors to Cain Hoy" Visitors to Cain Hoy signed a leatherbound guestbook. Others who stayed regularly at Cain Hoy include daughter Joan, who married Albert C. Van de Maele at Falaise in 1947. (Van de Maele worked for a Belgian public utilities company at the time, but when Harry reorganized Guggenheim Brothers he offered Van de Maele a job as partner.).

p. 174 "one of the most prosperous, wealthy" W.P.N. Tyler, "The Huleh Concession and Jewish Settlement of the Huleh Valley, 1934–48"*Middle Eastern Studies* 30, no. 4 (October 1994): 826–859.

p. 174 "He had interviewed Adolf Hitler a decade earlier" Lynne Olson, *Those Angry Days* (New York: Random House), 15.

p. 174 "But Smith lacked reliable intelligence" Olson, *Those Angry Days*, 16.

p. 174 "Would Hermann Göring" Olson, *Those Angry Days*, 16.

p. 174 "I AM CONVINCED" A. Scott Berg, *Lindbergh* (New York: Berkeley Books, 1998),. 358.

p. 174 "He witnessed aerial shows" Olson, *Those Angry Days*, 16.

p. 175 "Unlike the builder of the dugout canoe" Leonard Mosley, *Lindbergh, A Biography* (New York: Dell, 1977), 216.

p. 175 "Germany now has the means of destroying London" Olson, *Those Angry Days*, 17.

p. 175 "I was fishing on a salmon river on the Gaspé Peninsula" Letter from HFG to Lindbergh en route to Charleston, South Carolina, August 1, 1936, Box 13, Incoming Correspondence, Charles A. Lindbergh Papers, Sterling Memorial Library, Yale University.

pp. 175–176 "Lindbergh's opinions of Hitler's Germany" Olson, *Those Angry Days*, 19.

p. 176 "He and Anne relied on translators everywhere they went" Olson, *Those Angry Days*, 19.

p. 176 "What journalist would be foolish enough" Olson, *Those Angry Days*, 19.

p. 176 "Their house-hunting in the German capital" Mosely, *Lindbergh, A Biography*, 415–416.

p. 176 "I am glad that you have again decided to continue" Letter from Charles Lindbergh
 to HFG from Illiec, Cotes-Du-Nord, July 5, 1938, Box 2, Harry Frank Guggenheim
 Papers, Manuscript Division, Library of Congress.

p. 177 "Every tug that lands at the docks has to pay a fee" "The Way to End Racketeering,"
 The Journal, Meridien, CT, January 25, 1934, 10.

p. 177 "Dewey had been an assistant district attorney" "Thomas E. Dewey Is Dead At 68,"
 New York Times, March 17, 1971, 1.

p. 178 "In my judgement" Mary M. Stolberg, *Fighting Organized Crime: Politics, Justice and
 the Legacy of Thomas Dewey*, (Boston: Northeastern University Press, 1995), 196.

p. 178 "So you're the guy who put it over on me in Italy" Milton Lomask, *Seed Money: the
 Guggenheim Story* (New York: Farrar, Straus and Co., 1964),82.

p. 178 "We are neither a group of vigilantes nor reformers" "Civic Group Created to Fight
 Crime," *Daily News*, October 22, 1936, 4.

p. 178 "Harry headed up its launch" "Crime National, Guggenheim Says," *New York Times*,
 May 13, 1940, 16.

p. 178 with an annual budget of $50,000" Stolberg, *Fighting Organized Crime*, 195 Funds
 raised by the Crime Commission were also used as financial aid to the families of
 key witnesses, "the very nature of whose services to the state brought about loss
 of employment or savings or imposed other material hardships upon them," said
 Harry. Fundraising for the committee's operating costs fell to Harry, who strong-
 armed each committee member for a contribution. Lindbergh donated $250 to the
 committee, a vote of confidence Harry could use as fundraising tool.

p. 179 "In the coming year Harry and his staff produced 9,000 file cards" Stolberg, *Fighting
 Organized Crime*, 196.

p. 180 "grand juries were being fixed" Irwin Unger and Debi Unger, *The Guggenheims: A
 Family History* (New York: Harper Perennial, 2005), 280.

p. 180 "Finally, Amen was able to expose both a corrupt bail bond office" Thomas
 Reppetto, *American Mafia: A History of its Rise to Power* (New York: Holt
 Paperbacks, 2004), 178.

p. 180 "Two senior attorneys in the DA's office" Reppetto, *American Mafia*, 178.

p. 180 "About two weeks ago I asked you if Floreka" Letter from Caroline Morton
 Guggenheim to HFG, January 3, 1937, Box 54, Harry Frank Guggenheim Papers,
 Manuscript Division, Library of Congress.

p. 181 "After all marriage" Letter from Caroline Morton Guggenheim to HFG, January 3,
 1937, Box 54, Harry Frank Guggenheim Papers, Manuscript Division, Library of
 Congress.

p. 181 "Marriage for me, freedom for you" Letter from Caroline Morton Guggenheim to
 HFG, October 18, 1937, Box 54, Harry Frank Guggenheim Papers, Manuscript
 Division, Library of Congress.

p. 181 "Do you really think that it was possible" Letter from Caroline Morton Guggenheim
 to HFG, Box 54, Harry Frank Guggenheim Papers, Manuscript Division, Library of
 Congress.

p. 181 "You assured me that your one desire" Letter from HFG to Caroline Morton
 Guggenheim, February 3, 1938, Box 54, Harry Frank Guggenheim Papers,
 Manuscript Division, Library of Congress.

p. 181 "Little by little" Letter from HFG to Caroline Morton Guggenheim, October 13, 1937, Box 54, Harry Frank Guggenheim Papers, Manuscript Division, Library of Congress.

p. 182 "In 1938 Lindbergh made another trip to Germany" Olson, *Those Angry Days*, 20.

p. 182 "A few years earlier the Cuban dictator Machado attempted to bestow" Associated Press, "Guggenheim Honored by Cuba," Associated Press, *New York Times*, May 31, 1933, 4.

p. 182 "teapot tempest" Mosley, *Lindbergh*, 235.

p. 181 "the albatross" Mosley, *Lindbergh*, 235.

p. 183 "They have undoubtedly had a difficult Jewish problem" Mosley, *Lindbergh*, 235.

p. 183 "Imagine an American" Mosley, *Lindbergh*, 416.

12—WHEN HARRY MET ALICIA

p. 184 "the highest paid in the United States" George Abbott, *Mister Abbott* (New York: Random House, 1963), 141.

p. 185 "Neysa would be at her easel" Abbott, *Mister Abbott*, 143.

p. 185 "Often she would be in an old blue smock" Abbott, *Mister Abbott*, 143.

p. 185 "Patterson had recently bought the couple a wedding present" Alice Arlen and Michael J. Arlen, *The Huntress: The Adventures, Escapades, and Triumphs of Alicia Patterson: Aviatrix, Sportswoman, Journalist, Publisher* (New York: Pantheon, 2016) , 135.

p. 186 "One late-summer afternoon" Arlen and Arlen, 137. A version of this account of Alicia's visit to Falaise appears in Alice and Michael J. Arlen's biography of Alicia Patterson, *The Huntress*.

p. 186 "Neysa gathered up Alicia" Arlen and Arlen, *The Huntress*, 137.

p. 186 "The four of them hopped into Jack's" Arlen and Arlen, *The Huntress*, 138.

p. 186 "A game of croquet was underway" Arlen and Arlen, *The Huntress*, 138.

p. 186 "Neysa and company" Arlen and Arlen, *The Huntress*, 138.

p. 186 "The rain had nearly stopped" Arlen and Arlen, *The Huntress*, 138.

p. 186 "The arched wooden entrance door" Arlen and Arlen, *The Huntress*, 138.

p. 187 "Harry half-joked" Arlen and Arlen, *The Huntress*, 138.

p. 187 "no doubt gently touching Alicia" Arlen, Arlen and Arlen, *The Huntress*, 144. Alice and Michael J. Arlen describe this subtle, chivalrous gesture during another moment with Alicia.

p. 187 "The fisherman would display his best catch to Harry" Dorothea Strauss, *Showcases* (Boston: Houghton Mifflin Co., 1973) 97.

p. 187 "She couldn't remember" Arlen and Arlen, *The Huntress*, 139.

p. 187 "Harry had bought his first horse" Robert F. Keeler, *Newsday: A Candid History of the Respectable Tabloid* (New York: Arbor House, William Morrow, 1990), 45.

p. 188 "while on safari in Indochina" Arlen and Arlen, *The Huntress*, 105.

p. 188 "having earned her transport pilot's license" Arlen and Arlen, *The Huntress*, 91.

p. 188 "about 1,800 acres along the St. Marys River" Keeler, *Newsday: A Candid History*, 235.

p. 188 "Sometimes there'd be a snake or two" Keeler, *Newsday: A Candid History*, 235.

p. 188 "hypnotic influence" Keeler, *Newsday: A Candid History*, 22.

p. 188 "I would have died" Keeler, *Newsday: A Candid History*, 22.

p. 188 "At age eighteen" Keeler, *Newsday: A Candid History*, 25.

p. 188 "When she was twenty" Keeler, *Newsday: A Candid History*, 27.

p. 188 "filler items" Keeler, *Newsday: A Candid History*, 27.

p. 188 "At night she resumed her playgirl lifestyle" Keeler, *Newsday: A Candid History*, 27.

p. 188 "For a story about a divorce" Keeler, *Newsday: A Candid History*, 28.

p. 191 "Just then, she saw a car approach" Arlen and Arlen, *The Huntress*, 155.

p. 191 "He bore a telegram, which said: 'SUITABLE NEWSPAPER PROPERTY AVAILABLE. NEED RESPONSE SOONEST. MAX.'" Arlen and Arlen, *The Huntress*, 155.

p. 192 "Lindbergh arrived on the *Aquitania*" Lynne Olson, *Those Angry Days* (New York: Random House, 2013), 24.

p. 192 "Two days later" Olson, *Those Angry Days*, 24.

p. 192 "Like Harry and Lindbergh, Hap Arnold was a passionate believer" Olson, *Those Angry Days*, 26.

p. 192 "Ranked twentieth in size" Olson, *Those Angry Days*, 26.

p. 192 "while holding great potential" Olson, *Those Angry Days*, 27.

p. 192 "For a cause like this" Olson, *Those Angry Days*, 27.

p. 193 "Britain, France and the rest of Western Europe" Olson, *Those Angry Days*, xvii.

p. 193 "Even General George Marshall" Olson, *Those Angry Days*, xix.

p. 193 "We all knew you could fly straight" A. Scott Berg, *Lindbergh* (New York: Berkeley Books, 1998), 410.

p. 193 "Germany alone can either dam the Asiatic hordes" Berg, *Lindbergh*, 395.

p. 193 "a clandestine offer came from Roosevelt via Truman Smith" Berg, *Lindbergh*, 397.

p. 193 "if Lindbergh agreed to ease up" Berg, *Lindbergh*, 397.

p. 194 "I prefer intellectual and personal freedom" Berg, *Lindbergh*, 399.

p. 195 "In May of 1940" Alfred Rosenthal, *Venture into Space: Early Years of Goddard Space Flight Center* (Washington, DC: National Aeronautics and Space Administration, 1968), Goddard Space Flight Center, https://history.nasa.gov/SP-4301.pdf, 204.

p. 195 "Harry and Goddard offered" Rosenthal, *Venture into Space*, 204.

p. 195 "All three agencies" Rosenthal, *Venture into Space*, 204. A vindication came for Goddard on July 17, 1969, when the New York Times ran a correction of its condescending 1920 story ridiculing Goddard's assertion that a rocket could function in a vacuum. The original story noted: "That Professor Goddard, with his 'chair' in Clark College and the countenancing of the Smithsonian Institution, does not know the relation of action to reaction, and of the need to have something better than a vacuum against which to react – to say that would be absurd. Of course he only seems to lack the knowledge ladled out daily in high schools." Twenty-four years later the Times correction stated: "Further investigation and experimentation have confirmed the findings of Isaac Newton in the 17th century and it is now definitely established that a rocket can function in a vacuum as well as in an atmosphere. The Times regrets the error."

p. 196 "The Plain Truth" "F.D.'s Record on Aviation!" *Daily News*, October 12, 1940, 14.

p. 196 "Should ever the time come" "Pilot Training Assailed, *New York Times*, August 29, 1940, 2.

p. 196 "His radio addresses" Berg, *Lindbergh*, 410.

p. 197 "Sears, Roebuck and Co. heir Lessing Rosenwald" Berg, *Lindbergh*, 413.

p. 197 "In the coming year Lindbergh spoke" Berg, *Lindbergh*, 413.

p. 197 "No one has ever heard Lindbergh" Berg, *Lindbergh*, 423.

p. 197 "The three most important groups" Alexander Uhl, "Inside Story of Lindbergh," *The St. Louis Star-Times*, October 22, 1941, 1.

p. 198 "In fact, less than 3 percent of U.S. media" Olson, *Those Angry Days*, 385.

p. 198 "Catholic and Protestant alike" "Seven Hundred Protestant Leaders Score Lindbergh for Anti-Semitic Speech," *The Wisconsin Jewish Chronicle*, October 3, 1941, 1.

p. 198 "WHAT AN UNPATRIOTIC DUMB BELL YOU ARE." Western Union telegram from Cornelius Vanderbilt Jr. to Charles Lindbergh, 1941, Box 13, Incoming Correspondence, Charles A. Lindbergh Papers, Sterling Memorial Library, Yale University.

p. 198 "Libraries removed *We* from their shelves" Berg, *Lindbergh*, 421.

p. 199 "Does Lindbergh know" "Chat from the Capital, 'Hillel' the Observer," *The Modern View*, St. Louis, Missouri, September 27, 1929, 6.

p. 200 "shackled" American Air Power, Remarks by Harry F. Guggenheim, annual meeting of the Academy of Political Science, Columbia University, January 1942.

p. 200 "We gave birth to the airplane" American Air Power, Remarks by Harry F. Guggenheim, annual meeting of the Academy of Political Science, Columbia University, January 1942.

p. 201 "The compound housed" Associated Press, "Navy Commissions Delivery Deport for New Planes," The *Morning Call*, July 28, 1943, 3.

p. 201 "There are pilots and crews" "Navy Commissions Delivery Deport for New Planes," 3.

p. 201 "We are the last link" "Navy Commissions Delivery Deport for New Planes," 3.

p. 202 "With thanks for my life" Jeffrey S. Rubin, "Parachute Pioneer Saluted," *Asbury Park Press*, May 13, 1996, 1.

p. 203 "Harry's posting at Mercer field" Harry's military service at Mercer Field and in the Pacific is drawn from Record of Officers, U.S. Navy, Harry F. Guggenheim, National Archives and Records Administration, 1942–1945. Under Harry's command, 37 percent of the combat planes produced for the Navy during the last eight months of the war were tested at Mercer Field. During the war Mercer Field commissioned some 15,000 planes and held first place in the lowest average time required for commissioning aircraft. Harry was awarded the Navy's Commendation Ribbon and cited on September 25, 1945, by Secretary of the Navy James Forrestal, for delivering: "a marked saving in the time necessary to process new aircraft for the Fleet during a critical period, when delays in delivery might have hampered our successful prosecution of the war."

p. 203 "Soon he was on his way as an observer aboard the USS *Nehenta Bay*" While Harry was stationed on the *Nehenta Bay*, daughter Joan enlisted in the women's branch of the U.S. Army, known as the Women's Army Corps (WAC). Capt. Joan Guggenheim served with WAC in New Guinea, some 2,000 miles south of Harry.

13—HORSEPOWER

p. 205 "some $750,000 into the paper" "The Press: Alicia in Wonderland," *Time*, September 13, 1954.

p. 206 "Perhaps the unconventional marriage" George Abbott, *Mister Abbott* (New York: Random House, 1963), p. 161.

p. 206 "Alicia would swim across the river" Robert F. Keeler, *Newsday: A Candid History of the Respectable Tabloid* (New York: Arbor House, William Morrow, 1990), 235.

p. 206 "Abbott and Alicia spent hours talking to each other" Keeler, *Newsday: A Candid History*, 235.

p. 207 "finalized the donation of Hempstead House" Reginald M. Cleveland, *America Fledges Wings: The History of the Daniel Guggenheim Fund for the Promotion of Aeronautics* (New York and Chicago: Pittman Publishing, 1942), 216.

p. 207 "Pendray agreed to document Goddard's experiments" Pendray became a consultant to the HFG foundation. It was Pendray to whom Harry turned to investigate the feasibility of funding a research proposal he had received for a "man-powered airplane" (a project proposed by a respected engineer, but which went nowhere). Harry once dispatched Pendray on a confidential mission to Washington, D.C., to secretly obtain film footage of ancient texts on behalf of John Steinbeck, a contributor to *Newsday*. (Steinbeck believed he had discovered an historic Arthurian manuscript during a visit to an English castle. He broke the story in *Newsday*, likening the discovery to handwritten notes that led to the crafting of the Declaration of Independence.)

p. 208 "Harry reorganized Guggenheim Brothers," Associated Press, "Guggenheim Brothers–New Partnership to Carry on Interests," *Chicago Tribune*, December 18, 1951, 31.

p. 208 "One idea Harry pitched" Milton Lomask, *Seed Money: the Guggenheim Story* (New York: Farrar, Straus and Co., 1964), 70.

p. 209 "Ike liked the idea" Lomask, *Seed Money*, 70.

p. 209 "Each week 700,000 Americans" James C. Nicholson, *The Kentucky Derby* (Kentucky: University Press of Kentucky, 2012), 123.

p. 209 "By 1952" Nicholson, *The Kentucky Derby*, 123.

p. 210 "Calumet dominated racing" Nicholson, *The Kentucky Derby*, 127.

p. 210 "In 1948 Citation won 19 out of 20 races" Nicholson, *The Kentucky Derby*, 125.

p. 210 "He tracked pregnancy rates" Keeler, *Newsday: A Candid History*, 231.

p. 211 "There are so many variables and imponderables" "Captain Harry And His Cain Hoy Stable" *Sports Illustrated*, January 18, 1960, 42.

p. 212 "Harry named the horse Dark Star" Most of the names of HFG's horses were suggestions from friends and business associates. "Dark Star" was the name suggested by Charles Grimes, an assistant district attorney who had been a key aide to Dewey during Harry's time at the Crime Commission.

p. 213 "There were several approaches" Most Race Strategy: And They're Off!, graphic, *Jackson Sun* Tennessee, May 6, 1989, 4B.

p. 213 "some twenty million Americans" Nicholson, *The Kentucky Derby*, 138–139.

p. 213 "Nearly three-quarters of all American television sets" Nicholson, *The Kentucky Derby*, 138–139.

p. 214 "The Associated Press polled" Associated Press, "Cleveland Scribe Only Expert to Pick Dark Star," *Park City Daily News*, Kentucky, May 3, 1953, 8.

p. 213 "resembling cotton candy" "Dancer Could Get New Start in Preakness," *Courier-Journal*, May 3, 1953, 29.

p. 214 "In the boxes" Associated Press, "Reeking Rich and Painfully Poor Rub Elbows at America's Most Colorful Race, *Park City Daily News*, Kentucky, May 3, 1953, 8.

p. 214 "Diamond Jim" Moran "Diamond Jim Just a Speck of Color on the Many Hued Derby Scene," *Courier-Journal*, May 3, 1953, 8.

p. 216 "Go, baby" Earl Ruby, "Ruby's Report," *Courier-Journal*, May 3, 1953, Sports Section, 1.

p. 217 "I'm glad it was you" "Good Loser, Shy Winner Shake Hands," *Courier-Journal*, May 3, 1953, 1.

p. 217 "Dark Star's victory" After his Kentucky Derby win HFG made one of the sport's top trainers, W.C. (Woody) Stephens, an offer: $50,000 per year and 20 percent of all profits from his horses' winnings. Stephens accepted and worked for Harry for a decade. Stephens developed Never Bend, the two-year-old colt who came in second at the 1963 Derby. Stephens went on to win sixty-eight stakes races for Cain Hoy Stables. Stephens was added to thoroughbred racing's Hall of Fame in 1976.

p. 217 "Now, please don't put any intimate stuff" "Good Loser, Shy Winner Shake Hands," 1.

p. 217 "Racing was more or less a hobby" "Good Loser, Shy Winner Shake Hands," 1.

p. 217 "Alicia confided to the reporter" "Good Loser, Shy Winner Shake Hands," 1.

p. 217 "I tried to bum a couple of bucks off my owner" Gil Wood, "Portraits," *Burlington Daily News*, May 5, 1953, 6.

14—THE HOUSE THAT HARRY BUILT

p. 219 "ladling split pea soup" Associated Press, "Non-Objective Painting Brings Sense of Order," *Newport Daily Express*, March 8, 1948, 3.

p. 219 "It is like trying to explain music in words" "Non-Objective Painting Brings Sense of Order," 3. Rebay would explain that no one needed to comprehend Bauer or Kandinsky. "Non-objective art need not be understood or judged, it must be felt and it will influence those who have eyes for the loveliness of forms and colors. Non-objective pictures, being worlds of their own, have no meaning and represent nothing materially."

p. 220 "reduced to its essential elements" Jaqueline Weld, "Peggy: the Wayward Guggenheim," by Jacqueline Bograd Weld, E.P. Dutton: New York, 1986 , p. 109.

p. 220 "Sol's foyer was tinted a pale blue" Associated Press, "Eccentric Millionaire Lives Among Pictures He Bought Against Advice of Friends," *Greenville News*, December 1, 1935, 27.

p. 220 "I can't stay away from them very long" "Eccentric Millionaire Lives Among Pictures He Bought Against Advice of Friends," 27.

p. 221 "Attach your eyesight" Brochure, Hilla Rebay, Museum of Non-Objective Painting, New York, November–December 1948, https://archive.org/details /solomonrguggenhe1948reba.

p. 222 "a one-man show and a monthly contract" Joan M. Lukach, *Hilla Rebay*, (New York: George Braziller, 1983) 155.

p. 222 "meaningless scribbles and scrawls" Lukach, *Hilla Rebay*, 156.

p. 222 "The versatility of this great artist" and subsequent quotes come from the Rebay catalog, November–December 1948.

p. 223 "mystic doubletalk" "Museum in Query," *New York Times*, April 22, 1951, 3.

p. 223 "tampered with" "Museum in Query," 3.

p. 223 "clumsily removed" "Museum in Query," 3.

p. 223 "ruined" "Museum in Query," 3.

p. 223 "Presumably" "Museum in Query," 3.

p. 224 "a scathing critique of the museum" "Museum in Query," 3.

p. 225 "ridiculous" Milton Lomask, *Seed Money: the Guggenheim Story* (New York: Farrar, Straus and Co., 1964), 181.

p. 225 "Refreshingly free of the double-talk" "A Museum's Future," *New York Times*, August 5, 1951, 6.

p. 226 "believed that much of human sickness," Bruce Brooks Pfeiffer, *Frank Lloyd Wright: the Guggenheim Correspondence*, (Carbondale, IL: Southern Illinois University Press and the Press at California State University, Fresno, 1986), 2.

p. 226 "I want a temple of spirit" Pfeiffer, *Frank Lloyd Wright*, 2; Letter from Hilla Rebay to Frank Lloyd Wright, June 1, 1943. Bruce Brooks Pfeiffer, *Frank Lloyd Wright: the Guggenheim Correspondence*, (Carbondale, IL: Southern Illinois University Press and the Press at California State University, Fresno, 1986), p. 4.

p. 226 "Mr. Guggenheim is 82 years old" Pfeiffer, *Frank Lloyd Wright*, 2; Letter from Hilla Rebay to Frank Lloyd Wright, June 14, 1943 . Bruce Brooks Pfeiffer, *Frank Lloyd Wright: the Guggenheim Correspondence*, (Carbondale, IL: Southern Illinois University Press and the Press at California State University, Fresno, 1986), p. 6.

p. 226 "Mr. Wright, I knew you would do it" Letter from Hilla Rebay to Frank Lloyd Wright, June 14, 1943, 6. Frank Lloyd Wright relates his presentation of drawings to Solomon in a letter to Harry. Letter from Frank Lloyd Wright to HFG, May 14, 1952. Bruce Brooks Pfeiffer, *Frank Lloyd Wright: the Guggenheim Correspondence*, (Carbondale, IL: Southern Illinois University Press and the Press at California State University, Fresno, 1986), p. 169.

p. 227 "application denied" Lomask, *Seed Money*, 190.

p. 227 "Architecture, may it please the court" Lomask, *Seed Money*, 190.

p. 228 "an iron fisted ultimatum" Jane King Hession and Debra Pickrel, *Frank Lloyd Wright: The Plaza Years, 1954–1959*, (Layton, Utah: Gibbs Smith, 2017), 102.

p. 228 "Damn it, get a permit for Frank" Meryle Secrest, *Frank Lloyd Wright: A Biography*, (University of Chicago Press, 1998), 551.

p. 228 "I want the Guggenheim built!" Moses arranged for the hiring of a special inspector, costing $3,000. Harry "grumbled, but paid." Secrest, *Frank Lloyd Wright*, 551.

p. 228 "Querido Francisco" Letter from HFG to Frank Lloyd Wright, July 2, 1956, quoted in Lomask, *Seed Money*, 184.

p. 229 "I have no doubt, as time goes on" Letter from HFG to Frank Lloyd Wright, June 20, 1956, Solomon R. Guggenheim Archives.

p. 228 "not suitable" Letter from 21 artists to James Johnson Sweeney, undated 1957, Pfeiffer, *Frank Lloyd Wright*, 242.

p. 228 "We shall be compelled to paint" Ibid. "Dear Fellow Artists," Letter from Frank Lloyd Wright to 21 artists, undated 1957, Hessian and Pickrel, "Frank Lloyd Wright in New York" p. 107.., Pfeiffer, *Frank Loyd Wright*, p. 243. Wright was a foe of rectilinear forms in any architectural context. "We have finished with doors and

windows. I am tired of them. The building of the future will be organic architecture, the architecture of democracy, in which man resumes his correct relationship with the structures in which he lives and works," said Wright. The Guggenheim was a preeminent example of such architecture. "I hope we can get this built before some department store adopts the idea," he said. Associated Press, "Spiral Plastic Building Will Have No Doors or Windows," *Tampa Tribune*, September 30, 1945, 10A.

p. 229 "the ramp's grade was just 3 percent" Hession and Pickrel, *Frank Lloyd Wright*, 107.

p. 230 "quarrels between an architect" The Guggenheim Story: Where the Money Goes, book review of "Seed Money: the Guggenheim Story" by Milton Lomask, *Boston Globe*, July 4, 1964, 9.

p. 230 "Calder sculptures, his Mirós and Picassos" "Lively Gallery for Living Art," *New York Times*, May 30, 1954, 25.

p. 230 "The Interior of his home resembled a Mondrian painting" Peggy Guggenheim, *Out Of This Century* (London: Andre Deutch, 1979), 360.

p. 230 "a hideous lumberyard" "The Museum of Non-Objective Painting," by Karole Vail, Guggenheim Museum Publications: New York, 2009, p. 203.

p. 230 "Harry—Lieber!" Letter from Frank Lloyd Wright to HFG, May 7, 1958; Pfeiffer, *Frank Lloyd Wright*, 266.

p. 231 "toilets of the Racquet Club" Letter from Frank Lloyd Wright to HFG, March 17, 1958, Pfeiffer, *Frank Lloyd Wright*, 263.

p. 231 "You seem to have an unpleasant association" Lomask, *Seed Money*, 201.

p. 231 "True, the new reality knocks him out" Letter from Frank Lloyd Wright to HFG, May 10, 1958, Pfeiffer, *Frank Lloyd Wright*, 266.

p. 231 "the paintings must not be subjugated" Lomask, *Seed Money*, 199.

p. 231 "cease your diabolical maneuvers" Lomask, *Seed Money*, 199.

p. 231 "Dear Harry, I am fully aware" Letter from Frank Lloyd Wright to HFG, Nov. 28, 1958, Pfeiffer, *Frank Lloyd Wright*, 275.

p. 231 "Lieber Harry . . . You are now *the* Guggenheim" Letter from Frank Lloyd Wright to HFG, Dec. 27, Pfeiffer, *Frank Lloyd Wright*, p. 283.

p. 232 "The architectural integrity" Letter from HFG to Frank Lloyd Wright, March 31, 1958, Solomon R. Guggenheim Archives.

p. 232 "If this were an architectural matter" Letter from HFG to Frank Lloyd Wright, January 16, 1959, Solomon R. Guggenheim Archives.

p. 232 "connecting the New York art world" The Art and Political History of An Early Guggenheim Award, Solomon R. Guggenheim, https://www.guggenheim.org/blogs/findings/the-artistic-and-political-history-of-an-early-guggenheim-award.

p. 232 "stag dinners" "17 At Stag Dinner at White House," *St. Louis Post Dispatch*, February 4, 1955, 9.

pp. 232–233 "Juncosa wore a scarf" "Ike's Art Sensitive," *Irving Daily News*, Texas, May 12, 1964, 6.

p. 233 "very sensitive" *Irving Daily News*, Texas, May 12, 1964, 6.

p. 233 "I believe Mr. Wright to be a great man, a great genius" Mrs. Frank Lloyd Wright, "Mrs. Wright Meets Lindberghs, Bentons and the Guggenheims," *The Capital Times*, October 23, 1959, 3.

p. 234 "a war between" "New Building Starts a National Debate," *St. Louis Post Dispatch*, November 1, 1959, 4.

p. 234 " turned out to be the most beautiful building" Paul Berg, "New Building Starts a National Debate," 4.

p. 234 "On opening day" "New Building Starts a National Debate," 4.

p. 234 "one of the greatest rooms" Hession and Pickrel, *Frank Lloyd Wright*, 113.

p. 234 "134 pieces" UPI, "New 'Chambered Nautilus' Museum Opened Yesterday," *The Journal-News*, October 22, 1959, 15.

p. 234 "aftermath trash" Western Union Telegram from Hilla Rebay to James Sweeney, November 28, 1959, Art of Another Kind: Guggenheim Inaugural Exhibition, Solomon R. Guggenheim, https://www.guggenheim.org/video/art-of-another-kind -guggenheim-inaugural-exhibition.

p. 234 "who interviewed some 700 patrons" "Palette Talk," *The Daily Register*, May 5, 1960, 10.

p. 235 "She awoke at Falaise each morning" "The Press: Alicia in Wonderland," *Time*, September 13, 1954 (no page no.).

p. 235 "She would then drive her Oldsmobile coupe" "The Press: Alicia in Wonderland."

p. 235 "In 1954 Newsday was the most profitable" "The Press: Alicia in Wonderland."

p. 235 "We're a big city paper" "The Press: Alicia in Wonderland."

p. 236 "Dogs! Cats! Murders!" "The Press: Alicia in Wonderland."

p. 236 "Spend every nickel" "The Press: Alicia in Wonderland." Part of Newsday's editorial identity was its advocacy for housing and economic growth on Long Island. The newspaper was a strong supporter of Levittown, the original starter suburb, a giant housing development that gave favorable terms to veterans buying homes after the war. However, the Federal Housing Administration wouldn't underwrite mortgages to people of color seeking to live in Levittown. Even after the Supreme Court struck down racially biased housing covenants in 1948, Levittown founder William Levitt continued the practice—leases had a "whites only" clause. In its early years, Newsday offered little or no criticism of the practice. To Newsday's credit, it has since produced major stories on housing discrimination on Long Island, most recently in 2019, in a Newsday Opinion podcast series looking at the legacy of segregation at Levittown hosted by Newsday editorial board member Mark Chiusano.

p. 236 "It was like being nibbled to death" "The Press: Alicia in Wonderland."

p. 237 "Alicia fixed her husband with a glare" "The Press: Alicia in Wonderland."

p. 237 "moving in for a few weeks with close friend Phyllis Cerf" Robert F. Keeler, *Newsday: A Candid History of the Respectable Tabloid* (New York: Arbor House, William Morrow, 1990), 242.

15—TABLOID TITAN

p. 238 "perfectly fascinating" "Nehru Visits Art Museum," Associated Press, *Quad-City Times*, Davenport, Iowa, October 1, 1960, 8B.

p. 238 "escorted her imperial majesty" "Empress Takes Royal Tour of Museum," *Newsday*, April 16, 1962, 32.

p. 238 "a good idea" "Empress Takes Royal Tour of Museum," 32.

p. 238 "today worth $3 billion" Alastair Sooke, "The $3 Billion Art Collection Hidden in Vaults," BBC Culture, December 7, 2018, https://www.bbc.com/culture/article /20181207-the-3bn-art-collection-hidden-in-vaults.

p. 240 "and no double talk, please" Oral History Interview with Thomas M. Messer, Smithsonian Archives of American Art, October 1994–October 1995, https://www .aaa.si.edu/collections/interviews/oral-history-interview-thomas-m-messer-11803.

p. 240 "I knew that if Harry gave his nod" Oral History Interview with Thomas M. Messer.

p. 240 "He and Alicia strolled" Robert F. Keeler, *Newsday: A Candid History of the Respectable Tabloid* (New York: Arbor House, William Morrow, 1990), 284.

p. 240 "If anything ever happens" Keeler, *Newsday: A Candid History*, 284.

p. 241 "Alicia sent a note" Keeler, *Newsday: A Candid History*, 285.

p. 240 "a poll in late 1960" Bob Considine, "Taft-Hartley Act in '47 Ignited Nixon-Kennedy Debate Series," *Times-Leader*, Pennsylvania, November 1, 1960, 1.

p. 241 "A *Time* magazine story" Keeler, *Newsday: A Candid History*, 286.

p. 241 "The lunch started" Alice Arlen and Michael J. Arlen, *The Huntress: The Adventures, Escapades, and Triumphs of Alicia Patterson: Aviatrix, Sportswoman, Journalist, Publisher* (New York: Pantheon, 2016), 322.

p. 242 "They talked about" Arlen and Arlen, *The Huntress*, 322.

p. 242 "Pushing himself from the table" Keeler, *Newsday: A Candid History*, 289.

p. 242 "Get me Jeeb Halaby" Keeler, *Newsday: A Candid History*, 289.

p. 242 "He had been outflanked by his own wife" The universities would get their land, but years later Mitchel Field's aviation legacy would be enshrined by another institution on the property, the "Cradle of Aviation Museum," housing a sister version of the *Spirit of St. Louis* (used in the 1957 movie starring Jimmy Stewart), replicas of Harry's TBM Avengers, and one of Robert Goddard's A-series rockets, all located at One Charles Lindbergh Blvd.

p. 242 "In 1959 Robert Goddard" With Goddard gone, Harry continued to advance research in rocketry and propulsion in the 1950s–60s, just as the fund had supported aviation research in the 1920s. In 1953 the Daniel and Florence Guggenheim Foundation established the *Guggenheim Institute of Air Flight Structures* at Columbia University, providing grants totaling $529,000 ($5 million today) for graduate training in aerospace vehicle design and a center for structural research. In 1955 the *Jet Propulsion Center* (JPL) at Caltech in Pasadena received the second of two grants from the foundation, totaling $454,000 ($4.4 million today). In early 1957 the foundation created the *Harvard-Guggenheim Center for Aviation Health and Safety*, shelling out $250,000 ($2.4 million today). It studied medical problems of flight crews, ranging from chronic stress to emergency depressurization of cabins. In July 1961 the foundation funded the *Guggenheim Laboratories for the Aerospace Propulsion Sciences* at Princeton University, the third of three grants totaling $669,000 (nearly $6 million today). In early 1958 the first U.S. satellite was launched jointly by the U.S. Army and a team from the JPL. The satellite enabled the discovery of a radiation belt around the earth, the Van Allen Belt, providing valuable data for the first moon landing.

p. 242 "Most of the senior aerospace engineers" John H. Davis, *The Guggenheims: An American Epic* (New York, William Morrow and Co., 1978), 169.

p. 242 "In 1963" Arlen and Arlen, *The Huntress*, 325.

p. 243 "Adlai and Alicia sharing a suite" Arlen and Arlen, *The Huntress*, 325.

p. 243 "didn't take good care of herself" Keeler, *Newsday: A Candid History*, 311.

p. 243 "Alicia's staff" Keeler, *Newsday: A Candid History*, 311.

p. 243 "Later that month" Keeler, *Newsday: A Candid History*, 311.

p. 243 "Alicia's secretary" Keeler, *Newsday: A Candid History*, 311.

p. 243 "Her doctor" Keeler, *Newsday: A Candid History*, 311.

p. 243 "Holdsworth called Alicia's chauffeur" Keeler, *Newsday: A Candid History*, 311.

p. 244 "Alicia's doctors" Keeler, *Newsday: A Candid History*, 312.

p. 243 "Her doctors gave Alicia two choices" Keeler, *Newsday: A Candid History*, 312.

p. 243 "Adlai Stevenson came to the hospital" Keeler, *Newsday: A Candid History*, 317.

p. 243 "The operation went smoothly" Keeler, *Newsday: A Candid History*, 313.

p. 243 The doctors conferred" Keeler, *Newsday: A Candid History*, 313.

p. 243 "A final surgery was performed" Keeler, *Newsday: A Candid History*, 314.

p. 243 "An examination later led doctors" Keeler, *Newsday: A Candid History*, 315.

p. 243 "Among those who came to stay" Irwin Unger and Debi Unger, *The Guggenheims: A Family History* (New York: Harper Perennial, 2005), 322.

p. 243 "They described Harry" Unger and Unger, *The Guggenheims*, 322.

p. 243 "'I was supposed to die first'" Unger and Unger, *The Guggenheims*, 322.

p. 245 "I have known you now for so long" Letter from Charles Lindbergh to HFG, July 9, 1963, Box 252, Harry Frank Guggenheim Papers, Library of Congress.

p. 245 "A beautiful and spirited lady" Arlen and Arlen, *The Huntress*, 333.

p. 245 "Harry had not let Adlai Stevenson" Keeler, *Newsday: A Candid History*, 318.

p. 245 "The discovery enraged him" Keeler, *Newsday: A Candid History*, 318.

p. 245 "Harry called Dot Holdsworth" Keeler, *Newsday: A Candid History*, 318.

p. 245 "Unbeknownst to Harry" Keeler, *Newsday: A Candid History*, 318.

p. 246 "her golden retriever, Sunbeam" Keeler, *Newsday: A Candid History*, 343.

p. 245 "Once, in a contentious conversation" Keeler, *Newsday: A Candid History*, 343.

p. 245 "Under Harry, there was a tight agenda" Keeler, *Newsday: A Candid History*, 343.

p. 245 "252-person editorial staff" "The Captain Takes Command," *Time*, November 4, 1966, 32.

p. 245 "In trying to impose" Keeler, *Newsday: A Candid History*, 339.

p. 246 "a two-page memo to editorial writers" Keeler, *Newsday: A Candid History*, 343.

p. 246 "The President and his advisors" Keeler, *Newsday: A Candid History*, 343.

p. 247 "frequently lied" Keeler, *Newsday: A Candid History*, 340.

p. 247 "He was a proponent" "Mark F. Ethridge, Journalist, Dies at 84," *New York Times*, April 7, 1981, B10.

p. 247 "His appointment sent the unmistakable message" Keeler, *Newsday: A Candid History*, 342.

p. 248 "If the President seriously wants to talk about Latin America" Memorandum of conference with President Kennedy on September 5, 1963 at 6:00 p.m. at the Executive Office in the White House, undated, Box 248, Harry Frank Guggenheim Papers, Library of Congress. The account of HFG's conference with Kennedy is based on Harry's notes on the meeting. His suggestion for a Latin American envoy had been endorsed two years earlier by John S. Knight, editor and publisher of the Detroit News: "Consideration should be given to Capt. Harry Guggenheim's suggestion that the President appoint an ambassador-at-large to Latin America . . . to command respect south of the border."

p. 249 "In fact, Jeeb Halaby had sent Kennedy a private memo" Memo on Supersonic Transport, FAA Administrator Najeeby Halaby to President John F. Kennedy, June 3, 1963, John F. Kennedy Library and Museum.

p. 250 "In a brief toast" Audio recording, Toast of the president to the King of Afghanistan during dinner at the state dining room at the White House, September 5, 1963, John F. Kennedy Presidential Library and Museum.

p. 250 "The circulation department made an expensive suggestion" Keeler, *Newsday: A Candid History*, 349.

p. 250 "Harry also ordered a temporary ban on gun advertisements" Keeler, *Newsday: A Candid History*, 350.

p. 251 "Harry's appointment with Johnson" Memorandum of conference with President Johnson on Feb. 23, 1965 at the Executive Office in the White House, undated, Box 248, Harry Frank Guggenheim Papers, Library of Congress. The account of Harry's conference with Johnson is based on Harry's notes on the meeting.

p. 251 "Steinbeck's assignment" Steinbeck covered the Vietnam War for *Newsday* in 1967, writing a weekly column, "Dear Alicia," as a tribute to her.

16—DESTINY OF THE DYNASTY

p. 251 "Harry, there's got to be a way to stop" Interview with Peter O. Lawson-Johnston, December 23, 2019.

p. 255 "My premise is that men throughout history" Letter from Charles Lindbergh to HFG, May 10, 1966, Box 252, Harry Frank Guggenheim Papers, Library of Congress.

p. 255 "long and difficult journey" Letter from HFG to Dr. Paul Fitts, "Summary of Progress, Man's Relation to Man Project, April 15, 1961 to Aug. 1, 1965" p. 22, Harry Frank Guggenheim Foundation Archive

p. 256 "It was a joint settlement by" *This High Man: The Life of Robert Goddard* (New York: Farrar, Straus and Co., 1963), 404.

p. 257 "The Guggenheim family has helped to develop" Peter O. Lawson-Johnston, *Growing Up Guggenheim: A Personal History of a Family Enterprise* (Wilmington, Delaware: ISI Books, 2005), 70.

p. 257 "In planning the distribution of my estate" John H. Davis, *The Guggenheims: An American Epic* (New York, William Morrow and Co., 1978), 30.

p. 257 "daughtering-out" Davis, *The Guggenheims*, 22.

p. 257 "collectively had twelve daughters" Davis, *The Guggenheims*, 22.

p. 257 "Harry made Straus" Davis, *The Guggenheims*, 23.

p. 257 "He instead ended up in bitter arguments" Davis, *The Guggenheims*, 24.

p. 258 "After a while the two men" Davis, *The Guggenheims*, 24.

p. 258 "Dana was a quiet young man" Davis, *The Guggenheims*, 25.

p. 258 "He was trying to figure out his way in life" Robert F. Keeler, *Newsday: A Candid History of the Respectable Tabloid* (New York: Arbor House, William Morrow, 1990), 382.

p. 258 "You write of 'depressions and anxieties'" Letter from HFG to Dana Draper, March 12, 1962, Box 42, Harry Frank Guggenheim Papers, Library of Congress.

p. 259 "This is a birthday greeting" Letter from HFG to Dana Draper, June 23, 1961, Box 42, Harry Frank Guggenheim Papers, Library of Congress.

p. 259 "He took two summer school courses" Transcript of Letter from Professor Donald Shaughnessy to Dean Clifford Lord, School of General Studies, as dictated to George Fontaine, September 12, 1961, Box 42, Harry Frank Guggenheim Papers, Library of Congress.

p. 259 "In his first week" Keeler, *Newsday: A Candid History*, 383.

p. 259 "He was paired up" Keeler, *Newsday: A Candid History*, 383.

p. 260 "His copy was marked up so extensively" Keeler, *Newsday: A Candid History*, 383.

p. 260 "Dana had absolutely no future" Keeler, *Newsday: A Candid History*, 383.

p. 260 "Seven weeks later" Keeler, *Newsday: A Candid History*, 383.

p. 260 "I have ever tried to convince you" Letter from HFG to Dana Draper, May 2, 1967, Box 42, Harry Frank Guggenheim Papers, Library of Congress.

p. 261 "*Newsday* historian Keeler recounted a meeting" Keeler, *Newsday: A Candid History*, 279.

p. 261 "Uncle Harry took Joe and Madeline" Madeline Albright, *Madam Secretary: A Memoir*, (New York and London: Harper Perennial, 2013), 56.

p. 261 "Harry invited them" Albright, *Madam Secretary* , 56.

p. 261 "Gatsby-like circle of friends" Michael Dobbs, *Madeleine Albright: A Twentieth-Century Odyssey*, (New York: Henry Holt and Co., 1999), 188.

p. 261 "Joe got to know the business side of the paper" Keeler, *Newsday: A Candid History*, 279.

p. 261 "Then it was on to the copy desk" Keeler, *Newsday: A Candid History*, 280.

p. 261 "He inherited 12 percent" Dobbs, *Madeleine Albright*, 193.

p. 261 "There was dinner one Saturday night" Dobbs, *Madeleine Albright*, 195.

p. 261 "homemade jams" Dobbs, *Madeleine Albright*, 195.

p. 261 "Dear Uncle Harry, what a truly marvelous spot this is" Letter from Madeleine Albright to HFG, dated Christmas, 1964, Box 104, Harry Frank Guggenheim Papers, Library of Congress.

p. 262 "He was striving to please Uncle Harry" Albright, *Madam Secretary*, 60.

p. 262 "no one ever came forward" Albright, *Madam Secretary*, 60.

p. 262 "The quiet and unassuming" Dobbs, *Madeleine Albright*, 222.

p. 263 "Two such opportunities opened up" Keeler *Newsday: A Candid History*, 390.

p. 263 "Moyers had let his interests be known" Keeler, *Newsday: A Candid History*, 390.

p. 263 "Johnson was annoyed Moyers" Keeler, *Newsday: A Candid History*, 390.

p. 263 "Over 6,000 servicemen were killed that year" Battlefield: Vietnam Timeline, 1966, PBS Online https://www.pbs.org/battlefieldvietnam/timeline/index1.html.

p. 263 "The number of American soldiers" Battlefield: Vietnam Timeline.

p. 263 "Moyers recalled the conversation to Robert Keeler" Keeler, *Newsday: A Candid History*, 390–391.

p. 263 "His older brother, James Moyers" Keeler, *Newsday: A Candid History*, 391.

p. 264 "After a second meeting at the Metropolitan Club" Keeler, *Newsday: A Candid History*, 393.

p. 264 "I believe Bill Moyers" Harvey Aronson, "Moyers Begins Job at Newsday," *Newsday*, February 16, 1967, 4.

p. 264 "stopped the presses for ten minutes to honor him, 'like a 21-one-gun salute'" Aronson, "Moyers Begins Job at Newsday," 4.

p. 264 "I've got a star" Keeler, *Newsday: A Candid History*, 394.

p. 264 "Bill Moyers is at long last" Keeler, *Newsday: A Candid History*, 394.

p. 264 "a mammoth celebratory lunch" "Gov, Senators Lead Moyers Welcome," *Newsday: A Candid History*, February 18, 1967, 4.

p. 265 "A newspaper, in fact, is like politics" "Gov, Senators Lead Moyers Welcome," 4.

p. 265 "We're going to have to spend $1 million" Keeler, *Newsday: A Candid History*, 395.

p. 265 "This included" Keeler, *Newsday: A Candid History*, 395.

p. 265 "In the coming months" "Long Island's Newsday Gets Fat, Respectable as the Area Prospers," *Wall Street Journal*, December 2, 1968, 1.

p. 265 "He hired writers from the New York *Daily News*" Keeler, *Newsday: A Candid History*, 405.

p. 265 "Recognizing the lack of diversity" "Long Island's Newsday," 1.

p. 265 "Lyndon Johnson suggested to Moyers" Keeler, *Newsday: A Candid History*, 400.

p. 265 "Former New York Governor Averell Harriman told Moyers" Keeler, *Newsday: A Candid History*, 400.

p. 265 "Sen. Robert F. Kennedy asked Moyers" Keeler, *Newsday: A Candid History*, 401.

p. 265 "When Martin Luther King was assassinated" Keeler, *Newsday: A Candid History*, 401.

p. 266 "If you can shoot quail at Cain Hoy" Keeler, *Newsday: A Candid History*, 401.

p. 266 "he wanted me to do more" Keeler, *Newsday: A Candid History*, 407.

p. 266 "resembled a tropical jungle" "For the Birds, Too," by Charlotte Curtis, *The Times Tribune*, September 22, 1968, 3.

p. 266 "A flock of exotic birds" "For the Birds, Too," by Charlotte Curtis, *The Times Tribune*, 3.

p. 266 "All were apparently rounded up" "For the Birds, Too," by Charlotte Curtis, *The Times Tribune*, 3.

p. 266 "New York Racing Association" An investigation had been launched by the New York state legislature to look into why, in an era when horseracing revenues were booming nationwide, the New York tracks were badly underperforming. The answer was that the New York tracks were some of the poorest quality tracks in the nation—Belmont had not seen a major upgrade since 1903. Jamaica, Aqueduct, and Saratoga were, in varying degrees, also dilapidated. Bettors went to New Jersey instead, whose tracks offered more modern amenities. There were rumors that if revenue didn't improve the state of New York would intercede. Members of the Jockey Club held a dinner to discuss the situation. Harry delivered his own critique of track operations to the group. This led to Harry's appointment, with two others, to a committee tasked with devising a plan to finance improvements.

p. 266 The trio included John Hanes, a Yale grad who had served in the U.S. Navy in WWI and was FDR's Undersecretary of the Treasury. They took a year to study the economics of these racing associations. Harry commissioned Frank Lloyd Wright to design a futuristic new model of a race track that could be the basis for rebuilding any or all of the four tracks. (It was rejected.)

p. 266 Privatizing the tracks was not an option, said Harry. The wildly lucrative nature of such a monopoly would bring suspicions of favoritism. "A private individual shouldn't be given a gambling franchise in New York," he said. "How are you going to choose that man?" Harry and his partners instead proposed that all four New York

tracks, each with its own management and shareholders, be merged into a single public company. The group obtained appraisals for what a fair share price would be and proposed what would later amount to $109 million in improvements. Harry and his colleagues were labeled by some in the New York legislature as a "gang of socialists." But shareholders of all four tracks agreed they should be consolidated, swapping their old shares for ones in a new entity, the New York Racing Authority (NYRA). By the early 1970s, the NYRA became New York State's "biggest paying asset," said Hanes. "We pay more taxes than all the banks and insurance companies combined."

p. 266	"Over the course of 35 years" Cain Hoy Dispersal catalog, November 14, 1969, p. II.
p. 267	"for a record $4,751,200" "Five Percent Is Fine for Finney," Column: The Racing World of Bert Lillye, *Sydney Morning Herald*, February 8, 1971, 14.
p. 266	"At a circulation of 425,000" "Long Island's Newsday," *Wall Street Journal*, 1.
p. 268	"On election eve" Keeler, *Newsday: A Candid History*, 414.
p. 268	"Well, now it's over" Keeler, *Newsday: A Candid History*, 414.
p. 268	"The reaction of the people in my office" Keeler, *Newsday: A Candid History*, 414.
p. 268	"He was diagnosed with" Irwin Unger and Debi Unger, *The Guggenheims: A Family History* (New York: Harper Perennial, 2005), 339.
pp. 268–269	"The paper's editorials had generally been soft on Nixon" Keeler, *Newsday: A Candid History*, 456.
p. 269	"distressed" Keeler, *Newsday: A Candid History*, 457.
p. 269	"What is it that Moyers is trying to do?" Keeler, *Newsday: A Candid History*, 457.
p. 269	"*Newsday* editorials now reflected increasing public skepticism" Keeler, *Newsday: A Candid History*, 460.
p. 269	"*Newsday*'s sympathetic coverage of Vietnam Moratorium Day" Keeler, *Newsday: A Candid History*, 461.
p. 269	"As he wrote in a memo to Moyers" Keeler, *Newsday: A Candid History*, 461.
p. 269	"a book beside him with a rearview photo of a curvaceous woman" Keeler, *Newsday: A Candid History*, 460.
p. 269	"They would never have done this to Alicia" Keeler, *Newsday: A Candid History*, 460.
p. 269	"The mastermind behind the prank" Margalit Fox, "Mike McGrady, Known for A Literary Hoax, Dies At 78," *New York Times*, May 14, 2012, B12.
p. 270	"There will be an unremitting emphasis on sex" Keeler, *Newsday: A Candid History*, 457–458.
p. 270	"I wound up in a series of meetings" Keeler, *Newsday: A Candid History*, 460.
pp. 270–271	"So much of it had to do with his fantasies" Keeler, *Newsday: A Candid History*, 384.
p. 271	"Harry once suggested Peter" Keeler, *Newsday: A Candid History*, 464.
p. 271	"poor first impression" Keeler, *Newsday: A Candid History*, 465.
p. 271	"In late 1968 Harry added a codicil to his will" Keeler, *Newsday: A Candid History*, 414.
p. 271	"That was the dividing line" Keeler, *Newsday: A Candid History*, 463.
p. 272	"'crotchety,' 'unreasonable,' and 'suspicious of everybody.'" Keeler, *Newsday: A Candid History*, 463.
p. 272	"Peter recalled he had no idea" Interview with Peter O. Lawson-Johnston, December 23, 2019.

p. 272 "a quarterly income equal to 5 percent" Unger and Unger, *The Guggenheims*, 348.

p. 272 "a 40 percent share in Guggenheim mining interests" Unger and Unger, *The Guggenheims*, 347.

p. 273 "Harry sat on an overstuffed couch" Dorothea Strauss, *Showcases* (Boston: Houghton Mifflin Co., 1973) 102.

p. 273 "his small head resembling a skull" Strauss, *Showcases*, 102.

p. 273 "What do you mean, you're selling *Newsday*?" Albright, *Madam Secretary*, 75.

p. 274 "Joe and Bill Moyers had never been close" Albright, *Madam Secretary*, 75.

p. 274 "Joe and his family ended up with more cash" Albright, *Madam Secretary*, 75.

p. 274 "to the wrong company" Interview with Peter O. Lawson-Johnston, December 23, 2019.

p. 274 "Harry bought him out for $300,000" Interview with Peter O. Lawson-Johnston, December 23, 2019.

p. 275 "Peter, if I should die in my sleep" Lawson-Johnston, *Growing Up Guggenheim*, 69. In taking over for HFG as chairman of the museum, Peter Lawson-Johnston went on to oversee international expansion of the Guggenheim over three successive directors: Tom Messer, Tom Krens, and now Richard Armstrong. Peter later brought his three daughters into key roles in the family business: Wendy Lawson-Johnston McNeil is on the Guggenheim museum board; Tania McCleery is on the board of the HFG Foundation; youngest daughter Mimi Lawson-Johnston Howe is president of the advisory board of the Peggy Guggenheim Collection in Venice. Son LJ serves on boards of both the museum and the HFG Foundation.

INDEX

ACKNOWLEDGMENTS

B ooks that succeed are a function of great collaborations. I've been incredibly fortunate to have many great collaborators on *The Business of Tomorrow*, starting with Peter Lawson-Johnston II, who supported this biography of Harry Guggenheim from its earliest days. Peter LJ and his father, Peter O. Lawson-Johnston, gave generously of their time both in New York and at Cain Hoy, as did Wendy Lawson-Johnston McNeil.

I'm particularly grateful to Bill Moyers, one of the great figures in American broadcasting, for his review of material in this book and the insights he shared on his unique relationship with HFG. Reeve Lindbergh offered similarly candid impressions of the decades-long friendship between her famous father and Harry. I'm particularly thankful to Richard Armstrong, director of the Guggenheim Museum, who offered some fascinating takes on the past and the future of the museum. Many thanks to Guggenheim associate director Lindsey Cash, who made valuable connections for me with staff at the museum's archives.

Much of this book was written at the New York Public Library's Frederick Lewis Allen Room, an incredible resource for writers. Melanie Locay, researcher director at the Allen Room, went beyond the call with myself and other writers-in-residence, enabling remote access to archives during a very difficult year. Over the months of the pandemic I was hugely fortunate to again have the Southampton home of my daughter's Godmother, Aura Levitas, as a writer's refuge.

I am especially grateful to my agent, Leah Spiro, whose journalistic instincts strongly guided this project. Leah saw the potential in Harry's story and has been a brilliant guide every step of the way. Another wise influence was Ellen Kadin, who played a major role in developing the original proposal. Jessica Case, deputy publisher at Pegasus, also saw the potential for this book—her wildly smart

perspectives on Harry's life were invaluable. Jessica has become my new trusted advisor on both the world of narrative nonfiction and the marketplace. I truly appreciated the falcon-eyed editing of Stephanie Ward and her incredible attention to detail. Drew Wheeler's first editorial pass was also spot-on and much appreciated.

My multiple visits to Cambridge University were brightened by the presence of Jayne Ringrose, a semi-legendary character on campus and former honorary archivist at Pembroke College. My interviews with her over tea at Harry's alma mater were mini clinics on Cambridge history. I am grateful to John David Rhodes, the warden of Leckhampton, Harry's residence during his years at Cambridge, and manager Aldona Maliszewska, for the time and research they provided during my visits there. My sincerest thanks to Tim Ellis at the Hawk's Club, both for his research and warm hospitality. The Hawks' recently christened building on Portugal Street is a fitting new home for this worthy and venerable club.

Another academic institution to whom I owe a great deal of thanks: Columbia Grammar and Preparatory School. I am particularly grateful to Jennifer Rhodes, director of institutional advancement; and Marvin Terban, acclaimed children's book author and the longest-serving teacher in the school's history. Both offered their time and valuable insights on the school's storied history. Thanks also to Marquis Austin, communications coordinator, who unearthed records that were key to chronicling Harry's time there.

Other members of the Guggenheim family were tremendously helpful in the research for this book, notably Ingrid Butler and Carol Langstaff. I am very grateful to the time Pulitzer Prize-winning author Robert Keeler spent sharing some of his thoughts about HFG formed during research for his definitive history of *Newsday*. Thanks also to two award-winning directors: Lisa Immordino Vreeland, who generously took time to share her insights on Peggy Guggenheim, Harry's cousin, and the correspondence between them; and Darroch Greer, director of "The Millionaires' Unit," a film about the first Naval aviators in WWI (and to Marc Wortman, author of the book by the same name that inspired the movie).

An early mentor on this project was Lt. Gen. Josiah Bunting III, former president of the HFG Foundation and former superintendent of the Virginia Military Institute. The hours we spent discussing this book and so many other topics deeply inspired me. I'm also grateful to the Department of the Navy and the National Archives and Records Service for their assistance in expediting my Freedom of Information Act request for HFG's military records. I owe a great debt to the talented reference librarians at the Manuscript Division of the Library of Congress in Washington, D.C., guardians of the Harry Frank Guggenheim Papers. I could not have done this book without you.